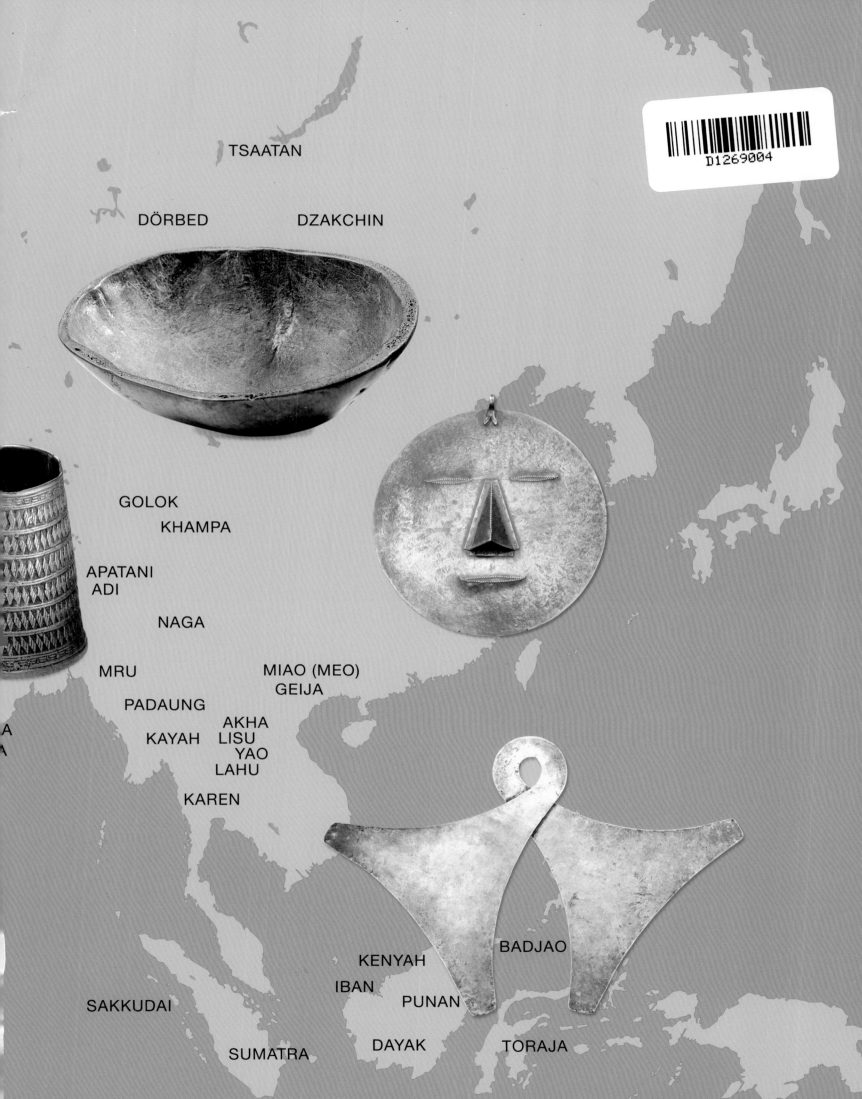

TSAATAN

DÖRBED DZAKCHIN

GOLOK
KHAMPA

APATANI
ADI

NAGA

MRU MIAO (MEO)
 GEIJA
PADAUNG
 AKHA
KAYAH LISU
 YAO
 LAHU

KAREN

KENYAH BADJAO
IBAN
 PUNAN
SAKKUDAI

SUMATRA DAYAK TORAJA

 BALI FLORES TANIMBAR
 SUMBA TIMOR

Tribal Asia

Robert Schmid Fritz Trupp

Tribal Asia

Ceremonies, Rituals and Dress

Thames & Hudson

Translated from the German *Asien: Kulte, Feste, Rituale* by John Nicholson

First published in the United Kingdom in 2004 by
Thames & Hudson Ltd, 181A High Holborn, London WC1V 7QX

www.thamesandhudson.com

First published in hardcover in the United States of America in 2004 by
Thames & Hudson Inc., 500 Fifth Avenue, New York, New York 10110

thamesandhudsonusa.com

British Library Cataloguing-in-Publication Data
A catalogue record for this book is available from the British Library

ISBN 0-500-54285-6

Printed and bound in Austria

Contents

We dedicate this book to all the people whose hospitality we were privileged to enjoy
in the course of our travels all over Asia. Their traditional ways of life allow us to understand
the variety and beauty that make up the glorious rainbow of human cultures,
and that may soon vanish in the anonymity of our own civilization.

The Forgotten Tribes of Asia

As time goes on, there seems to be less and less room in our global village for traditional tribal cultures. The lives led by the last tribes of Asia are now so restricted that their very existence is seriously threatened. It would nevertheless be wrong to put all the blame on Western expansionism. The fact is that the cultures of the world have always been in contact with one another, and so have influenced each other over the course of time. No society is static. All societies are subject to the dynamic processes of change and transformation and it is only through these processes that new developments can take place. It is also by no means easy to define which societies should be considered 'traditional' and which 'industrialized'. We all carry on traditions in one way or another and even industrialized societies have their own unique characteristics – their own religions, customs and modes of behaviour – and always have done.

We can only hope to understand the life of the forgotten tribes of Asia if we open ourselves up to the adventure of seeing their world through their eyes. Their belief in the existence of many different worlds inhabited by many different beings evokes in us a need to coexist with these worlds and beings, but it also challenges us to work out where we stand on these points and, where necessary, to confront them. They, the 'guardians of the earth', live a life free from all coercion, a life that is lived direct from the heart. Directed by reason and by knowledge of themselves and of their feelings, standing on the firm foundation of ancient but continuing traditions and world views, looking infinity bravely in the eye, they live their lives as their grandparents and their great-grandparents did before them. Free from the thought patterns of our achievement-orientated society, they are the real masters of the art of survival in a world that is, according to their standards, still unspoilt. Just as we do, they live out their own esoteric rituals, customs and taboos, and cultivate their own particular modes of behaviour – in short, they are all unique and living cultures.

The incredible adaptability of the tribes has made it possible for them to settle in places where human life was not thought to be possible, places such as the eternal ice expanses of Siberia, the red-hot sand dunes of the Gobi Desert or the subtropical equatorial rainforests. Each of these challenges has led to them shaping their lives anew with freshly developed techniques for survival. Just as their existence is characterized by harmony between man and nature, they can also be threatened by nature; consequently, their day-to-day life is permanently marked by the struggle for survival. Each time one of the innumerable tribes of Asia has adapted, it has simply gone through another stage of sociocultural development.

At this point it is important to refute once and for all the widespread fallacy that the ways of life and cultures of the tribes of Asia have stood still over the centuries. This kind of lack

of understanding of other cultures is not something which is restricted to Westerners as they look at their tribal brethren, but is something that is also common between the tribal groups themselves. Ethnic enmities were – and all too often still are – the main cause of tribal feuds and wars. We, the tribes of the developed world, have this in common with the tribes of Asia. The only difference is that our wars, the wars of the so-called 'first world', are no longer waged with primitive weapons. Instead, multinational corporations and lobbies use all possible means to come out on top on the battlefield of the commercial and financial markets. This struggle for power and honour seems to be as firmly entrenched in the consciousness of modern man as it is in the heads of those who have never even set eyes on a television screen. But there are great differences between the ways that we and they wage war. While world wars tear apart whole societies, tribal conflicts are mostly pursued in a ritualized manner, so that damage is minimalized. The important thing is the re-establishment of customary rights. It is quite possible to see both tribal and world wars as motivated by power struggles and greed, but all that is at stake in the case of tribal wars is usually a few stolen pigs, infringements of hunting territories or abducted members. And there is another important difference – tribal wars often end with marriages, ceremonies and the mutual giving of gifts, leading in their turn to alliances that secure peace in the future.

The elements that make up the Asian ethnic collage can be divided into two main categories. On the one hand there are the large and dominant societies, such as the Hindus in India or the Han Chinese in China, and on the other the smaller societies, the tribes. This book is concerned with these minority groups. Modern-day Asians see their own indigenous tribes as a disturbance, peripheral groups who are only concerned with obtaining rights for their traditional tribal lands; what is more, they attract a further nuisance – anthropologists who ask many awkward questions and tell the whole world about the things they have seen on their travels.

Many tribes have become the playthings of governments and big business. Their territories often lie in areas in which oil and mining companies have interests; when push comes to shove, the companies have an easy time of it and it is the indigenous peoples who have to suffer. In order to satisfy the growing demand for energy, mineral resources and consumer goods, bulldozers plough their way deeper and deeper into the mountains and rainforests, and thus into the traditional tribal lands. And yet it would be an over-simplification to lay the blame entirely at the door of the mining and drilling companies. On the contrary, we should take a long look at ourselves, since after all, we are the ones who create the demand that determines what they put on the market.

Commercial interests sometimes lead to entire villages being burnt to the ground without the outside world ever hearing about it. If the news does get out, the voices that are raised are immediately silenced. Places of worship are destroyed, mostly because they are in contradiction to what missionaries are preaching. Tribal members become refugees in their own country. For many of them, life is a daily struggle for the preservation of their identity; for many others, life is simply a struggle for survival.

In spite of all these adversities, they never leave their land, the origin of their existence; after all, their land is what feeds them, keeps them alive and teaches them to treat nature with care. However great the cultural differences between the various tribes of Asia, there is one thing that they have in common, namely their closeness to nature – for them, the core of their culture and their identity is Mother Earth. If their land is taken away from them, they lose that identity and end up living in slums, for to them the material and spiritual worlds are quite inseparable.

The survival of many tribes is dependent on the survival of the forests with which they live in symbiosis. Their knowledge of the art of living with nature – something which we

Westerners need to relearn – means that the forests provide them with protection and nourishment. The only thing that guarantees them a basis for life is their harmonious relationship with nature, a relationship that the tribes still show an extraordinary ability to maintain. We have not only lost that ability, but have also relinquished our original homeland in nature; going back to nature is something that only very few of us succeed in doing. That is all the more reason for us to admire tribal peoples for the way in which they rise to the challenges life brings them. While we Westerners subject the earth to our control, they live in harmony with it, knowing that the earth alone guarantees their survival and gives them nourishment, shelter, medicine and clothing. The earth is the source of their independence, which is why it is so important to preserve it. For the tribes of Asia it is nature that determines the law of life which they obey.

The power of the ancient nature religions with their spirits, gods and demons is still unbroken, because it is the nature religions which determine their religious ideas about the power of the natural elements. The tribes of Asia have their own kind of perception of reality, one in which the close link between the forces of nature and dream experiences is an important element. These tribal peoples view themselves as the centre point of their world and achieve awareness of universality through their belief that they are the original creators of their ideas and deeds. The tribal peoples have particularly well-developed powers of imagination; their depth of consciousness enables them to hold firm to their origins, with the result that their earliest history still remains part of their present. All this is neither logically nor mathematically explicable, and much of it has a deeper meaning, beyond the grasp of physical laws. But the tribes of Asia teach us to stop wanting to explain everything rationally; there is so much of value hidden away in our subconscious that we ought first of all to rediscover and put to use.

Tribal people do nothing that is superfluous, because any waste of resources and energy can be life-threatening. The fact that their whole life is permeated by the habit of concentrating on essentials allows them to survive in the deserts, the high mountains, the steppes and the rainforests. The tribes of Asia have never tried to subjugate nature, but have found their own place in nature's endless realm. They have learnt how to adapt to their environment and to be content with taking only as much out of nature each day as they need to survive. The prerequisites for this are a solid family structure and a functioning society. They know that when life is dangerous we all need companions, and companions can only be found if we follow a common path, one that we all recognize as being the right one.

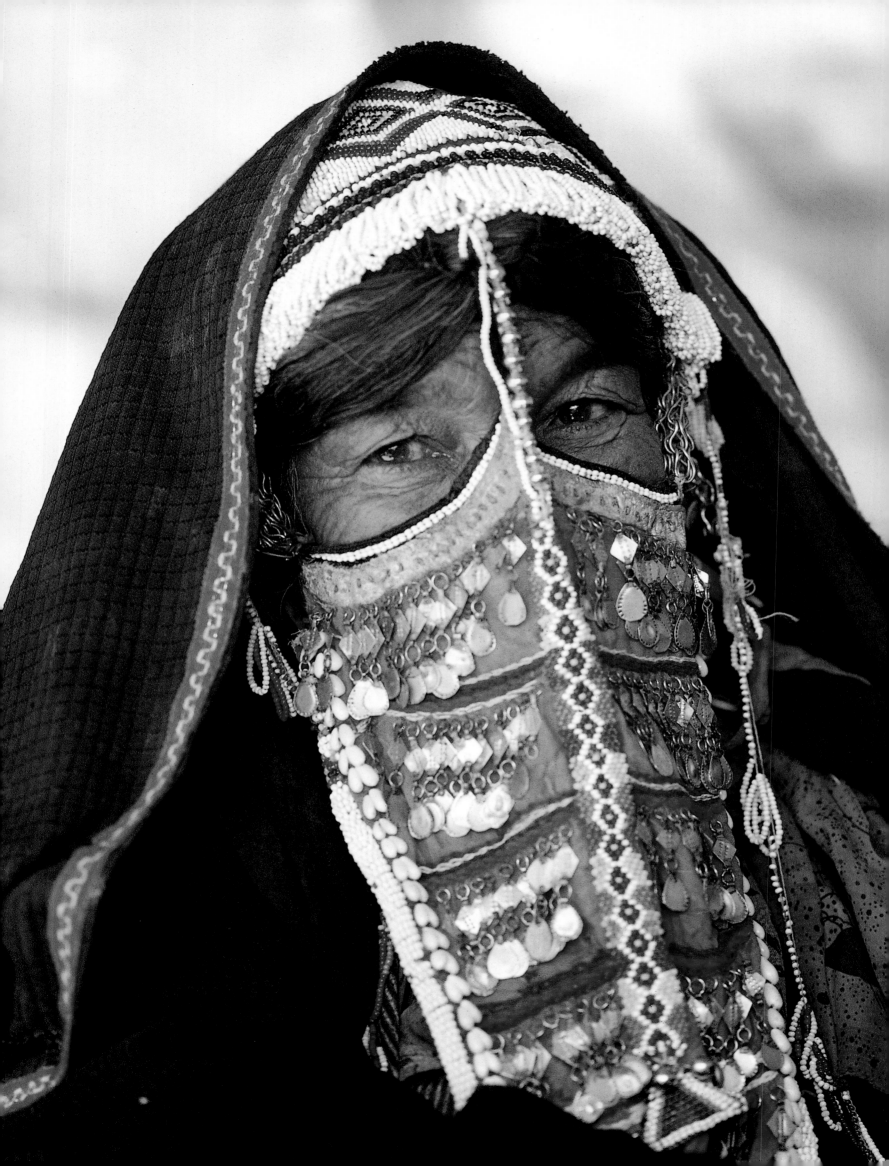

'On the oil-fields, the Bedu could find the money of which they dreamt. They could earn large sums by sitting in the shade and guarding a dump, or by doing work which was certainly easier than watering thirsty camels on a nearly dry well.... Their love of freedom and the restlessness that was in their blood drew most of them back into the desert, but life there was becoming more and more difficult. Soon it might be altogether impossible.'

Wilfred Thesiger, *Arabian Sands*, 1959

Chapter 1
Ancient Arabia
Silver Moons and Copper Coins

The southern part of the Arabian peninsula is a world of wonderful landscapes – mighty mountain massifs, bare highland plateaux, life-threatening wildernesses, sea-like sand dunes, only occasionally interrupted by oasis settlements. At the heart of the peninsula is a desert that is almost half as large as Europe and so bare that it is known as Rub al-Khali or 'Empty Quarter'. This desert area has had an eventful history and has been home to major cultures, with trading relationships that once stretched across the known world. From the Indian Ocean, the legendary incense trading route led through the Arabian peninsula to the Mediterranean, bringing its beneficiaries enormous wealth. Legend also tells of a woman famous for her beauty and intelligence, whom history records as the Queen of Sheba.

Since time immemorial, the desert areas have been home to the Bedouins, Arabian nomads who slowly expanded their territories over the entire peninsula that separates the Indian Ocean and the Persian Gulf. Pure nomads in the strict sense of the word are no longer found in southern Arabia. Although most of those in Yemen lead a semi-sedentary life, they have still to a very large extent preserved their traditional tribal structure. The Bedouins are very well adapted to their traditional lifestyle. They dwell in lightweight, easily transportable tents made from poles and cloths that are woven from the wool of black long-haired goats. They restrict their stores of food to what is absolutely necessary. The nomadic economy is of particular importance today because it uses ecologically peripheral areas that would otherwise become barren. Nowadays many Bedouins live in temporary settlements on the edge of desert areas or oases, and some plant date palms and breed sheep and goats. Camels are particularly highly valued because as well as being beasts of burden and a mode of transport, they also supply wool and milk. Some tribes in Wadi Hadramaut supplement their income by collecting resin to make incense.

In the partially inaccessible mountain and highland regions of the 'roof of Arabia', northern Yemen, lie the tribal areas of a sedentary, peasant community divided into several classes. Their economy is based on the cultivation of coffee, millet, wine and above all *qat*, a bush-like plant whose leaves have a stimulating effect when chewed, and for which there is consequently considerable demand.

Bedouin woman from the Sinai with a richly decorated veil.

The oases are many things to many people – not only are they the settlement areas for settled agriculturalists and centres for trading and crafts, but they were also the places where the conditions were created for urban culture. Their beginnings lie many thousands of years back. In the bigger towns there are lively bazaars and harbours, where dhows can still be seen lying at anchor, those ancient boats that remind us so vividly of the stories of Sinbad the Sailor.

These last decades have seen far-reaching changes overtaking the Arabian peninsula. Within a generation the combination of oil riches and an economic boom have catapulted a whole region as if from the medieval period into modern times. But in spite of all today's economic, social and political problems, there is still a hidden Arabia, flourishing as it always has done. Many tribal traditions and elements of their ancestral culture are still maintained in the south-west of the peninsula, among them fascinating architectural forms, clothing and jewelry. Most of the photographs in this chapter were taken on research trips to northern and southern Yemen.

In Yemen, as in all Islamic countries, an important role is played by the great variety of veils, turbans, skullcaps and other headwear. They are not only worn as decoration or to protect the wearer from sun and desert dust, but also have a spiritual or religious function, warding off imminent harm and the evil eye. For tradition-conscious Muslims, however, headwear has another significance, because the head is thought of as the part of the body that stands in a direct relation with God, but is also at risk from harmful magical forces. Boys often wear a cap, even when they are quite small, which is decorated with magical motifs or sewn about with amulets, to ward off harm. Like jewelry, all forms of clothing may also give information about the provenance and social status of the wearer.

One special and many-faceted theme is that of women's headwear, in particular the veil. Sonja Stockhammer described the veil in the Middle East as follows: 'This much-debated attribute becomes a symbol of female self-presentation, whether for the contemplative women of European culture, who wear it as "pure, innocent brides of Christ", or as a means of preventing the face from being seen, as in the case of sexually mature and/or married women in Islam. Veils always draw attention to the thing that is hidden and usually exert a certain fascination on the opposite sex; the veil appears sometimes to protect and sometimes to imprison its wearer. Whatever the case, it is always ambivalent.' It is the Bedouin women and women in remote mountain regions who have the greatest freedom in the extent to which they use the veil. The only time that they pull a part of their headscarf over their face is when they are confronted with strangers. And it is in the towns that the veil is used most strictly.

There is hardly a single part of the female body that is not thought suitable to be decorated with jewelry. A woman receives jewelry as her dowry; it is handed down from mother to daughter and is considered part of a married woman's personal property. A common feature of the folk religion practised by many classes of Islamic society is the idea of wearing magically significant jewelry. Amulets and talismans are worn by both sexes to avert need and poverty, and to protect the family, the harvest and livestock. Amulets come in various forms but are always worn as pendants on necklaces or belts.

There has been little thorough research into the origins of the silver jewelry of the Arabian peninsula. Antique pieces of jewelry are rare, because jewelry is constantly being melted down in order to produce new pieces. Pieces of silver

jewelry with a marked stylistic likeness to those of pre-Islamic cultures are to be found all over the Islamic world.

Although silver is the metal blessed by the Prophet and it is believed that gold is the metal of the Devil and so brings bad luck, many Arabian women no longer spend their money on silver jewelry. Instead, they prefer machine-manufactured gold jewelry from Italy or the Far East. Any silver that is still required for making jewelry comes from China in the form of ingots.

For many centuries, silver was obtained by melting down coins and old pieces of jewelry. The best-known coin was the so-called 'Maria Theresa thaler', first minted in 1751 and bearing the head of the Austrian empress. The coin was used extensively throughout Europe and the Ottoman Empire, and was probably owed its success with traders to the fact that it always had a silver content of at least 84 per cent. From 1783 the coin was minted mainly for export, and particularly for the coffee bean trade. According to Werner Daum's calculations, in 1900 there were around 200 million thalers, that is to say roughly 6 million kilograms of silver, in circulation in the countries on either side of the Red Sea. For two centuries Maria Theresa's 'Levantine thaler' was a favoured currency throughout the Middle East and until the Second World War it was the official state currency of Abyssinia. The coin was also much in demand as a piece of jewelry and was worn as a pendant around the neck. It was not until the twentieth century, when the coin was imitated in mints all over the world, that demand began to wane; Saudi Arabia officially declared the thaler valueless in 1928. But in the bazaars of the Middle East, particularly at the silver market in Yemen's capital of San'a', the Maria Theresa thaler is still a much-loved souvenir.

The decline of silver jewelry production in the south-western corner of the Arabian peninsula was also partly due to the fact that in 1948, the Jews of Yemen left the country to go to Israel. For centuries the production of silver jewelry had been in the hands of Jewish silversmiths. Nowadays the only areas where Muslim craftsmen may be found producing high-quality jewelry are Tihama and Wadi Hadramaut.

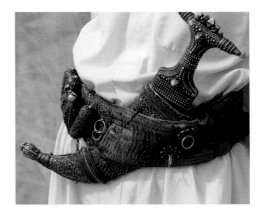

The greatest status symbols for Yemenite men are weapons – the traditional curved dagger and the modern Kalashnikov rifle. The most crucial features of the curved south Arabian dagger, or djambiya, *are the material used for the sheath and the artistry with which it is made, for these give clues to the provenance and rank of its owner. Some materials and forms of decoration are exclusively used by high-ranking religious leaders.*

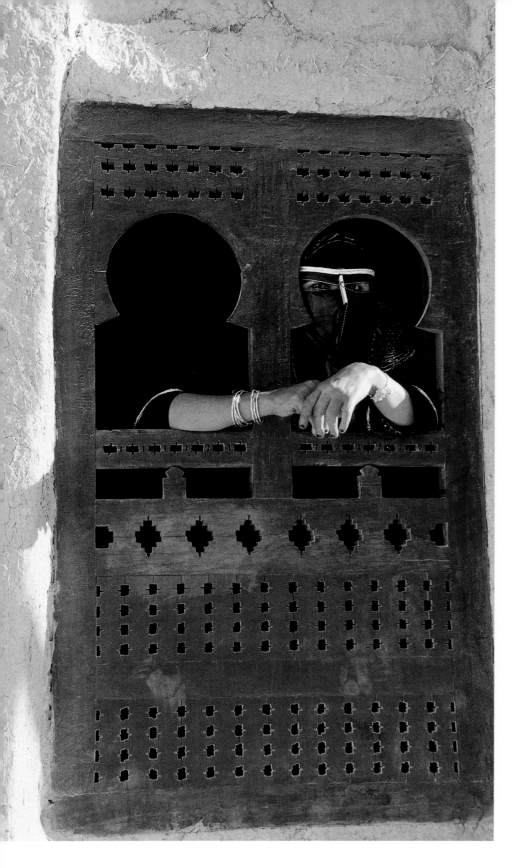

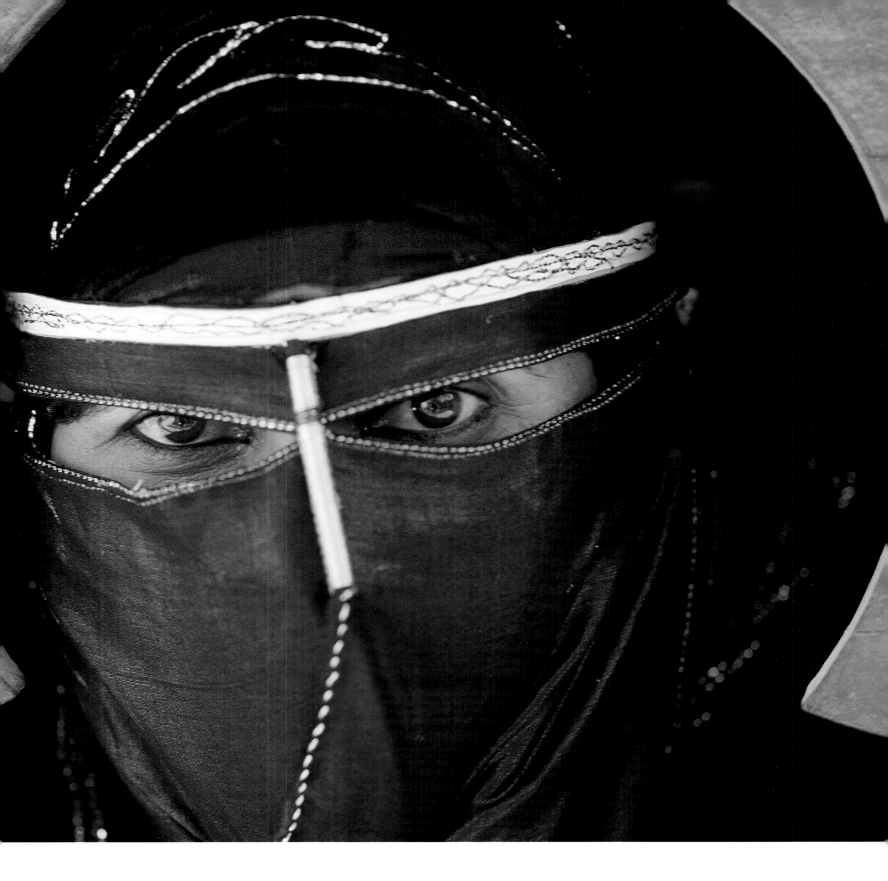

The Power of a Glance

In the southern Yemenite towns of the Wadi Hadramaut, women
wear a long black garment when out in public, and also the *burka*,
a mask-like facial veil made of fine muslin materials. A brass bar
over the bridge of the nose connects the forehead band with the
veil itself, leaving slits for the eyes. The oval-shaped wooden
opening focuses attention onto the eyes, which are made up
with kohl and black vegetable pigment.

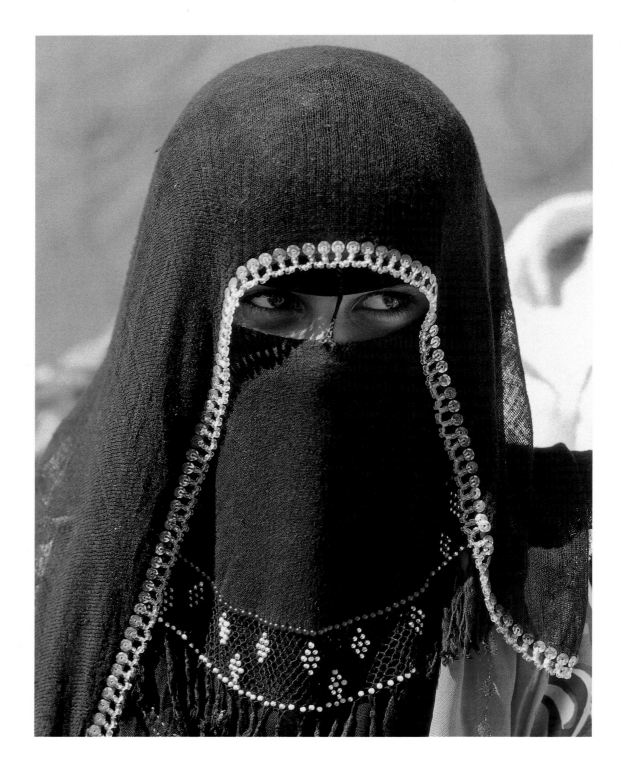

Desert Veils

Even before girls reach puberty, they begin to hide their faces with simple veils. As the years go by, they add silver threads, old coins and small amulets to their veils, thus giving them their own personal character. Most Bedouin women do not wear veils in the privacy of their homes.

Above: A Bedouin girl from the Shabwa region with cotton veils.

Opposite: It used to be customary among the Bedouins of the Negev for married women to wear heavy strings of coins in front of their faces, attached to a woven forehead band. The number of the mainly Turkish coins indicate the wealth and social status of the woman concerned. The beaded pendants on the temples have a magical function: the blue colour of the glass beads offers protection from the evil eye, the carnelians promote fertility and the amber beads promise good health.

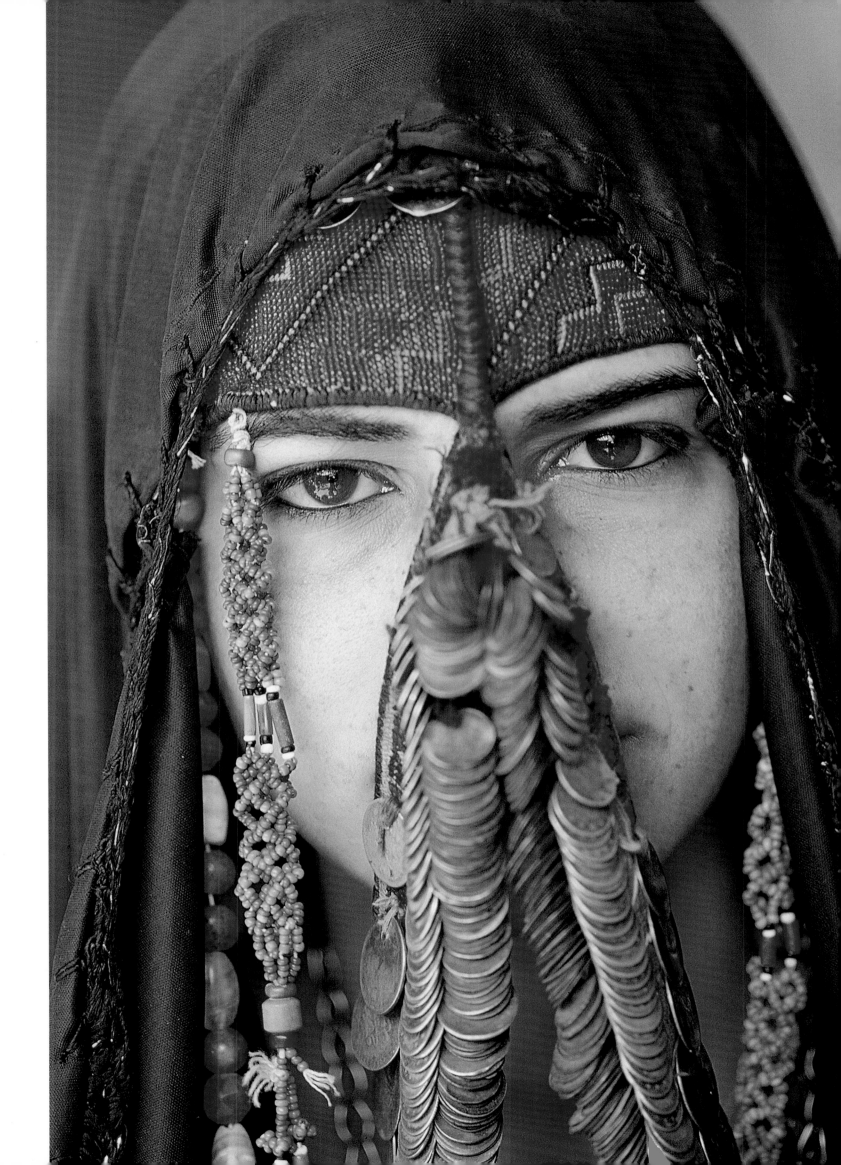

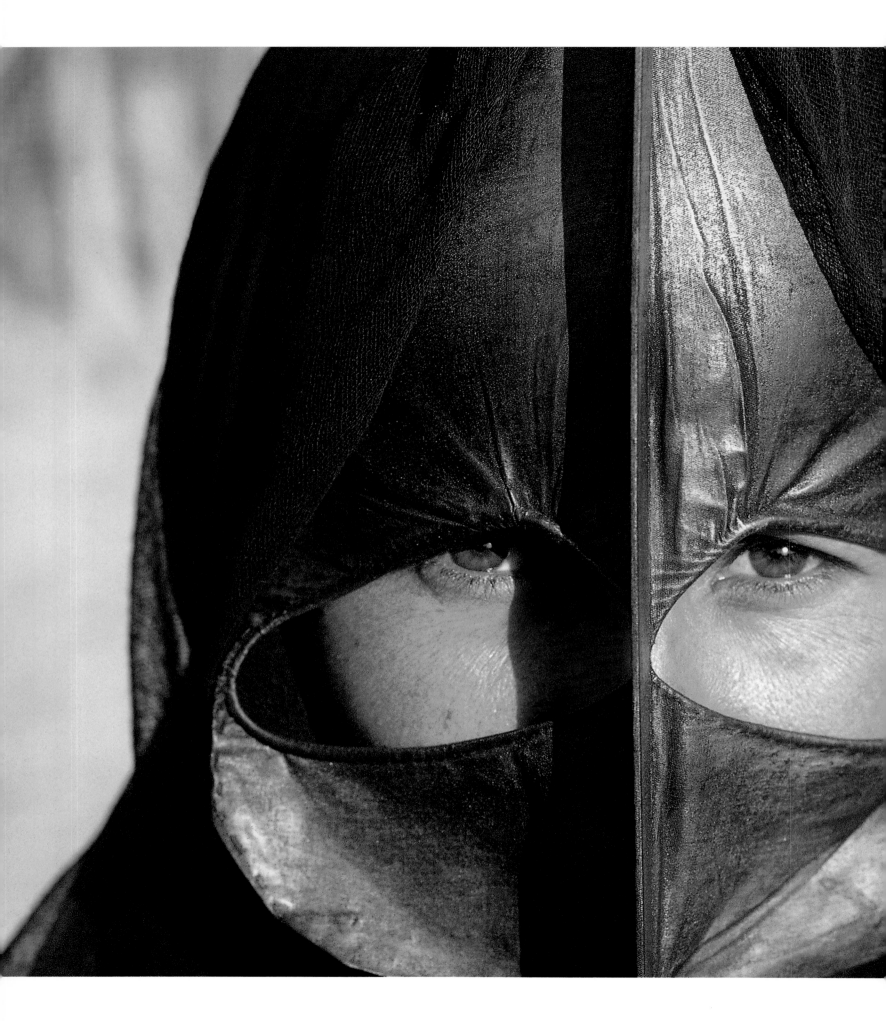

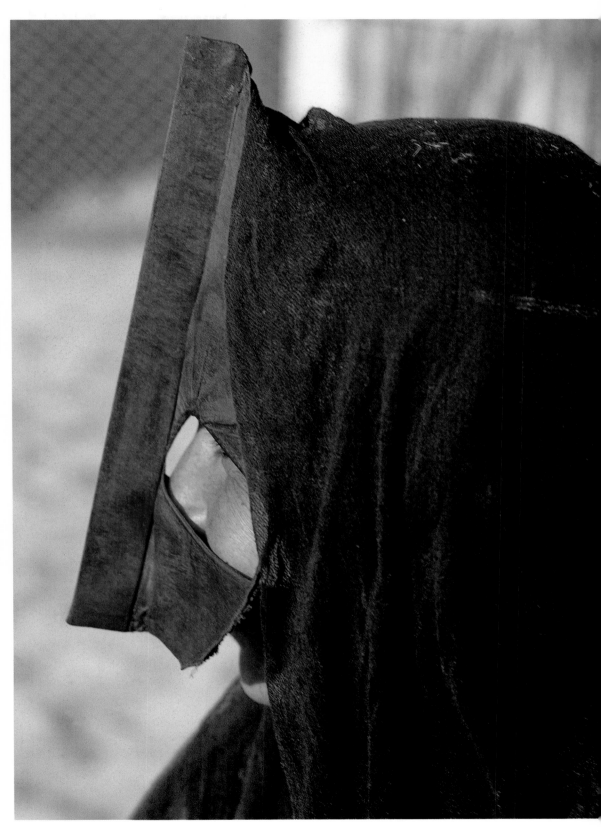

Veil Variations

This woman from the Wahiba Sands, an area on the edge of the Rub al-Khali in Oman, is wearing a so-called beak mask, with cardboard reinforcing the bridge of the nose.

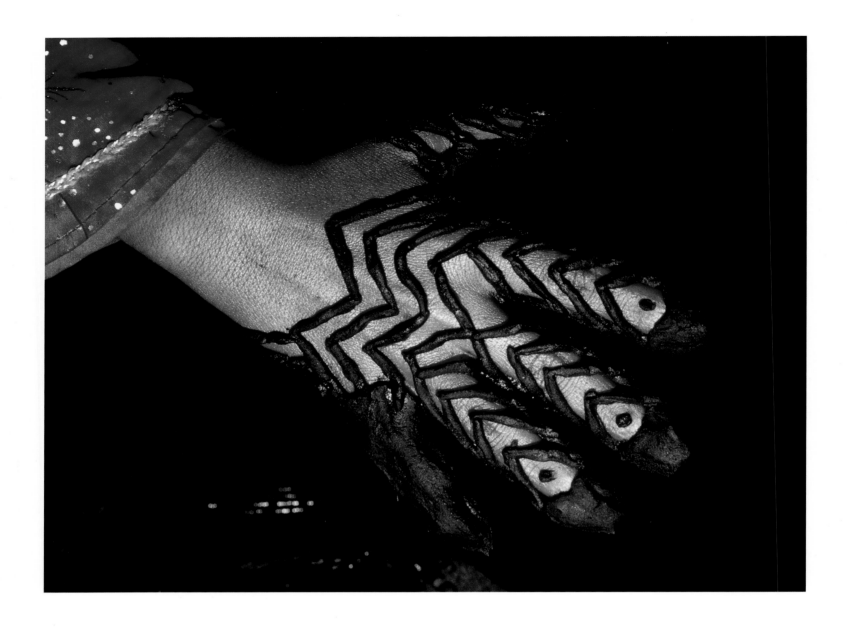

Henna Hand Decoration

The practice of painting the hands in the Middle East and in India derives from age-old traditions and is strongly associated with religious festivals, particularly weddings. In Yemen, the motifs applied with henna paste are not merely meant to look beautiful, but are also magical symbols that promote health and fertility. The raw material for the paste is provided by the pulverized leaves of the henna bush. These are combined with other vegetable substances to achieve colour tones ranging from bright red to pitch black.

The women are very careful with the decoration that they have applied to their hands, for as long as the decoration has not faded, the bride enjoys a period of grace during which she does not have to do any hard manual work. The floral hand decorations (opposite) come from the southern mountains, and the black geometric patterns (above) from central Yemen.

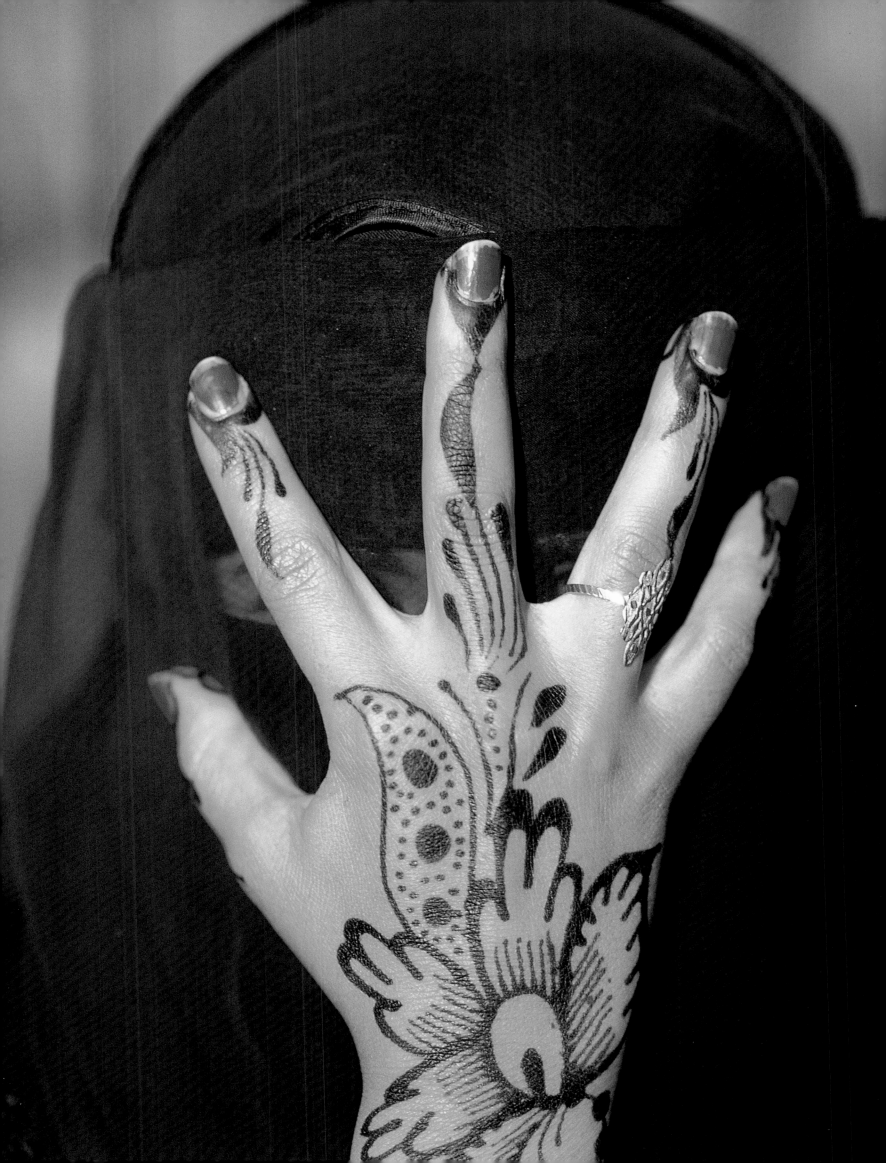

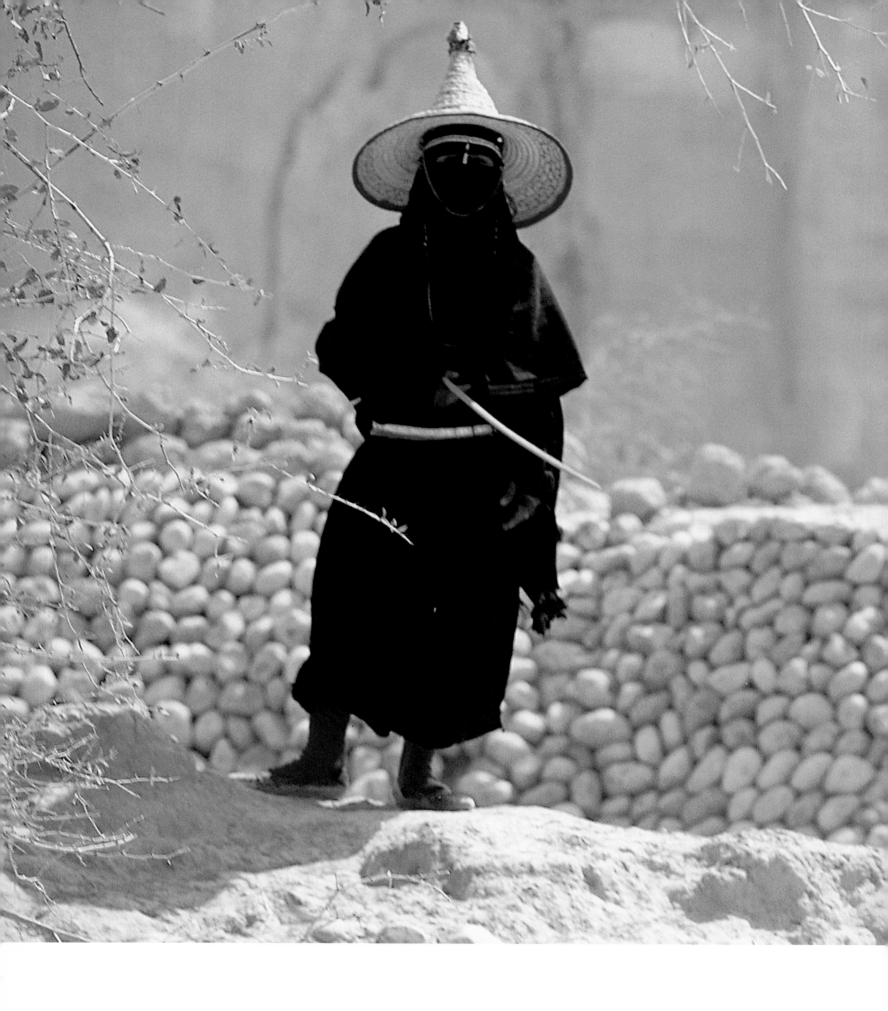

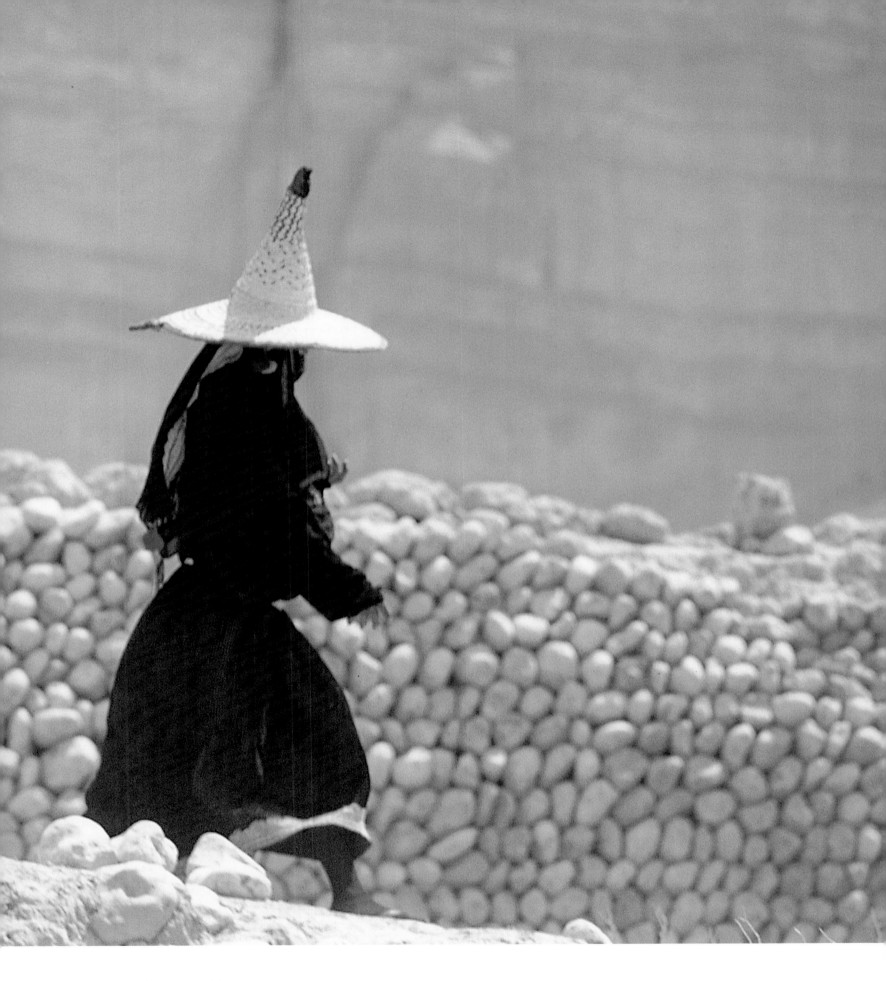

Hadramaut Hats

In the Wadi Hadramaut, cone-shaped hats made from palm fronds
protect the women from the sun when they are working in the fields.

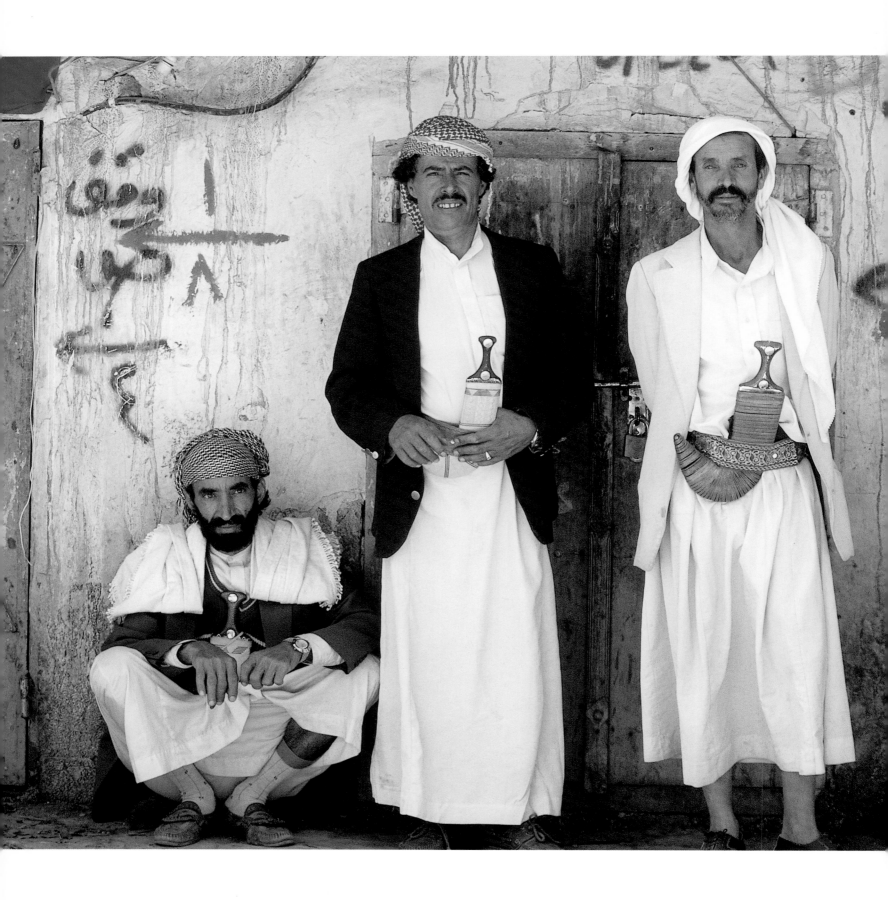

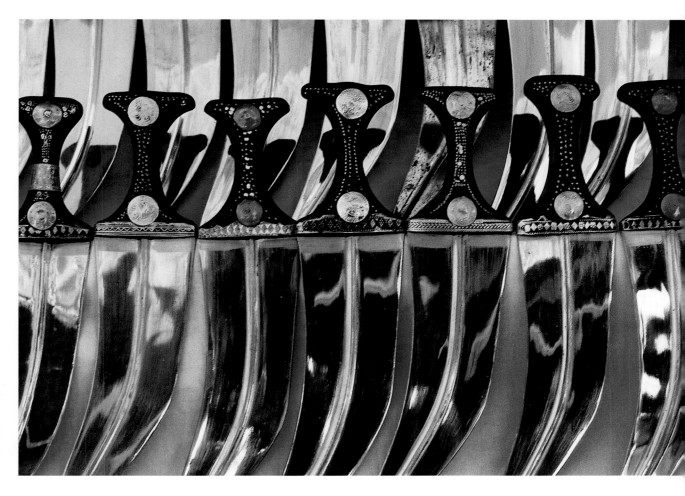

Symbols of Male Status

Left: There is nothing the northern Yemenite man is more proud of than his *djambiya*, or south Arabian curved dagger. No man over the age of twelve will appear in public without it. It is not so much a weapon as a sign of dignity and an expression of legal status. These men are wearing their markedly curved *djambiya*s right in the middle of their bodies, an indication that they are *galibi*, or free tribal warriors.

Above: In the bazaar in San'a', mass-produced curved daggers are now widely available. In many cases, the blades will have been imported from Kenya or the Far East. The handles are mostly made from the horns of Indian water buffalo or even from those of local cows.

Yemenite Tribal Warriors

The greatest prestige is attached to daggers with handles carved from rhinoceros horn. The blade must be cast in one piece, and the handle and sheath give an indication of its owner's rank.

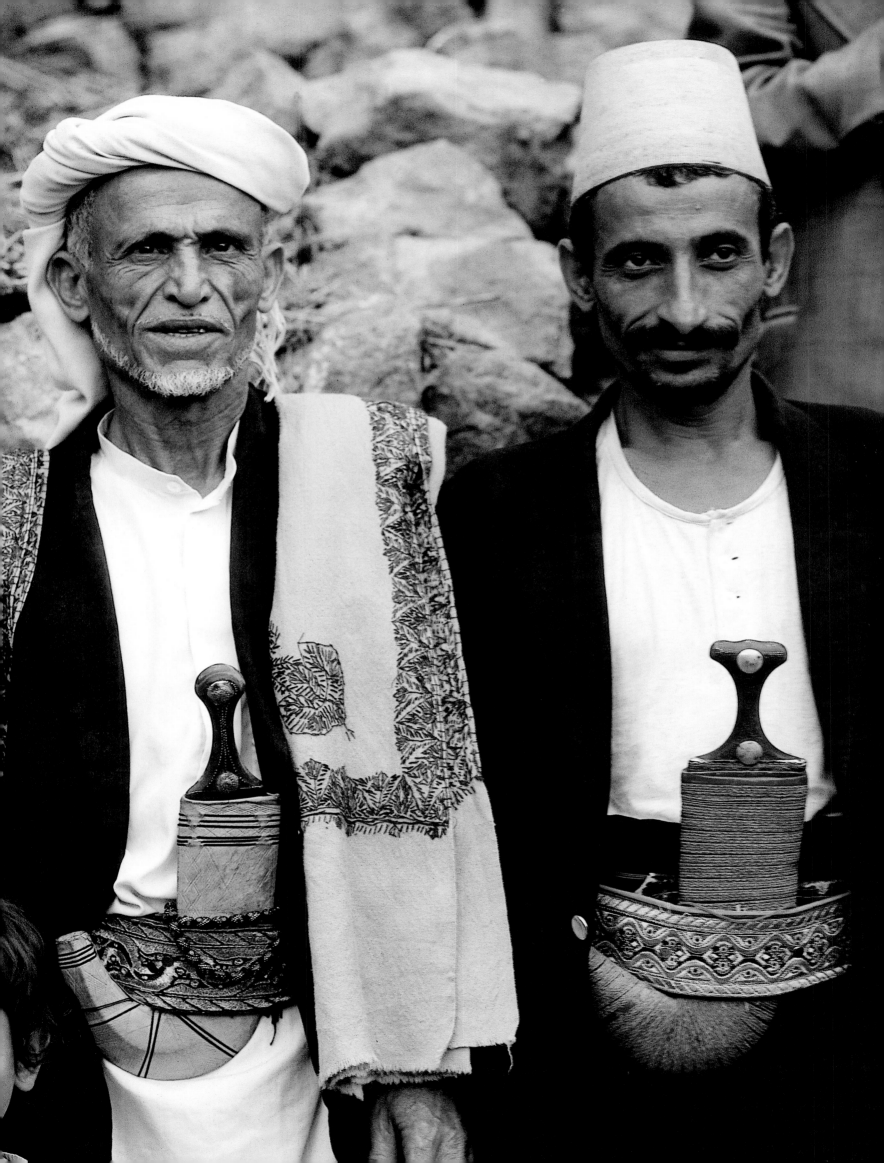

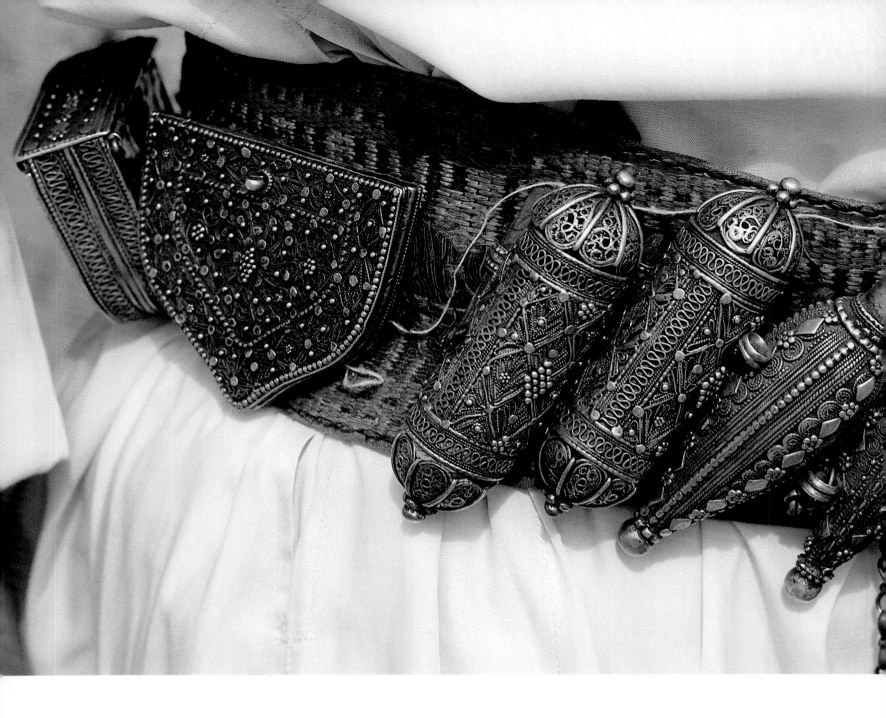

Amulets and Amulet Cases

Beautifully worked solid silver amulet cases are among the most common forms of jewelry in Yemen. They are hung around the neck on a chain as pendants, or attached to the wearer's belt. Many contain verses from the Koran, or magical formulas to ward off evil.

Above and opposite, top and centre: Cylindrical amulet cases are worn by both men and women and are particularly common in the highlands of north Yemen.

Opposite, below: These three amulet cases are notable for their unusual shape. The lids of the cylinders open upwards and the round shape, decorated in the middle with a rose, is reminiscent of a female breast. They belong to Bedouin women from the eastern desert area of south Yemen.

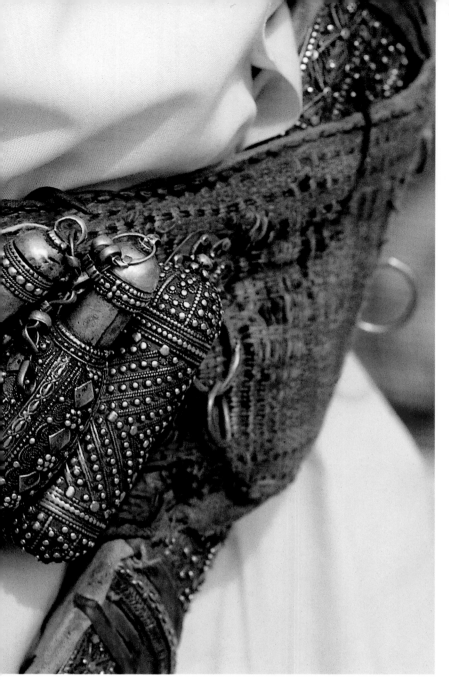
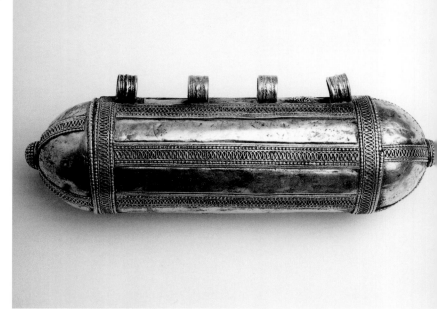
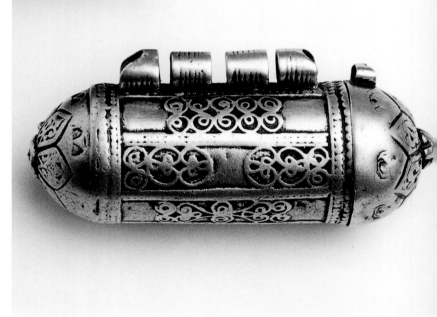
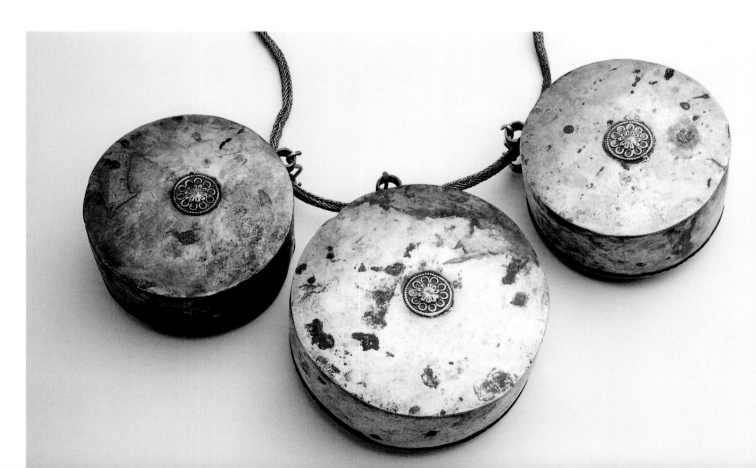

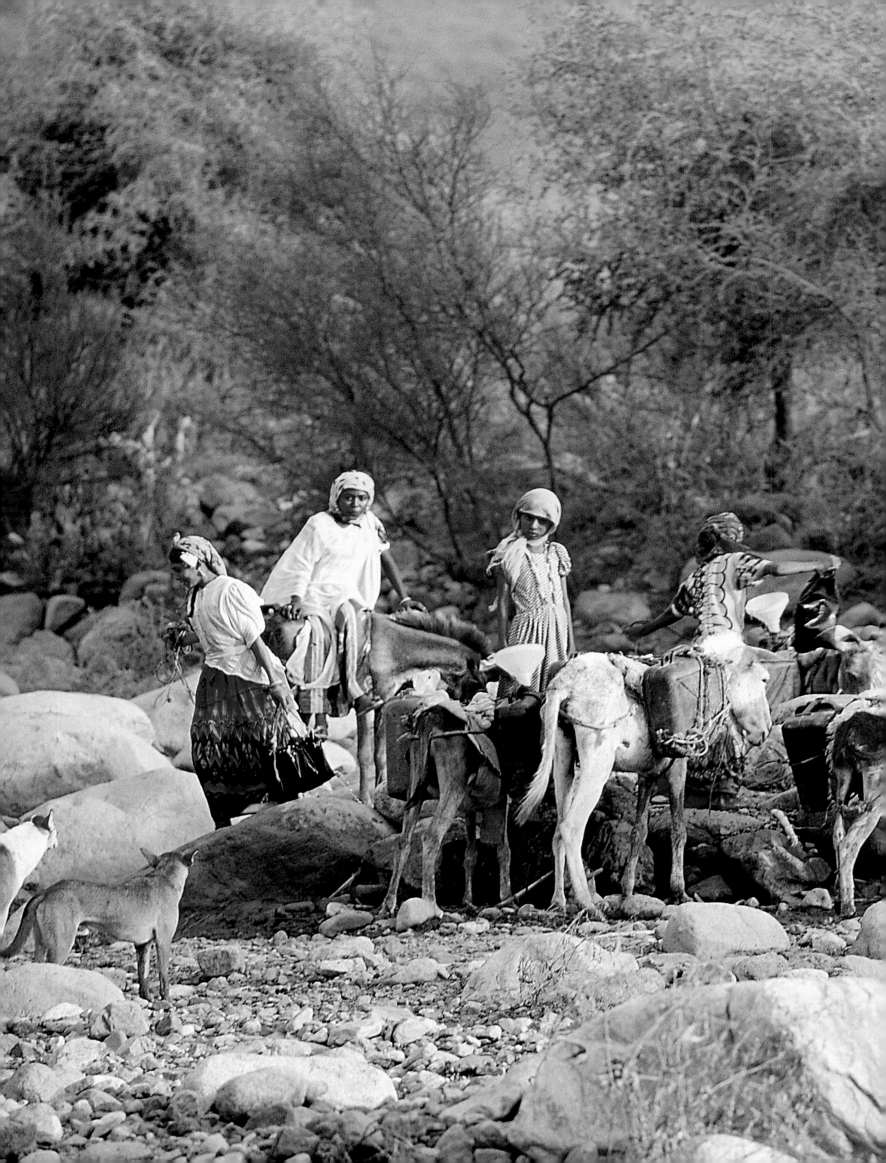

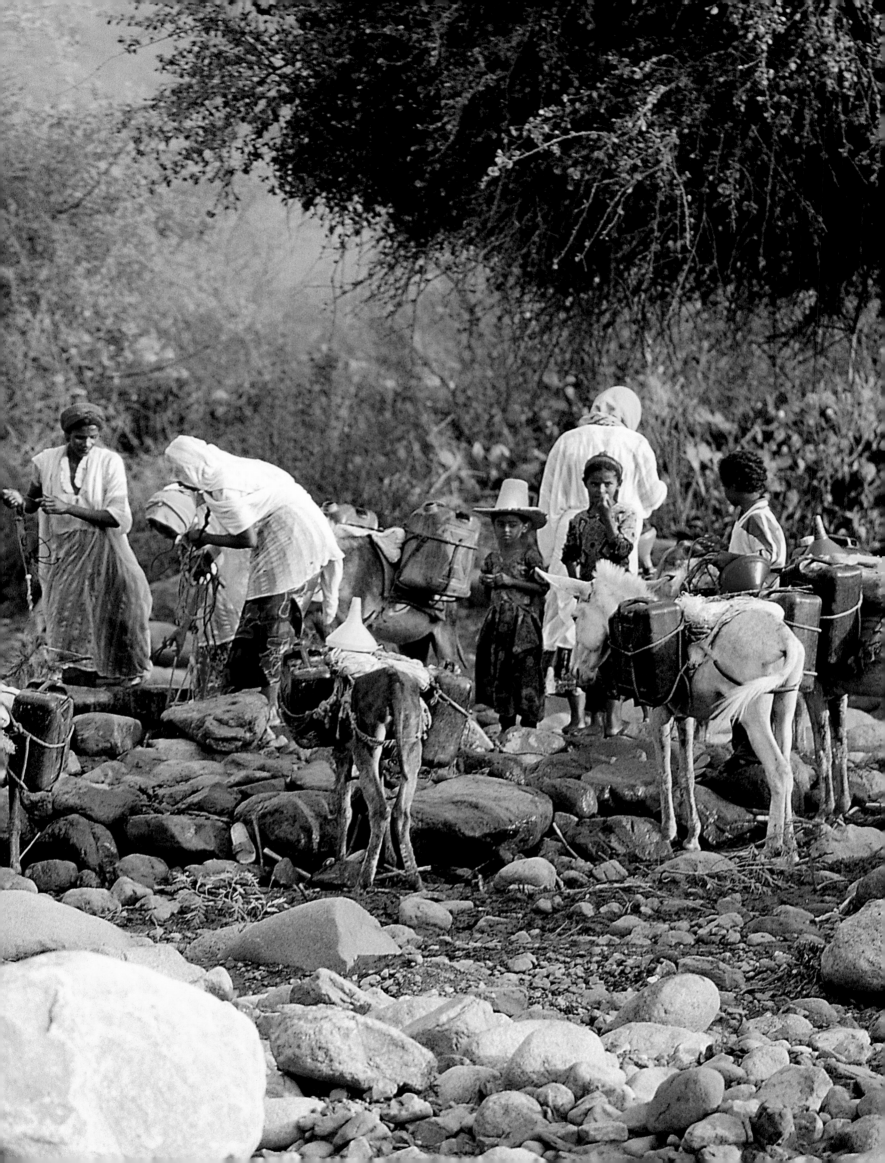

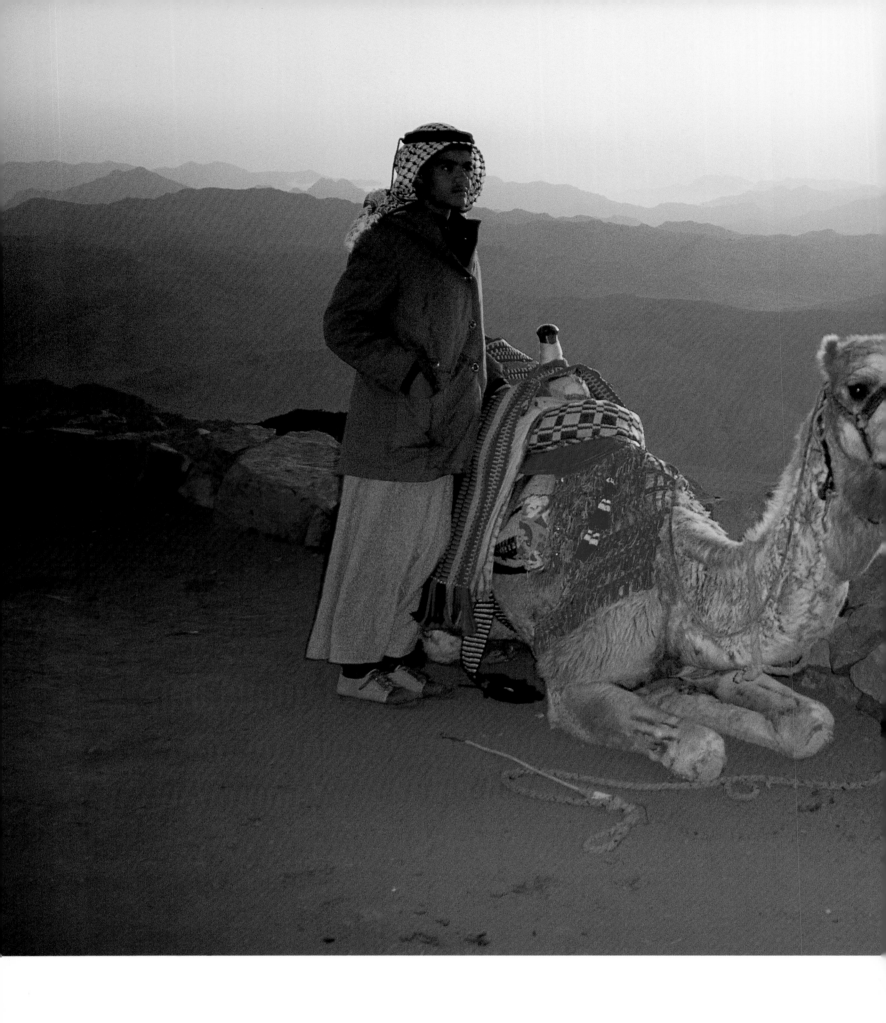

Arabian Landscapes

Previous pages:
Women drawing water in the Tihamah,
the coastal strip separating the Red Sea
from the Arabian mountains.

Left: A Bedouin from the northern Sinai
with his camel.

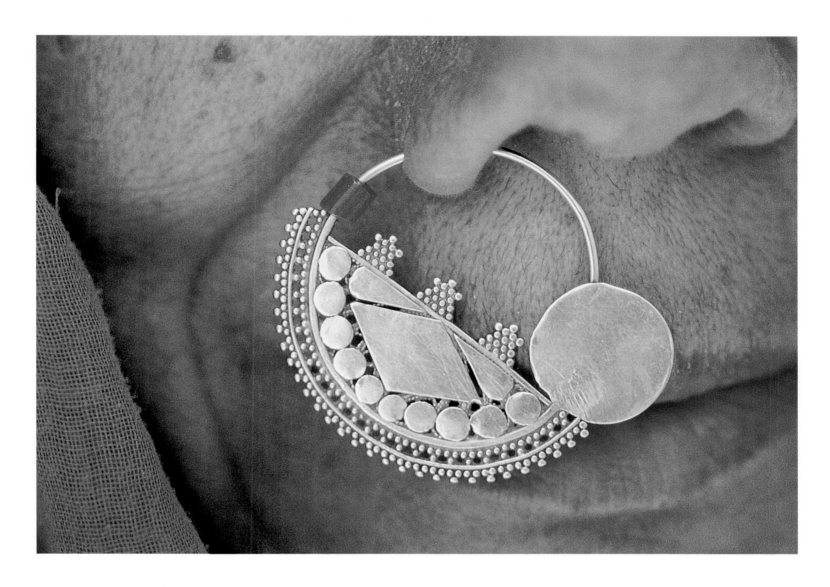

Golden Sun, Golden Moon

Above: A gold nose-ring from Egypt adorns the face of an old Bedouin woman from the Sinai. Gold ornaments were common in the cultures of antiquity, but nowadays it is often believed that gold brings bad luck, and silver is a symbol of purity. The majority of jewelry in the Islamic world is made of silver because that metal was favoured by the Prophet.

Opposite: The last rays of the setting sun illuminate a ruin in old Marib, which is reputed to stand on top of the legendary city of the Queen of Sheba. Both the sun and the half-moon are popular jewelry motifs.

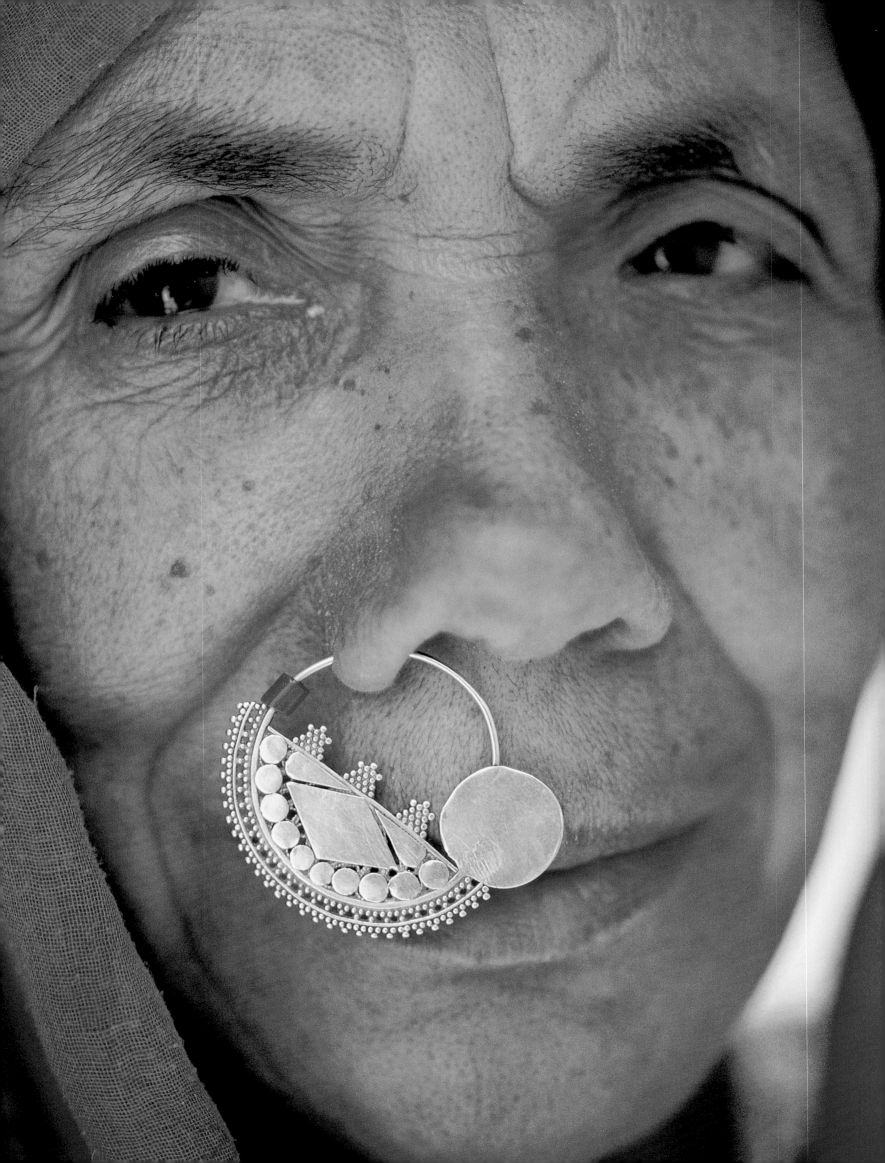

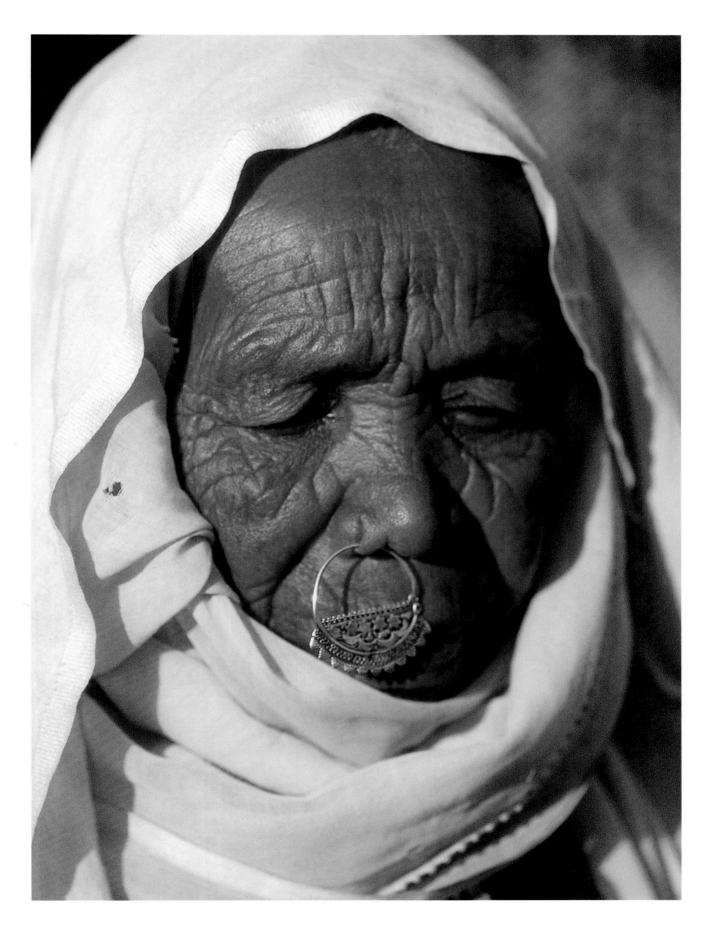

Some striking examples of half-moon jewelry. The woman opposite
comes from the Sinai and the woman above is from the Negev Desert.

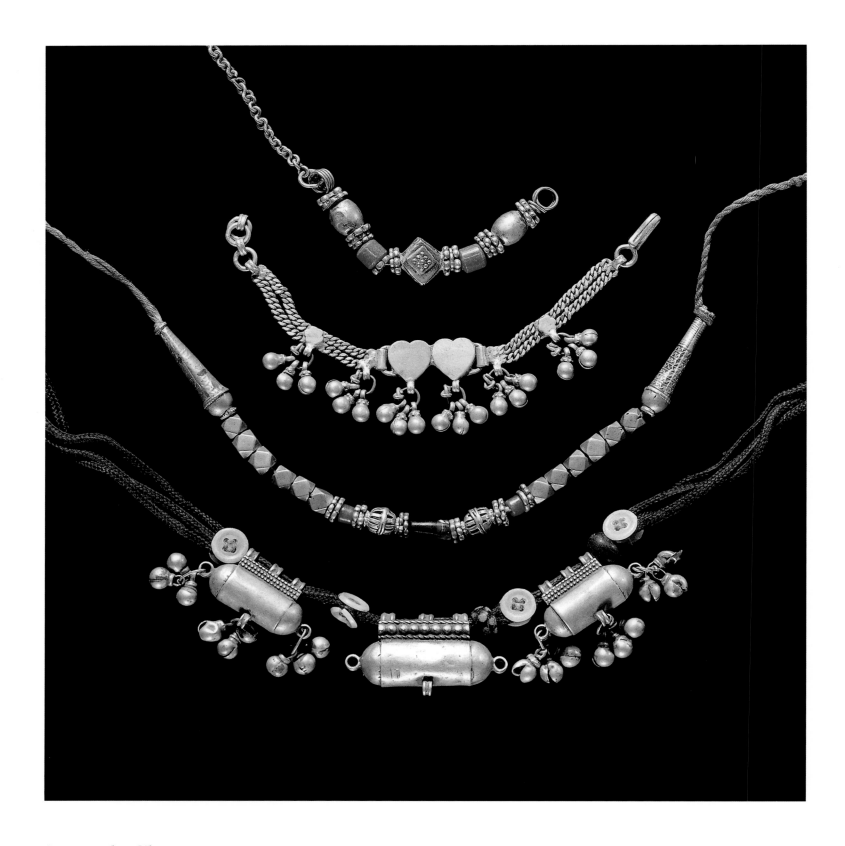

Spectacular Silver

Above: Girls' necklaces and amulet cases from Hadramaut in south Yemen.

Opposite: A woman from the mountains of Yemen wearing wedding jewelry, an impressive example of the craftsmanship of traditional Yemenite silversmiths. The filigree work is typical of the jewelry of the mountains, which is decorated with fine wire and the use of granulating and embossing techniques.

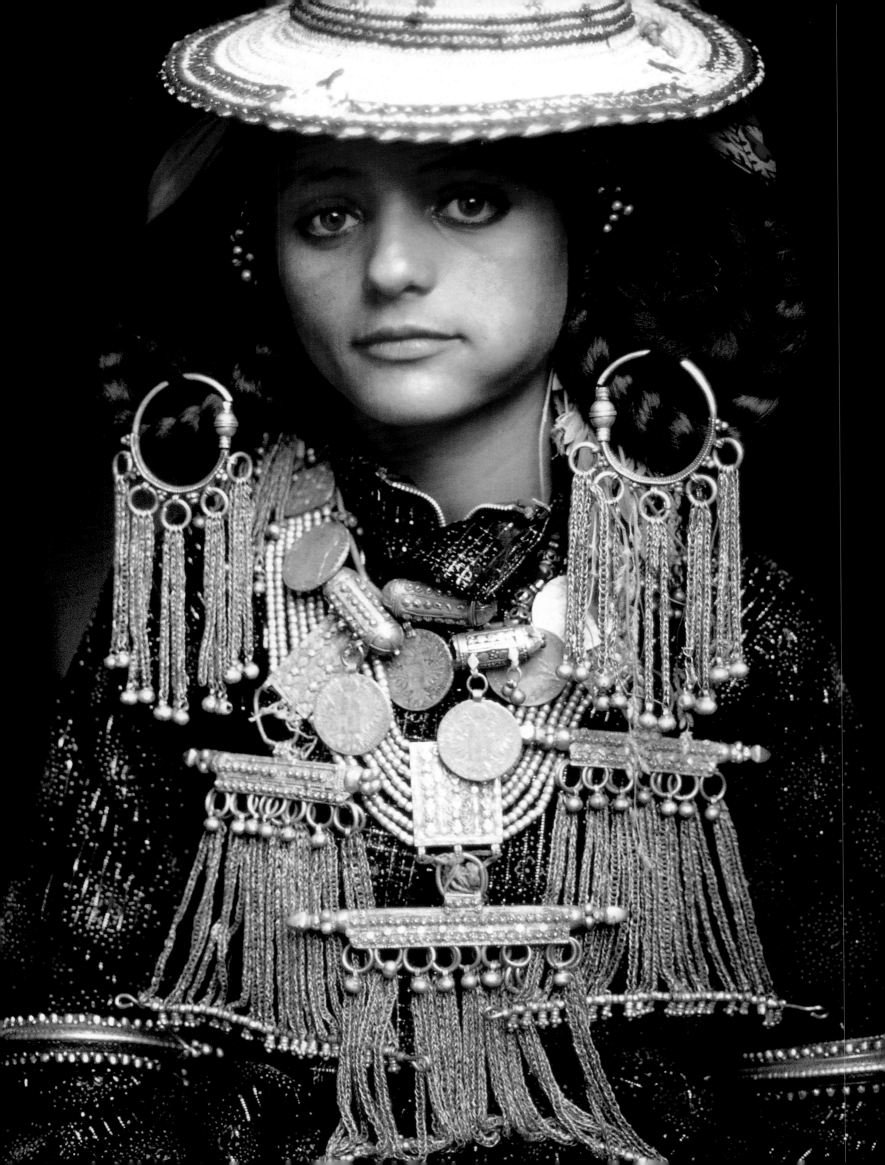

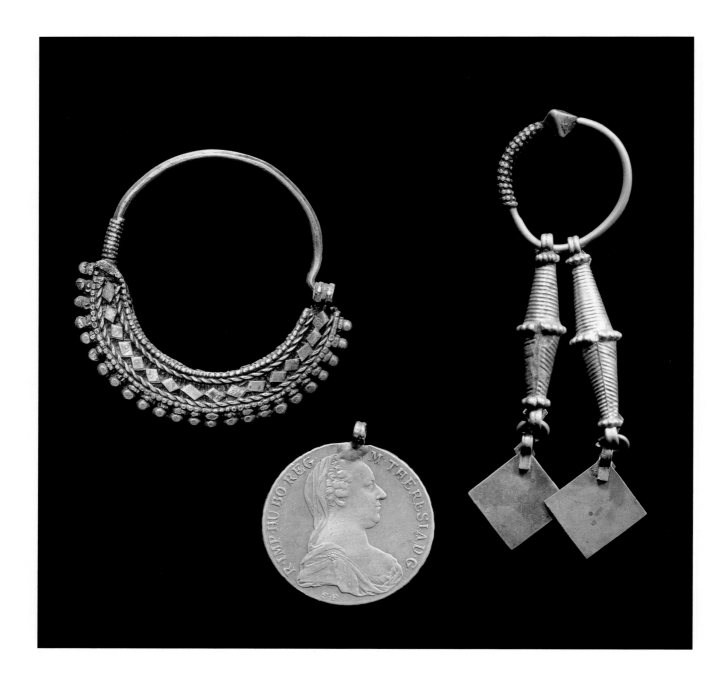

Earrings and Necklaces

Above: Earrings from the Marib area. The Maria
Theresa thaler used to be a popular pendant but as
the twentieth century went on and it was minted all
over the world, it began to go out of favour.

Opposite: Silver balls, chain links and beads, belts
in woven silver, and filigree settings are all important
elements in traditional Yemenite jewelry.

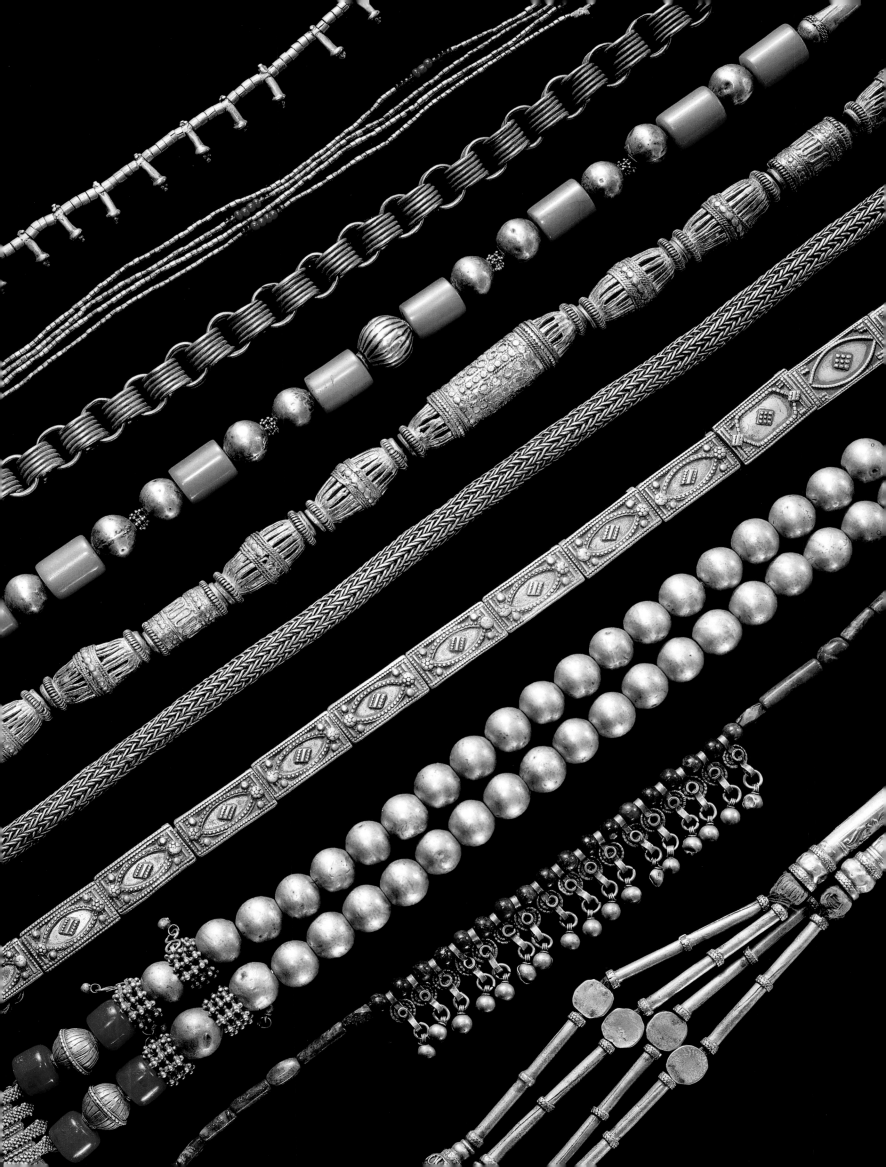

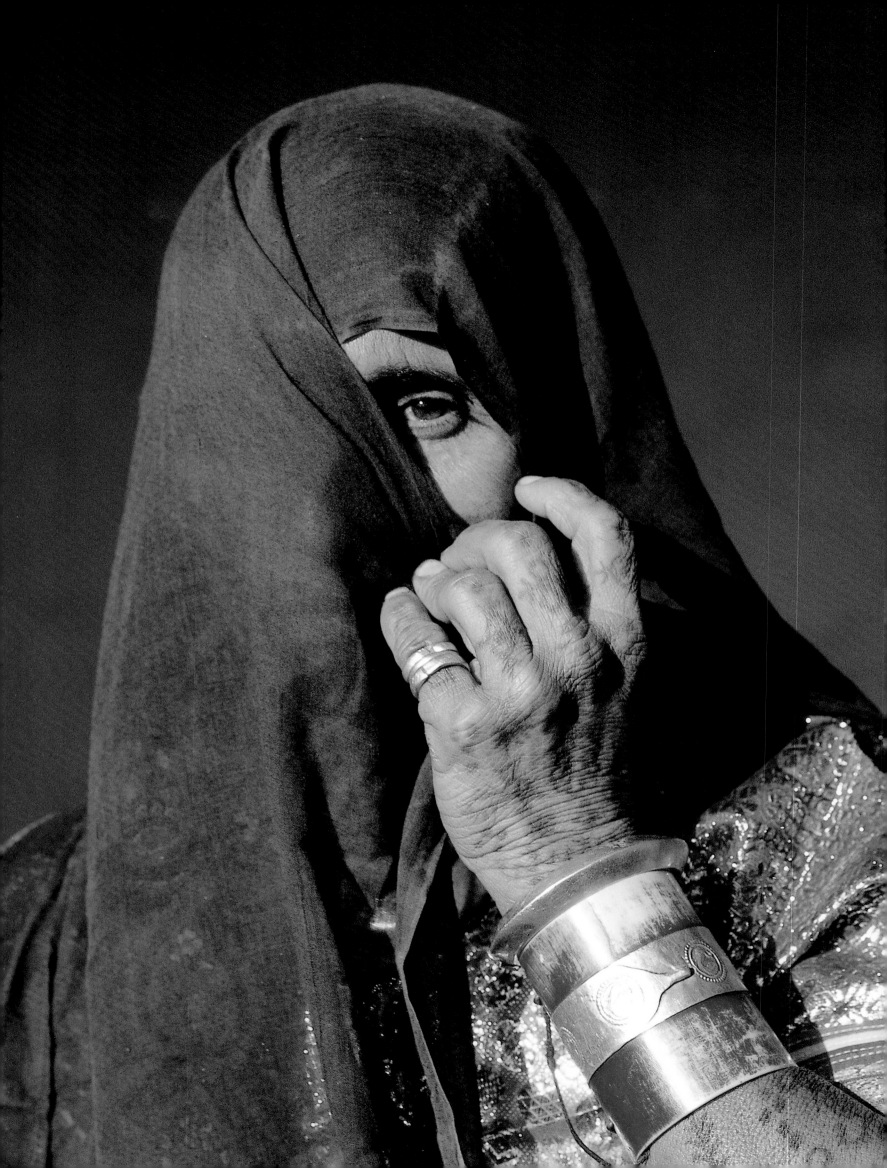

Chapter 2
Adivasi
The Indian Subcontinent

Indian tribal peoples who do not belong to one of the major religions such as Hinduism, Islam or Christianity are known as *Adivasi*, a Hindi word literally meaning 'first inhabitants'. The term is now used to designate the numerous tribes that occupied the Indian subcontinent in prehistoric times, non-Aryans at first, followed by Dravidians and later groups speaking Indo-European languages. India, with its extremely ancient and highly developed cultures and religions, is also a very complex ethnic entity. A great many foreign conquerors have ridden roughshod over the Indian subcontinent – Indo-Aryans came from Iran, Greek princedoms extended as far as the Indus, and central Asian horse-riding peoples such as the Scythians and Parthians established their principalities on Indian soil. Peoples speaking Munda languages migrated from South-East Asia, and Christians and Jews settled on the west coast, soon to be followed by Arabian traders. All of these brought their art and culture with them.

In the course of history, the world views of tribal cultures have often been fused with those of Hindus and Muslims, and vice versa. This phenomenon is particularly noticeable in the case of Indian artistic traditions, which boast continuous histories going back thousands of years. The famous stone figures of Sanchi and Konarak or the frescoes of Ajanta, for instance, feature representations of forms of jewelry still worn by the womenfolk of certain tribes.

Although there is great variety among the languages, cultures and ways of life of the Adivasi, they also have a great deal in common. Castes are foreign to them and they do not believe in reincarnation; women have equal rights with men and enjoy freedom in their choice of spouse, something which is a quite unimaginable privilege for many women living in India, where marriages are frequently arranged in accordance with Islamic and Hindu law. In most Adivasi groups it is furthermore not customary for brides to bring dowries, a practice that in the past has not only led to the financial ruin of many a family but also to the deaths of thousands of young women through 'dowry-murders'.

Adivasi peoples are very fond of celebrations and take advantage of every possible opportunity to commemorate their relatives, their ancestors and their gods. Sometimes buffalo are sacrificed in honour of the gods and a festival will often end with a drinking bout in which palm wine and home-distilled spirits flow like water until the break of day.

Such practices, so different from the customs of Hindu society, have led to the view, commonly held among Indians, that the tribal peoples – who eat the meat of cows, drink alcohol

A richly-tattooed Rabari woman.

and have a certain sexual freedom not enjoyed elsewhere – are barbarians, and more specifically 'impure'. Over the course of the centuries, the Adivasi were either assimilated to varying degrees or displaced and forced into uncultivable jungle or desert areas. The fact that their religion and way of life embraced many elements of Hinduism sometimes clouds the present boundaries between tribal society and caste society. The Adivasi were often integrated into the caste system, but on the very lowest rung of the ladder, which now means that they live out a poverty-stricken existence on the margins of social development.

Although almost all the tribal peoples of India have to struggle for survival, there are nevertheless some relatively isolated enclaves that have only been influenced to a very limited degree by Hinduism and Islam. These peoples, the last nature peoples, have resisted pressures exerted by religious zealots and the aggressive apostles of progress and still venerate the natural world, which they believe to possess a soul, and pay homage to local gods. Ritual leaders hold important positions in religious practice and in society, playing various roles such as healing the sick and acting as priests and shamans. Their artistic creations, which take the form of jewelry, clothing, architecture, music and dance, almost always serve a ritual purpose and serve as tributes to ancestors and gods. In India, the tradition of wearing jewelry (which may include all forms of personal adornment apart from what is actually clothing) is a very highly developed one; within this context, tribal jewelry has a particular significance as a symbol of ethnic identity.

The Bhil, the Gond and the Santals are settled in the so-called 'tribal belt' stretching from the Arabian Sea in the west through central India to the Bay of Bengal in the east. For them the only alternative to struggling to eke a basic existence from the barren soil is to give up their land and to try to earn a meagre living as rural labourers, an option pursued by an increasing number of tribal peoples in modern times.

The Eastern Ghats, a mountain range accessible only with great difficulty, is home to various Khond groups. They live mainly from slash-and-burn agriculture, and sometimes from hunting, in cases where over-population and deforestation have not driven wildlife out of their mountain homeland. When a series of harvests have exhausted the soil's nutritional reserves, a new piece of woodland has to be made arable, the burning process also serving to enrich the soil with ash. The neighbouring peoples, the Bondo, the Gadaba and the Saora have to varying degrees been successful in isolating themselves from the outside world. In these tribes, an important social role is played by the so-called 'youth dormitories', which used to be a feature of every village; these were places where young men and women would learn to dance and sing, and they also provided an opportunity for the sexual experiences that would later help them in married life.

The famous Bondo tribe is the most spectacular tribe of its kind in all India. Bondo means 'the naked ones', a name given them by the Indians of the plains, who traditionally have never had a good word for the peoples living in the jungle hills, whom they both despise and fear. Bondo men are stereotypically viewed as nothing but argumentative drunkards and infamous shots with the bow and arrow. The Bondo's own name for themselves is *Remo* which simply means 'human being'; they speak Munda, a complex Austroasiatic language. The so-called Bondo Hills, where they are settled, has been declared a prohibited

area by the government of India; the zone has a population of less than 5,000 tribal people, spread over 32 villages. The real reason why they have gained a reputation for being unpredictable and untamable is probably that they have thus far preserved their independence and have successfully resisted attempts at integration by the dominant Hindu culture.

Given that the Bondo have few material possessions, it may seem surprising that the women, who are distinguished for their gentleness and gracious looks, have a particularly strong attachment to forms of personal adornment. According to a traditional law derived from myth, they are allowed neither to let their hair grow nor to wear any clothing other than a home-woven loincloth. To compensate for their lack of clothing, they adorn themselves with a great range of forms of personal embellishment – several brass or aluminium rings are piled on top of each other around their necks and magnificent necklaces of coloured pearls cover their naked torsos down to the hips. They also wear armbands, belts and finger rings. The women seem to spend their every rupee on self-beautification, buying pieces of metal jewelry and glass beads and stringing them together to form chains.

In spite of their economic independence, many tribal groups nevertheless produce relatively little in the way of material cultural assets. Jewelry, textiles, clothing or objects for everyday use are bought at markets or from particular castes of artisans such as potters, smiths or metal-workers. In some areas, the Khond have lived for many centuries in symbiosis with some of the so-called 'scheduled castes'. For example, it is the Ghasia, members of a low caste of metal-workers, who are commissioned by the Khond to manufacture a range of jewelry, ritual objects and bronze figures which in earlier times were never put up for sale on the open markets.

The Khond revere some bronzes that possess ritual significance as votive offerings for gods. These include figurative representations of men and women, stylized animal figures and other motifs originating from their magical-religious world view. The bronzes, known as *dokhra*, served as tribal emblems, formed part of a bride's trousseau, and were in earlier times used in connection with human sacrifice. These bronzes have a characteristic network-like surface decoration created by the so-called wax thread technique.

If bodily adornment provides the most powerfully expressive elements in the catalogue of Indian tribal art, it is closely followed by domestic adornment. For the Adivasi, the home not only offers protection from the threats and dangers of the natural world, but also houses a holy and magical focal point, which is decorated with particular care. However, only a few isolated examples still exist of this style of monument, although they were once found way down into South-East Asia; likewise, carved wooden constructions are only occasionally found in the ritual houses of the Juang or the Khond.

The catalogue of artistic creation shows us the elements most typical of the artistic activity of these tribes when we look at their traditional mud-and-dung architecture. Cultic reliefs in mud and symbolic wall paintings are not only intended to be decorative, but also to release magical forces to enhance the well-being of the house's residents. The mud walls are coloured reddish ochre, black, white and bright yellow with mineral and organic pigments.

The wall painting of the central Indian tribal peoples is primarily geometric and decorative in character, covering relatively large surfaces; in their figurative

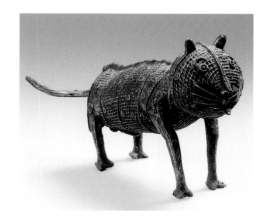

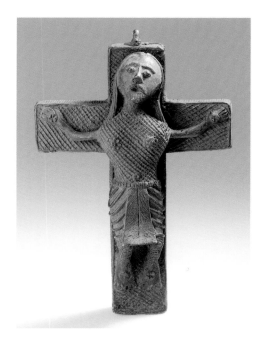

Dokhra *bronze figures of the Khond people. Above: The tiger plays an important mythological role as a beast of prey. Below: Christ on the cross – an example of acculturation.*

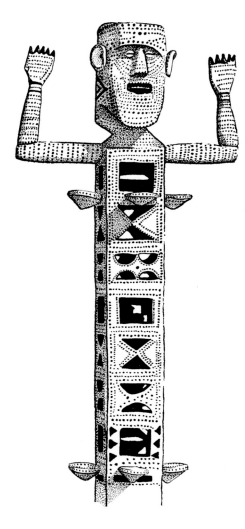

Gond wedding column, eastern India.

art, human figures are often represented in an abstract and linear manner, while plants and animals tend to be given a naturalistic treatment. The ritual nature of wall painting is at its clearest in the pictograms of the Saora, who live in southern Orissa, and is relatively familiar to us through the excellent documentary account of the Saora written by Verrier Elwin in 1951, in which he emphasized the high quality of their tribal painting.

These pictograms, known as *ittal*, are produced in honour of ancestors, guardian spirits or gods. The Saora believe that wall pictures not only avert bad luck and unhappiness but also promote fertility. They are instructed in dreams to portray the world of the spirits in a painting that will placate a specific angry spirit. Using a mixture of rice flour and water, a selected artist, who has likewise received instructions as to his motifs and scenery, paints in white upon the reddish-brown mud wall. A shaman checks the painting to see that all is in order and conducts a ceremony in which the picture is entrusted to a guardian spirit. After this consecration, the ritualized image is considered to be a sacred place and home to a favourable spirit, to whom homage is then paid through sacrificial offerings.

A variety of interesting ethnic groups living in the north-west of the subcontinent have a particularly important place on the ethnographical map of India. This region stretches from the Arabian Sea to the foothills of the Himalayas and is blessed with a great variety of landscapes; it has furthermore been the homeland of farmers, artisans and traders since time immemorial, and of herdsmen who roam around in search of pasture for their livestock.

Of particular importance to this region were the caravan routes that ran from the Ganges plain to Sind and from the north through the wastes of the Thar Desert to the harbour towns of Gujarat. The contact between traders and craftsmen resulted not only in commercial relations but also in an exchange of knowledge and ideas. Goods were sent by sea from the coast of Gujarat in Arabian dhows, which meant that Indian jewelry styles and working techniques found their way to southern Arabia and the east coast of Africa. Evidence of this influence can not only be seen in the jewelry of those regions but may also be admired in the ornamentation of magnificently carved wooden gates in Oman and Yemen, and on the island of Lamu.

In our own day the Rabari, Hindu livestock breeders, still traverse the broad expanses of bush and desert steppe between Gujarat and Rajasthan just as they did in ancient times. But from the onset of the dry season through until the monsoon it becomes increasingly difficult for them to find sufficient pasture land, as expanding populations from round about push further and further into their traditional territories. Life is made additionally difficult for these nomadic herdsmen by landowners who put up fences around their estates. Once camel-breeders, the Rabari now have few camels left in their possession and have specialized in raising sheep and goats, ensuring their survival through selling dairy products, meat, wool, and dung for heating purposes.

Many of them live in permanent settlements, cultivating the land and pursuing crafts, which have been kept up particularly well in the Kutch area. During the rainy season, this region in the boundary area between India and Pakistan is quite isolated, with some villages being turned into islands for months on end. Caste Hindus and Muslim livestock breeders live at peace with one another in the region, and it boasts a number of unique artistic traditions, most famous

among which are the great variety of textile techniques such as seal or stamp printing, embroidery and appliqué work. Similar techniques and motifs are also used to decorate house walls.

Another interesting ethnic group are the Bishnoi, a religious community whose beliefs commit them to taking particular care in preserving natural resources. They are spread over a wide expanse of the Thar Desert and have developed successful strategies for survival in this extremely dry region. They are forbidden to keep sheep and goats, since these would eat the land bare, and only keep the smallest of cattle herds, in order to avoid over-grazing.

The Banjara, today mainly employed to help in road-building, were originally a nomadic tribe; it was amongst the forebears of the Banjara that the Roma (or Romany) people originated, who by the late Middle Ages had spread as far as the Mediterranean. The Banjara women are easy to identify because they always wear magnificently embroidered clothes, ivory armbands and heavy silver jewelry, even when they are doing heavy work.

Many of the nomadic and semi-nomadic livestock breeders and herdspeople who are Muslims or Hindus by confession still have typically tribal characteristics and have preserved their own customs and way of life. With their colourful clothes and sumptuous silver jewelry, they are often seen at the livestock markets and festivals of north-west India.

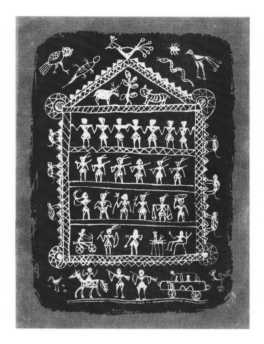

Ittal *wall painting of the Saora people.*

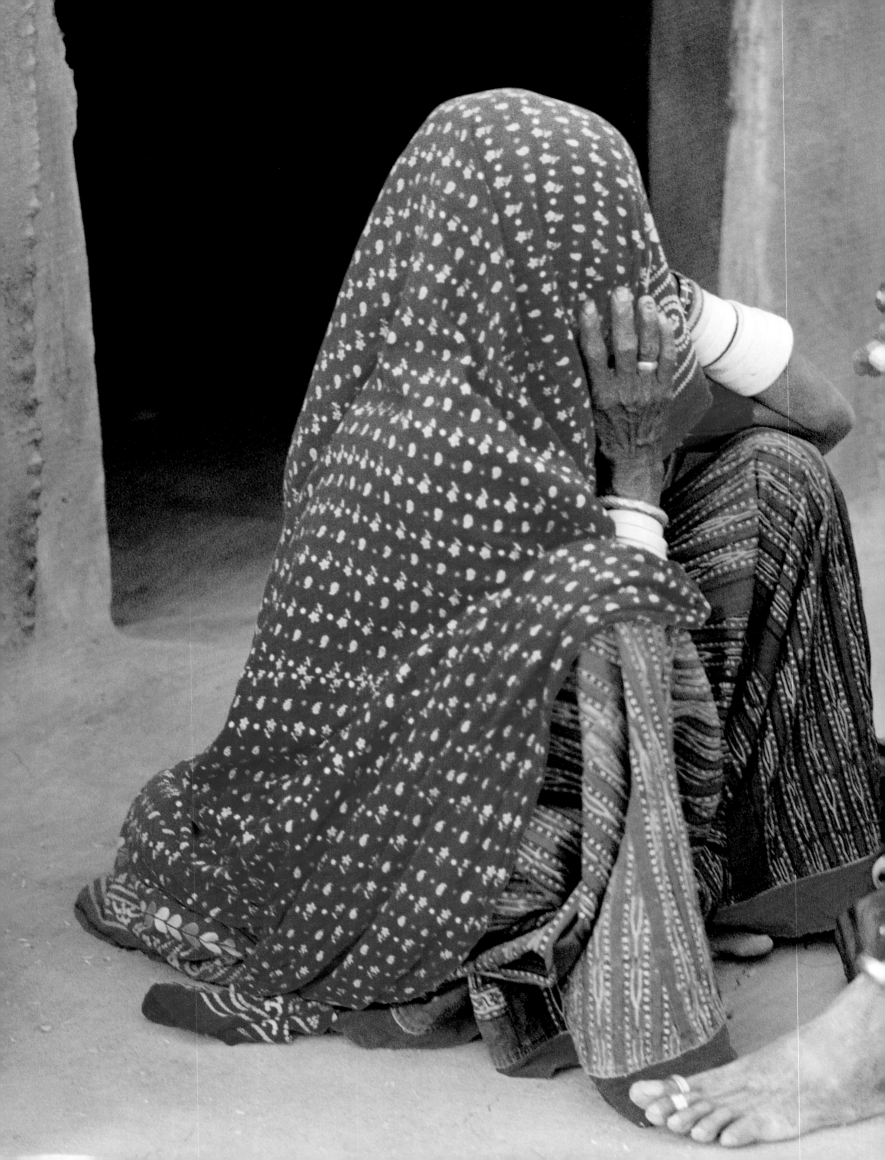

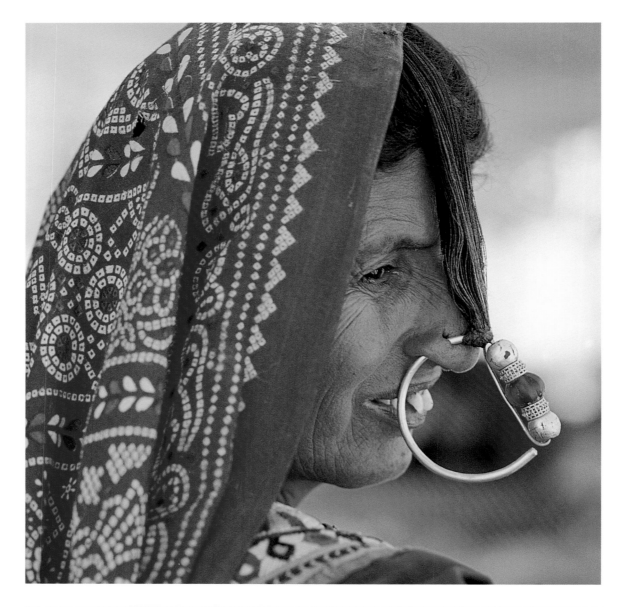

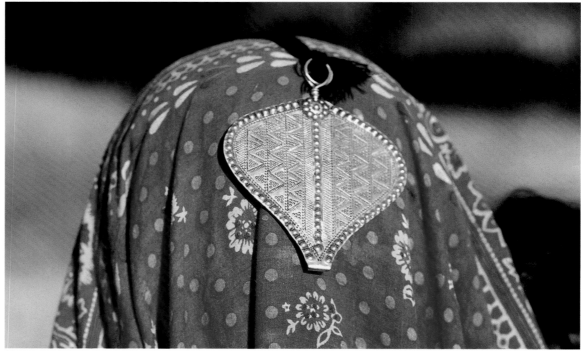

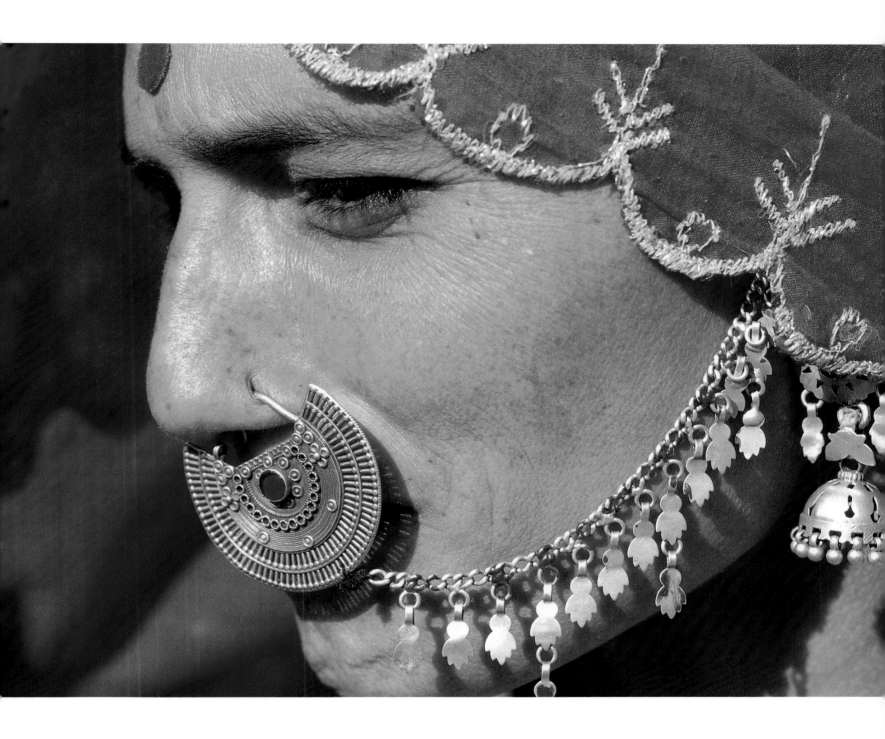

The Islamic Inheritance

The practice of ornamenting the nose was not always common in India and may have Islamic origins. The oldest documentary evidence of nose jewelry is a painting from the Moghul period. Now the practice has spread to all parts of the population and nose-rings are a key part of Indian wedding jewelry. Like earrings, they are meant to prevent evil spirits from entering the body.

Previous pages:
Women wearing typical Indian bangles and ankle rings.

Opposite: Large nose-rings are a particular feature of the women of the Muslim Jat livestock breeders of Gujarat. The heavy brass ring is anchored in the wearer's hair with a black woollen band with an engraved silver plaque attached at the other end as a counter-weight.

Above: A Bishnoi woman from southern Rajasthan with a finely worked gold nose-ring in the shape of a waxing moon.

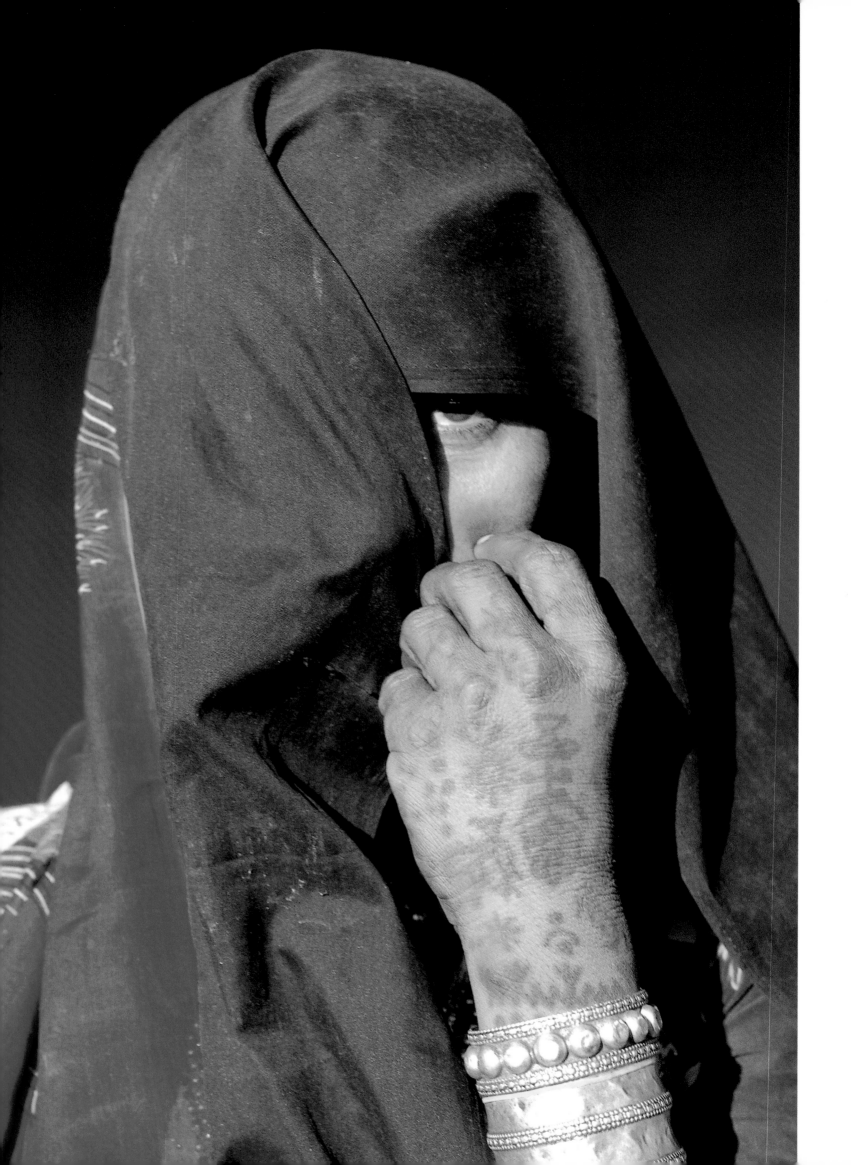

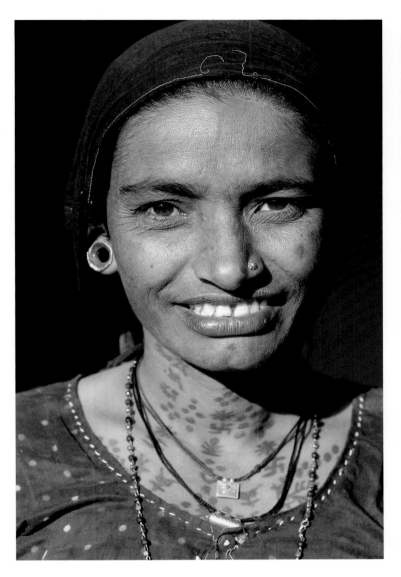

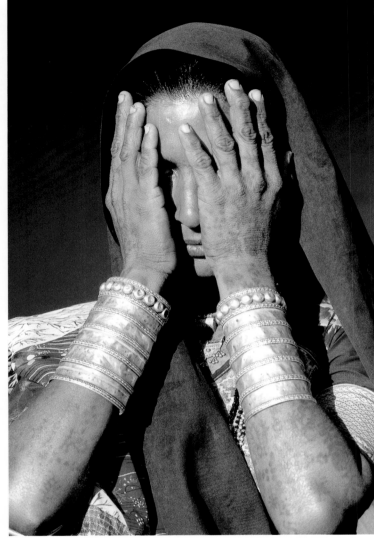

Permanent Patterns

Rabari women from the Kutch area use tattoos on every visible part of their bodies. They decorate their hands and feet, their necks, faces and breasts with symbols of good fortune. The swastika, for instance, is an ancient Hindu symbol that counters the evil eye and keeps harmful forces at bay.

The traditional patterns are etched into the skin with the aid of a needle and a dark ink made of soot and plant juices. Some tattoo motifs can also be found as embroidery on textiles or on the walls of mud houses.

Bracelets and Bangles

Right: A Banjara woman with white plastic armbands covering her arms, in place of expensive ivory adornments. These arm bangles were originally made of ivory and dyed a reddish colour. They have a particular significance for the women of the nomadic herdspeople of north-west India – they are part of a woman's dowry and there are rules that determine how many should be worn on particular occasions. Only married women wear arm rings on the upper arm. They are supposed to have a magical effect that deflects the evil eye and eases birth pains.

Below: Hourglass-shaped cuffs, made of ivory or elephant bones, are a typical part of the garb of the Rabari women from the Kutch area. Traditionally, a woman would only take off this heavy and valuable armwear after her husband's death.

Overleaf:
These women are wearing a great many bangles, which could be made of ivory, glass, plastic, silver or gold. A typically Indian feature is the variety of decoration lavished on the back of the hand and on the fingers.

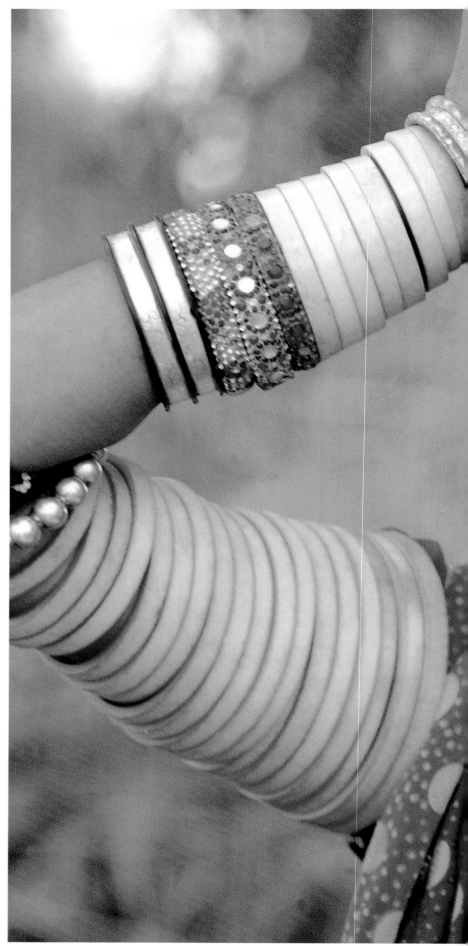

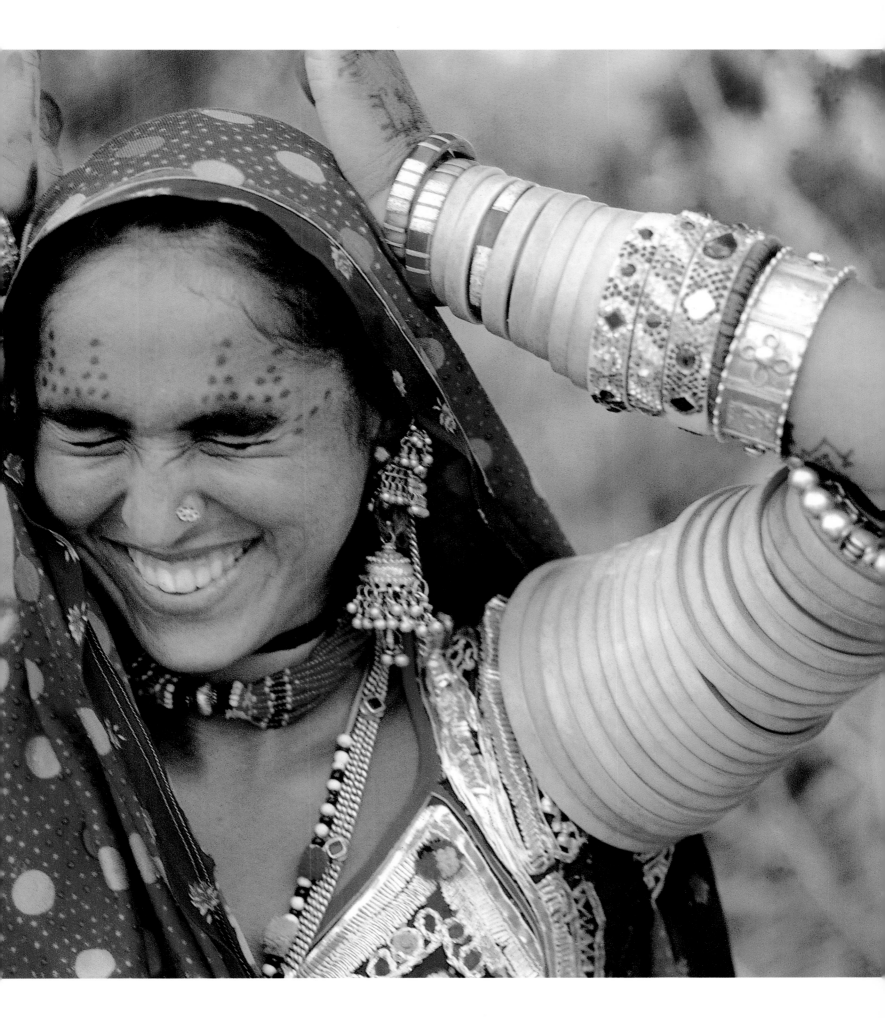

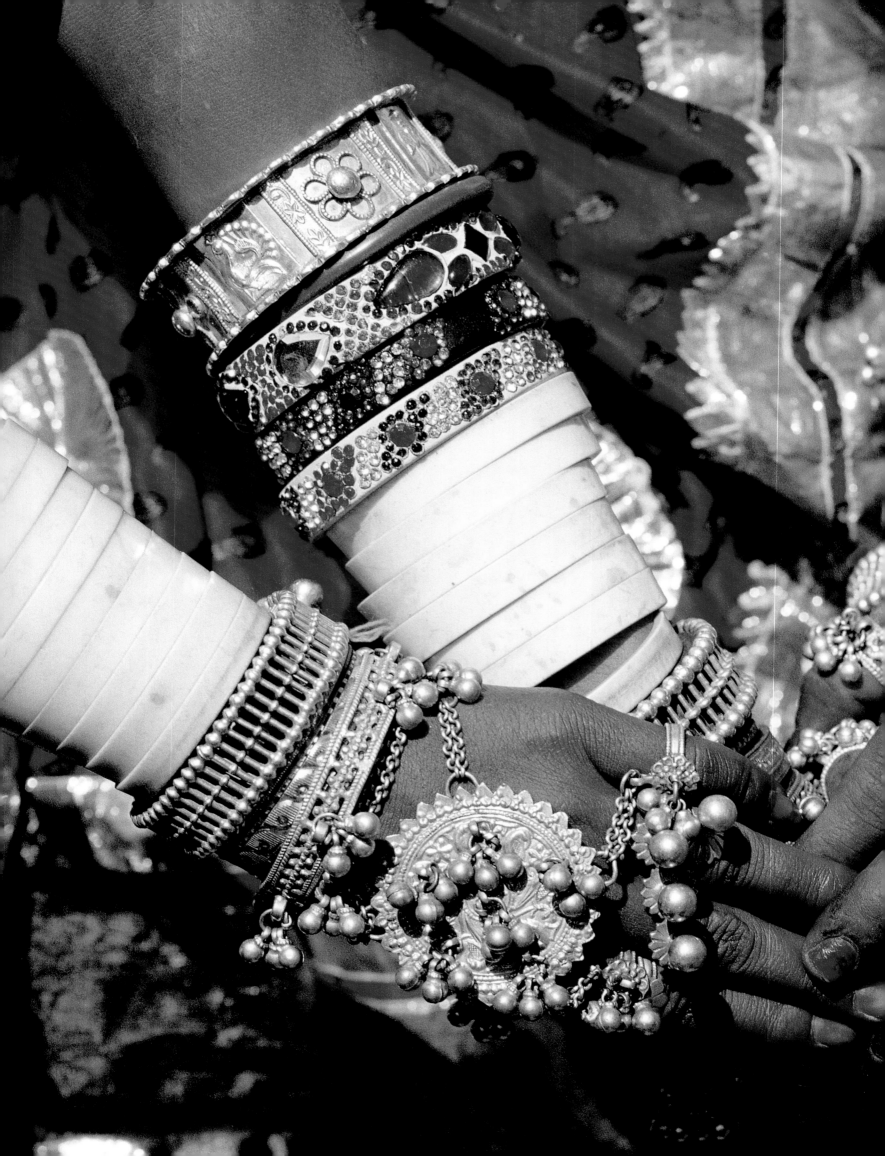

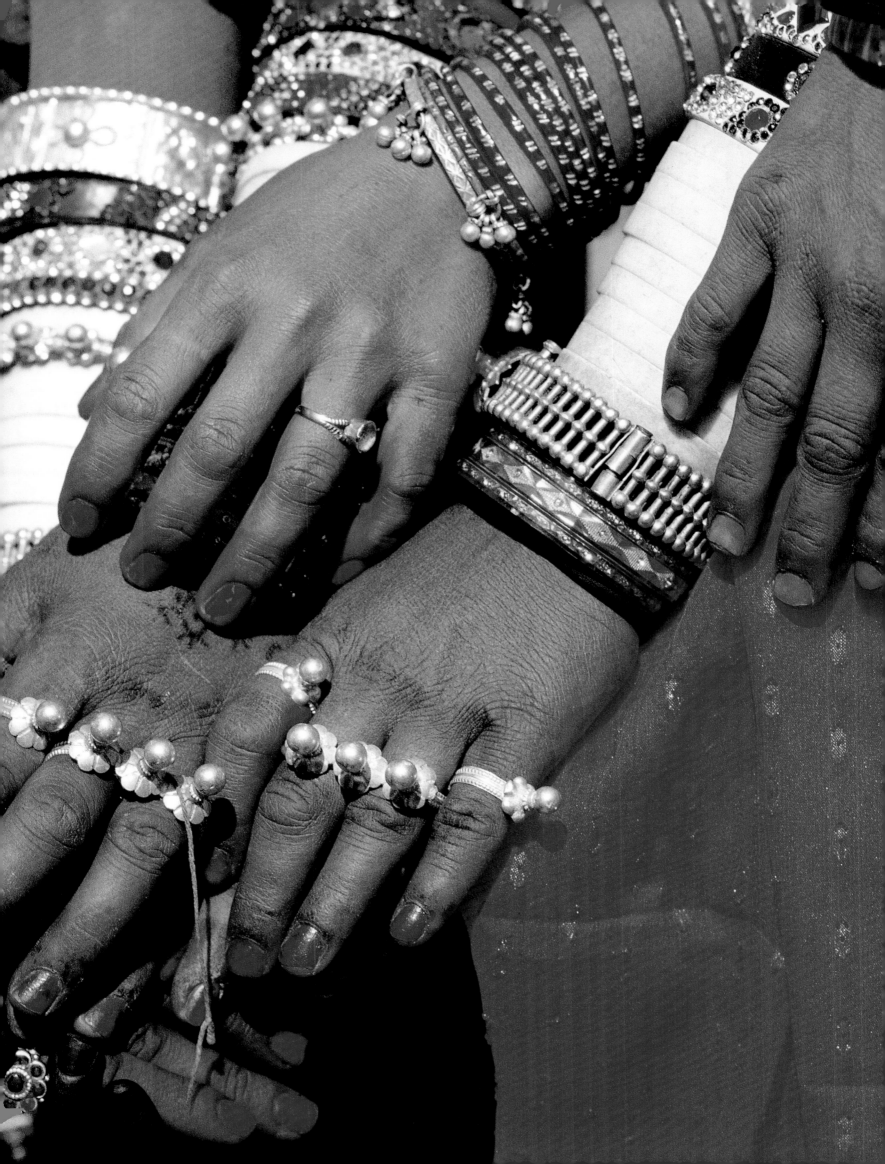

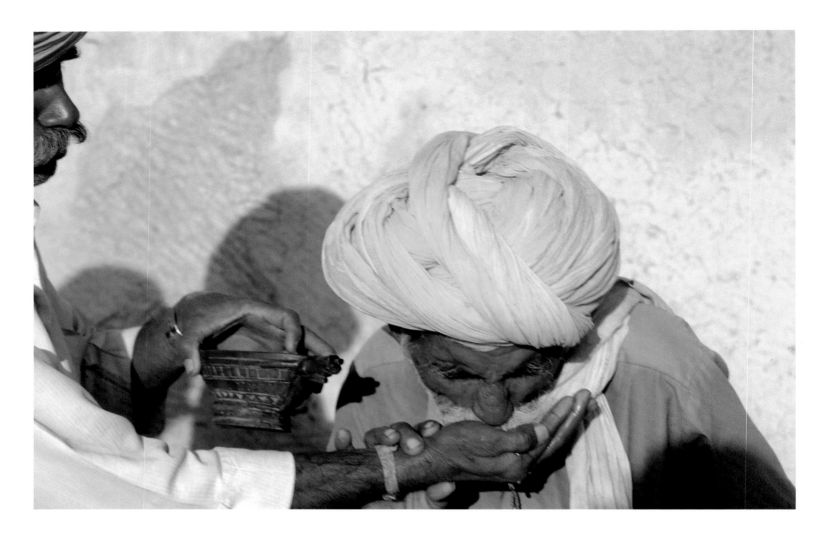

An Opium Ceremony

Opium in liquid form is taken from the open hand of a friend. In north-west India the ritual taking of opium is a common practice on festive occasions.

Overleaf:
Once a year, at the time of the springtime festival of Holi, the men arm themselves with clubs and are divided into two groups; the 'alcohol-drinkers' (or 'non-vegetarians') have the task of defending a town and the others, who are 'anti-alcohol' (or 'vegetarians') have to attack it. It is quite possible that blood will flow freely, with the participants in high spirits as a result of taking opium.

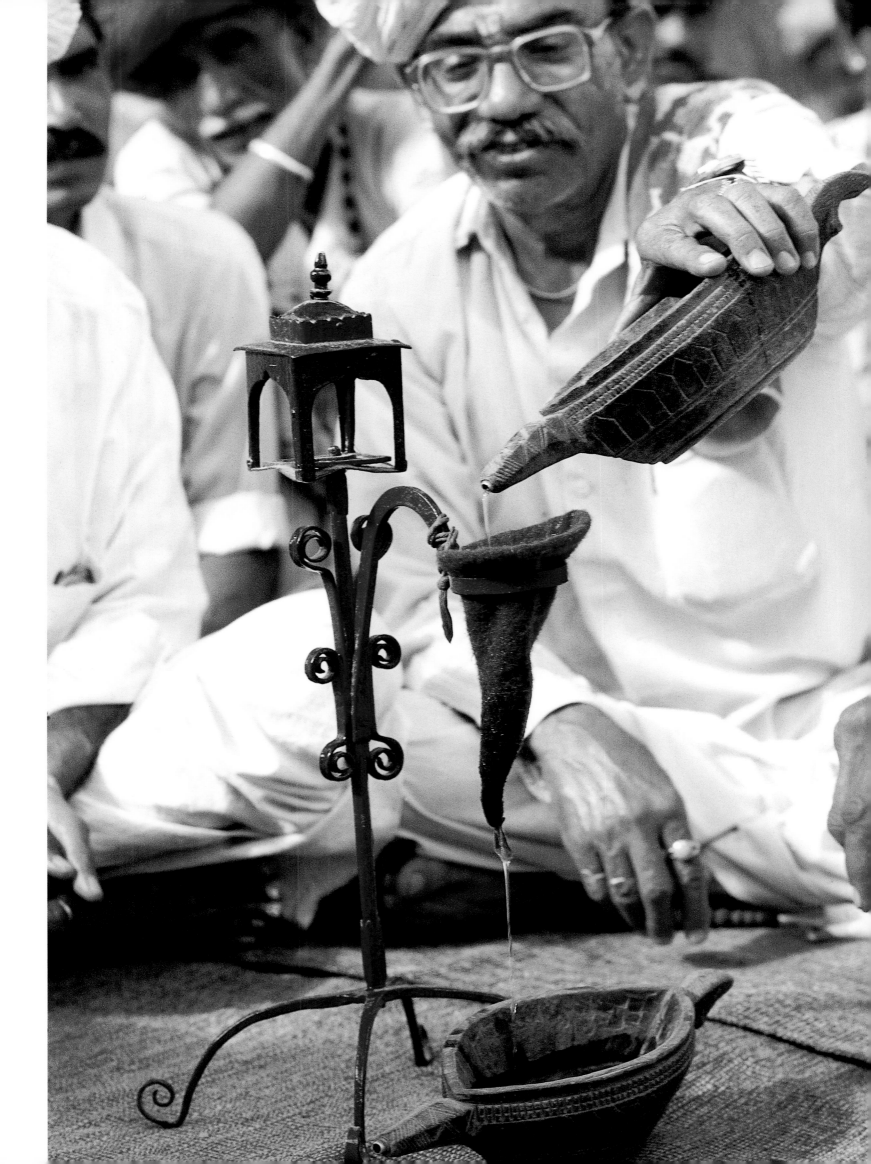

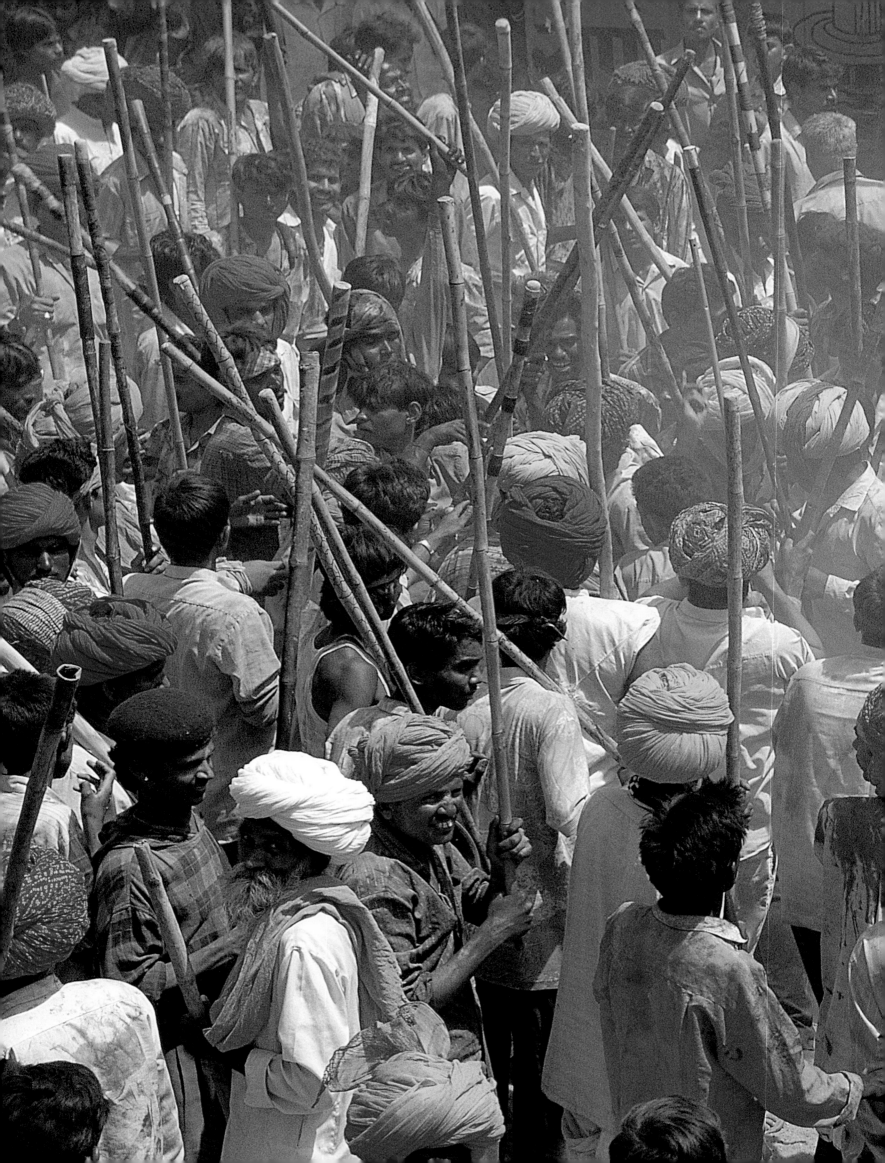

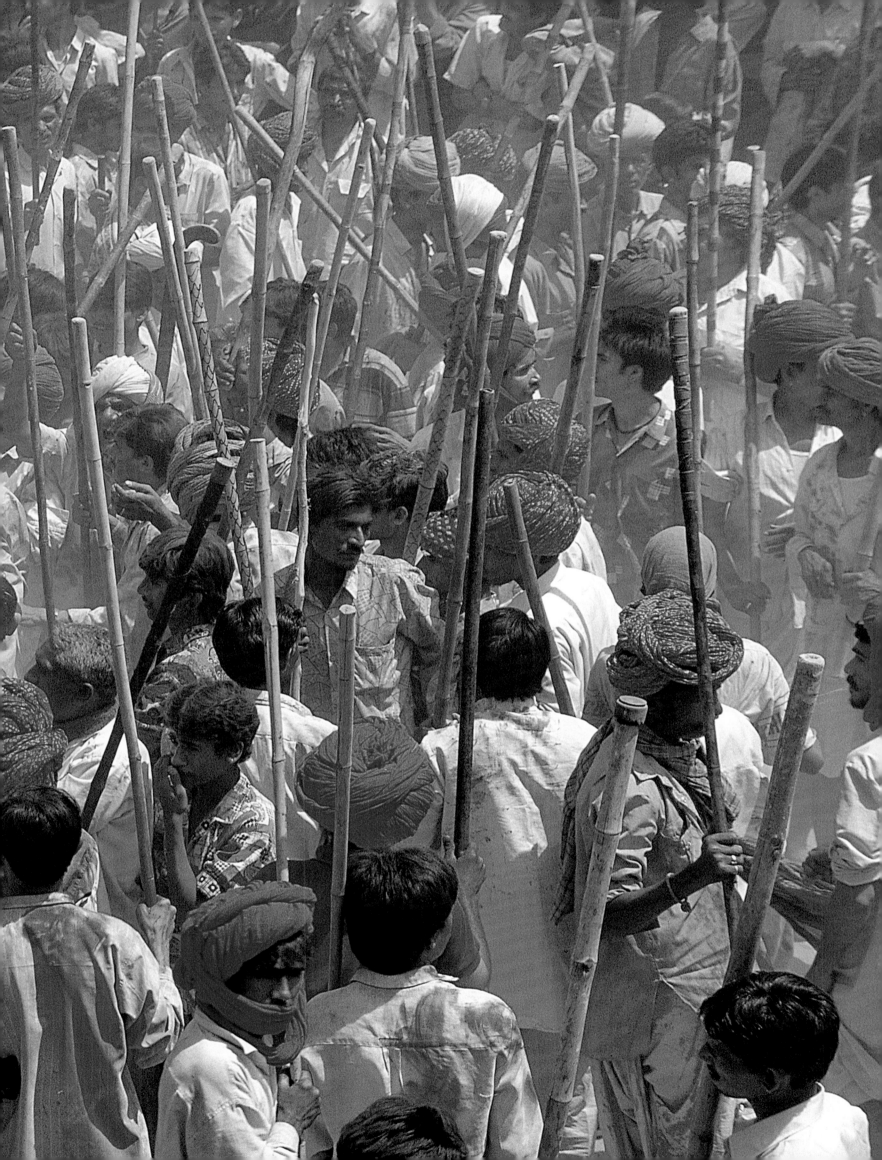

A Child Marriage

Although child marriages are forbidden by Indian law, they are still part of life in the more remote districts, particularly among herding castes. After the wedding, the children continue to live with their parents until the girl is old enough to have a baby. Child marriages were known in pre-Christian times and spread over the whole country in the eleventh century. The Rabari only marry within their own group and into families in the surrounding area.

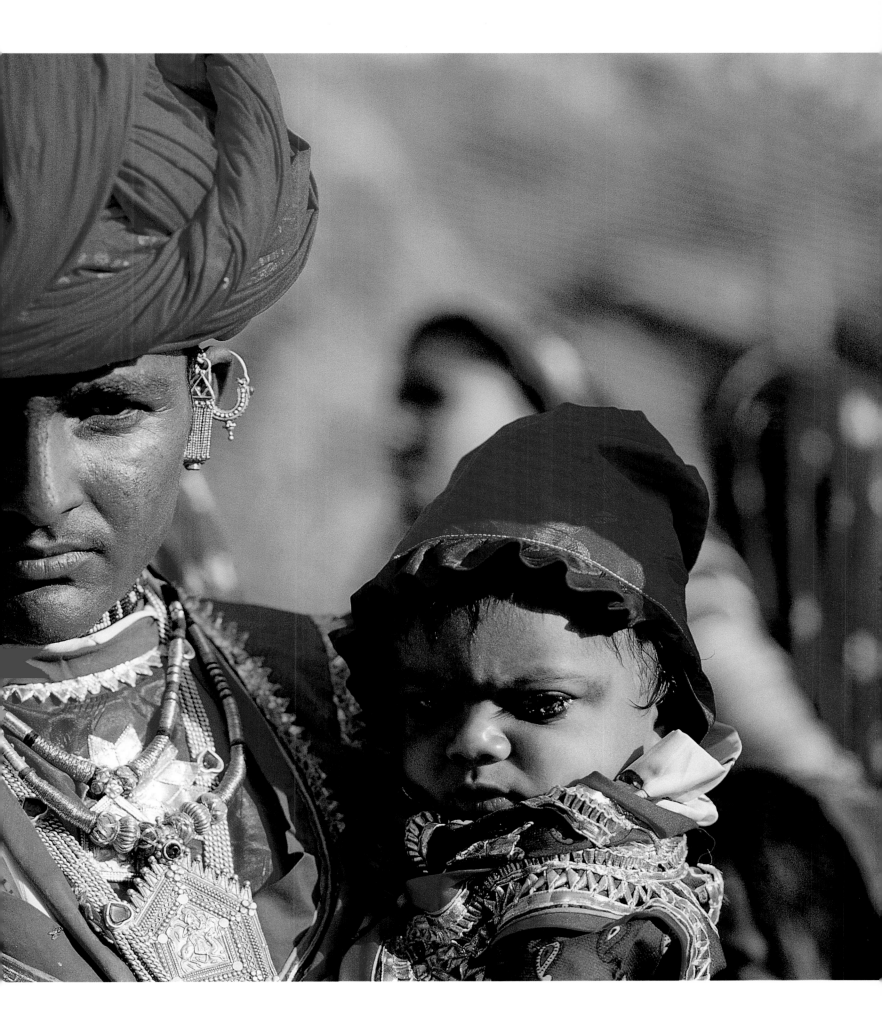

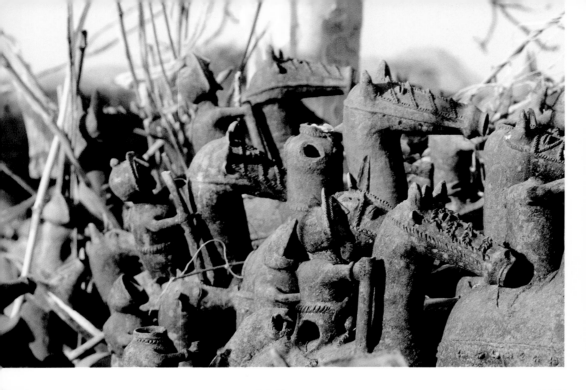

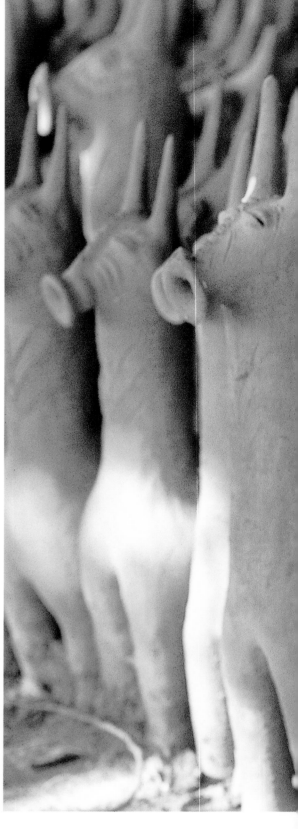

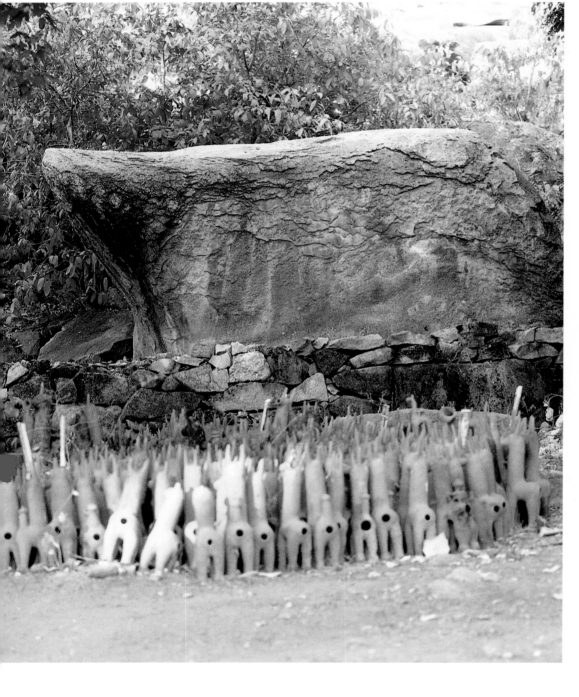

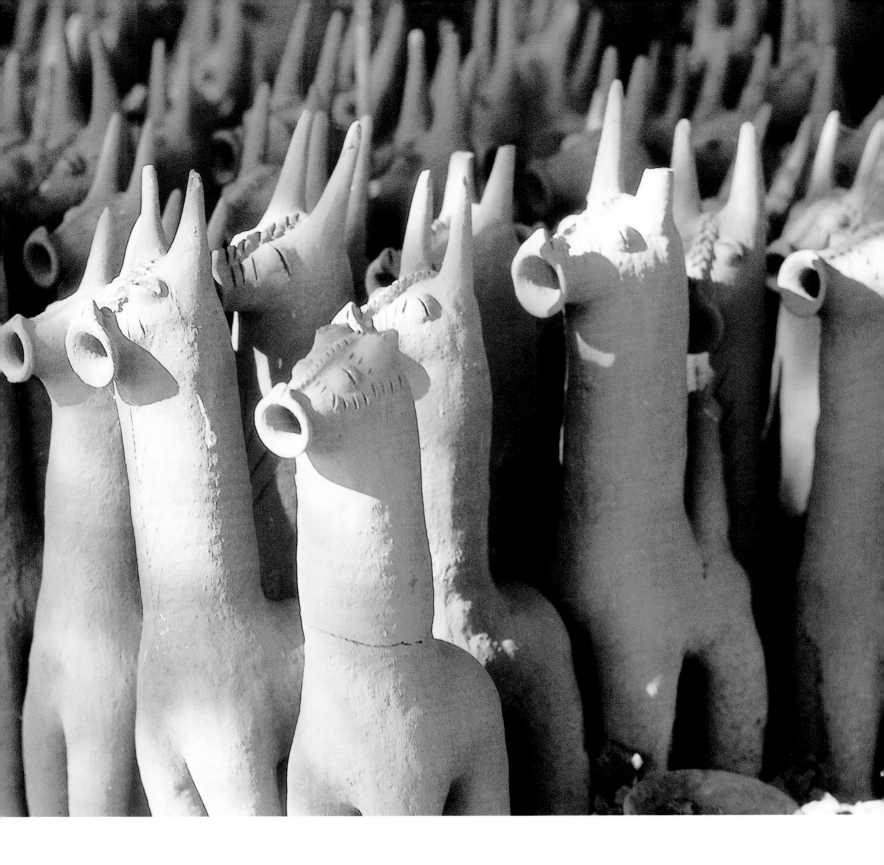

Ritual Offerings

A number of different Bhil tribes use terracotta figures as votive offerings for their gods, spirits or ancestors. The Garasia Bhil from the border country between Gujarat and Rajasthan set up secret ritual sites in the middle of the jungle, on high mountain tops or on the edge of rock faces.

They offer sacrifices in the form of terracotta figures of horses and riders, made by members of the local potter castes. The Bhil believe that the tigers that can still be found in this region act as guardians for their gods and their votive offerings.

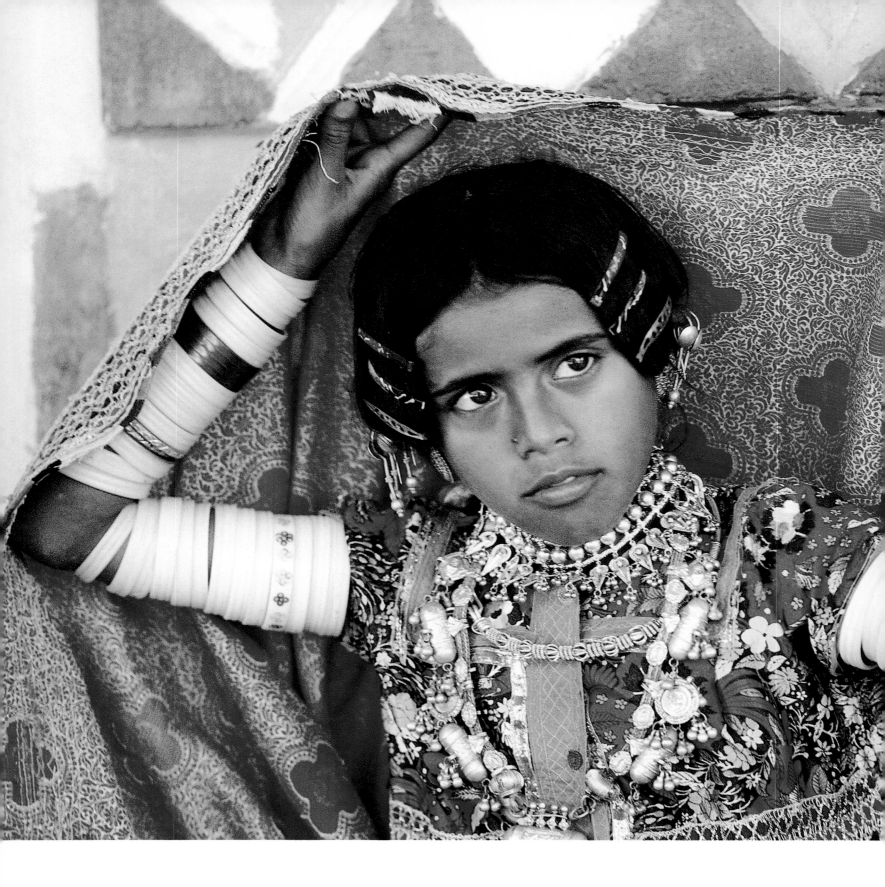

Kutch Dowries

Above: The women of Kutch in Gujarat are famous for their
lavish silver jewelry and the magnificent textiles that form
part of their wedding costume. Even as small girls they
begin to collect items for their trousseau, and further items
are collected over the course of their childhood. After
a betrothal, the future bride's family will commission
nose-rings, earrings and arm bangles that will be handed
over at the wedding.

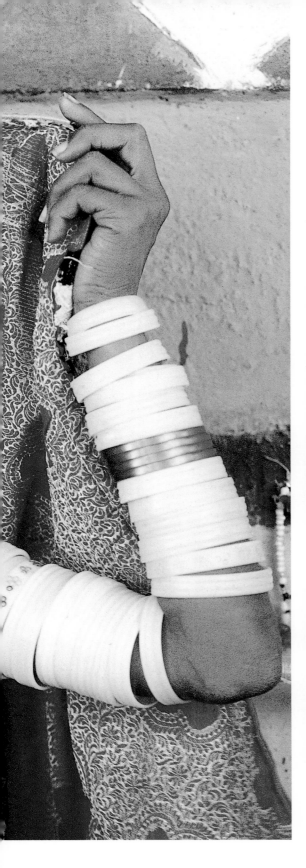

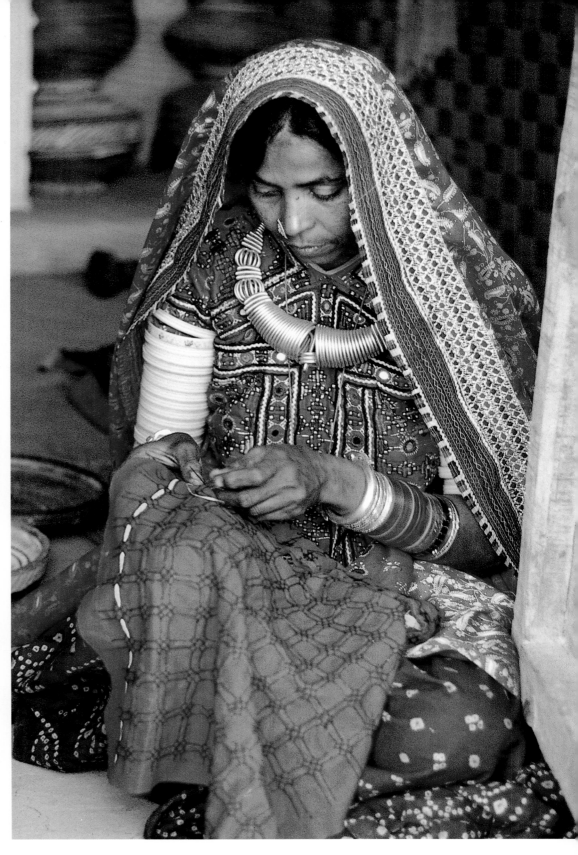

The bridegroom's family presents the bride with a pair of heavy silver bangles for her feet and ivory ones for her arms. The bride carries her whole trousseau in large, embroidered bags, or *kothris*, to the home that she will share with her new husband.

Above right: The women from Banni, the desert-like area north of the town of Bhuj, specialize in fine embroidery and appliqué techniques.

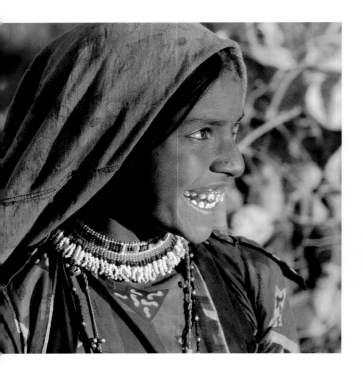

Bhil Designs

The girls of the Garasia Bhil still wear their own traditional costume and jewelry. But many Bhil tribes have already taken on the clothing and many other elements of the predominant Hindu culture.

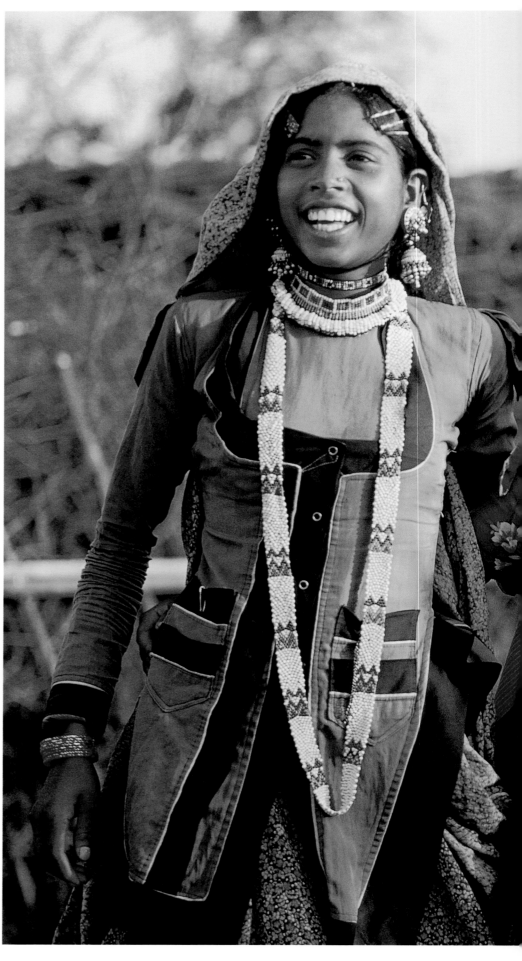

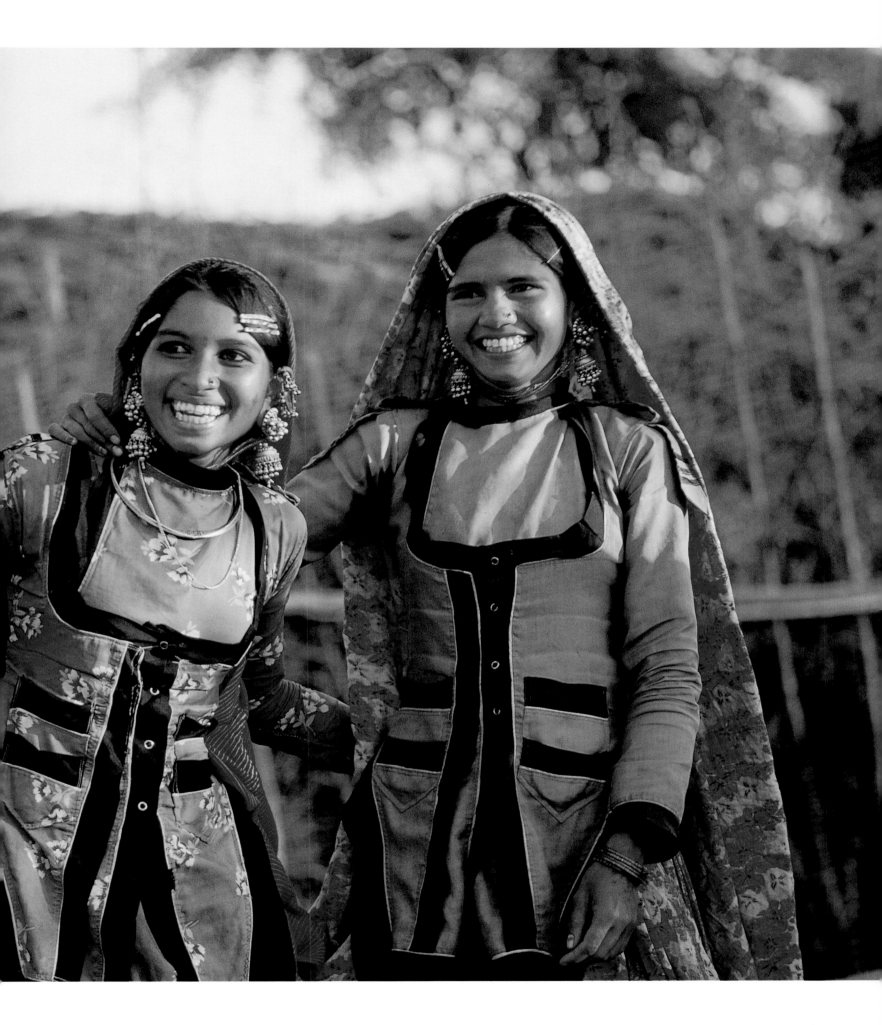

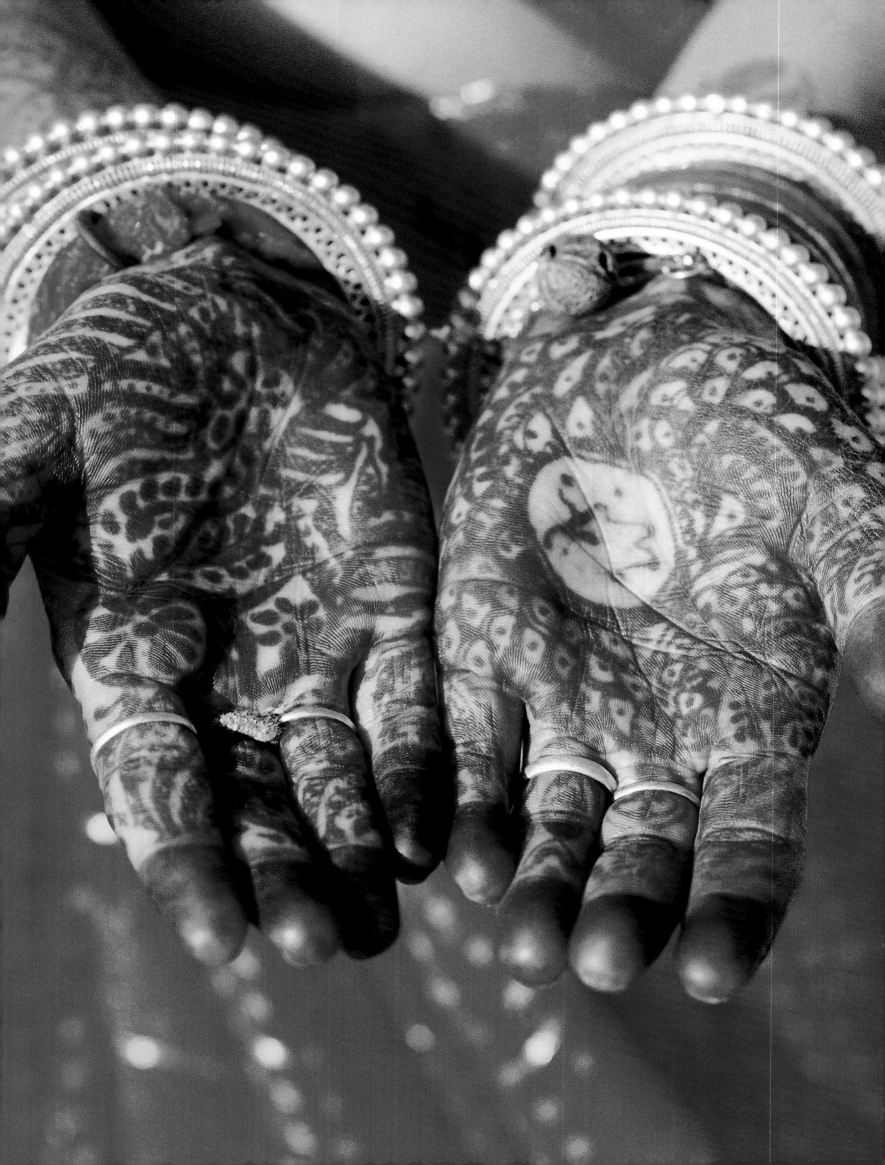

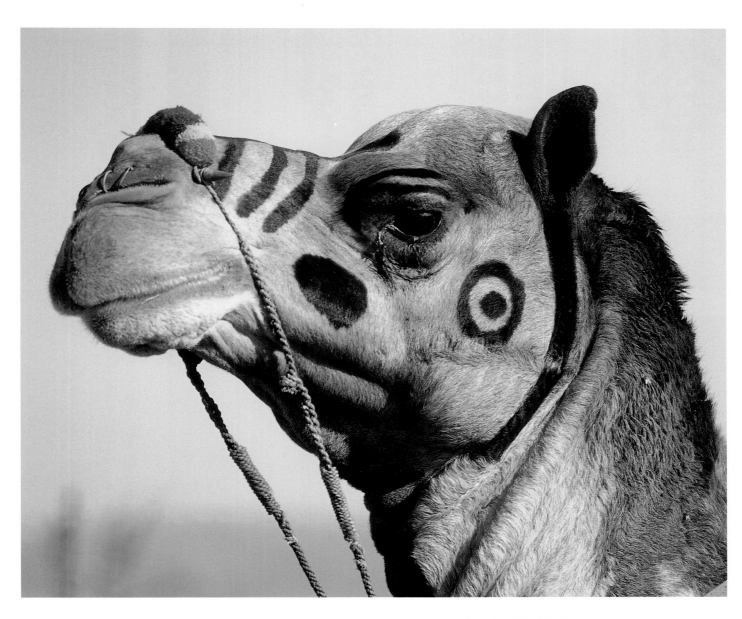

Painted Bodies

Opposite: Henna hand tattoos.

Above and right: Body painting is not only practised on humans but also on animals, both for aesthetic and protective reasons. The handprint is an ancient motif intended to protect cattle from danger. Motifs are also painted on as signs of ownership, comparable with brand marks.

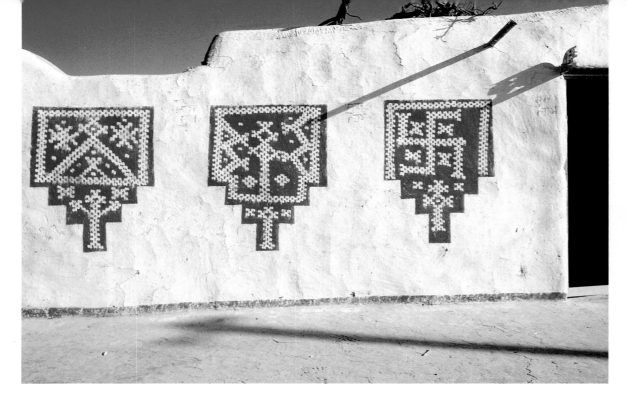

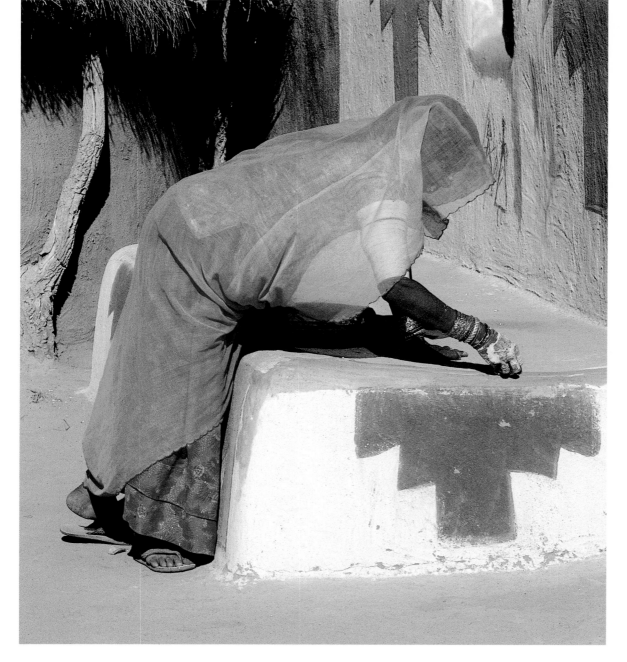

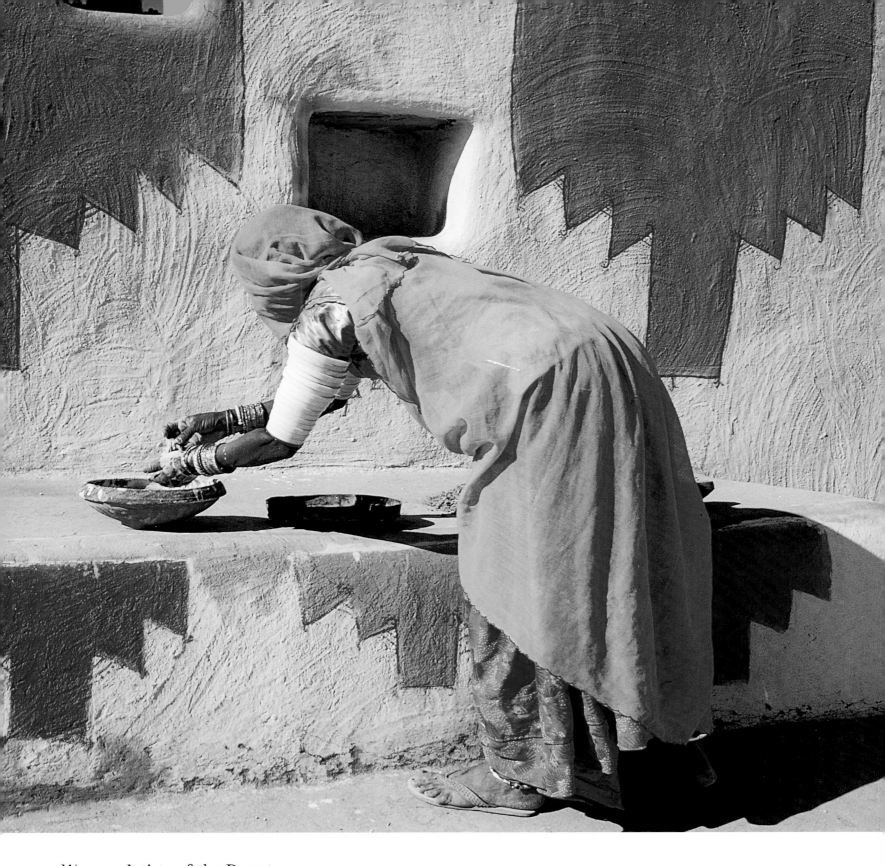

Women Artists of the Desert

Above and opposite, below: A woman from the western Thar
desert paints the walls of her farmstead. The desert women of
Rajasthan regularly display their artistic skills, particularly before
the great spring festival or before Divali, the Hindu New Year
festival; the old decorations on the mud walls are repainted with
fresh colours, new luck-bringing patterns of geometric symbols
are created and often, the background on which they paint –
a mixture of mud and camel dung – is reapplied .

Opposite, above left: The motifs bear a striking resemblance to
cross-stitch embroidery patterns.

Overleaf:
Mythological motifs decorate the house walls of the Rathwa
and the Bhil in the border area between Madhya Pradesh
and Gujarat.

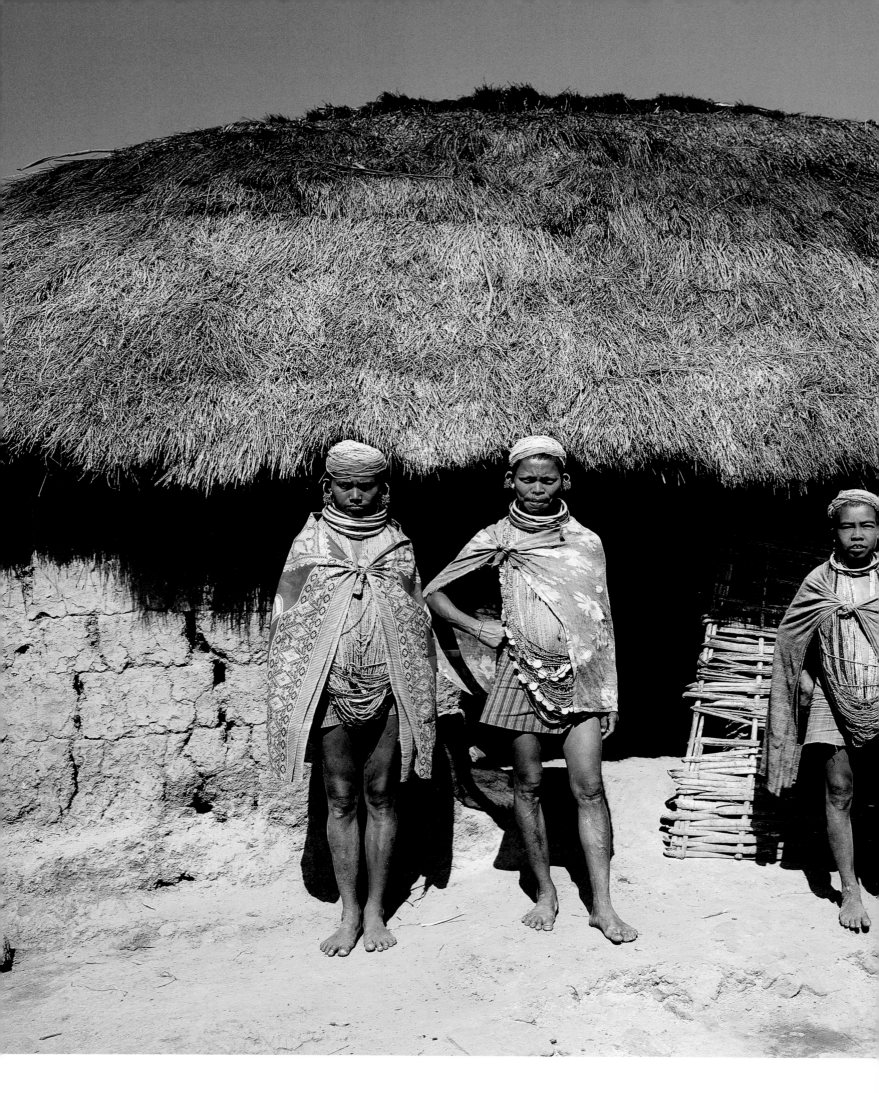

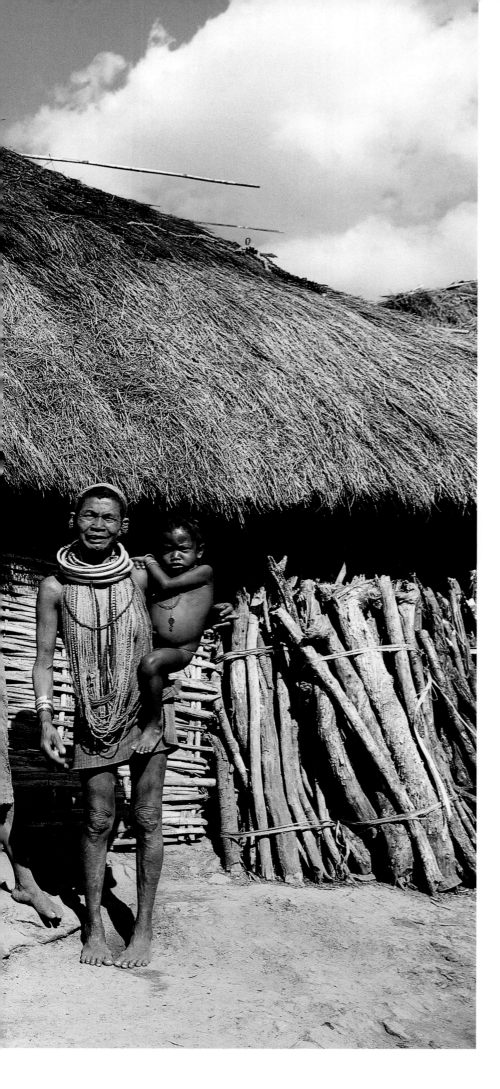

The Bondo

The homelands of the Bondo have been declared a prohibited zone by the Indian government, and access to Bondo villages is extremely difficult to obtain.

Less than 5,000 tribal people live in a total of 32 villages in the Bondo Hills of Orissa. It is their reputation as 'unpredictable savages' that has allowed them to preserve their independence for so long, and to resist being overtaken by the dominant Hindu culture.

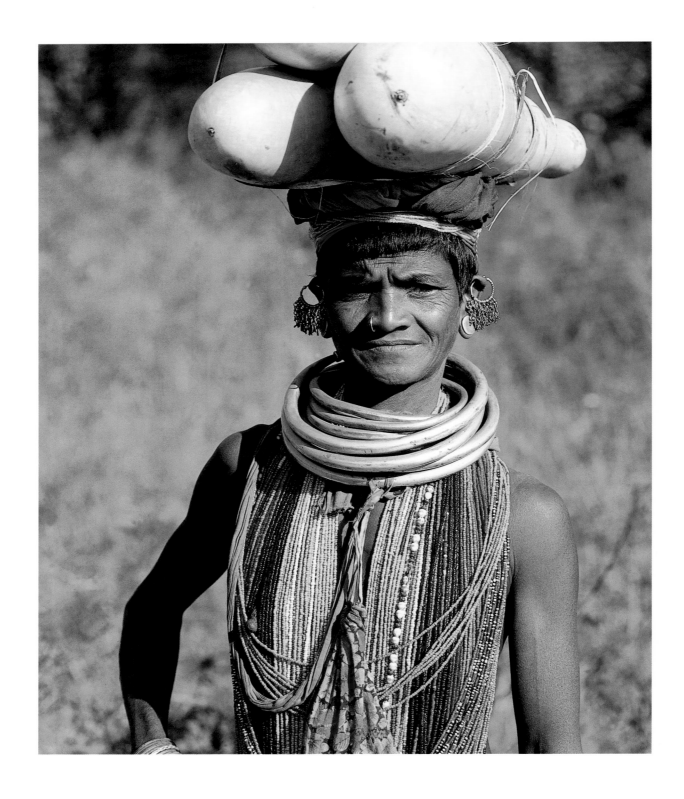

The Body as a Decorative Object

Bondo women make no secret of the need they feel to adorn their bodies. According to legend, a commandment forbids them either to grow their hair or to wear any other clothing apart from a loincloth. They compensate for this restriction by adorning themselves with a great number of brass or aluminium neck rings and magnificent necklaces of glass beads that cover their naked torsos down to their hips. They also wear bangles, finger rings and belts.

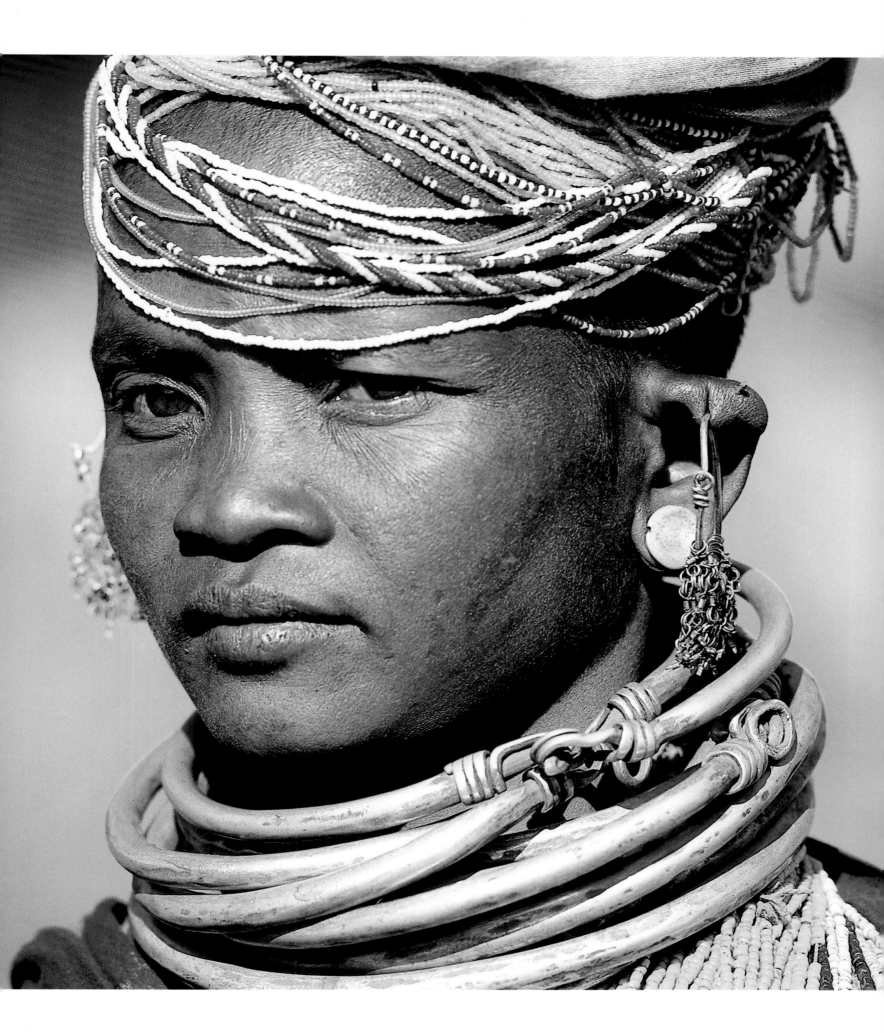

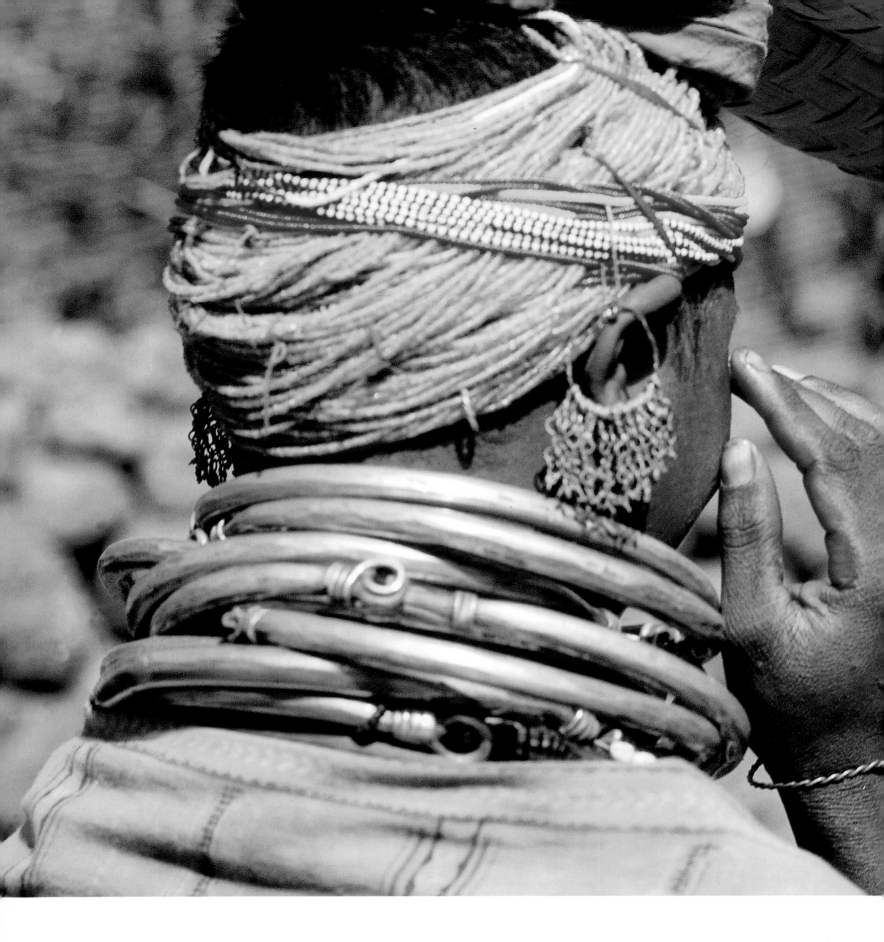

Tribal Traditions

There is a legend which claims that in mythical times the Bondo women were condemned to shave their heads bald and to wear nothing on the rest of their body save a loincloth. In order to cover the bareness of their torsos, they wear colourful chains of glass beads and chains made of shells or seed pods, which hang down to their hips. The women buy the glass beads with their own money at the weekly markets, and the men pay for the cotton thread on which they are strung.

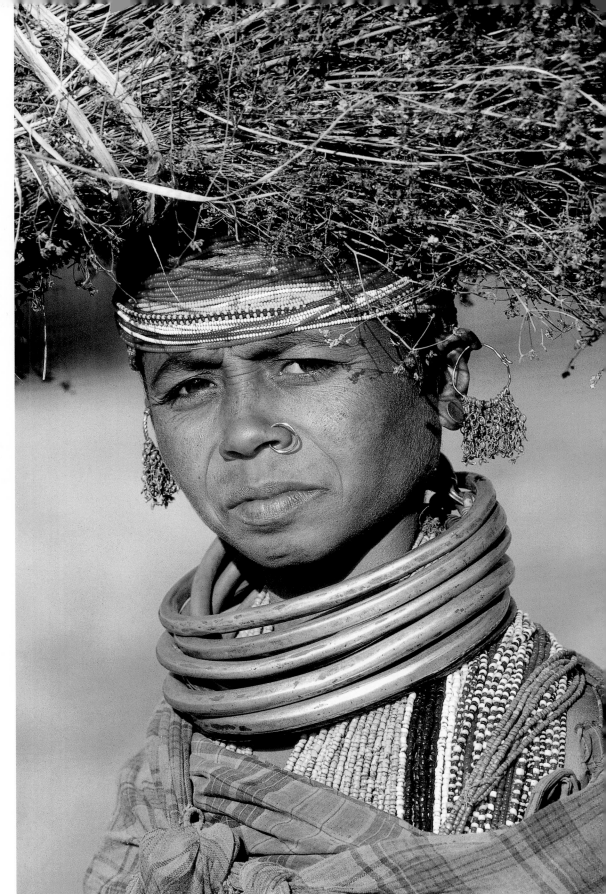

The Bondo women have a graceful way of balancing their wares – woven raffia mats and forest fruits – on their heads as they go to market. They wear brass or aluminium bangles and neck-rings and their shaven heads are tied with strings of glass beads.

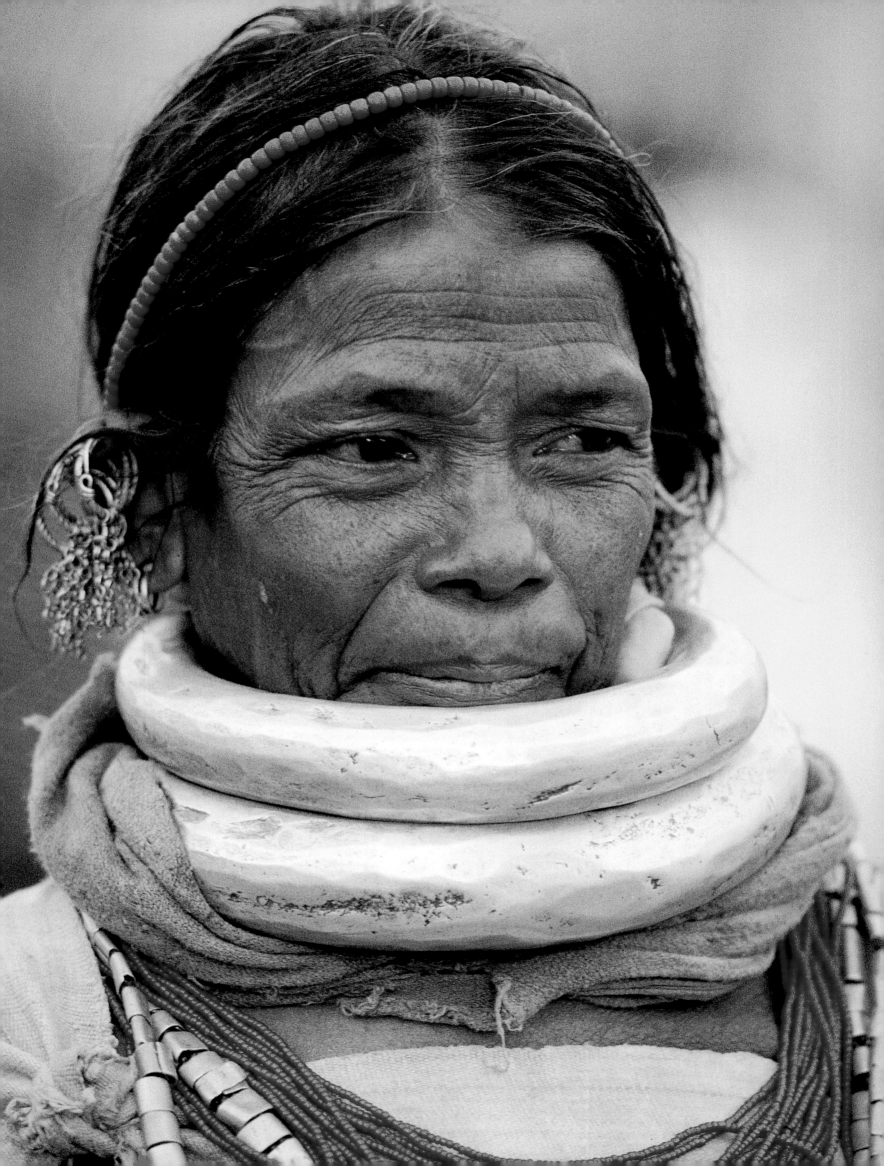

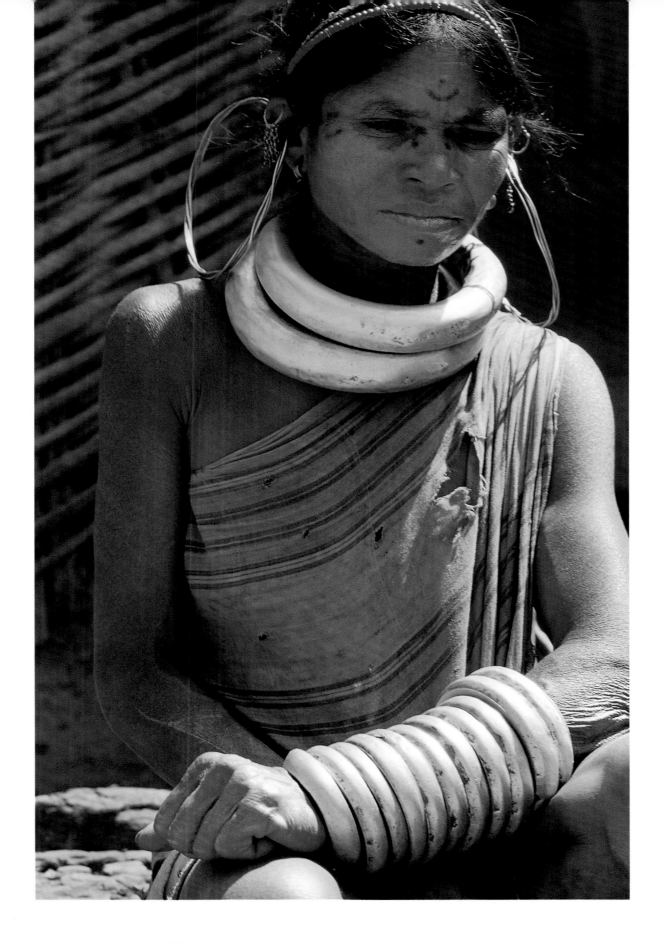

Gadaba Marriage Rings

Above and opposite: When a Gadaba woman marries, she
receives thick aluminium neck-rings which she then wears for
the rest of her life. These are complemented with silver bangles
and large copper wire earrings.

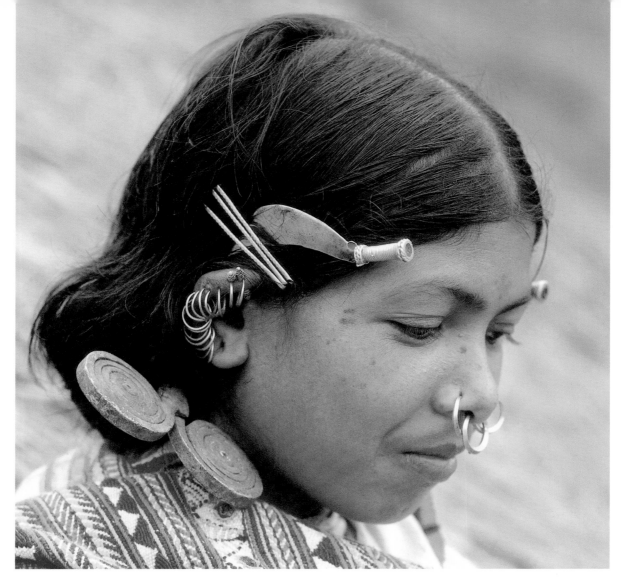

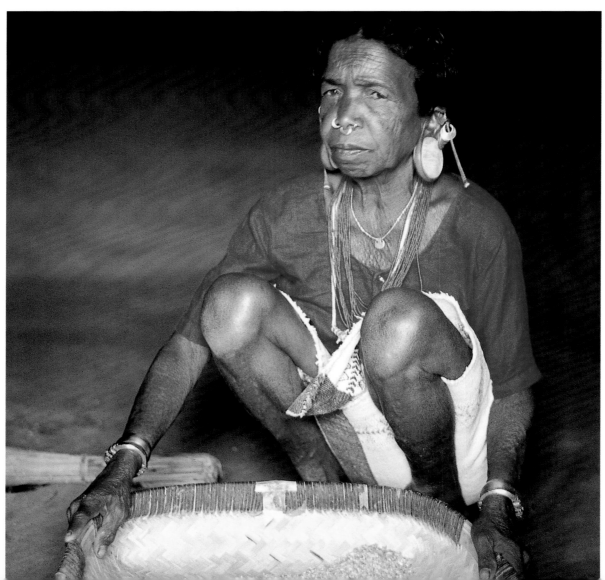

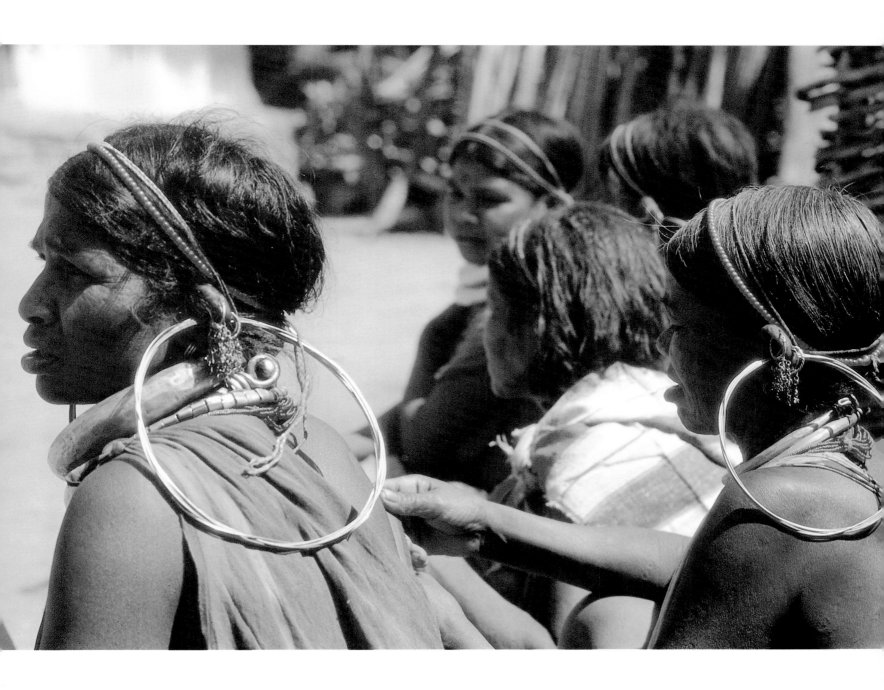

Pegs, Discs and Hoops

Unlike nose jewelry, earrings have been worn in India since ancient times, as many surviving statues and stone reliefs show. This tradition is still alive in many tribes today.

Opposite, above: A woman of the Dongaria Khond from the Eastern Ghats, wearing nose and ear jewelry. Her unusual hair ornaments include a miniature version of a ceremonial knife for buffalo sacrifice and a spiral ornament with a scissor-like shape.

Opposite, below: A woman of the Lanja Saora with facial tattoos and large wooden ear discs. Similar motifs can also be seen on the famous temple reliefs of Konarak. The nose and the upper part of the ear are decorated with golden rings and little chains.

Above: The characteristic jewelry of Gadaba women includes large hoops of twisted copper wire, pulled through the ear.

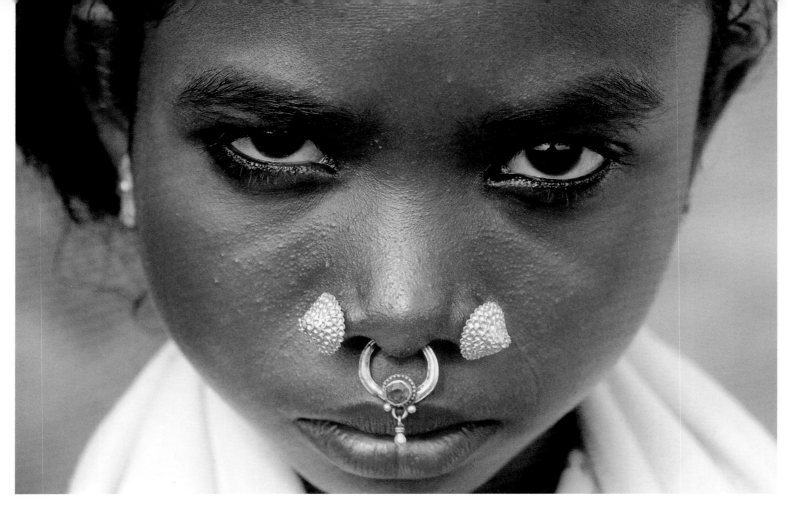

Piercings

Right: In many tribes in Orissa, noses and ears are pierced and edged with metal rings. This custom is not simply for decoration, but also provides protection against evil spirits that might otherwise penetrate the body's openings.

Above: A girl from the Didaya with golden nose jewelry.

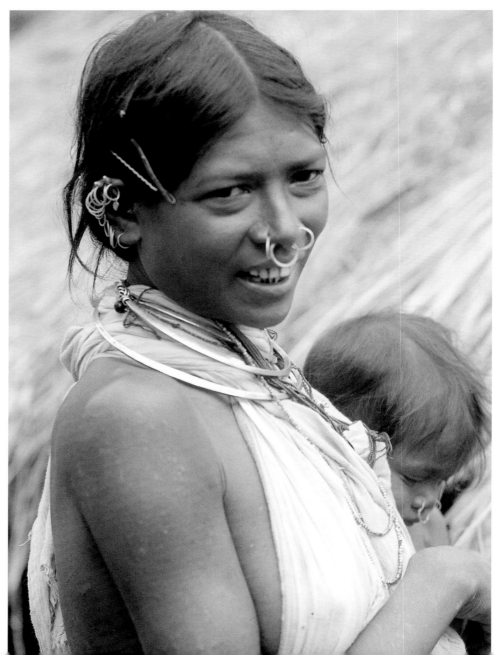

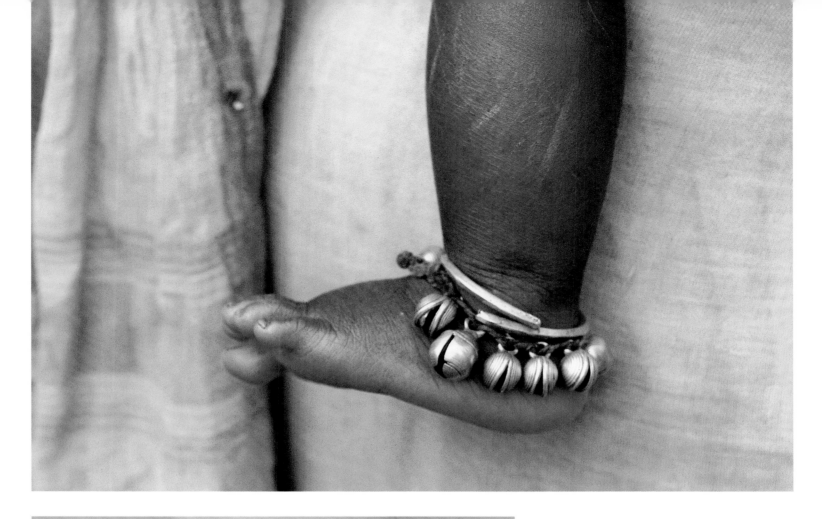

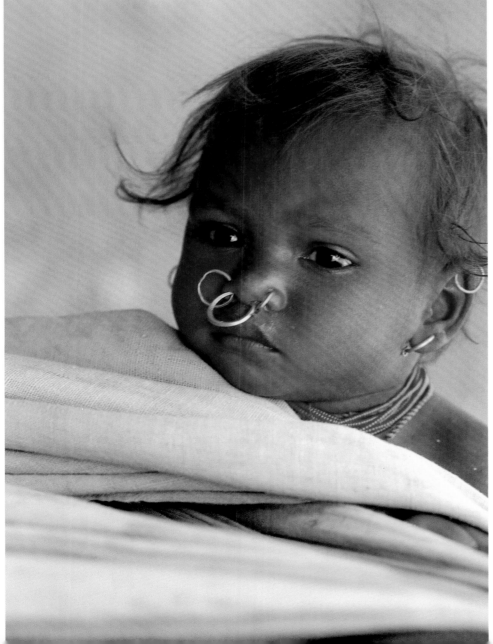

Girls of the Dongaria Khond have their noses and ears pierced when they are still babies (left), and decorated with brass rings like their mothers'. The ringing of the bronze bells on their ankles (above) is meant to keep evil spirits away.

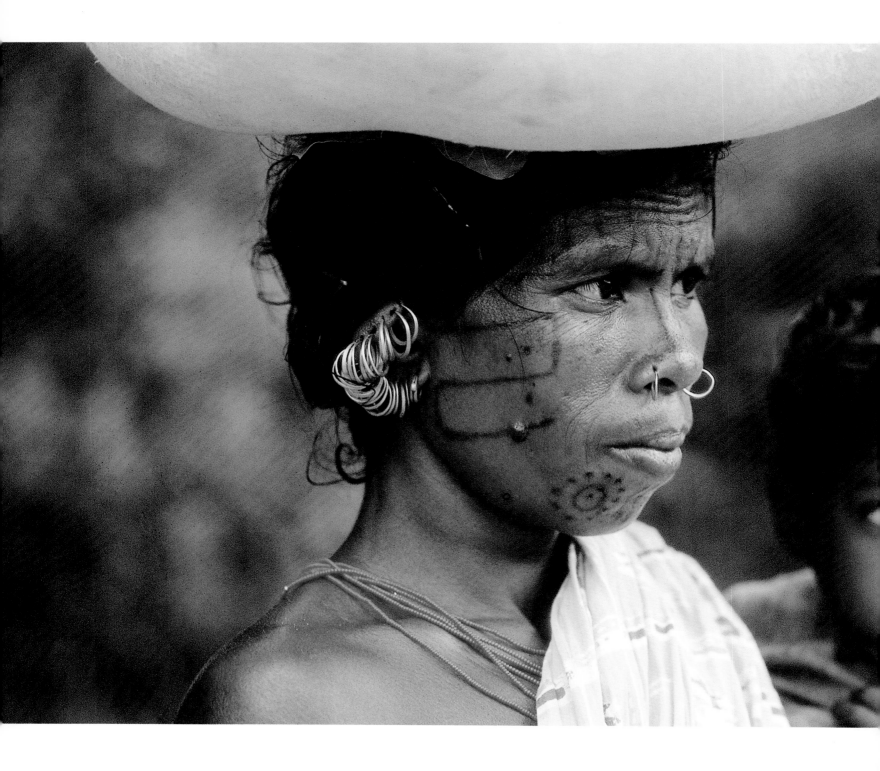

Identifying Marks

Above and opposite, below: Khond women with facial tattoos. Concentric ring motifs on the chin symbolize the beard of a tiger.

Opposite, above: In some sub-groups the young men also like to adorn themselves.

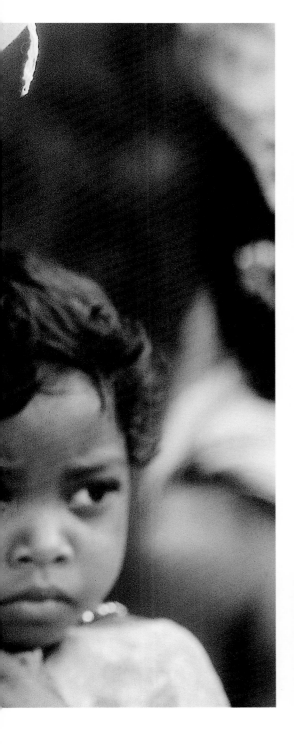
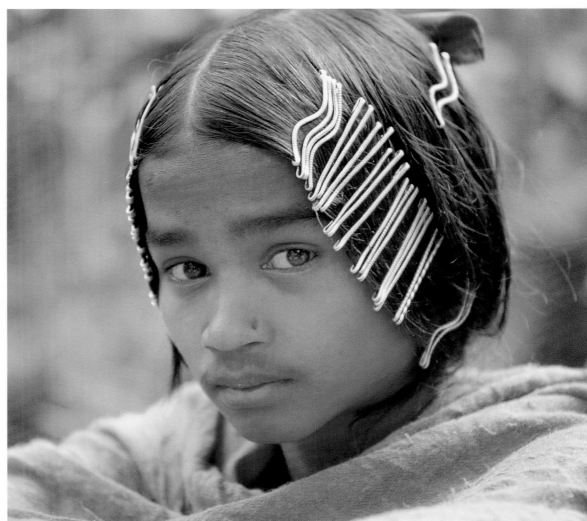
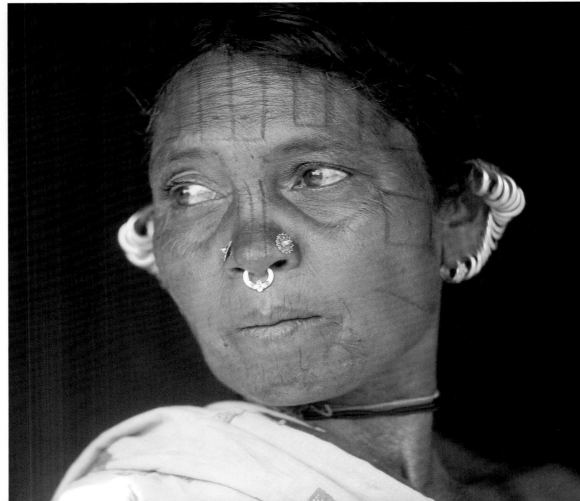

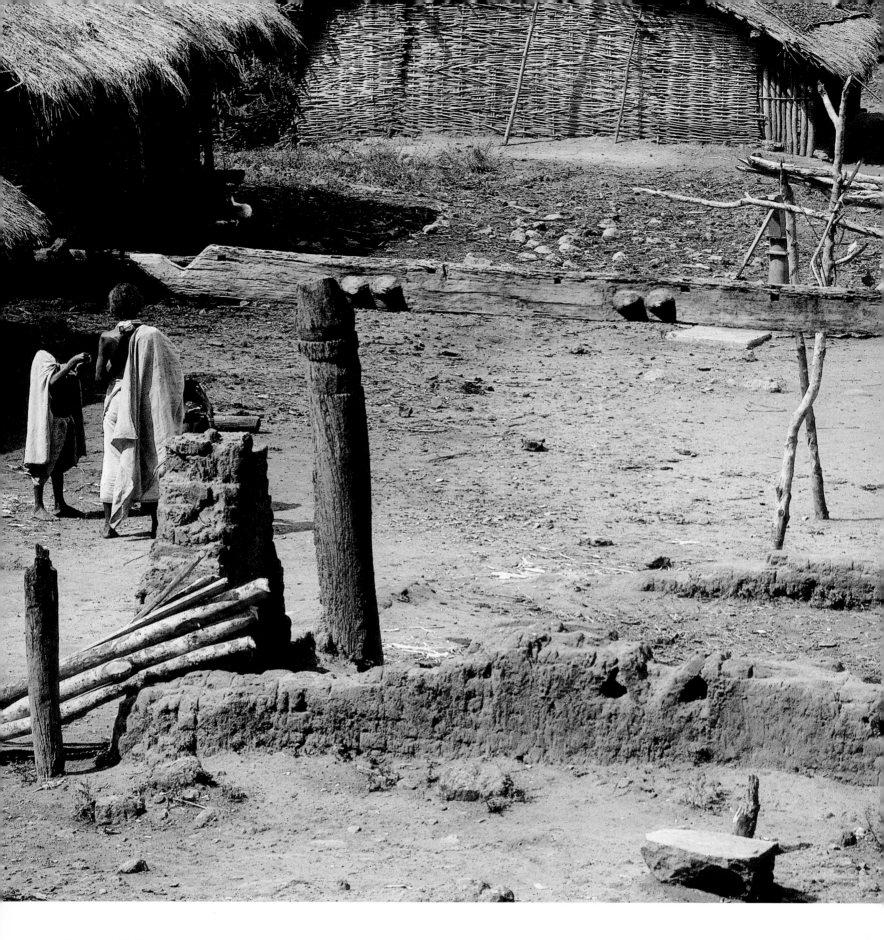

Carved Relics

Above: This piece of ceremonial architecture in a remote village of the Dongaria Khond is consecrated to a male divinity and is reminiscent of the early Buddhist monumental entrance gates from the first century BC.

Opposite, above and below: The Kuttia Khond tie buffalo to these carved stakes before ritual sacrifices.

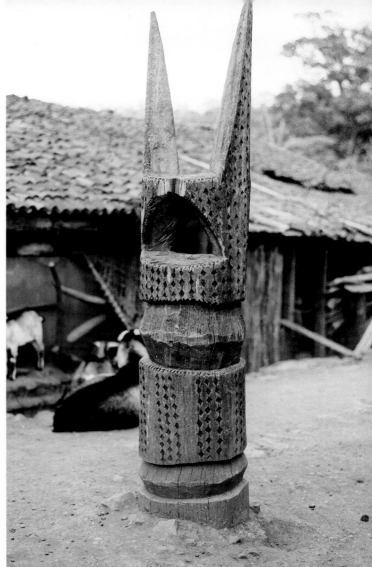
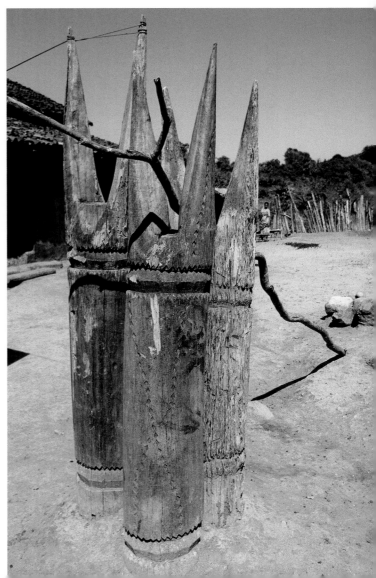

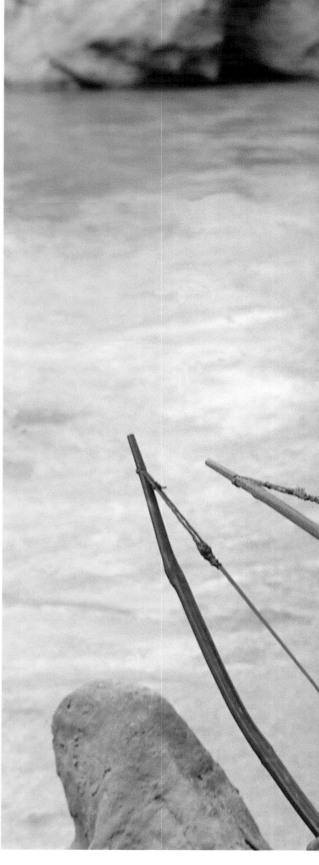

Rainforest Dwellers

A small group of the Dharuva Gond are among the last surviving hunters and gatherers of the Indian rainforest. Deforestation and industrialization restrict their freedom of movement more and more as time goes on.

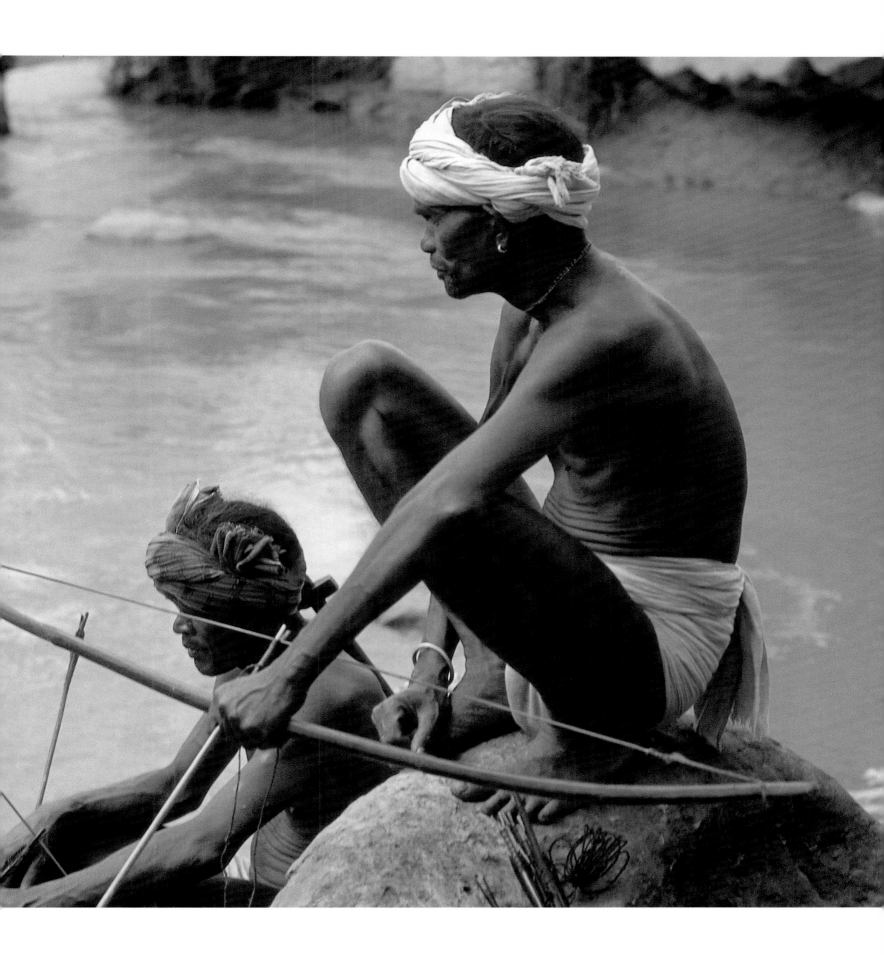

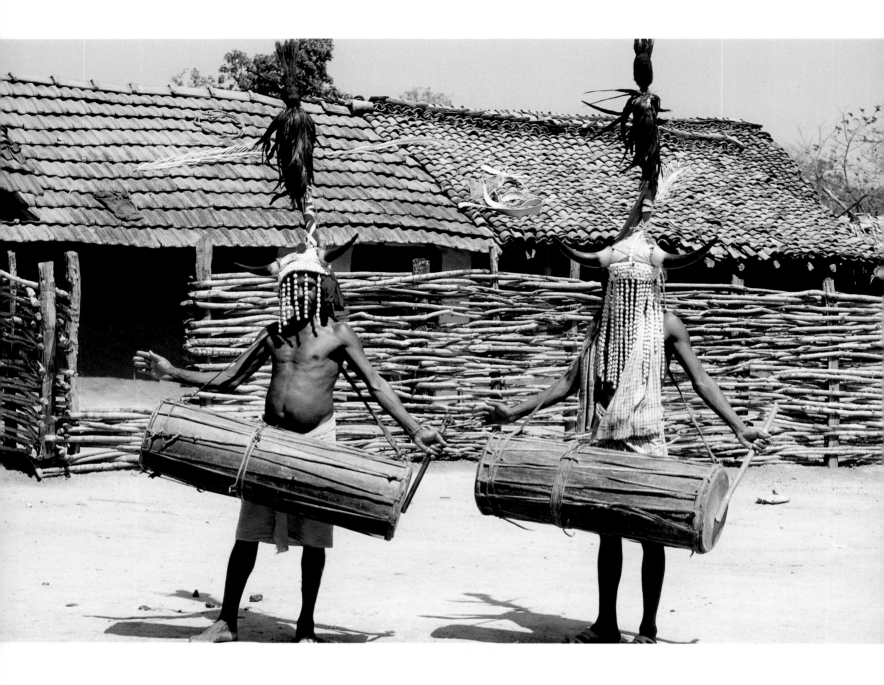

A Veil of Shells

The Koya, cattle-breeders in the border area of Orissa and Madhya Pradesh, wear festive headdresses made from polished buffalo horns and a veil made of cowrie shells in front of their faces to protect them from the evil eye.

Overleaf:
Once a week the womenfolk of the Dongaria Khond leave their villages, which lie hidden in the jungle on the mountain tops, to attend the market in Chatikona in Koraput District. They all still wear traditional clothes and jewelry.

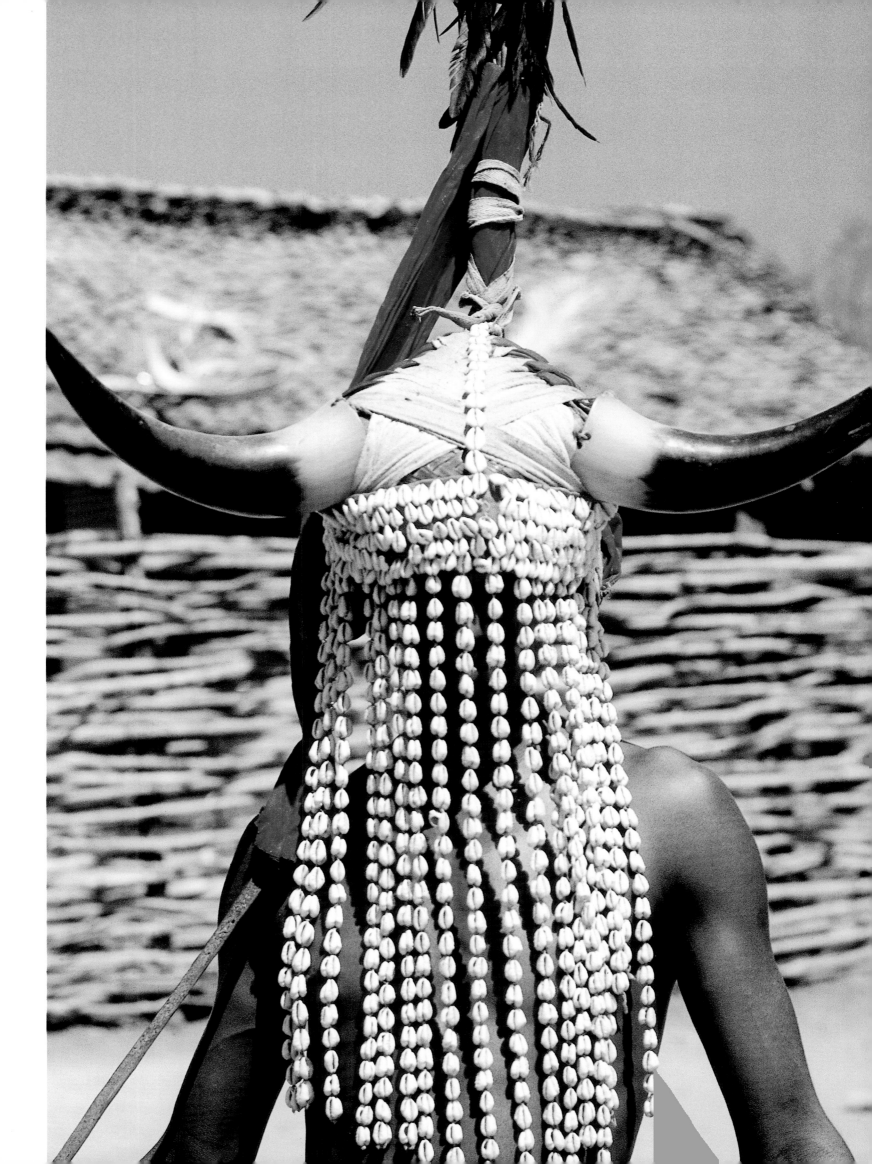

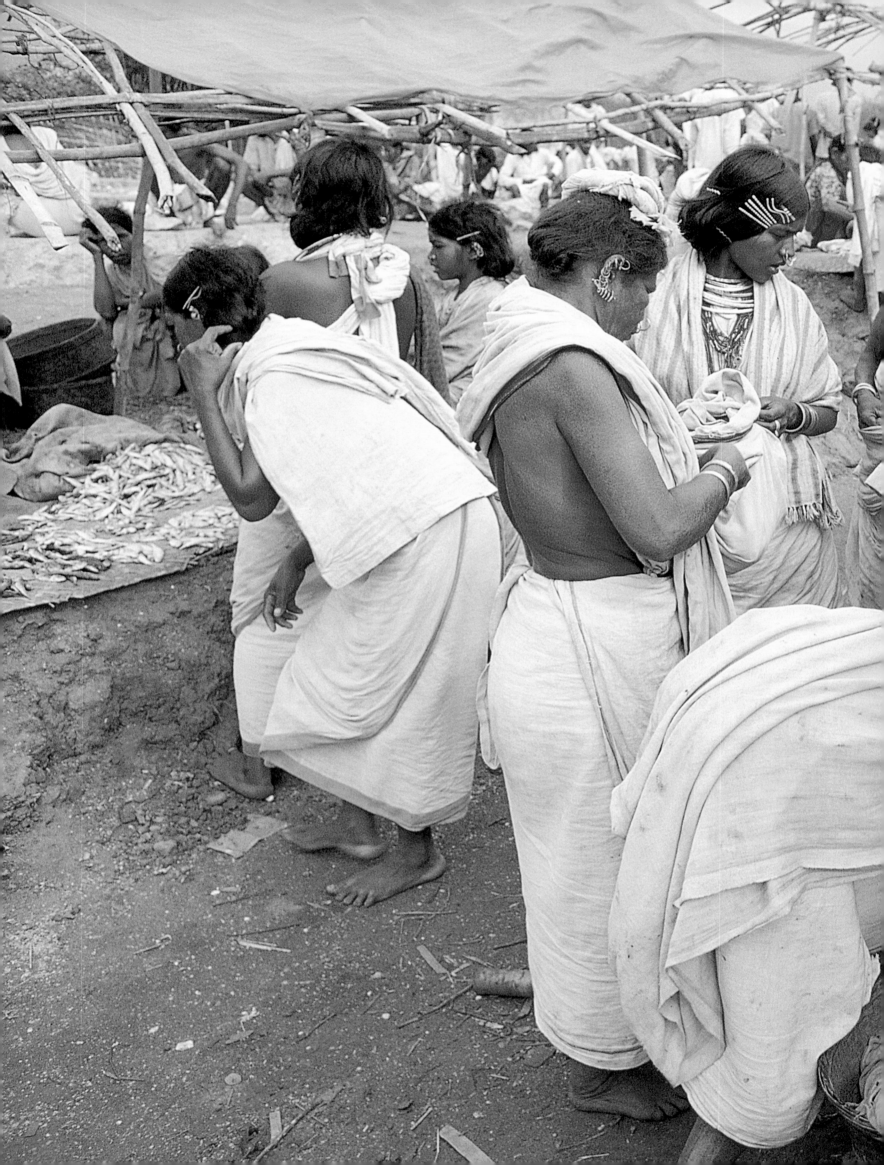

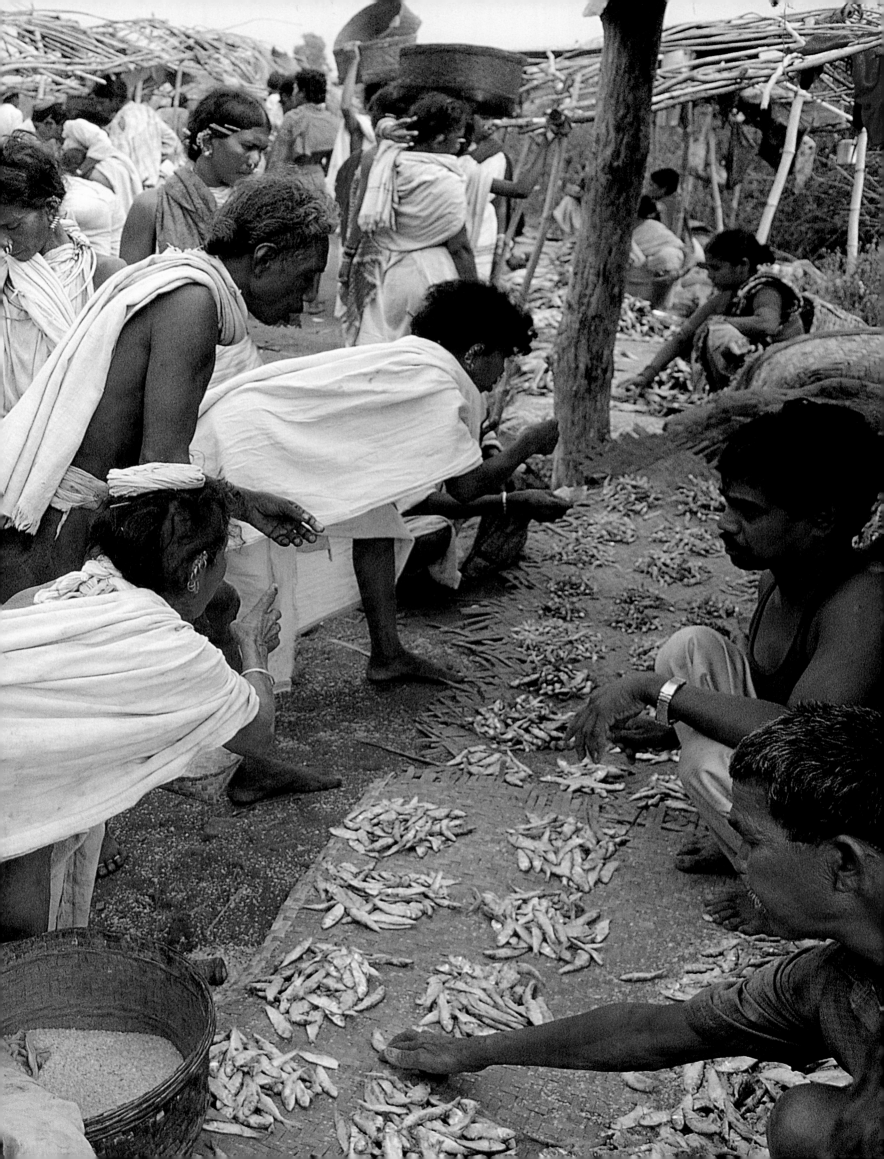

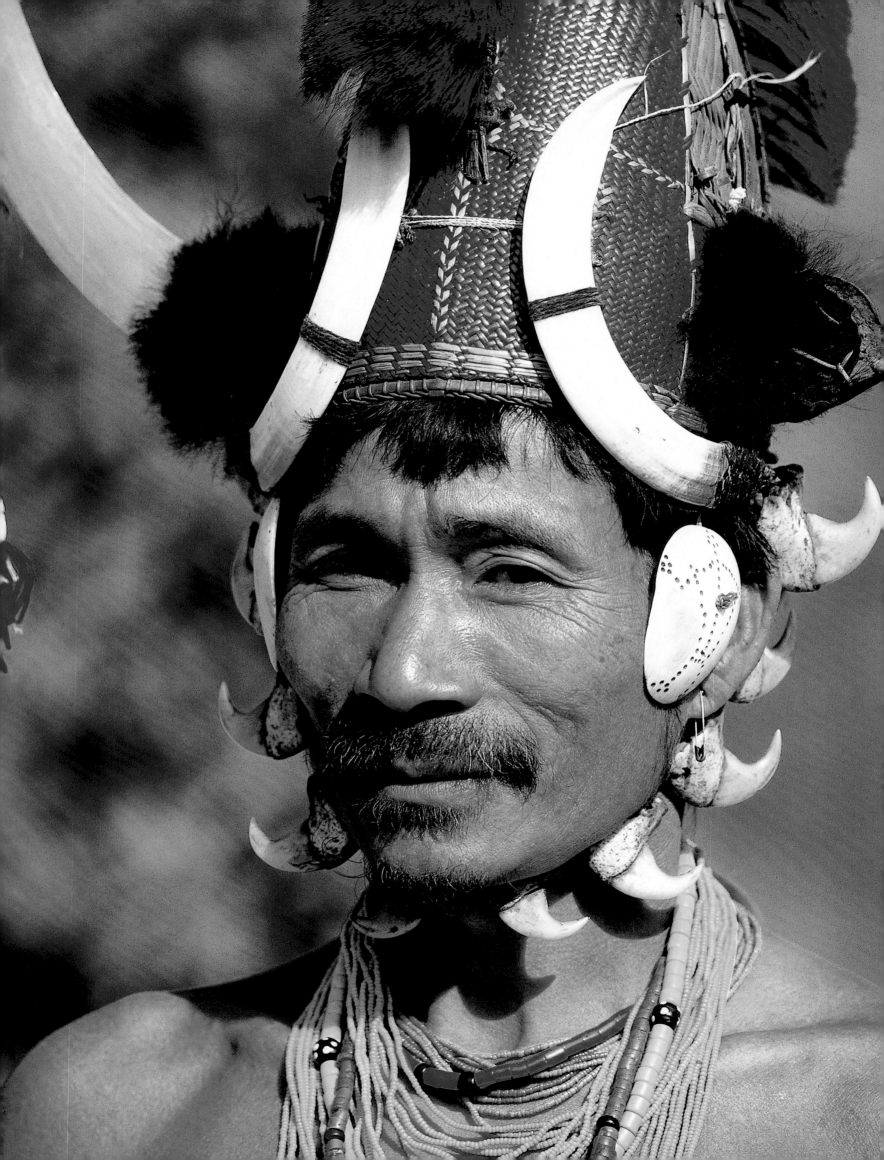

'Only in a few Naga villages has Christianity really gained the upper hand. There were also many villages that refused to abjure their old religion. But the paralyzing of the old village organization, upon which so many processes and procedures were dependent, had so weakened them that they were unable to keep up the old institutions such as the men's houses. Surprisingly enough, the old Naga believers are rather more tolerant toward the Baptists than the latter are towards them.'

Christoph von Fürer-Haimendorf, *The Naked Nagas*, 1939

Chapter 3
North-East India
Between Myanmar and Tibet

The wild foothills of the eastern Himalayas stretching between Tibet and Myanmar (formerly Burma) were for a long time forbidden territory. Even today, they remain a final enclave of mystery at the heart of the continent of Asia. This huge area in the extreme north-east of India used to be known as the NEFA (North-East Frontier Agency) and could be compared, as Herbert Tichy once put it, to a massive horseshoe spanning the Brahmaputra river. These oft-contested stretches of land form the Indian boundaries with Tibet, as well as with Myanmar and Bangladesh; they constitute a militarily-controlled prohibited zone that is only accessible from the rest of India through a twenty-kilometre-wide corridor.

This remote region hit the international headlines in 1959 when the Dalai Lama, fleeing from Lhasa, found refuge in the monastery of Tawang in the state of Arunachal Pradesh, which borders on Tibet. In 1962, Chinese soldiers crossed this northern border and it seemed that an invasion was about to take place. Thereafter the area was for strategic reasons declared a prohibited area that even Indians were not permitted to enter. Arunachal Pradesh thus became one of the few areas in what had been the NEFA of British India to which – by contrast with Nagaland and Mizoram – even missionaries had no access. It was only relatively recently that the Indian government finally began to issue permits to visit some of these tribal areas.

This mountainous region is home to numerous small mountain peoples of the Tibeto-Burman language group; here they live in isolation from the rest of the world, preserving their traditional ways of life as they have done for centuries past. They have little or nothing in common with the Indo-Aryans of 'mother India', or with the Indians of the plains. There is much evidence in their languages and oral traditions to suggest that they share a common area of origin, namely the lands of the north Burmese frontier. The inhabitants of one valley are often incapable of communicating with their neighbours, even though the latter live no more than a gunshot away. Some are Buddhists, but most have retained their animistic beliefs.

In spite of all their differences, the tribal groups nevertheless have much in common. They practise shifting cultivation and build terraces on steep mountain slopes in order to grow rice, maize and millet. Others such as the Apatani are particularly skilled farmers and breed cattle. Because they live in a high-lying valley of Arunachal Pradesh situated in a rain-shadow with

A Naga warrior from Myanmar in full ceremonial garb.

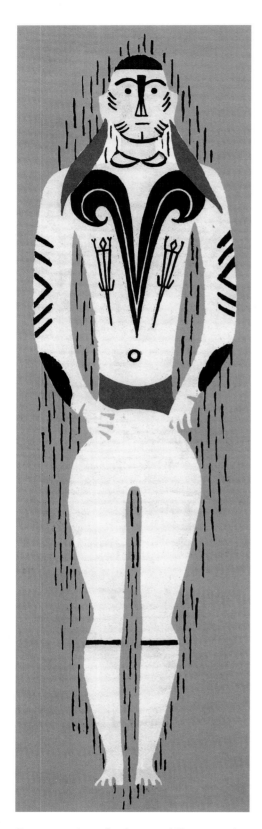

Representation of a decorated Naga warrior.

a correspondingly low level of precipitation, they use irrigated fields in order to grow rice.

The mountain tribes were famous – even notorious – for their fighting spirit and many of them had a religious reverence for the practice of headhunting, which also formed part of their fertility cults. This was particularly true of the Naga tribes who live in the frontier area between Assam and Myanmar. Their mountain villages are principally situated under the 2,000-metre line in the range that stretches between the Brahmaputra plain and the valley of the river Chindwin. The tribes can be divided up into numerous sub-groups, each with its own language, and can be distinguished by the different ways in which they adorn their heads and bodies.

Their forms of artistic expression are primarily connected with the practice of headhunting and are linked with associated occult and religious concepts. Their representations of the human figure emphasize the head, which is thought to be the seat of magical power that can increase fertility in humans, in animals and in the fields. There were certain symbols that only a successful headhunter had the right to use and the total number of skulls he had accrued was what determined his social status.

Traditionally, a central role was played by the so-called 'men's house' (or 'bachelors' house'), known locally as the *morung*. It stood in the middle of the village and was thought of as a kind of training centre for young men, containing places for unmarried men and women to sleep and to gather sexual experiences. The holding of 'feasts of merit' used to be a characteristic feature of Naga culture – at these feasts, personal prestige could be acquired through the ritual sacrifice of mithan buffalo (a cross between a yak and a cow) and through the distribution of meat to the villagers.

Reminders of these feasts still exist in the form of decorated gables on houses and memorial stones. Some tribes had a particularly developed 'merit' system, which led to the slaughter of whole herds of mithan and to the ceremonial destruction of valuable ritual objects such as Tibetan bells, bronze panels and swords as one family tried to outdo the next. Personal possessions and wealth were decimated and goods were distributed to other villagers.

During the period of colonial rule there were frequent skirmishes between the British and rebellious ethnic groups. On their pillaging raids, the mountain people often pushed far into the plains of Assam, which resulted in colonial troops being sent on punitive expeditions. The Naga tribes in particular engaged in a stubborn guerrilla war against the British, laying whole expeditions low. This resulted in a decision on the part of the government of British India to leave the mountain peoples largely in peace, so long as they refrained from ambushes and headhunting. Their determination to resist strict control by outsiders meant that during the Second World War the Naga were regularly caught in the crossfire of the British and Japanese forces. The conflicts continued even after Indian independence. In 1955 the Naga rebelled and demanded their own independent state or at least a greater degree of autonomy. This led to a long drawn-out jungle war that has in fact been continued into the present day by one small militant minority group, even though the Indian government agreed to the establishment of the federal state of Nagaland in 1963.

The works of art both of the Naga and of a number of their neighbours are among the most important of their kind to have come out of the whole continent

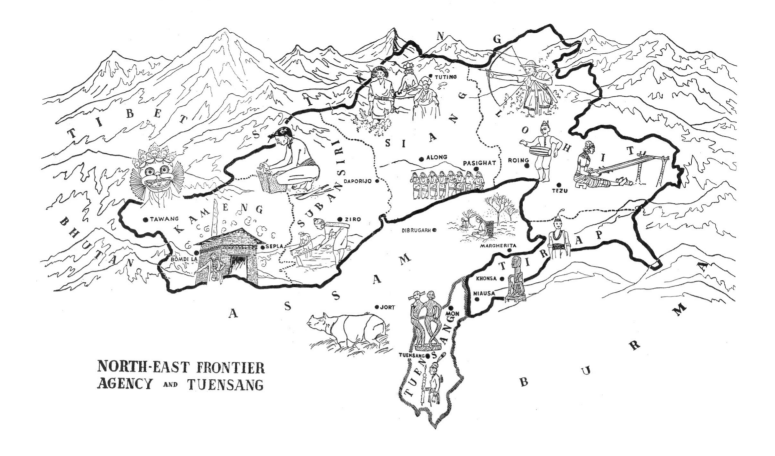

NORTH-EAST FRONTIER AGENCY AND TUENSANG

of Asia – megalithic stone monuments, avenues of stones and stone tables, jewelry with headhunting symbols, memorials of feasts of merit and magnificent carved wooden works in the monumental style. The fascinating culture of the Naga first became known to a wider public through the field research of the Austrian anthropologist Christoph von Fürer-Haimendorf. His monograph on the Naga is now considered as one of the classics of ethnographic writing.

Nowadays the majority of the Naga are Christians, with the influence of Baptist fundamentalist preachers having been particularly strong. Instead of visiting the *morung* they go to school; instead of fighting wars they carry on political discussions, and the official language of Nagaland is English.

Old map of the North-East Frontier Agency (North-East India).

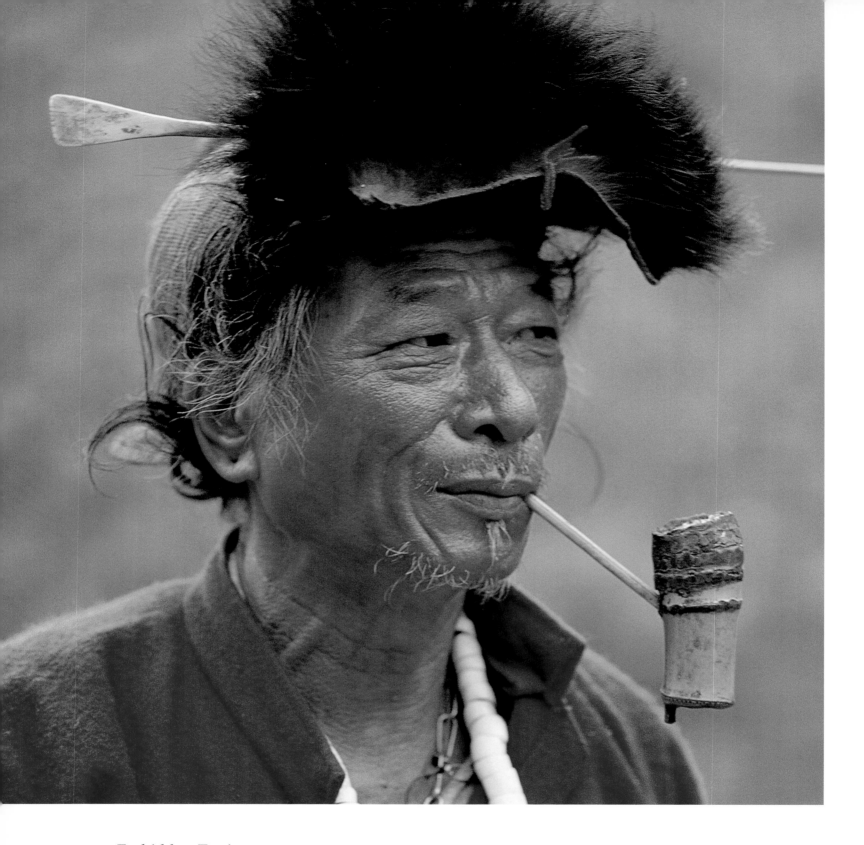

Forbidden Territory

Above: The mountain peoples of Siang Province are animists who sacrifice animals and consider the river a deity. A red jacket, first introduced as a robe of office by the British, shows that the elderly Adi man who is wearing it is the head of the village. His wicker helmet is decorated with a bird's beak and bearskin.

Opposite: The Brahmaputra rises as glacier water in western Tibet and is known by a variety of names before it finally flows into the Gulf of Bengal. It breaks through the eastern mountain ranges of Tibet and flows as the Siang under a 180-metre-long hanging bridge made of bamboo poles, bushrope and steel cables, which was put up by tribal peoples just a little south of the disputed China–India border. For a long time the zone was prohibited territory to outsiders.

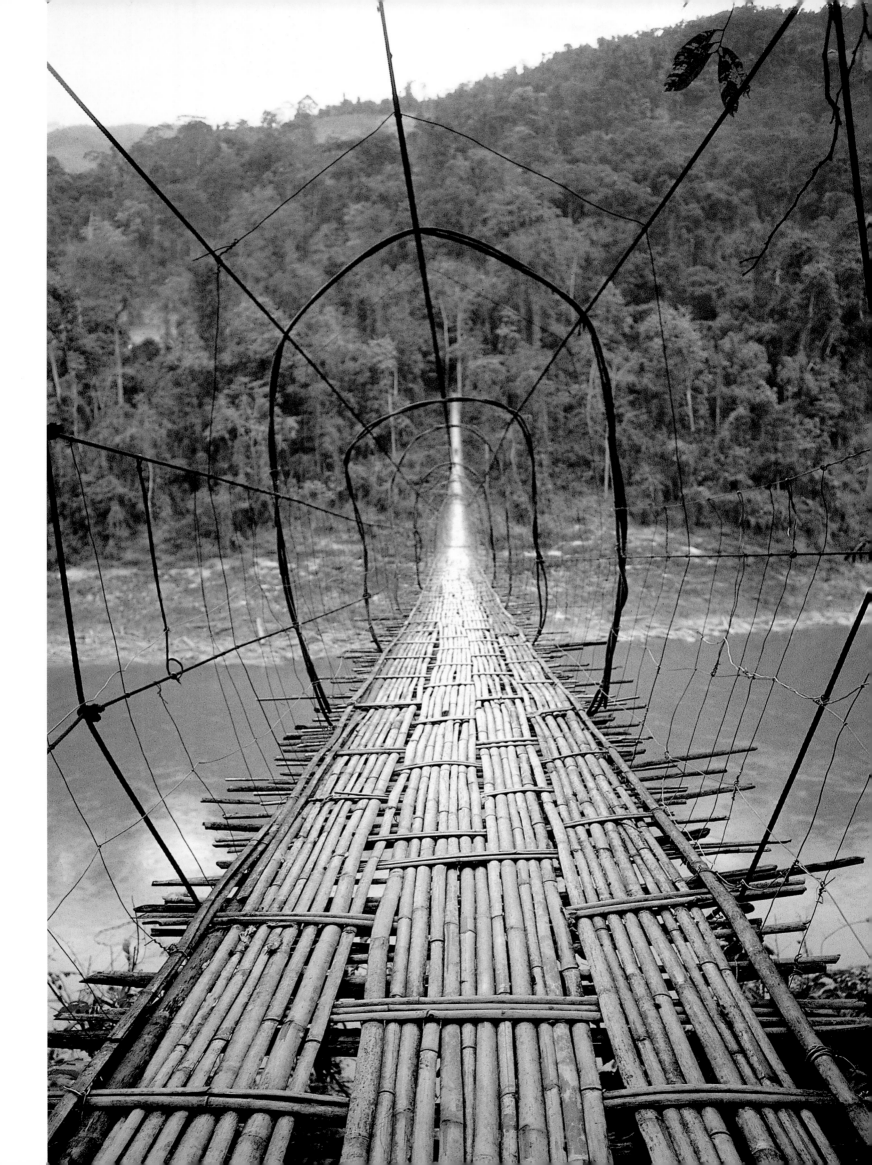

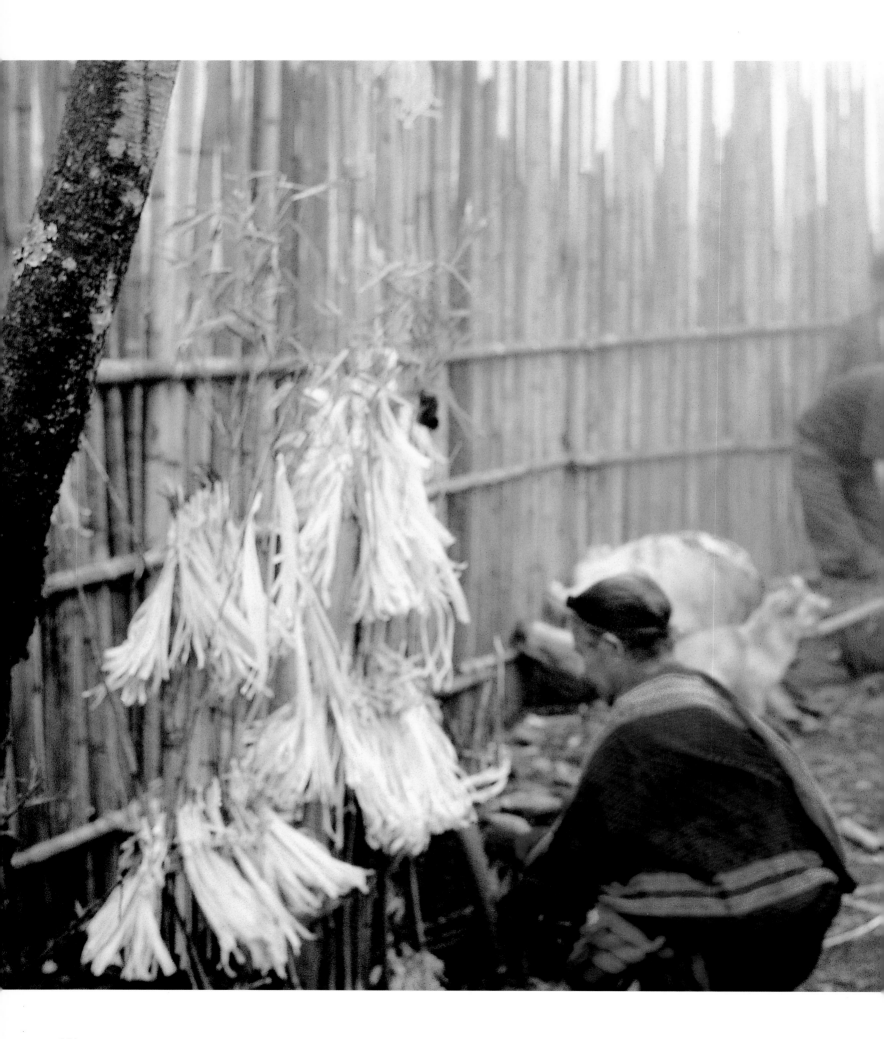

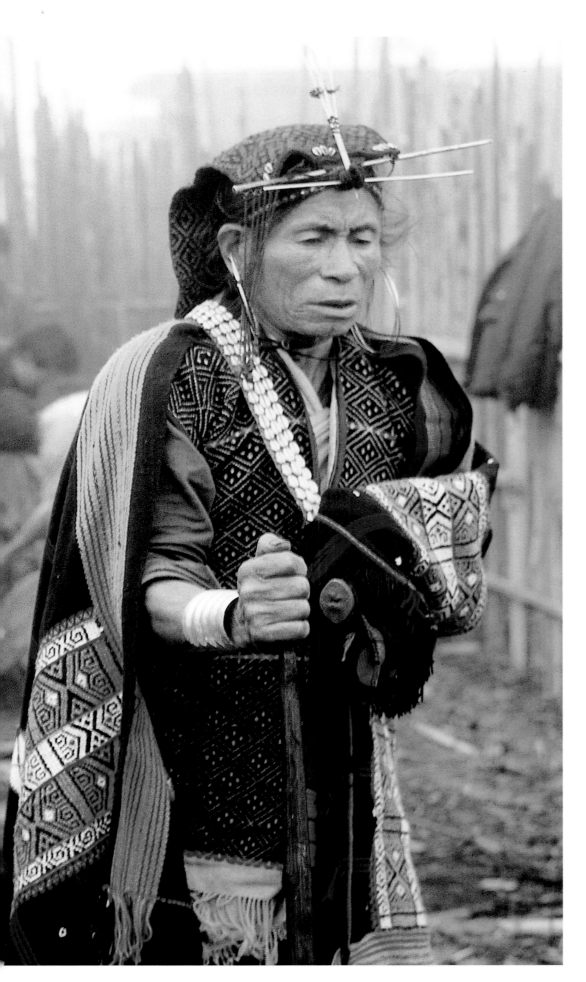

Ritual Sacrifices

The Apatani have specialist ritual leaders who act as mediators between mankind and the supernatural powers. They have a great variety of tasks to fulfil, including carrying out ceremonies to guarantee the fertility of the rice fields, and entering the spirit world in their dreams in order to win back the stolen souls of the sick.

Left: A shaman in full ceremonial clothing, accompanied by his assistants, performs a fertility ritual at the place of sacrifice situated outside the village of Hong. Eggs and chickens are offered up in front of the tasselled bamboo poles that symbolize the altar of local deities. Then a dog is tied to a sacrificial scaffold and has its throat cut.

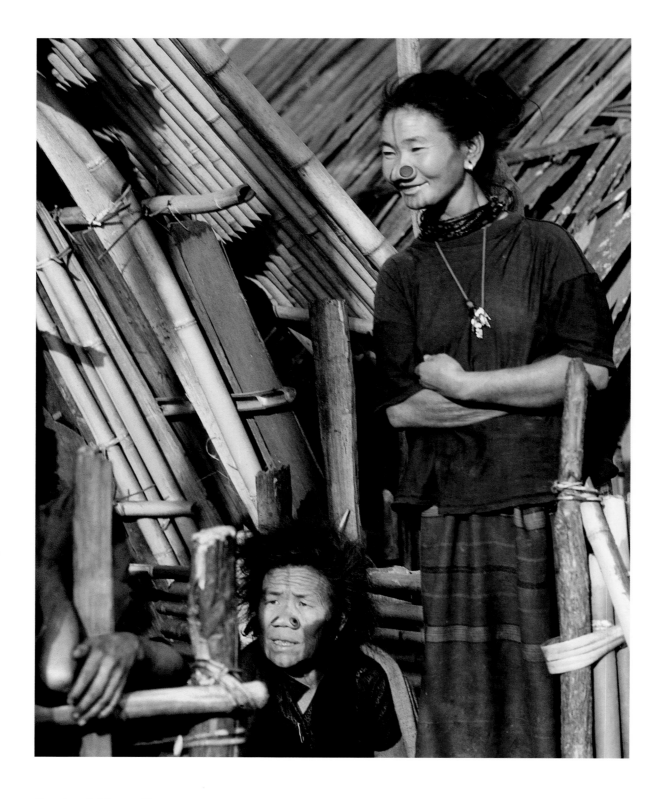

Apatani Nose Ornaments

Above and opposite: The most conspicuous feature of the Apatani women is the way they adorn their noses – they consider it the height of beauty and a sign of tribal allegiance to pierce both nostrils with dark-coloured pegs up to three centimetres across. This tradition may go back to the times of tribal feuds, when abductions were commonplace, and a beautiful woman who had been disfigured was less likely to be abducted. The blue-black tattooed stripes running vertically down from the forehead over the bridge of the nose to the chin were intended to protect the woman from evil. Nowadays this kind of facial decoration is only seen on older women.

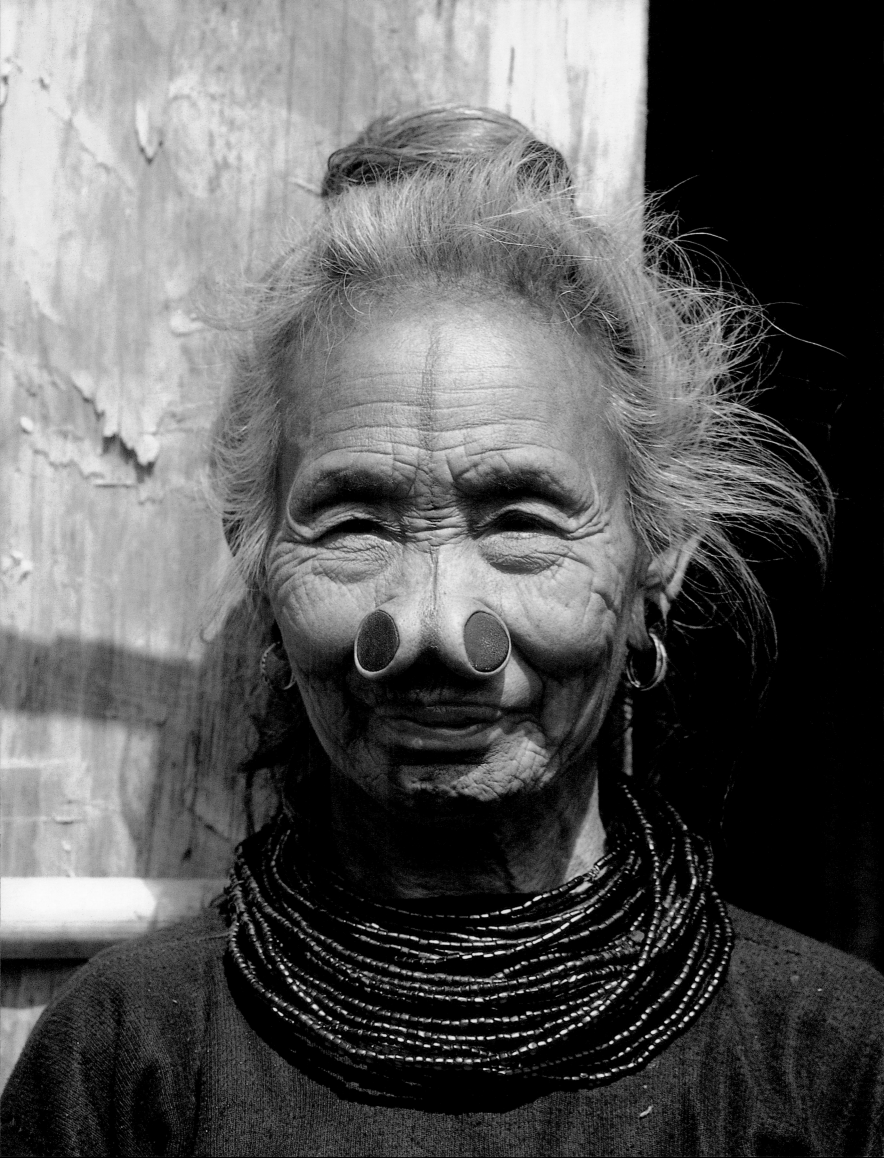

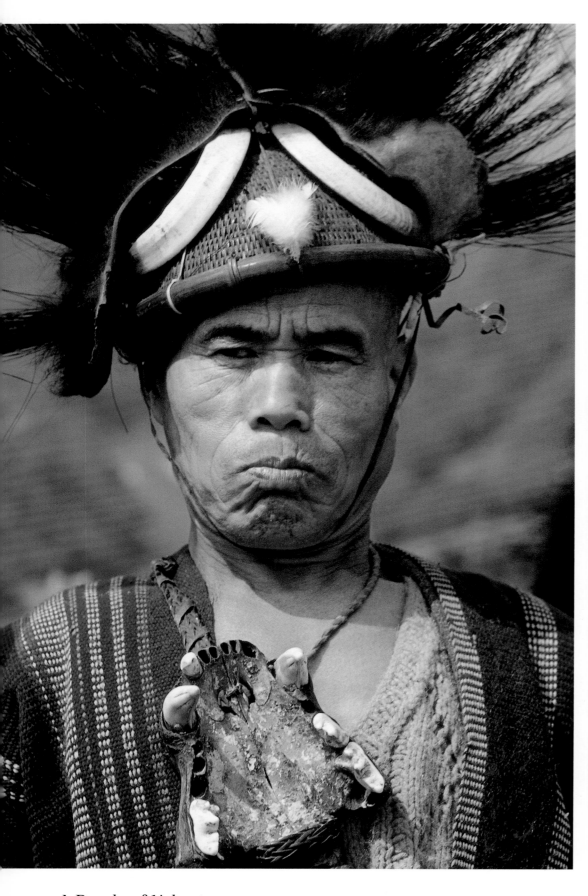

A Parade of Helmets

The male tribal inhabitants of Arunachal Pradesh have an impressive line in headdresses. Their wicker helmets are so closely woven that they are completely watertight, as well as resistant to blows and thrusts from weapons. Decorated with the teeth of wild boar and the fur of the Himalayan black bear, the men of the Adi cut proud and warlike figures. The man on the left is wearing on his breast the lower jaw of a leopard, a highly prestigious trophy.

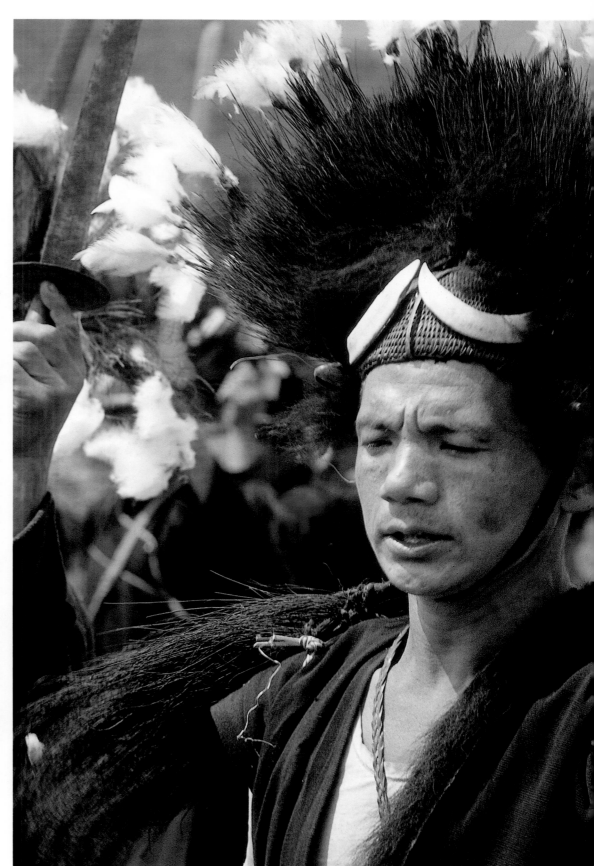

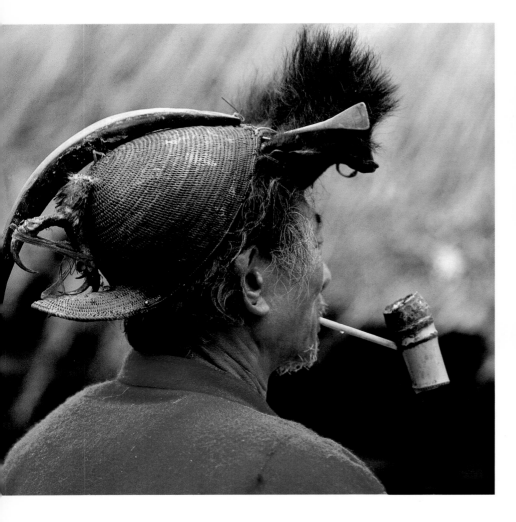

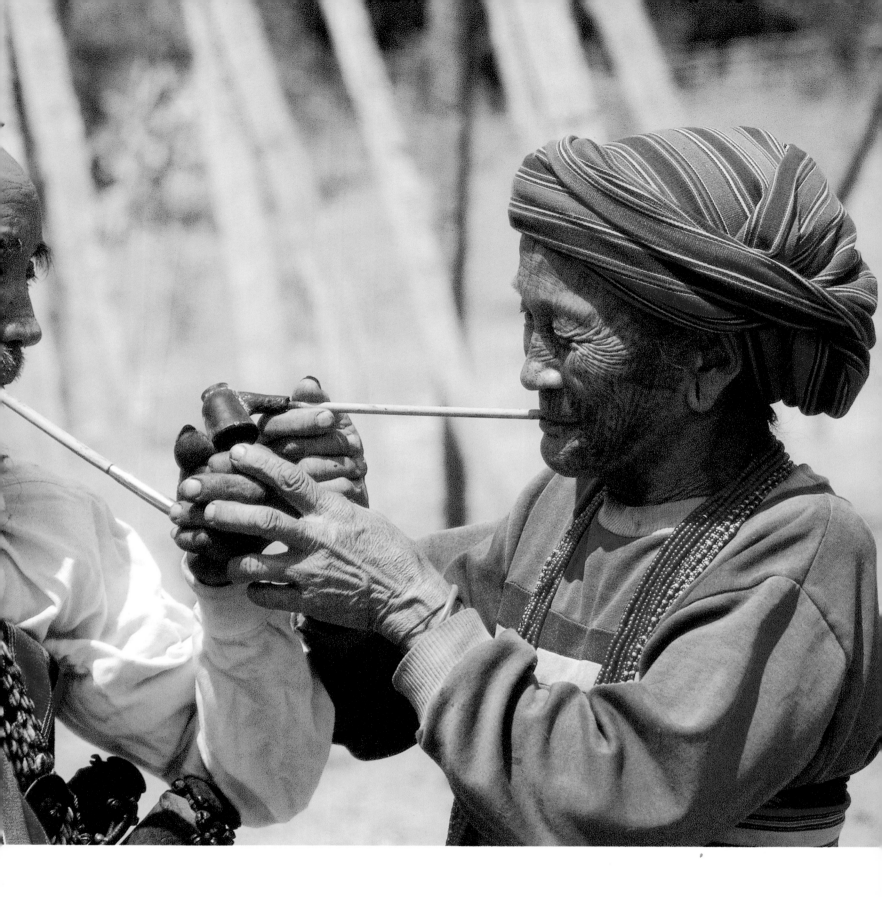

Pipe Smoking

Above: A Chin couple from the mountains of Myanmar. The Chin are well-known for their distinctive facial tattoos, but nowadays only a few elderly Chin women sport them.

Opposite, left: An Adi man from Arunachal Pradesh smoking a bamboo pipe and wearing a typical Adi headdress decorated with the beak of a rhinoceros hornbill.

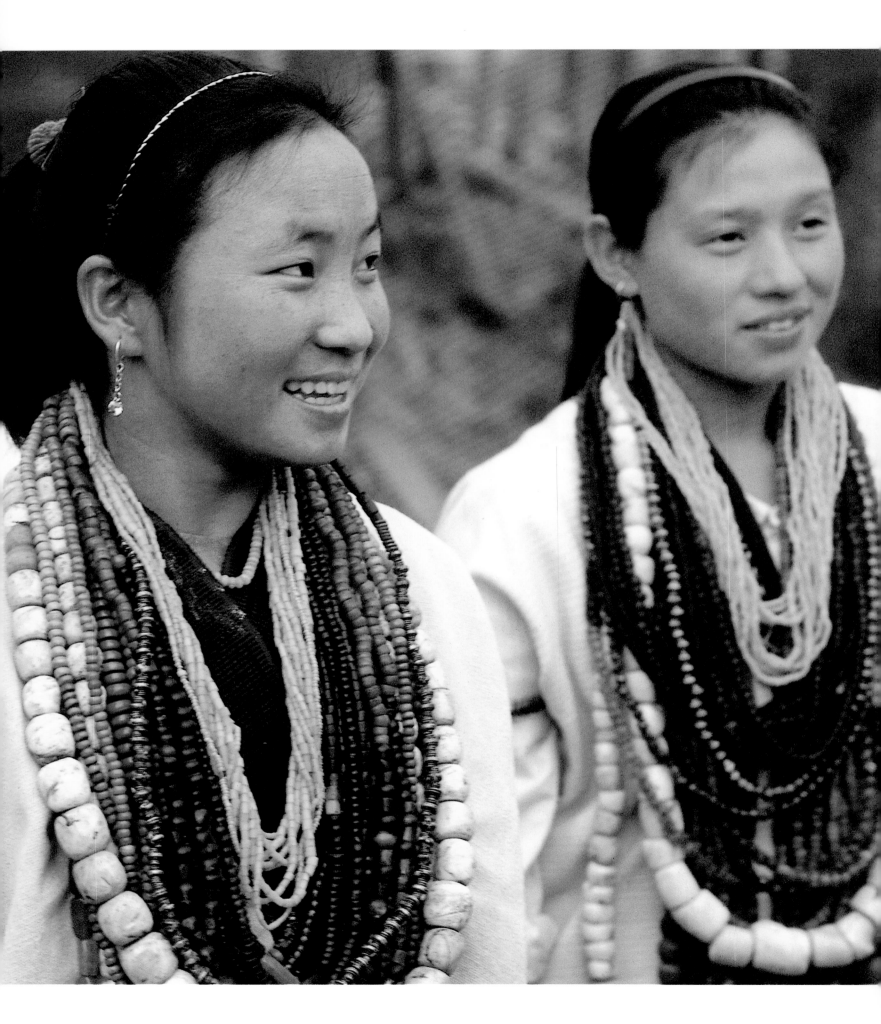

Shell Necklaces and Brass Discs

Above: Until the birth of their first children, Adi women wear a belt of ornamental brass discs (*benyop*) on their hips. Small girls sometimes wear one as a loin-cloth. There is a legend that tells of its origin. A male deity fell in love with a young woman, and every time they made love, he presented her with a *benyop* disc. After she bore a child, she stopped wearing the *benyop* belt. The spiral motif represents the wheel of life.

Opposite: Shell necklaces are very valuable, and are handed down from mother to daughter through many generations.

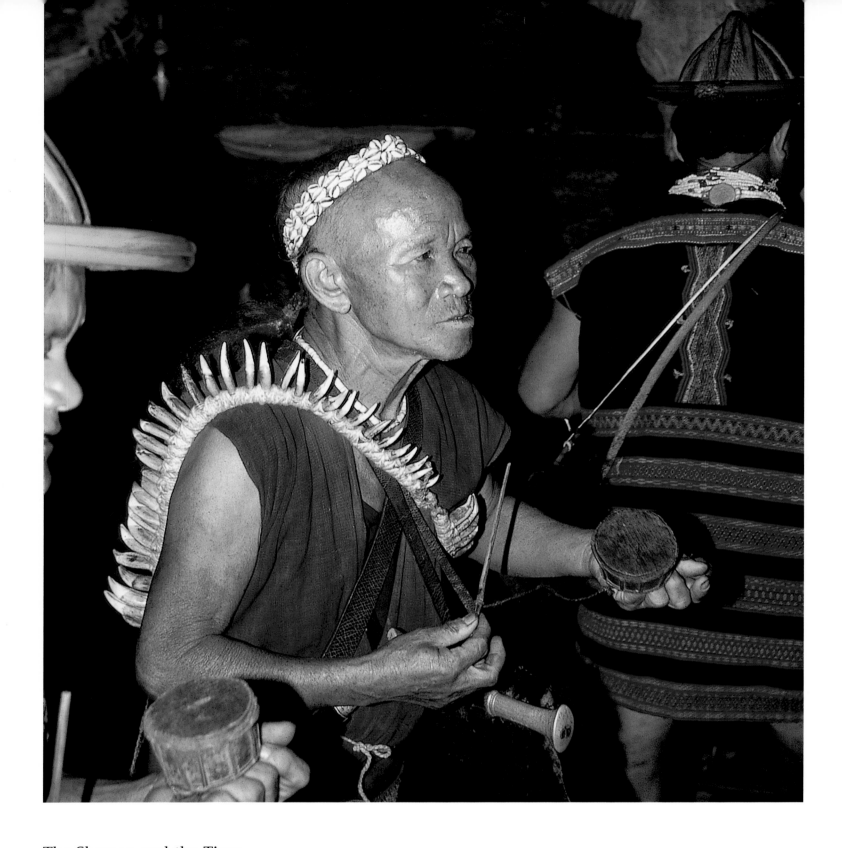

The Shaman and the Tiger

The indigenous peoples of the Asian tropics have high regard for the tigers, leopards and bears that were and are the masters of the rainforest. They believe that these animals' most dangerous weapons, namely their teeth and claws, contain great magical power, and that when the latter are worn as amulets or talismans, they bestow this magic on the wearers.

Above: Ritual dances in the assembly house of the Idu Mishmi, a Tibeto-Burmese ethnic group. The shaman beats a small drum to call up the spirits of the ancestors, wearing over his shoulder a large chain of tiger's teeth. A headband of cowrie shells and a bearskin bag complete his regalia.

Opposite: Tiger's teeth endow the shaman with magical powers. The cymbals and little bells worn on the back clink together, driving away the evil spirits.

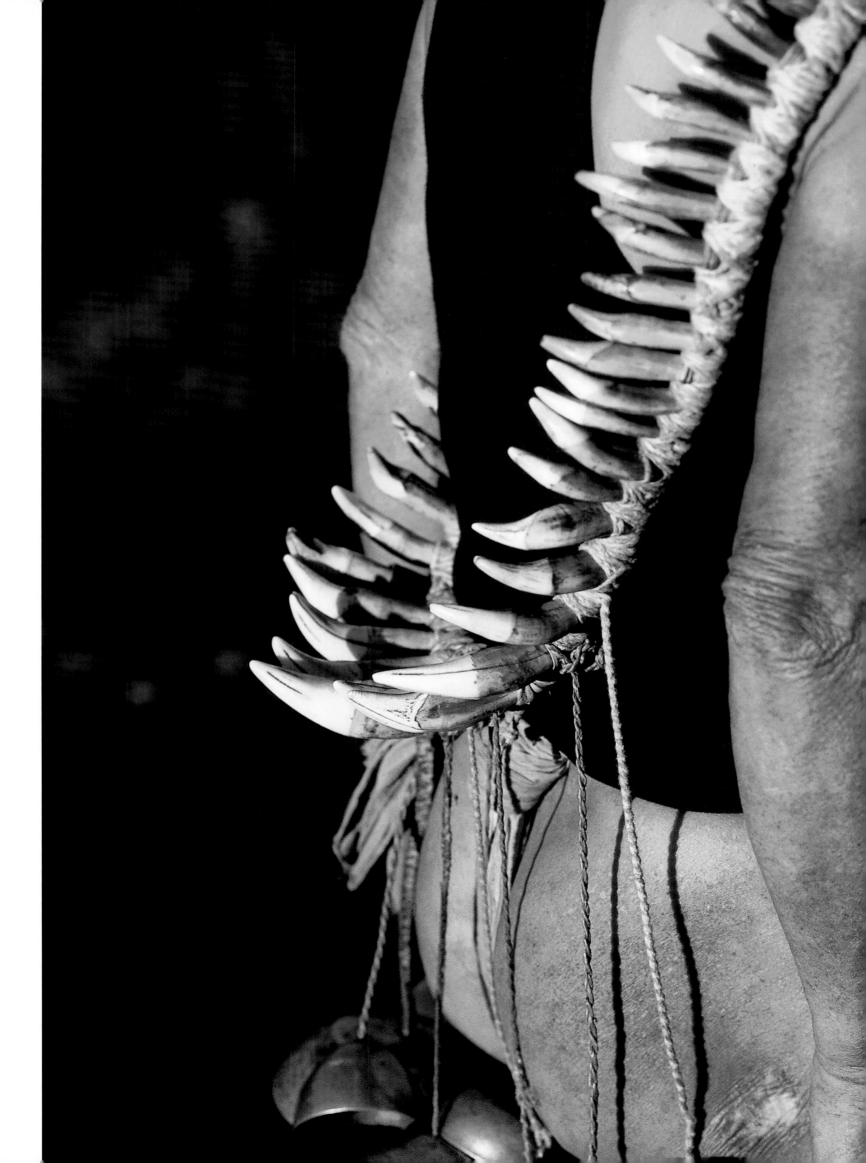

Symbolic Significance

Left: A breastpiece made from the lower jaw of a tiger, and a belt made from spliced reed spirals. For men from the Tirap region, the belt is almost a sacred object, because the belt has the sheath of the *dao*, or chopping knife, affixed to it.

Below: A Wancho tribal chief with decorative objects on a necklace, and armbands made from silver and a shell (*Xancus pyrum*) that is only found in the Gulf of Bengal. These impressive shells also play an important role as ritual objects in the Hindu-Buddhist cultural zone.

Opposite: A Naga warrior from Singkaling Hkamti on the river Chindwin in Myanmar in traditional costume. The face is framed by a string with ten tiger claws, all coming from the front paws, and the wicker helmet is decorated with two wild boar's tusks.

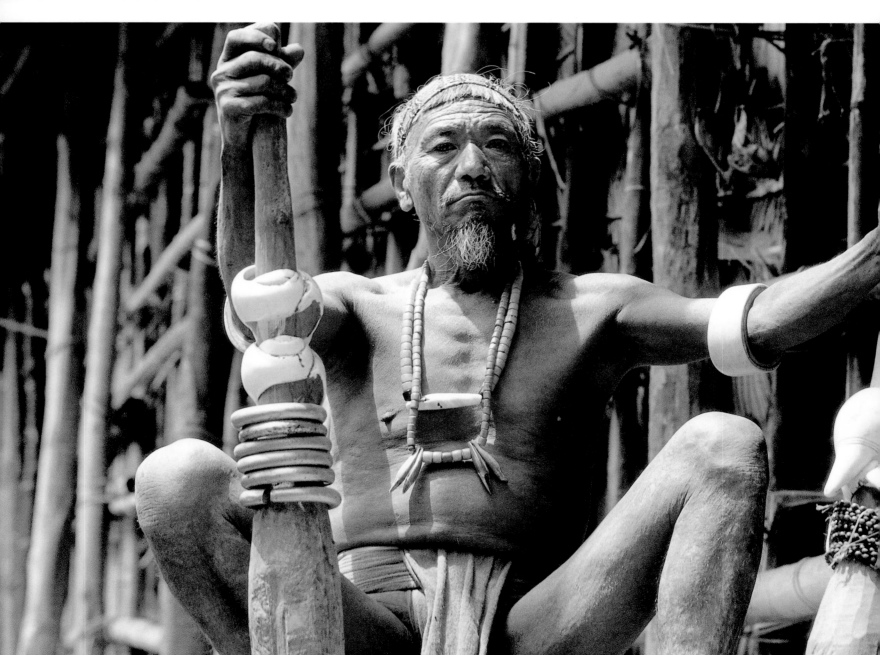

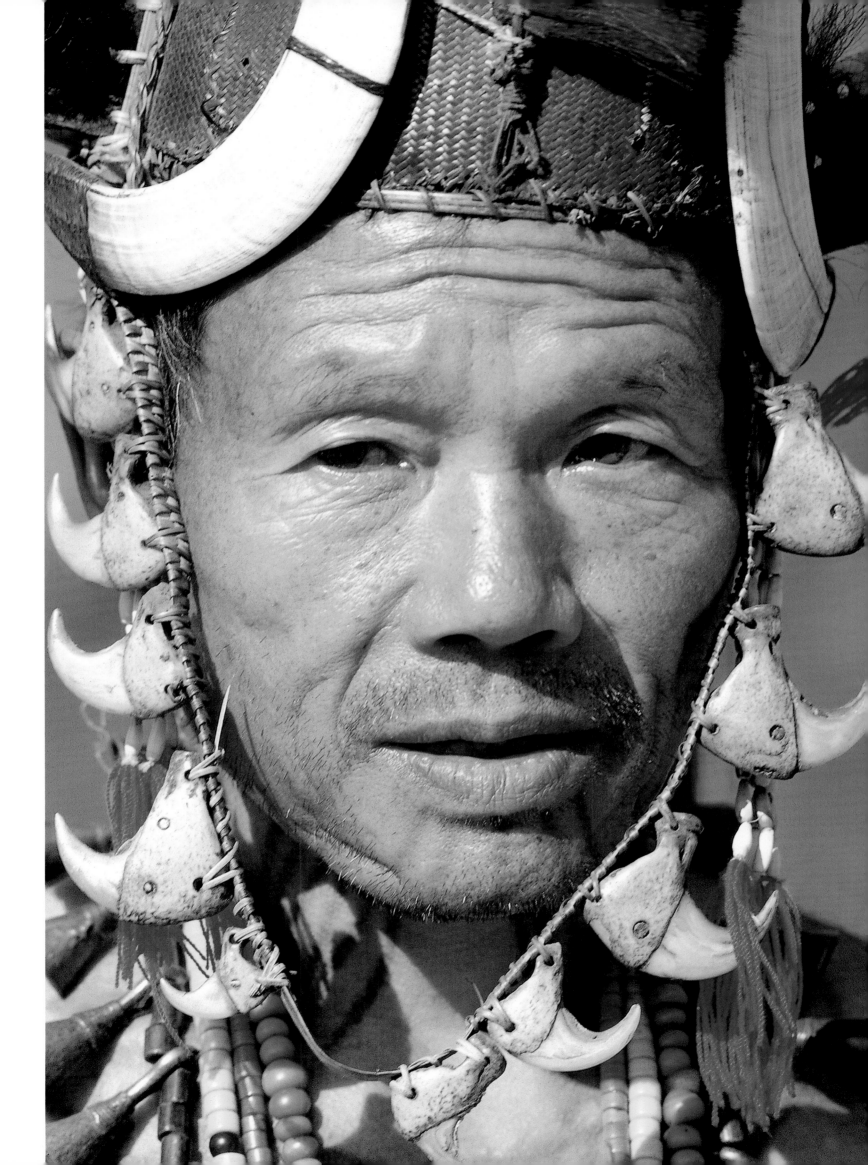

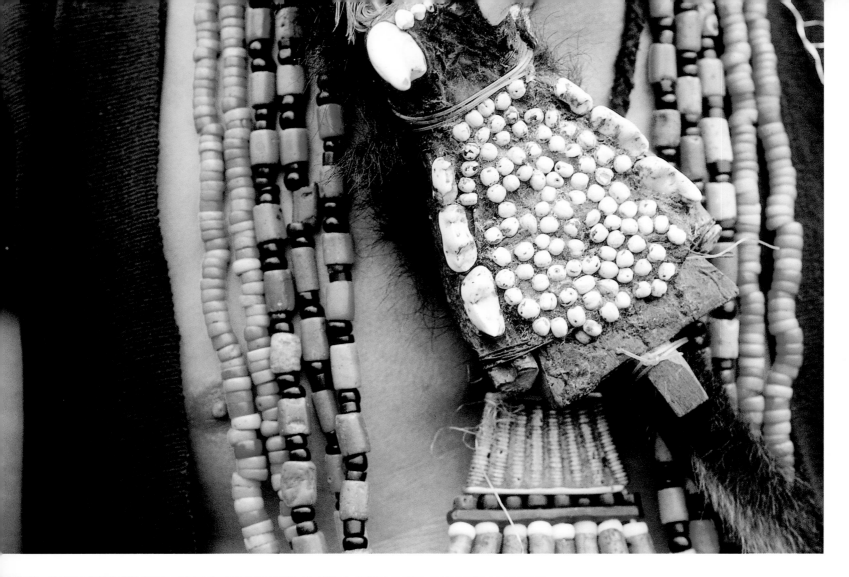

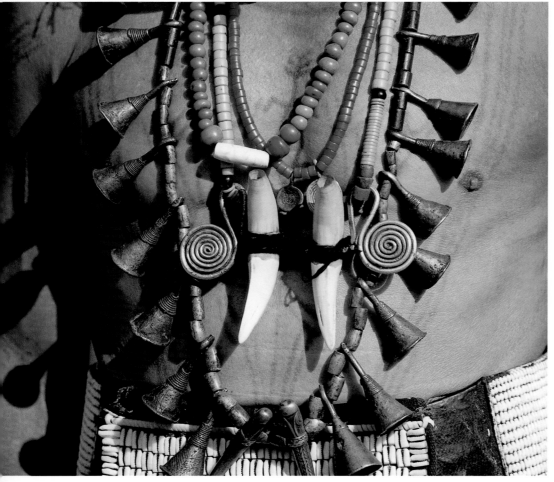

The Signs of a Hunter

Above: A man of the Adi with a pectoral made from a leopard's lower jaw, beneath which he wears an ornament typical of the Padam Minyong, made from bones and brass cylinders. This combination is completed with chains of blue glass beads.

Left: A Naga warrior's pectoral, made of copper spirals, glass beads and two tiger's teeth, particularly precious additions. The loincloth is attached to a band set with cowrie shells.

Opposite: A Naga from the mountains of Myanmar with his typical embroidered cotton cape.

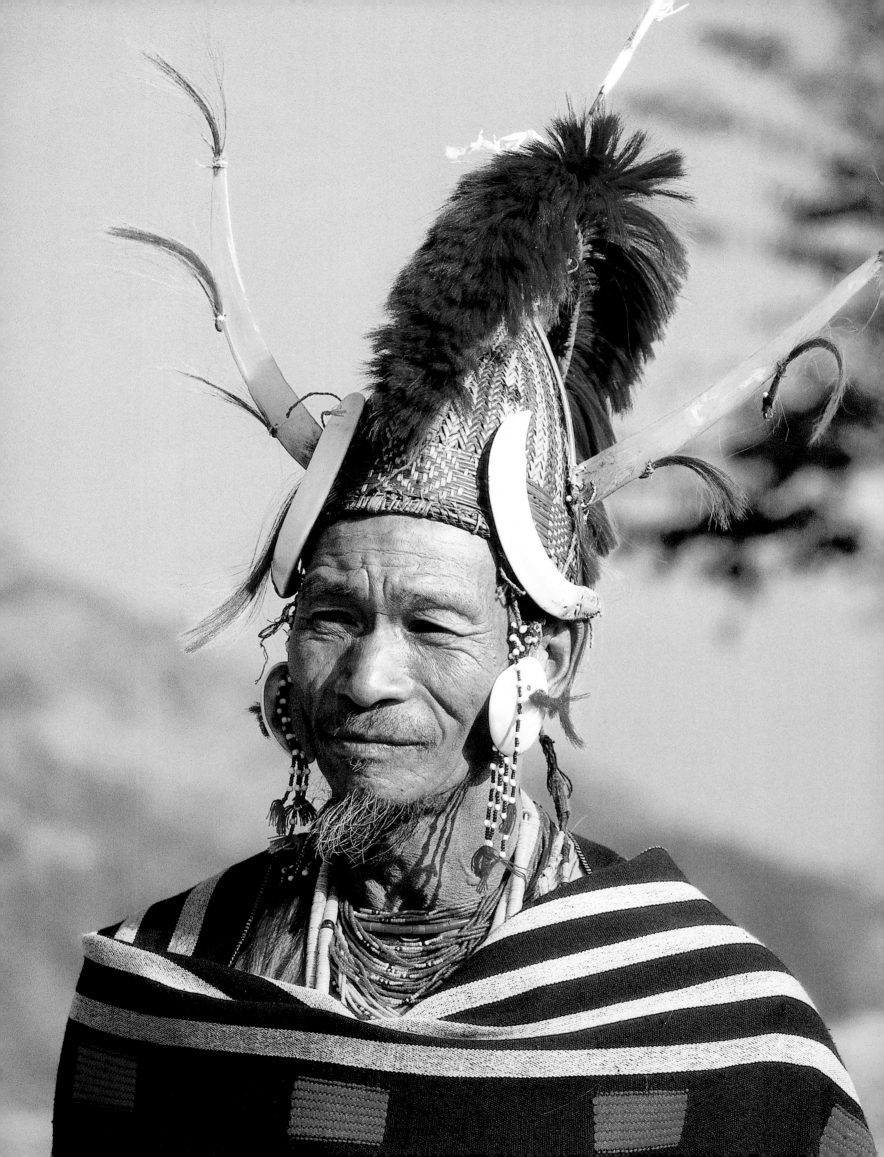

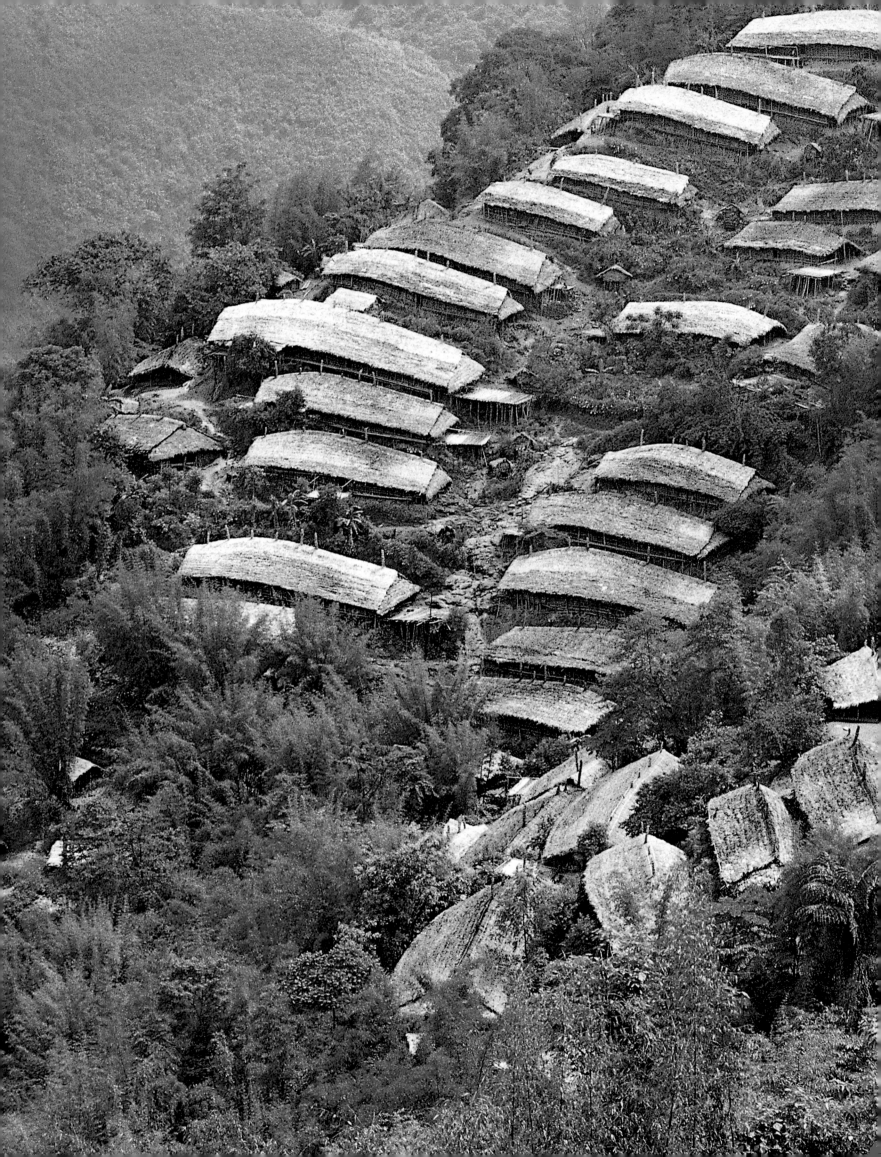

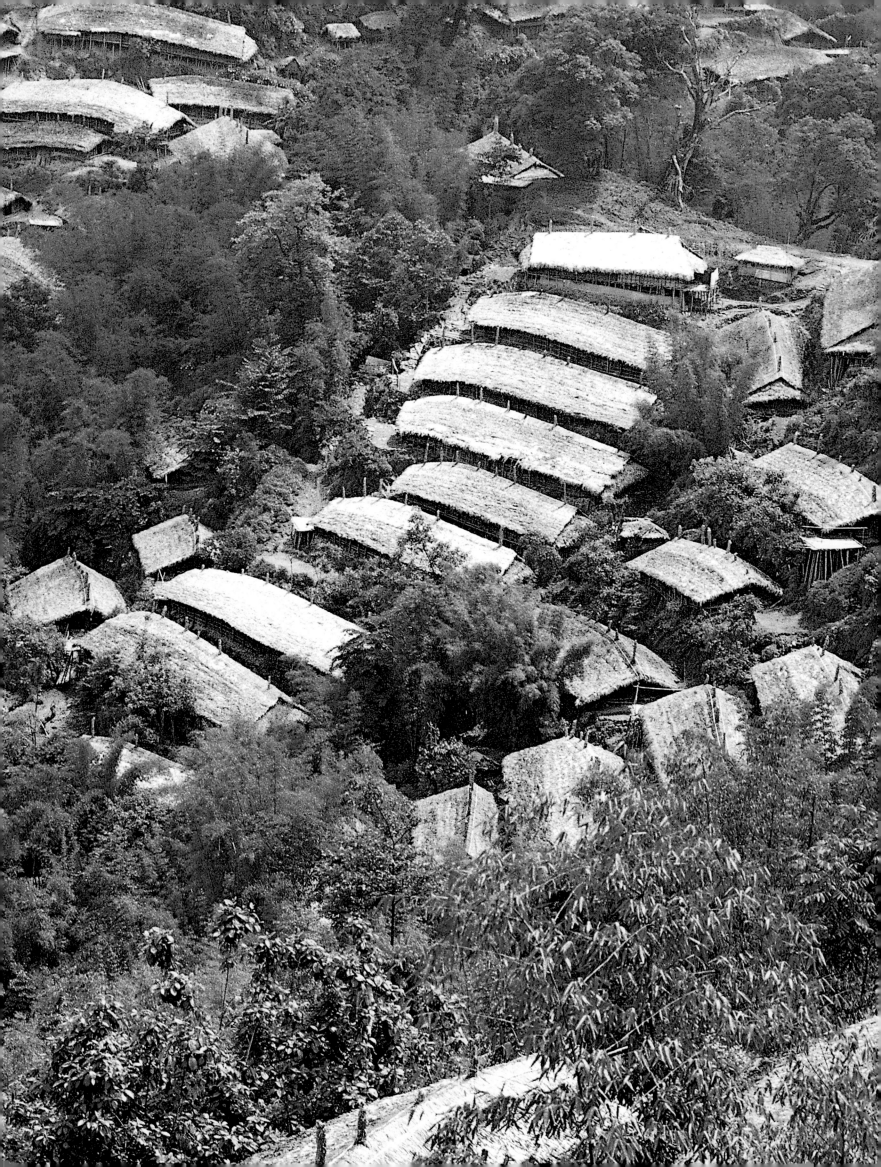

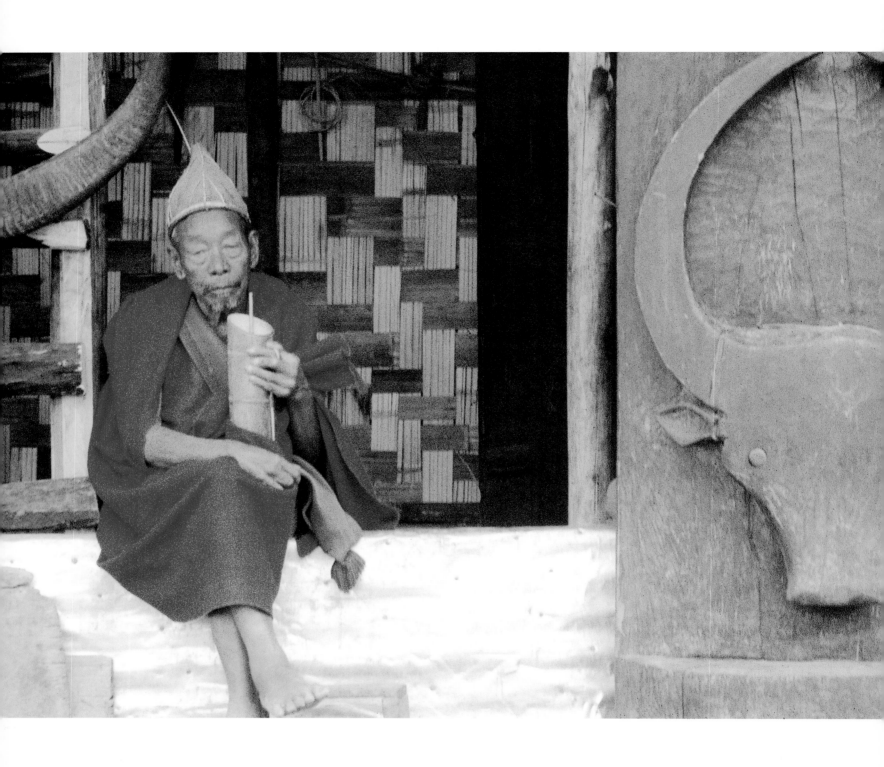

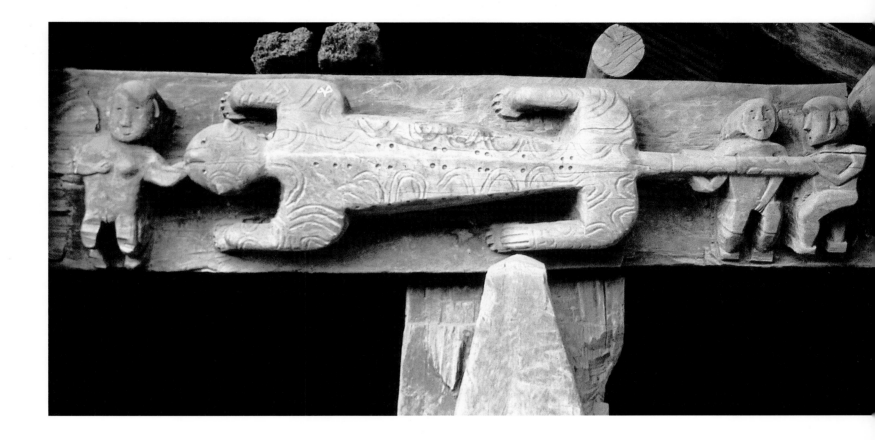

Monumental Carvings

Opposite: A Chang tribal chief from Tuensang sitting before his imposing house front and holding a bamboo vessel of millet beer. The stylized representation of the head of a mithan buffalo decorates a heavy standing wooden panel by the entrance. This motif is a good example of the symbolic or monumental style of carving typical of the Naga, without any additional ornamentation. It is a reminder for the village folk of the sacrificial oxen and of the merits that the owner has accrued as a feast-holder. Among the Naga, a person's prestige and status is measured by the number of feasts he has held and the number of buffalo he has sacrificed.

Above: A carving in the form of a tiger, from a men's house.

Previous pages:
A traditional Wancho village in the Tirap district of Arunachal Pradesh blends harmoniously into a mountain side. There is not a trace of corrugated iron to spoil the view, nor are there any of the piles of rubbish typical of the civilized world. The large houses are stable with their massive corner posts and strong roofs covered with several layers of palm leaves.

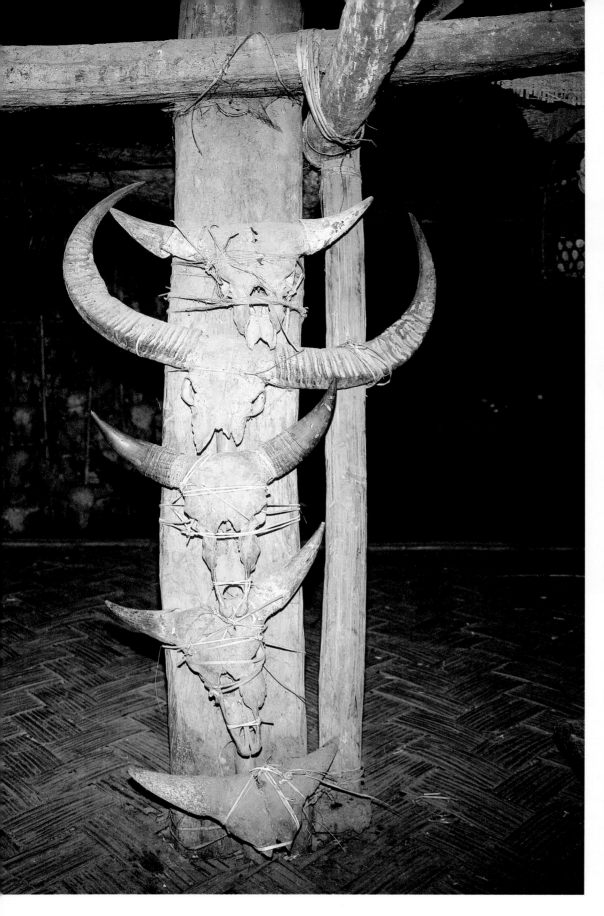

Monumental Drums

Among the most impressive artefacts of the Naga are the huge slit-drums that are used to send pieces of news to people many kilometres away. These drums are in fact hollowed out tree trunks up to twelve metres long with a slit opening stretching all along the upper side. There was a time when the dull but powerful tones of these drums resounded around the mountains, sending out war signals. Now the few remaining drums are used for different purposes. They are used to call people to festivities

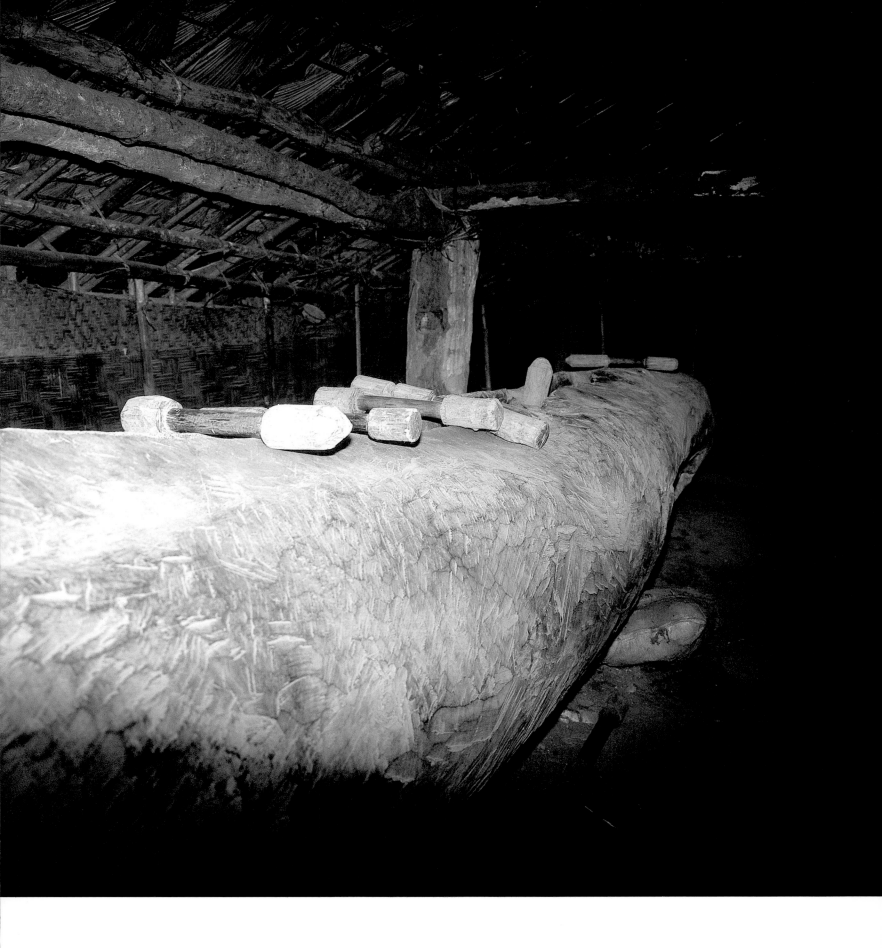

or to important assemblies, or as an alarm signal when a tiger has come close to a village or when there is a danger of fire. The slit-drum (above right) and the skulls of sacrificed buffalo (above left) are kept in the *morung*, the ritual and artistic centre of the village, where the men gather to rule on all tribal matters. These drums are from the Langdang region in Tirap.

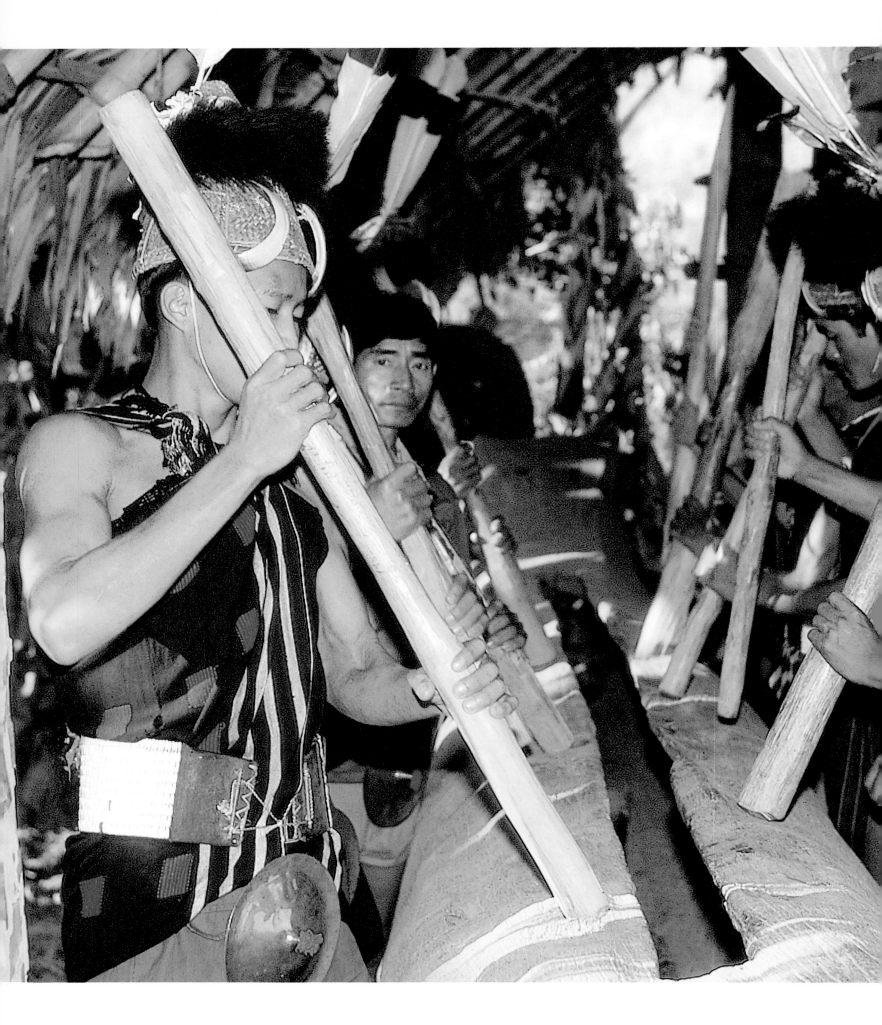

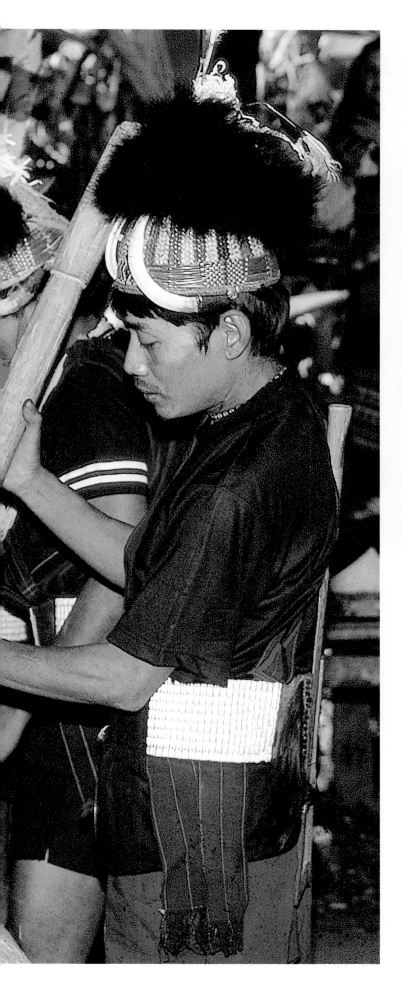

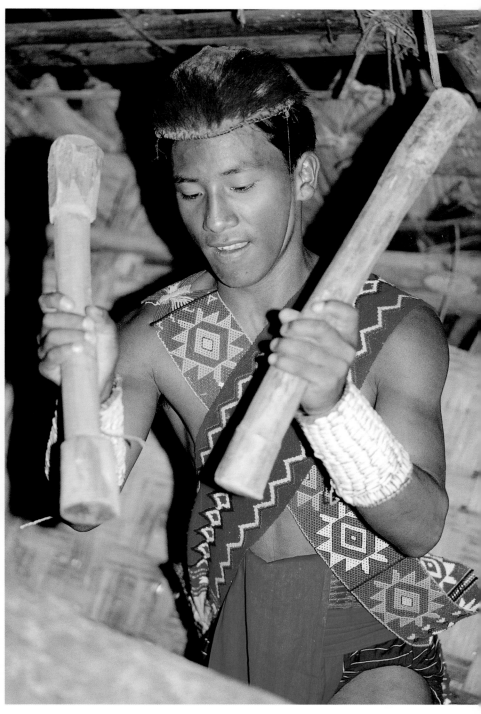

Drum Rhythms

Men young and old beat with heavy wooden sticks on the outer wall of the drum. The fact that the drum is on a stand above ground level gives it a better sound. The drum rhythms, each of which had a particular meaning, used to be accompanied by the clanging of bronze gongs.

Overleaf:
A group of Naga dancing at New Year celebrations in Myanmar.

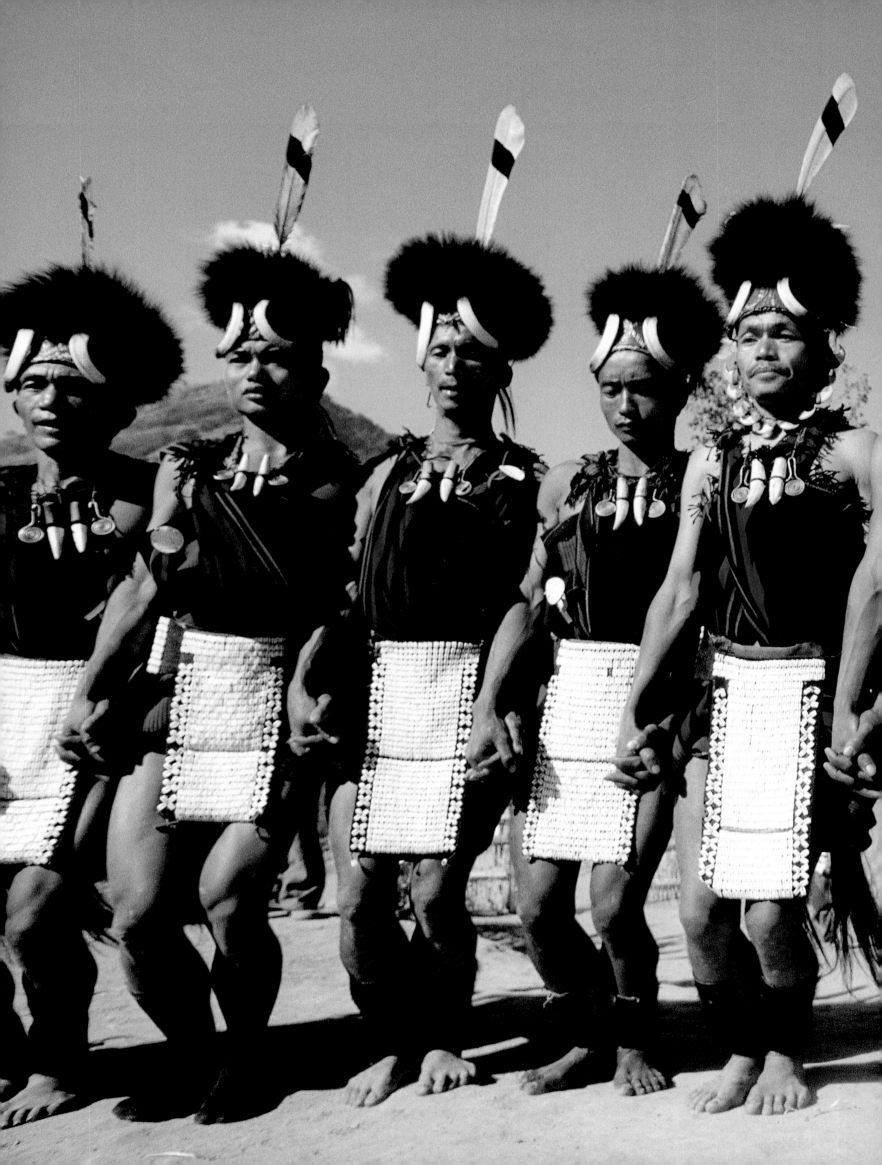

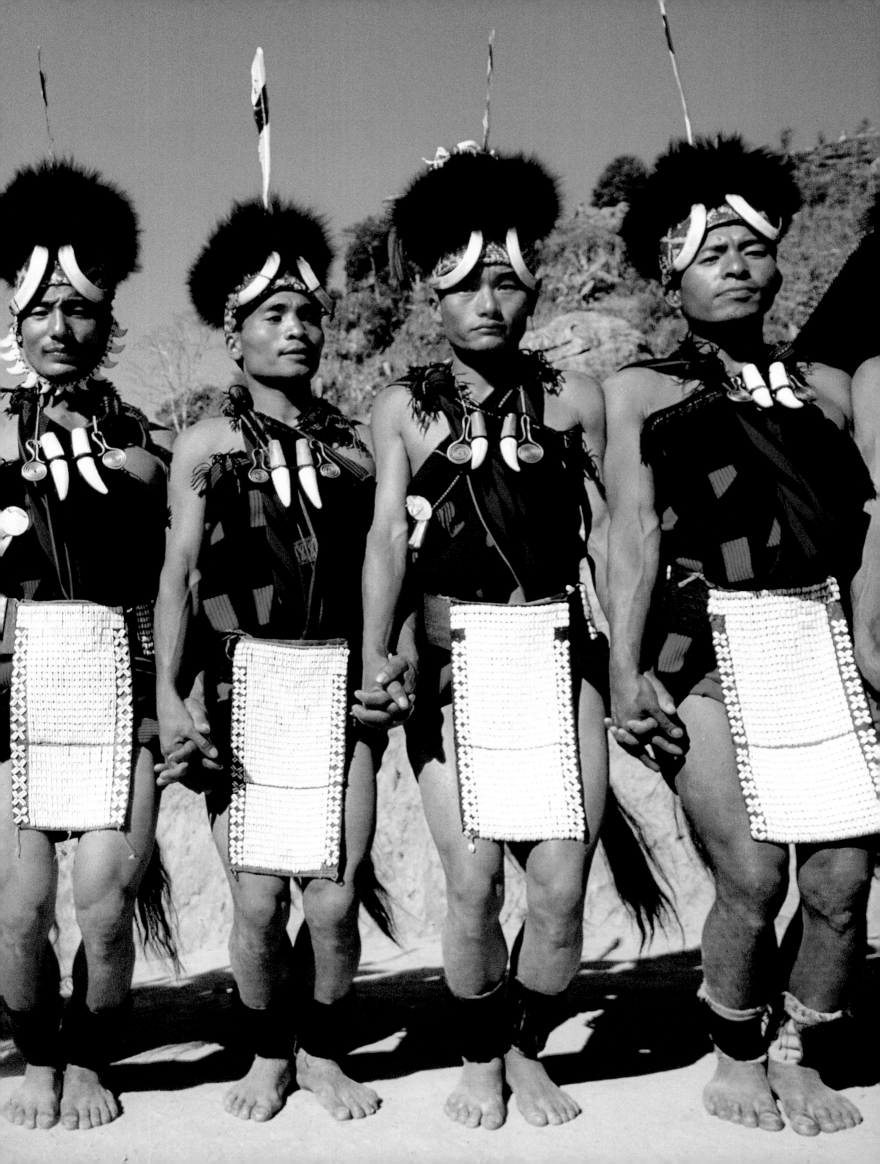

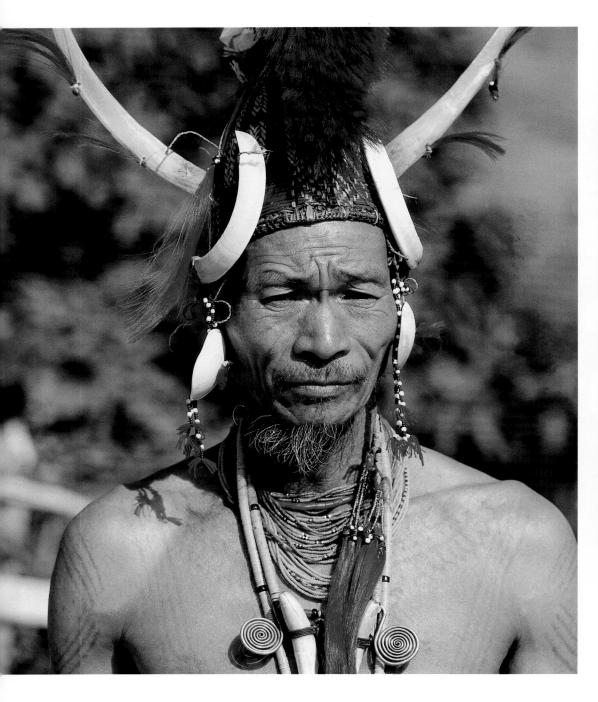

Headdress Variations

The sub-groups of the Naga can be differentiated not only by the language they speak, but by their distinctive forms of decorative headdress. All the variations derive, artistically speaking, from aspects of headhunting and with the religious and magical ideas related to it.

Overleaf:
Tribal meeting at the Naga New Year celebrations in the Sagaing province of Myanmar. Every year several hundred Naga meet for a joint celebration in the Myanmar mountain province on the border to India. There was a time when the shields were principally used for protection in battle, but now the men regard them as status symbols.

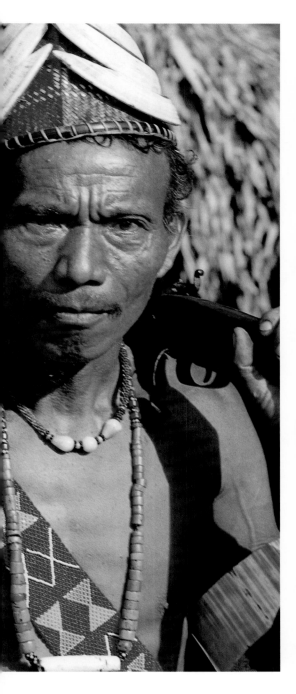

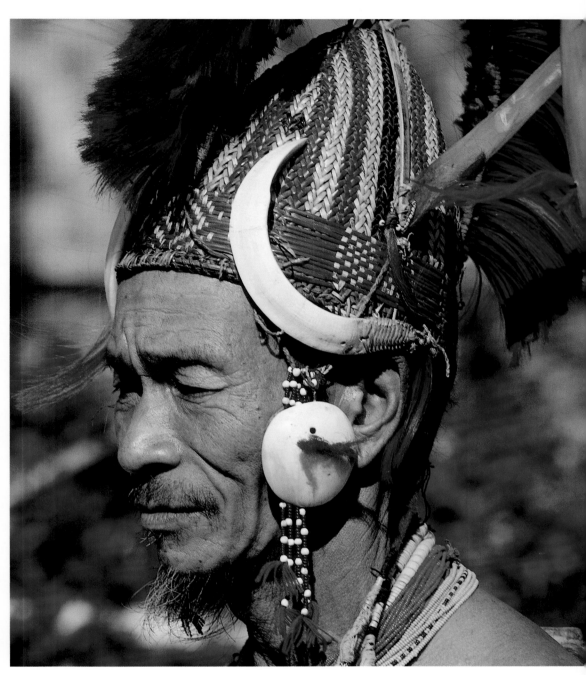

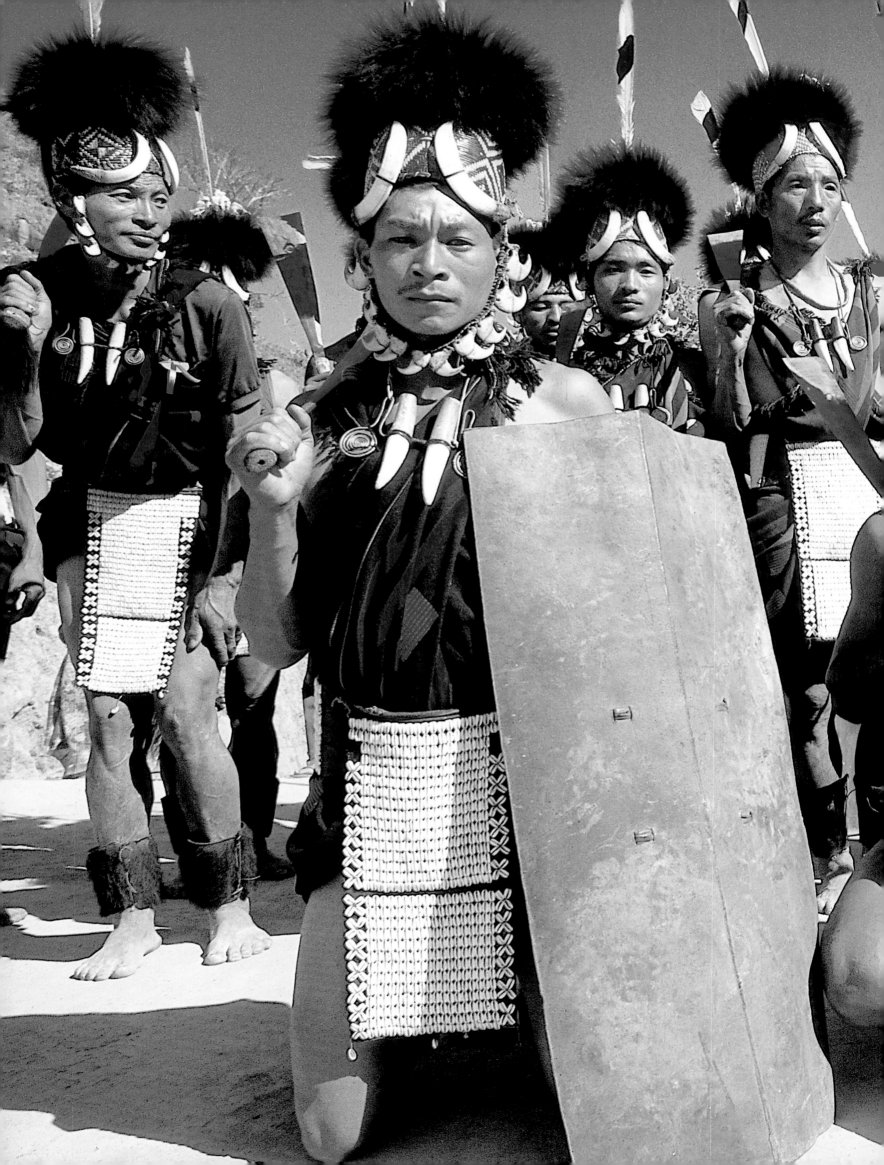

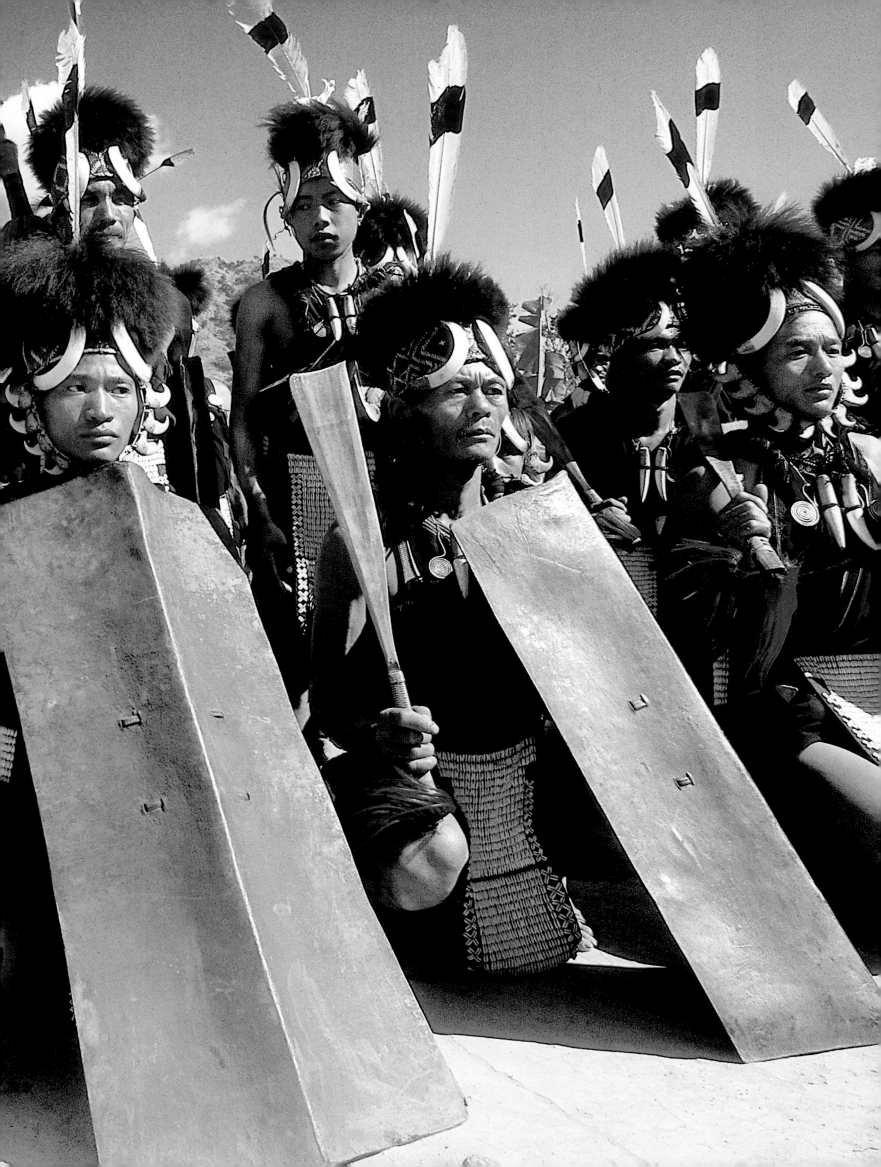

Badges of Merit

The pride of a bygone era radiates from the face of this old Naga warrior, who is performing a ceremonial dance with his spear and buffalo leather shield. His brass chestpiece in the form of four small stylized head trophies and a pair of buffalo horns is an indication of the number of enemy fighters he has killed in battle. Only successful headhunters are allowed to wear these ear decorations (the horns of a particular kind of goat) and to sport the tattoos that adorn his face.

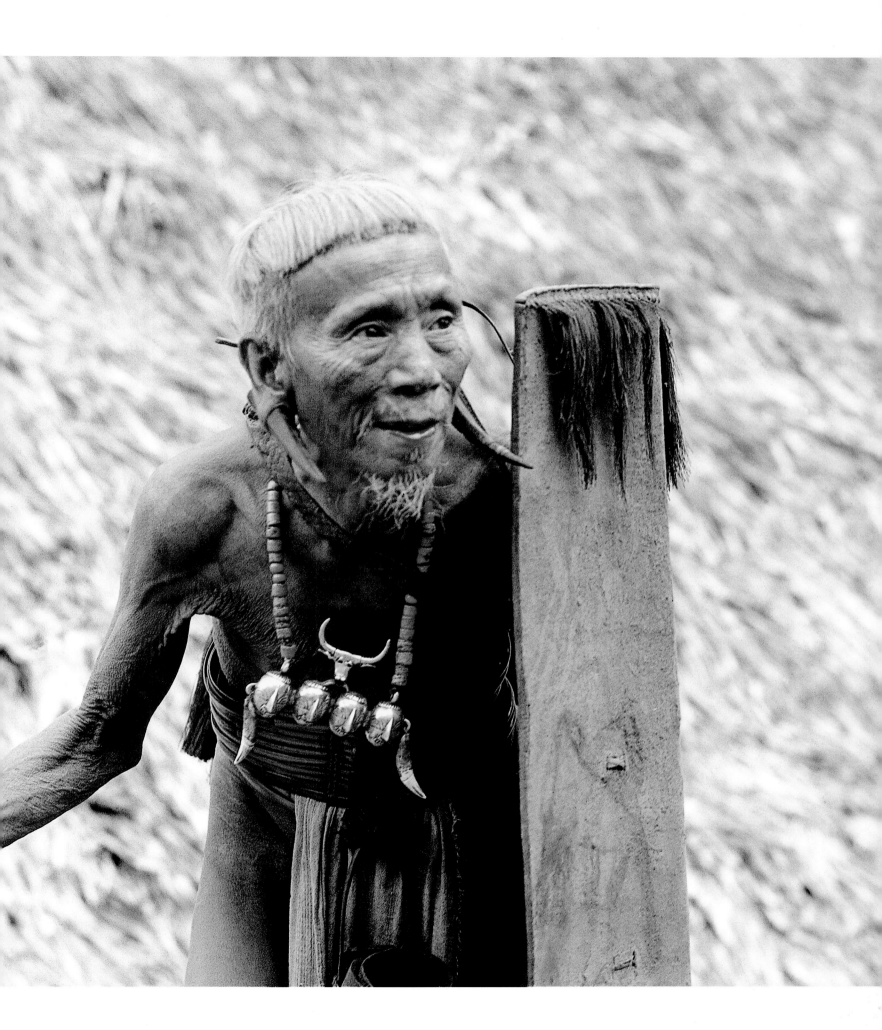

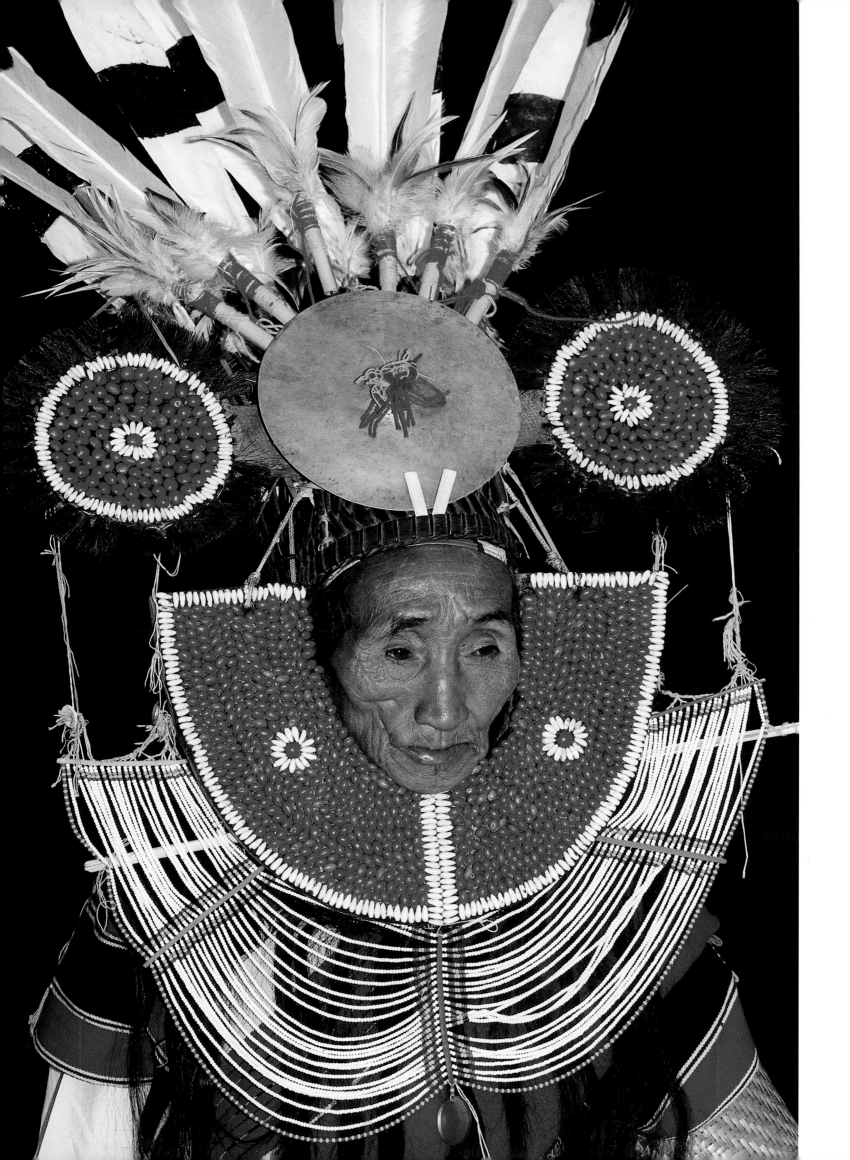

Beads and Seed Pods

Opposite: A Naga with a *luhupa* headdress in the shape of a half-moon with sun and stars; the two wooden discs flanked by a brass disc and the U-shaped wickerwork frame that curves around the face are both covered with small red seed pods.

This photograph was taken in 1999 during the Naga's New Year celebrations in the border country between India and Myanmar.

Above: A girl with multiple bead necklaces.

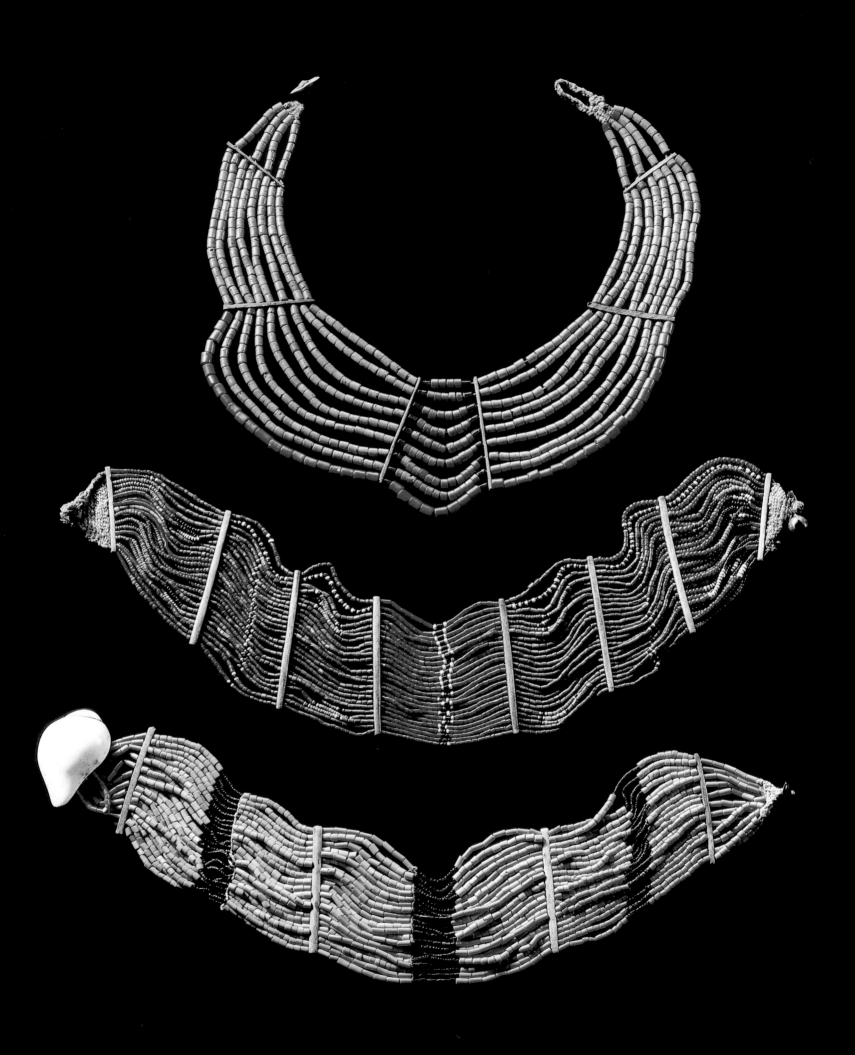

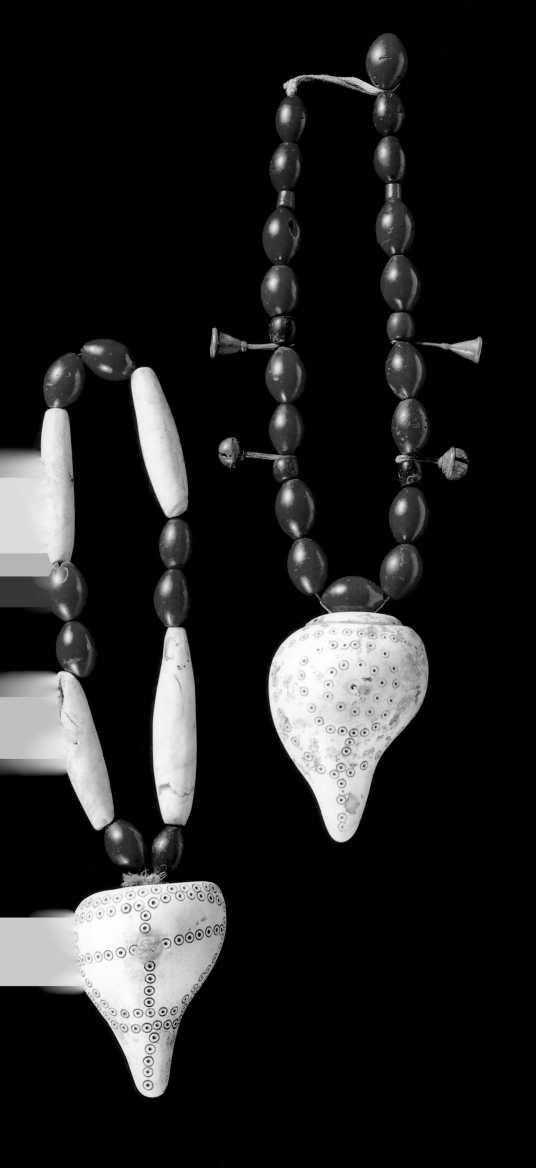

Some striking
examples of
bead jewelry,
made from
glass, shells
and seed pods.

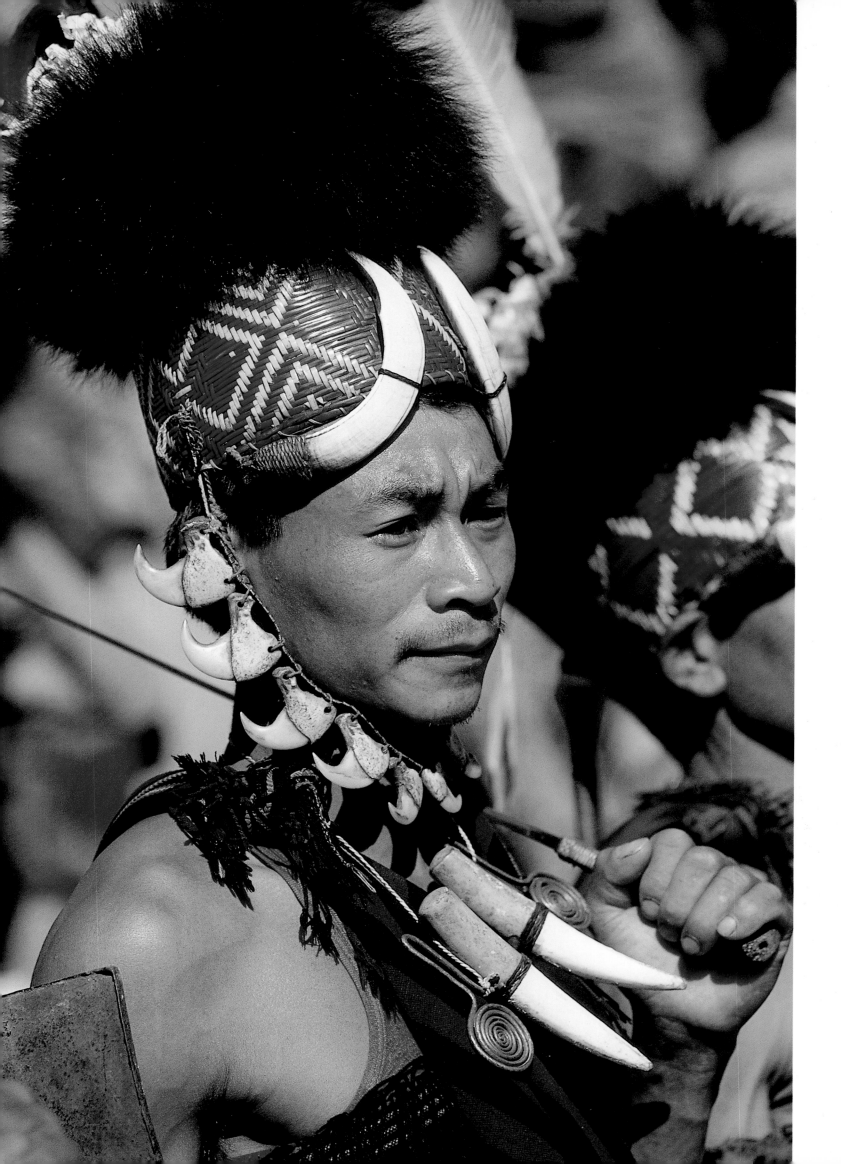

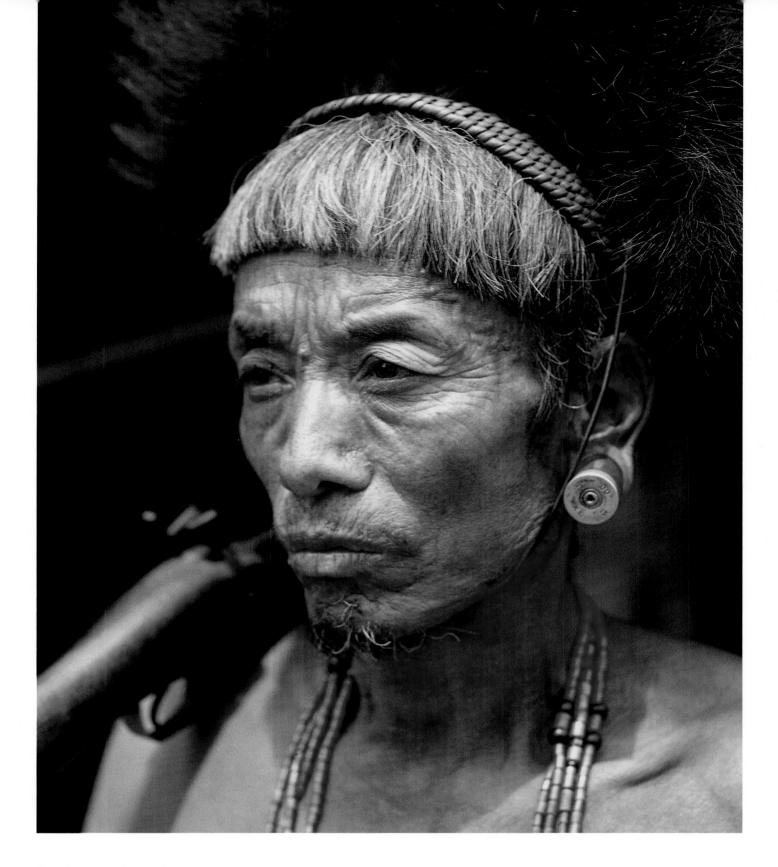

Ancient and Modern

Machete knives and tiger's teeth were traditionally symbols of male status (opposite), but nowadays their place has been taken by empty shotgun cartridges, used as ear ornaments (above).

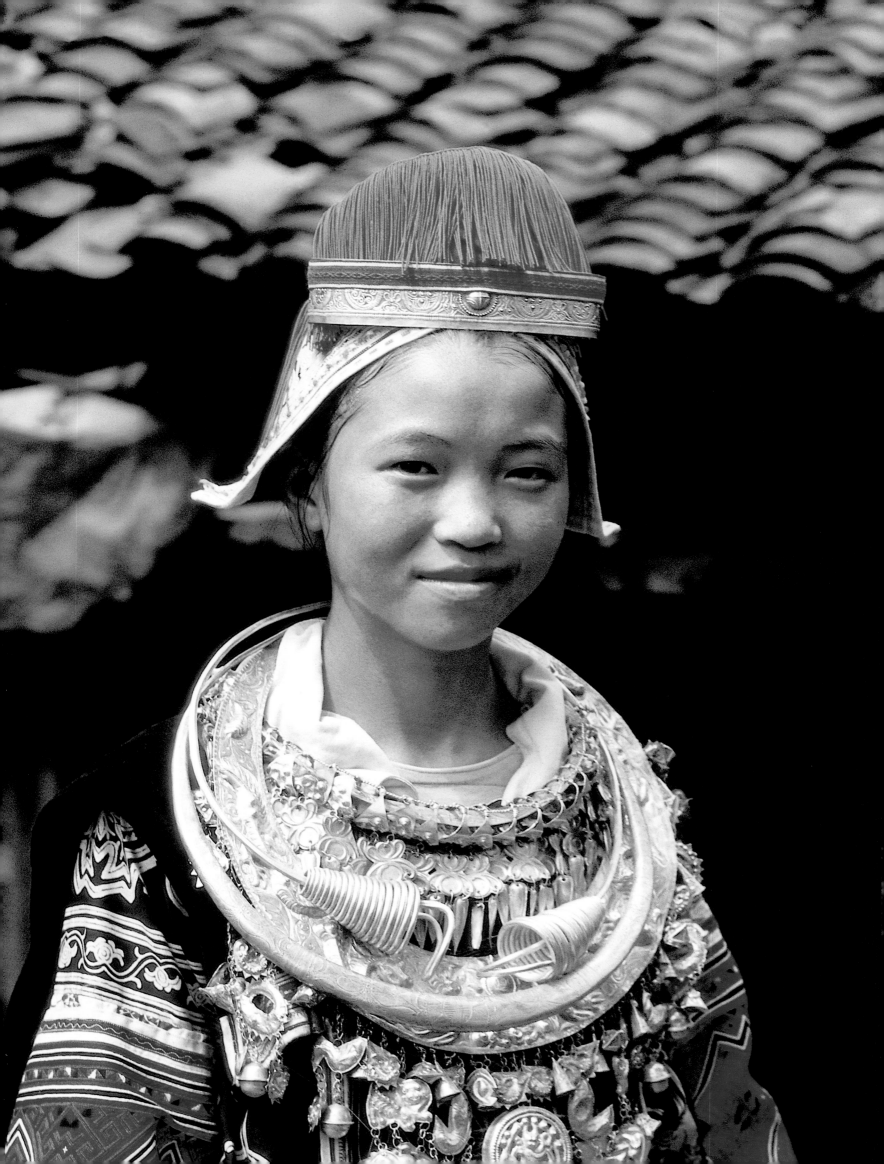

East of India

Peoples of the Cloudy Mountains

The cultural region with which this chapter is concerned contains a thousand mountains and
a hundred mountain tribes, thus boasting the greatest variety of ethnic groups in all Asia.
Roughly speaking, it covers the mountain and hill regions of mainland South-East Asia and is
bordered on the north-west by the eastern foothills of the Himalayas, Assam in India and the
Chittagong Hills in Bangladesh. It spreads eastwards through Myanmar and into China –
Yunnan, Guizhou and Guangdong provinces and the Autonomous Region of Guangxi – as far
as Vietnam, with the southernmost fingers of the region reaching down into Thailand and
Malaysia.

The influence of Indian culture on the peoples of the South-East Asian mainland as they
set up their states led to the creation of the South-East Asian Buddhist cultural region, which
has, among others, Burmese, Thai, Lao, Mon and Khmer members. The region is home to
more than one hundred tribally organized minorities, with tribal societies making up as much
as 33 per cent of the population of Laos and as little as 1 per cent of the population of
Cambodia. In South-East Asia the rule of thumb is that the more mountains there are in a par-
ticular area, the more varied will be its ethnic composition. The closer one gets to the plains,
the more uniform – and the more identifiable with their nationality – the local people become.
This is also one of the reasons why many tribes have been pushed back into peripheral areas
and have become populations in retreat.

A particular feature of the region is the transnational minorities that migrate from north to
south and back again, and are thus continually on the move from one country to another. The
majority of the Miao live in southern China in Yunnan, Guangxi and Guizhou, and in parts of
Sichuan, but other groups of Miao live in northern Vietnam and in Laos, where they are
known as the Hmong, as well as in northern Thailand, where they are known as the Meo or
Meau. In a similar fashion, the Kachin people live in Yunnan in China, in north-east India and
also in northern Myanmar.

The languages spoken in this region belong to four main groups. Kachin, Karen, Hmong,
Yao, Chinese and Burmese belong to the Sino-Tibetan group; Khmer, Mnong, Bahnar and
Vietnamese belong to the Austroasiatic group. Thai, Laotian and the Shan languages belong

*Young Gejia woman from
the mountains of Guizhou.*

143

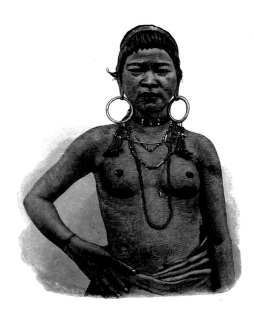

Engraving of a Mhong woman.

to the Tai-Kadai group. The fourth group is formed by the Austronesian languages, including Cham, Rhadé, Jarai and Malayan.

The traditional beliefs of the tribes do not derive from organized religious communities but are determined by the existence of individual culture-specific tribal religions. But the main religions of the region are bound together by common animistic and mythical elements. New minority religions have also come into being as old beliefs have been turned into new religions through the agency of missionaries of various confessions. The tribes live as rice farmers in scattered settlements. Their existence remains, as it always has been, closely tied to their unshakeable conviction that their traditional way of life is the only right way for them to live.

The Mru live in the Chittagong Hill Tracts in south-east Bangladesh, a world that is to a large extent unfamiliar to us and only accessible with the greatest difficulty. They refer to themselves as the *Mru-tsa*, meaning 'children of men'. Their villages remain in the same place for decades and are called after the name of the head of the village, or *karbari*. Their language has a status all of its own within the Tibeto-Burman group.

Equally unique are the cattle feasts of the Mru, which are a quite exceptional phenomenon among the customs of mountain tribes in mainland South-East Asia. The hosts are exclusively unmarried men, for whom this is the most significant celebration of their whole life. Occasion is given for a feast of this kind by some important event such as a particularly good harvest or the overcoming of a dangerous illness. The most important host is the *karbari*, who also raises his prestige by his presence. At big feasts, not only cattle are sacrificed but also dogs, chickens, buffalo and gayal (a breed of domesticated ox). These feasts of merit, or cattle-feasts, prevent individual family clans from becoming too economically powerful because they mean that surplus products that are not necessary for survival are distributed to others. What the presiding clan is left with is prestige.

These celebrations are restricted to December and January, the months following the cotton harvest and the tilling of the fields. The sacrificial animals are bought in from other villages. Those who go in search of the animals spread the word of the forthcoming feast at the same time and publicize the reason why it is being held. Several days are required for the preparation of the bigger feasts. Rice must be pounded and beer and schnapps produced in sufficient quantities, the latter being the particular preserve of the Mru womenfolk. On the evening before a feast, the young men meet up to repair their mouth-organs and practise playing them, activities that take precedence over their usual evening activity of courting the girls. Mouth-organs called *ploong*, with pipes ranging in length from ten centimetres to several metres, may only be played before and during cattle feasts. The place where the feast is to be held is decorated with three- to four-metre-high bamboo poles on which tassels are hung. Two poles stand in the middle of the space to decorate the sacrificial stake to which the animals will be tied. Next to the stake stands a sacrificial altâr. Once the ritual decoration of the feasting place is finished (an activity carried out exclusively by men), the musical instruments can be put in their places.

The following legend lies behind the ritual followed in the killing of the animal and the cutting out of its tongue. When God created the world, he sent a cow to teach mankind certain customs and practices for their lives. The cow taught the Bengalis, the Muslim inhabitants of the plains of Bangladesh, that they

should weed three times a day and harvest three times a day. The cow then went on to visit the Mru in the mountains, carrying a scroll in its mouth with the information that it was to pass on to the Mru. On the hard and wearisome path up to the mountains the cow became tired, hungry and thirsty and its tongue began to wave uncontrolledly to and fro. And this was how it happened that it swallowed the scroll. When it arrived at the Mru, the cow could not remember properly what was written on the scroll and told them that they should weed three times a day but harvest only once a day. The Mru were naturally discontented and complained angrily to God, who struck the cow on the snout, and ever since then cows have gone without their upper front teeth. He gave the Mru permission to tie the cow to a stake, to dance around it to the sound of music and, once it had been killed, to cut out its tongue and nail it to the stake. The Mru were nevertheless destined to weed thrice a day but to harvest only once, which is why the Mru still take their revenge upon cows for the incorrect message a cow once brought them.

The Padaung are one of the most unusual peoples of South-East Asia and have their home on the border between Thailand and Myanmar. Officially the Padaung belong to the Mongolian tribal people of the Karen and it is thought that they originally migrated from northern China. *Pa* means 'roundabout' and *daung* is the word for all sorts of shining metal. The name refers to the brass rings that the Padaung women wear around their necks. The brass spirals are distinctive feature which enables everyone to recognize the culture they come from and have earned them the nickname 'giraffe women'. The origin of this custom has never been definitively explained, although it was once thought that the rings were for protection against tiger bites. Another theory suggests that they served to frighten off slave-traders. Nowadays, many anthropologists have come to the conclusion that the reasons are mythological in nature. The Padaung have their own explanation why their womenfolk adorn their bodies in this strange way – they see themselves as the descendants of snake and dragon spirits. In order to express this descendancy in visual terms, it was at some point decided to stretch the necks of the women so that they resembled the necks of snakes and dragons. The spirals were imitations of their ancestors. But for the Padaung women, this mode of self-adornment has only one justification – they like it. It is not part of a ritual, nor does it have a religious function.

It used to be the case that girls had their first ring put on them at a very tender age, when they were between five and eight years old. The investing of the girl with her first ring was accompanied by a ritual ceremony carried out on a day that had been found favourable by shamans using a horoscope and astronomical calculations. An ointment was applied to the girl's neck, which was then massaged for several hours to relax the musculature. Cushions were used, not only to reduce the possible pain but also to prevent grazing when the ring was put on. On the same day every year the Padaung girl received one more ring. The fact that the rings were replaced at yearly intervals meant that the shoulders were stretched a little further away from the throat each time without causing the young woman any lasting pain. By the time she was grown-up she would be carrying several kilograms of solid brass around her neck.

The only objection that the Padaung women have to the removal of the rings is aesthetic. It is a fallacy to think that the neck muscles are so greatly weakened that they would not be able to hold the head up once the rings were removed;

that is simply not the case. It may look as if the cervical vertebrae are stretched and have become extremely unstable, but the rings simply press the collarbone and shoulders downwards, giving the impression that the neck is longer – in fact, the spine remains entirely intact and unaffected. As years of wearing the rings do however lead to an atrophy of the neck muscles and to a deforming of the cervical spine, the practice was, at least in earlier times, life-threatening. Similar body-modification practices, it may be noted, are to be found in other cultures as well.

The Padaung people first became familiar to a wider public when the Thai government featured them and the 'giraffe women' in advertising campaigns. Clever marketing presented them as a crowd-pulling attraction and reduced them to freak objects, paraded to satisfy tourists' appetite for the out-of-the-ordinary. In Myanmar, by contrast, the Padaung's homelands are still prohibited areas for travellers. For the Padaung, the most richest and most respected families were the ones in which the women wore the most rings. It is thought that some women wore as many as twenty-five rings, and won a correspondingly high level of respect from society. Nowadays the custom is progressively dying out and relatively few girls are prepared to keep the old tradition alive. Some girls simply wear a small number of rings, so that the neck is not stretched. It is more and more the case that the Padaung men's admiration is reserved for the modern girls in Western dress with whom they come into contact in the Thai schools. The Padaung remain a people surrounded by a mystifying spirit-world; their history is unknown and their origins have only been partially researched. Although they are one of the most-photographed peoples of South-East Asia they are certainly also one of the least researched. The Padaung population is now only 7,000.

The mountains of northern Thailand, which are actually foothills of the Himalayas, are home to some half a dozen mountain tribes. The people that have remained closest to their traditions are the Akha, who are known for the magnificent headdresses worn by their womenfolk. The other tribal peoples in this area are the Karen, the Lisu, the Lahu, the Yao and the Hmong. Their ethnic identity has been preserved as a result of the remote life they lead in the mountain forests. This has however been put under great threat by Thailand's mass tourist industry, which in principle will market any attraction it can and has certainly had no scruples about exploiting the world of these tribal peoples. They are, generally speaking, no more than tolerated in the land they live in, and they in turn have no choice but to tolerate the tourists who come to photograph them. They have, however, managed to learn a little about how to earn money from tourism for themselves.

The basis for the Akha's livelihood is rice-farming, but the mountain slopes are not so fertile as the valleys – where rice can be grown in paddy fields – so that their surpluses after the harvest are always very limited. Every Akha village is considered a social entity. Important figures in its traditional structure include the head of the village, or *dzoema*, the shaman, or *pima*, who is also a reciter of poetry, and the healer shaman, or *nipa*. There are normally two smiths in the village, known as *baji*, one for tools and one for jewelry making. The latter is highly respected because he uses silver coins to produce jewelry with talismanic powers. The Akha live in accordance with a highly complicated, orally transmitted life philosophy with an intensive ancestor cult at its very centre. The Akha's

awareness of their own uniqueness has led to their continual avoidance of contact with other societies.

The Miao and the Gejia are among the lesser-known tribes of South-East Asia and live in south-west China, in Guizhou, Yunnan and Hunan provinces and in the Zhuang Autonomous Region of Guangxi. Their extraordinary headdresses and clothes are an important part of their culture and are displayed every year at the traditional *lusheng* festival. At the ritual dances, only unmarried girls are allowed to wear the headdress.

The crown-shaped headdress of the Miao is made of small silver plates ornamented with various mythological motifs, which knock against each other during the dance and produce highly sensual sounds. The sound of the *lusheng* pipe which accompanies the dance has a highly stimulating effect on the young men, as do the pleasing movements of the dancing girls; it is not surprising that the entire point of the festival is to bring the two sexes together. All Miao groups celebrate the *lusheng* festival every year in the cold months of January and February. The headdress with its silver ornaments varies from group to group. In the area around Kaili it is made of silver chains that are bound into the hair. This silver headdress is the property of the woman alone, and her husband has no rights over the piece, even after their wedding.

The Gejia, a sub-group of the Miao, are ancestor worshippers. A drum the height of a man plays a significant role in their rituals, because the Gejia believe that the drum is the place where their ancestors spirits reside. The day on which the ceremony is to take place is determined by a destiny-reading. As soon as the drum hangs over the place where the ceremony will take place, the ritual begins with dances, and the high point is the slaughtering of a cow. Its hide is used as a skin for the drum and fastened with bamboo needles. Storytellers relate the history of the tribe and all the tribal members dance to the sound of the *sheng*, a musical instrument made of bamboo.

The Gejia hold both regular and irregular ceremonies in honour of their ancestors, the former taking place every year at the winter solstice in the drum hall, and the latter, which last three days and three nights, being held every thirty or fifty years, usually in a year with a very good harvest. The origins of this ancestor cult are still as shrouded in mystery as they ever were. According to their history, the Gejia once worked so hard throughout the day for their tribal chief that many laid themselves down under a camphor tree and died from exhaustion. When the surviving Gejia struck the tree trunk in grief, it made a sound like that of a great drum. It was thought that the souls of the departed had gone into the tree and now rested there in peace. They therefore began to dance around the tree and from this custom developed the ceremony of ancestor worship that has survived to this day. This ancient story, known as *harong*, is also reflected in the structure of Gejia society.

The Mru

Only a few of the mountain peoples
survived the bloody disturbances
caused by Bengal's resettlement policies
without sustaining any lasting damage.
The peaceful Mru, whose name simply
means 'people' in their own language,
are settled in a prohibited military zone
on the Myanmar border and have
preserved many facets of their original
way of life. The Mru live in a world of
bamboo, which provides them with the
material for their houses, musical
instruments and smoking pipes.

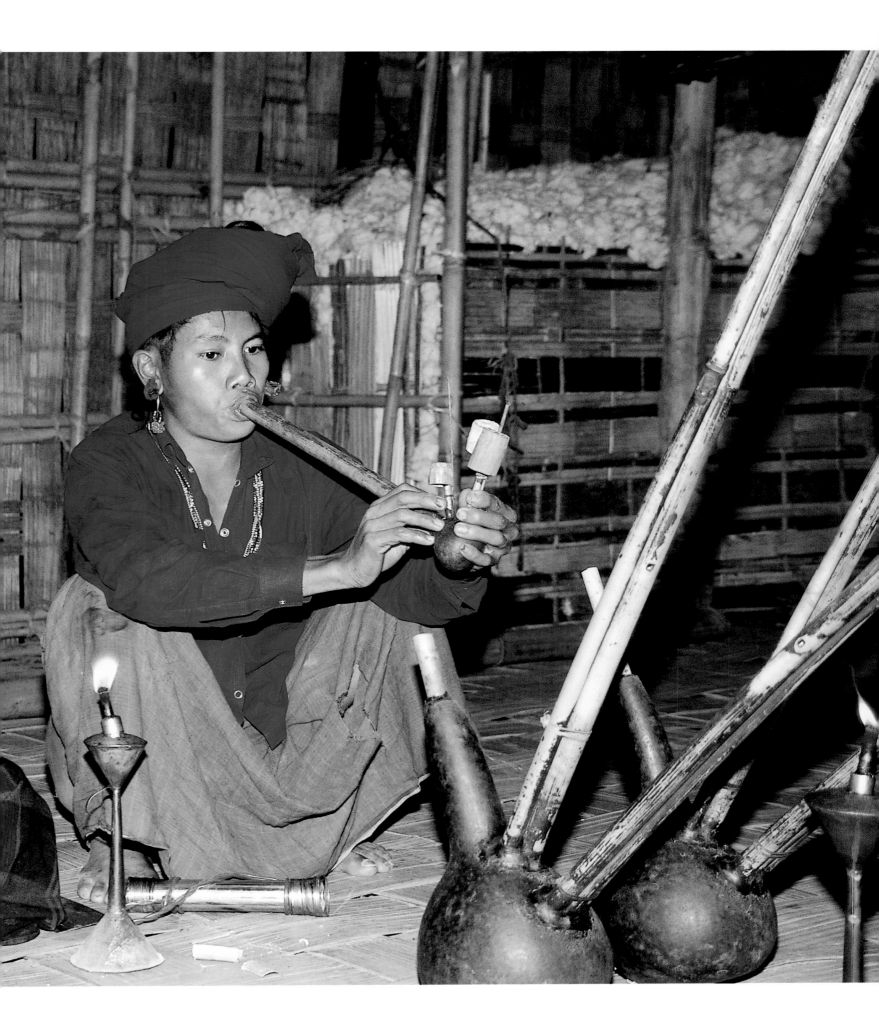

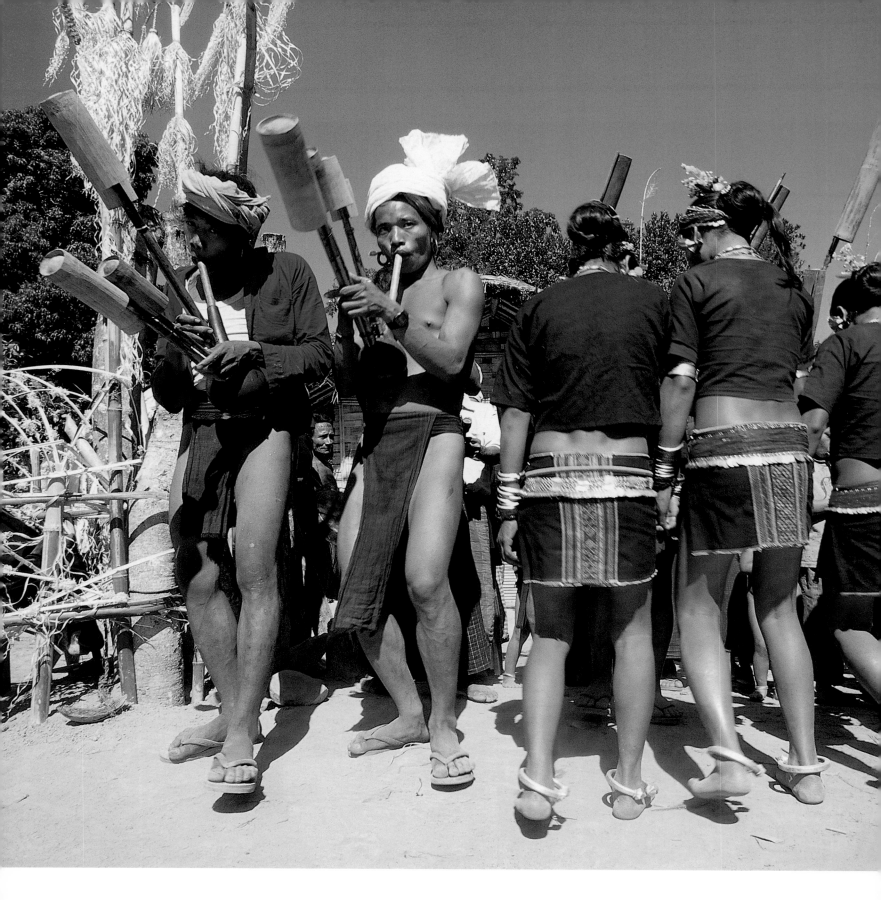

Mouth-Organ Music

The unmarried girls dance to music played by young men at a feast. To hear Mru music is to experience music anew. The strange melodies that come from the mouth-organs are monotone and yet shrill. The instruments come in a variety of sizes, and are made from bamboo pipes and hollowed-out bottle gourds. The feast accompanies a ceremony centred around the ritual killing of a bull.

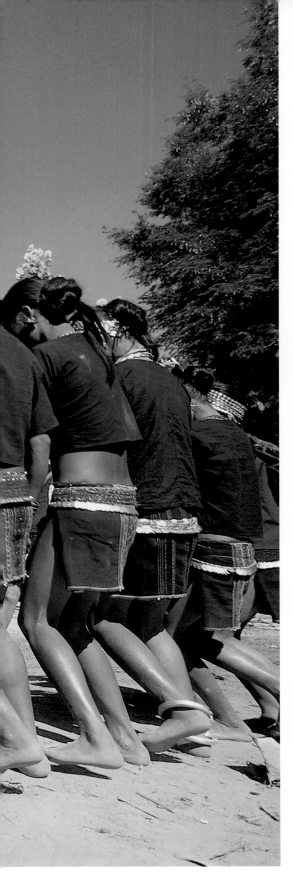
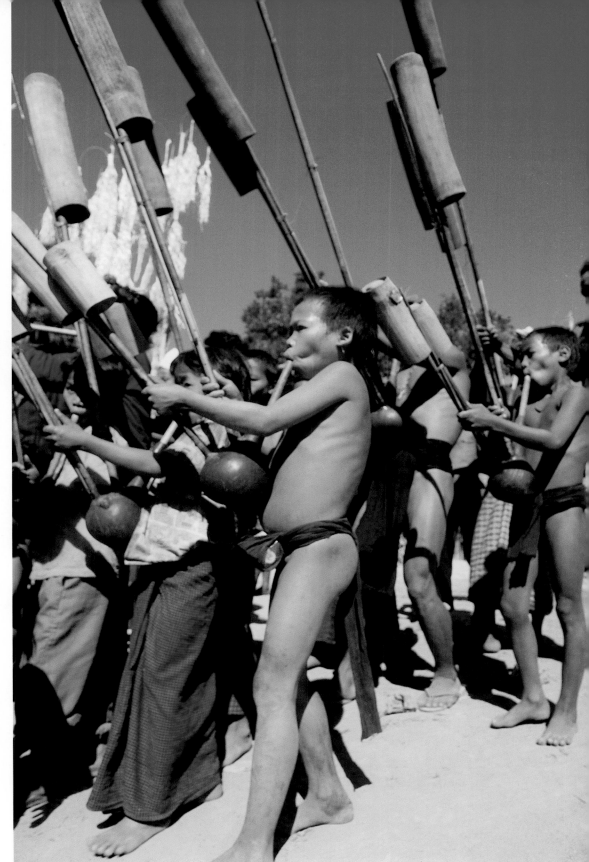

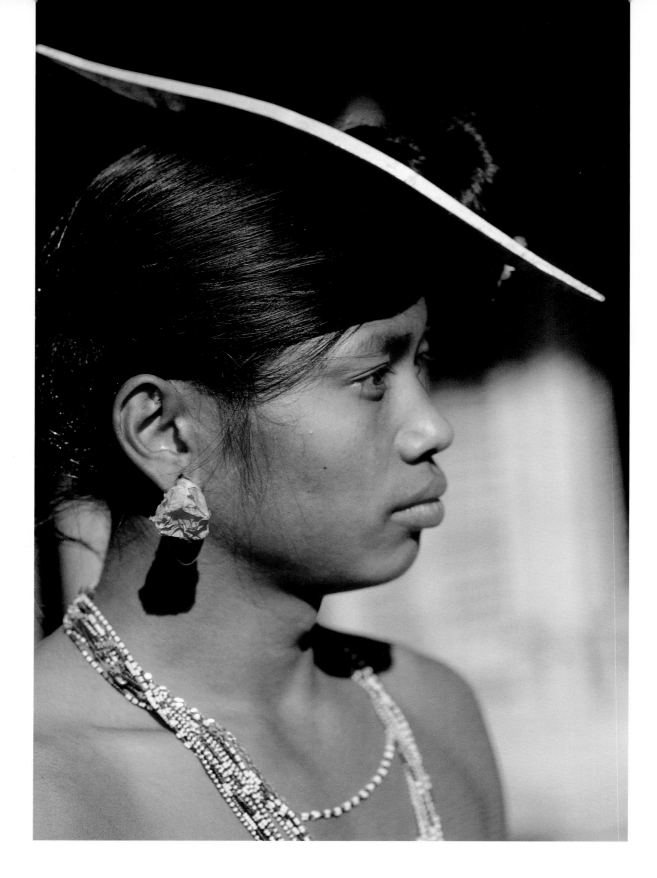

In Search of a Wife

Young Mru men dress themselves up to attract the girls – their teeth are coloured black, their long hair is skilfully tied into a knot and they are also adorned with hairpins, decorative homemade tin-plated combs, earrings and hibiscus flowers. The make-up applied to their cheeks and hands comes from the red seed pods of the annatto bush (*Bixa orellana*).

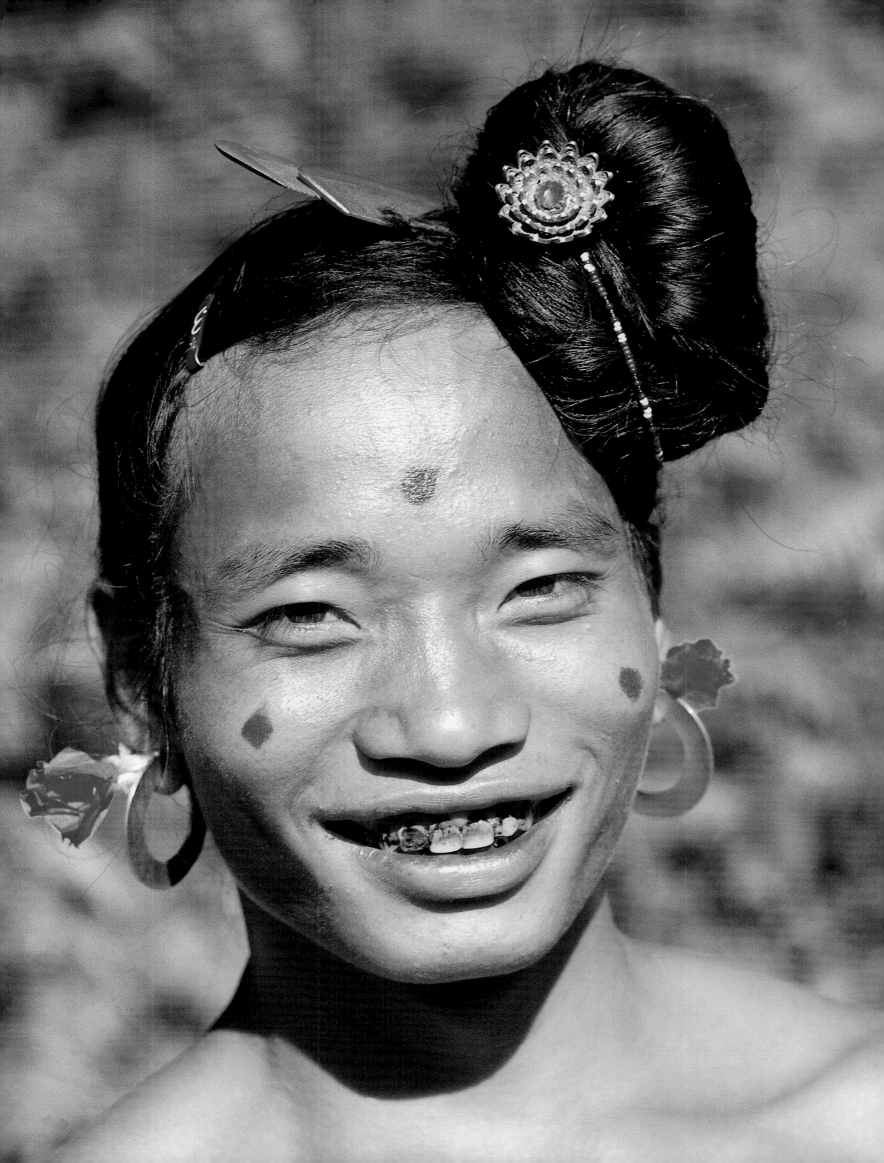

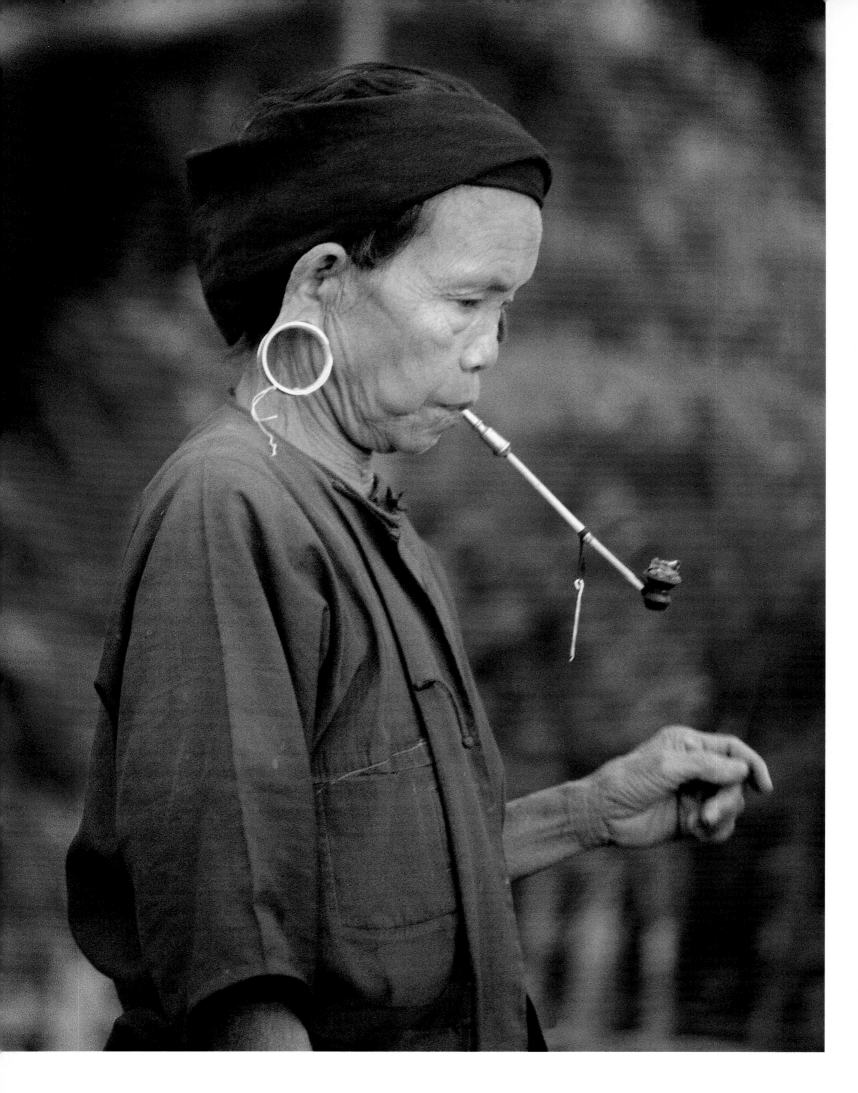

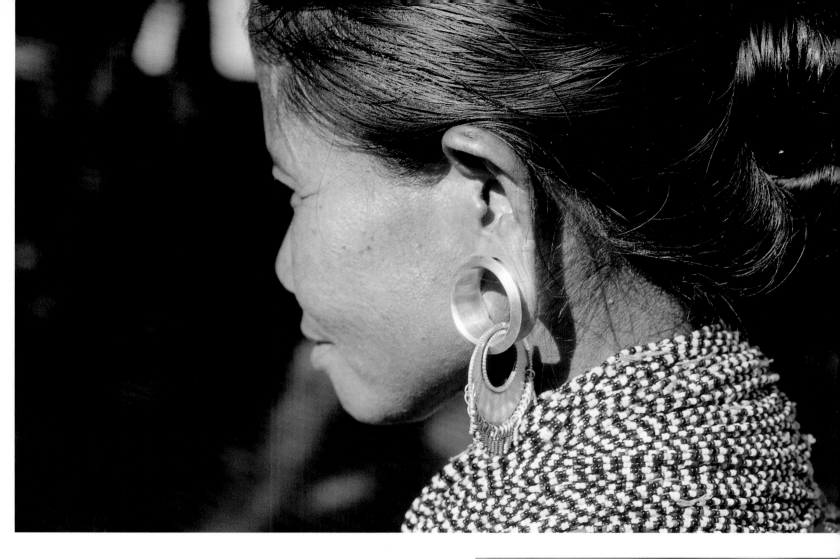

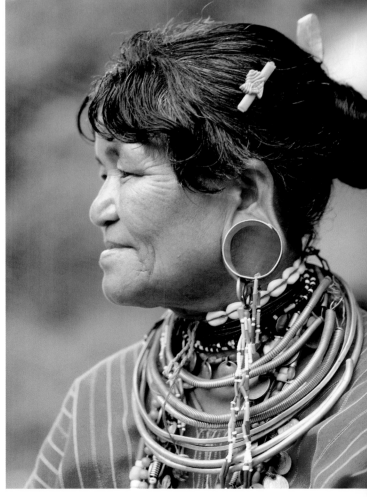

Amazing Earrings

Opposite: An elderly Tsak woman from south-eastern Bangladesh.

Above: A Prung woman from the Chittagong Hill Tracts, wearing large earrings and bead necklaces.

Right: A Kayah woman with a large earring, brass bangles, chains of Chinese silver coins and cowrie shells, from the border area between Thailand and Myanmar.

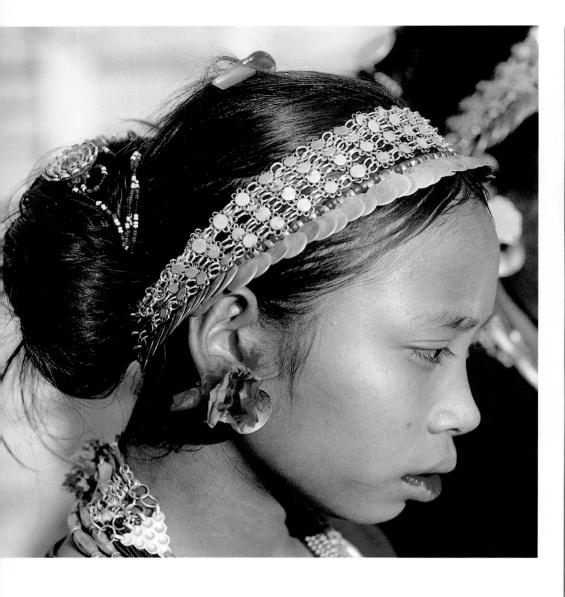

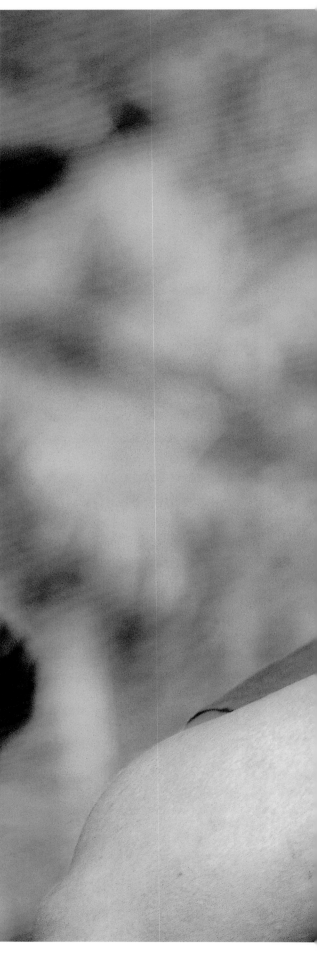

Silver Bands, Coloured Teeth

Above: A Mru girl wearing jewelry made from silver coins around her head and neck. The old silver rupees from colonial days are particularly treasured, and they make up a large part of bequests and dowries.

Right: Even when they are working, the girls wear silver armbands, earrings and pearl necklaces, which they buy at the markets down in the plains. Red-painted lips and teeth blackened with soot are all part of the Mru ideal of beauty.

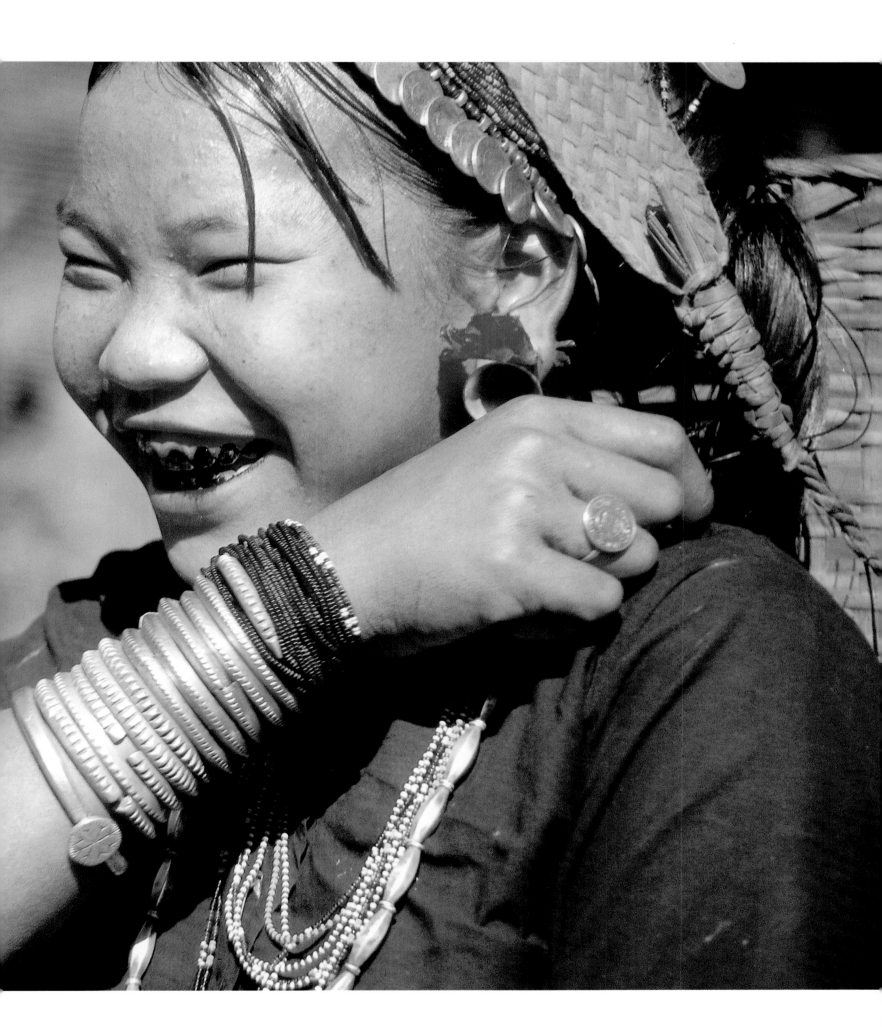

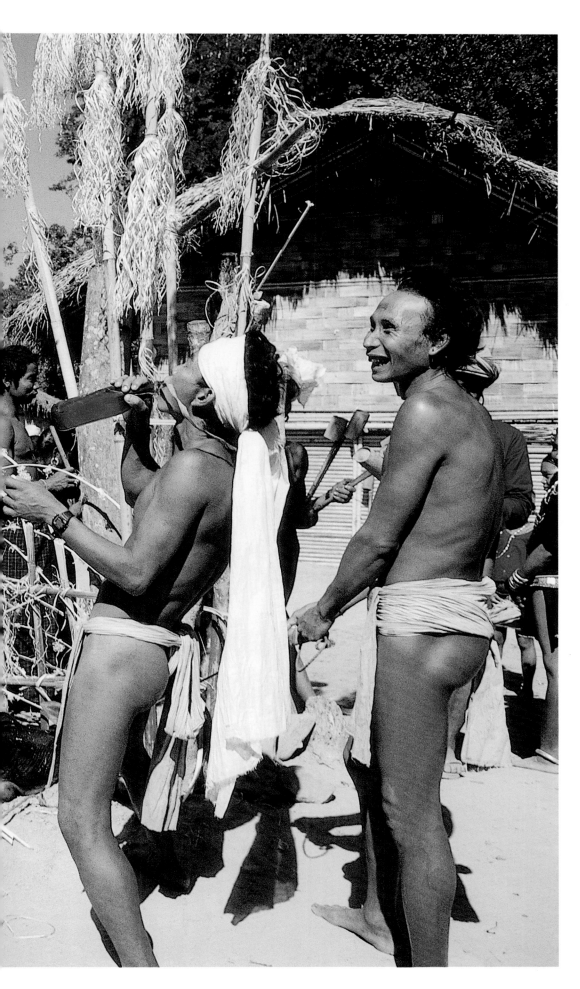

A Task for the Men

The setting-up of the place of sacrifice is exclusively a matter for the Mru men, as is the drinking session that accompanies the consecration of the sacrificial altar.

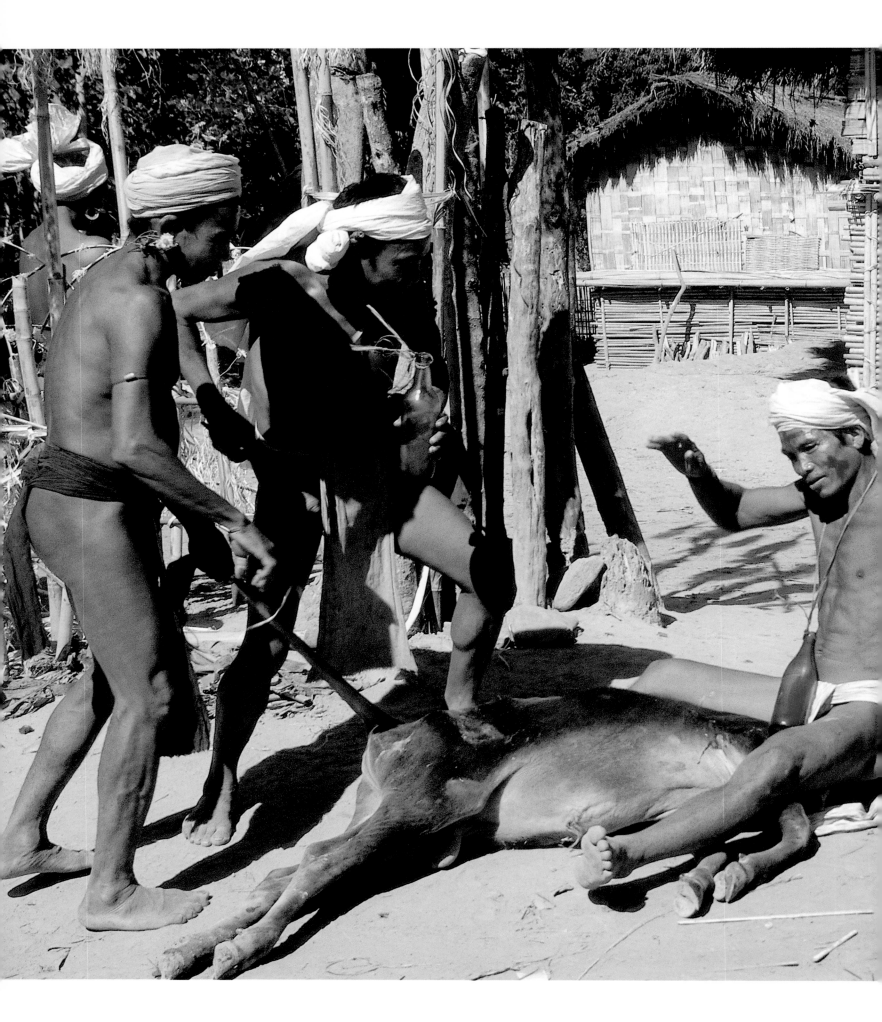

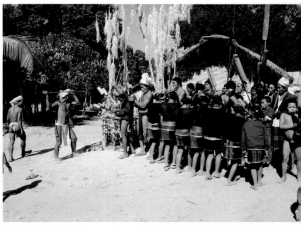

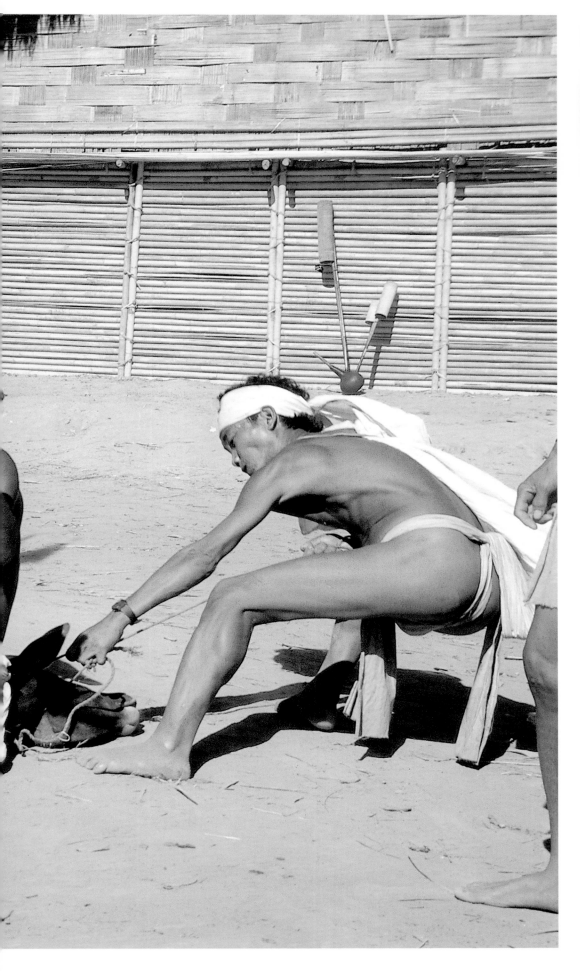

The Sacrificial Cow

According to mythical tradition, there was once a cow that ate a sacred scroll containing a list of the Mru's religious traditions. Every year, in revenge for this sacrilege, a ritual sacrifice takes place. Palm wine flows freely, and a Mru man takes an iron spear to kill the cow, which is forced into a enclosure made of decorated bamboo poles. Girls dance to the ritual music. The body of the animal is then jointed and cooked for a banquet at the house of the head of the village.

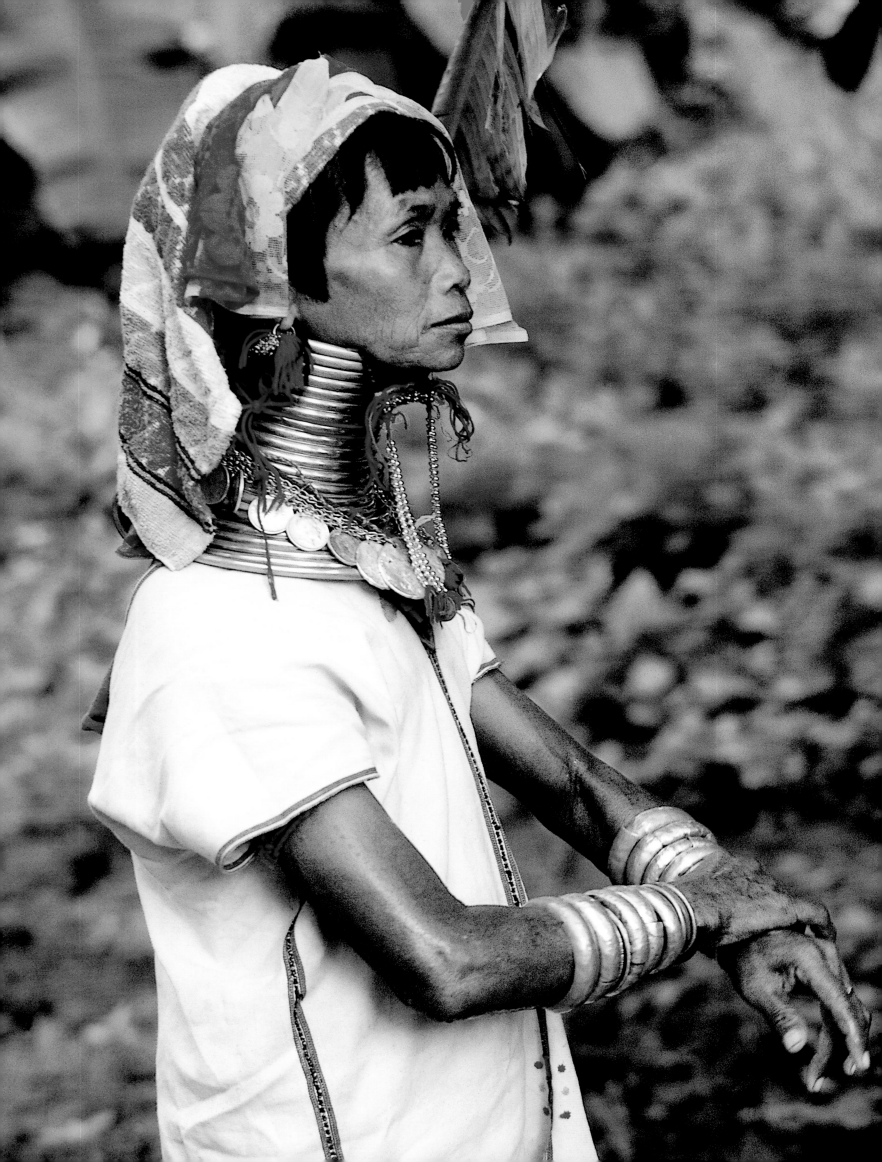

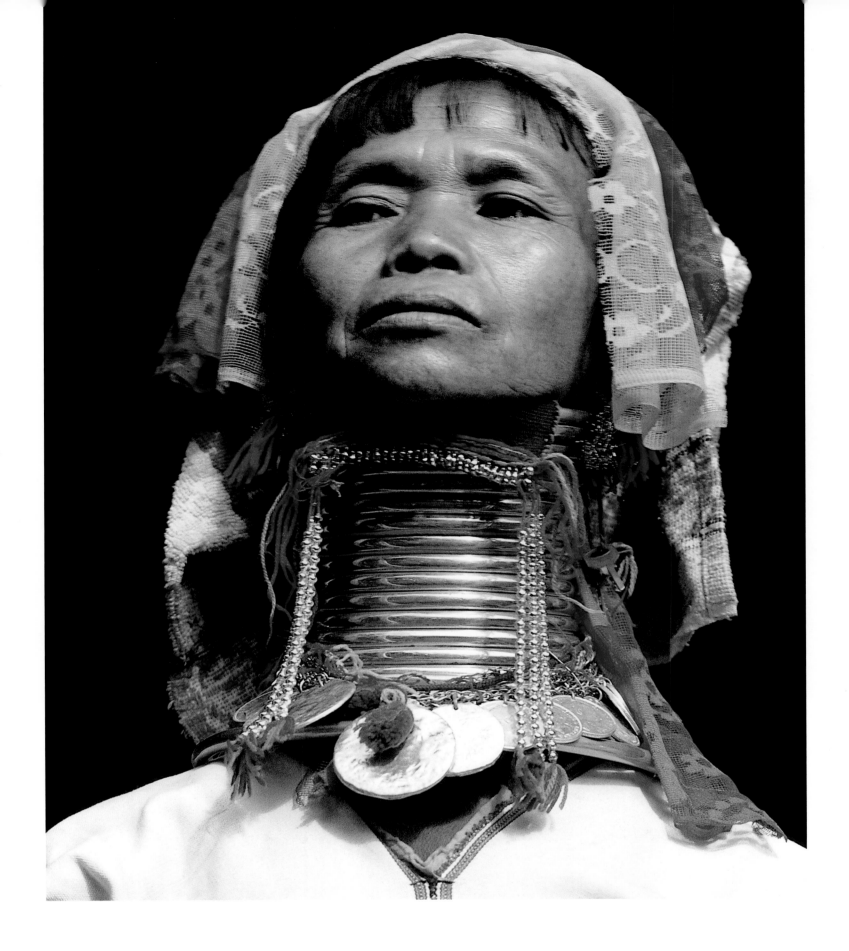

The Long-Necked Padaung

The heads of the Padaung women from the Burmese mountains seem to be supported on a tower of shining brass rings. The weight they have to carry is increased with pendant coins and silver clasps. Some Padaung women have left Myanmar and settled in the border country of Thailand where they are free to earn their living by offering their services as photo models.

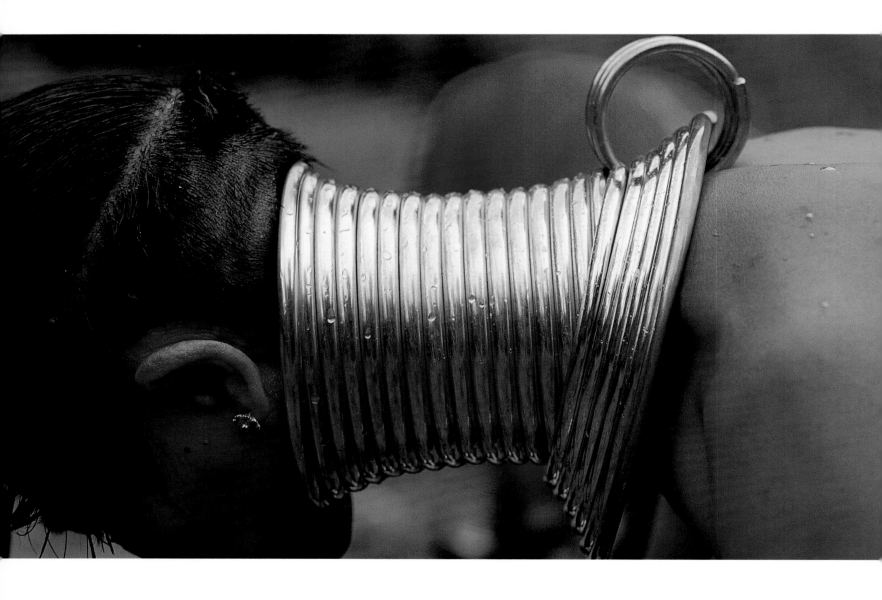

The Burden of Beauty

The neck corset of the Padaung is made of numerous layers of brass rings, lying on a broad shoulder-ring also in several layers and in its turn held together by a small ring. Some see this as a device that enabled slave-traders to chain together the women they had captured. The girls have the first rings laid upon their necks and legs when they are a mere five years old. As the years go by, the rings are taken off and replaced with bigger ones. As a result, an adult woman may have to carry a burden of almost five kilograms on her shoulders. Hygienic precautions are taken to avoid grazing to the skin.

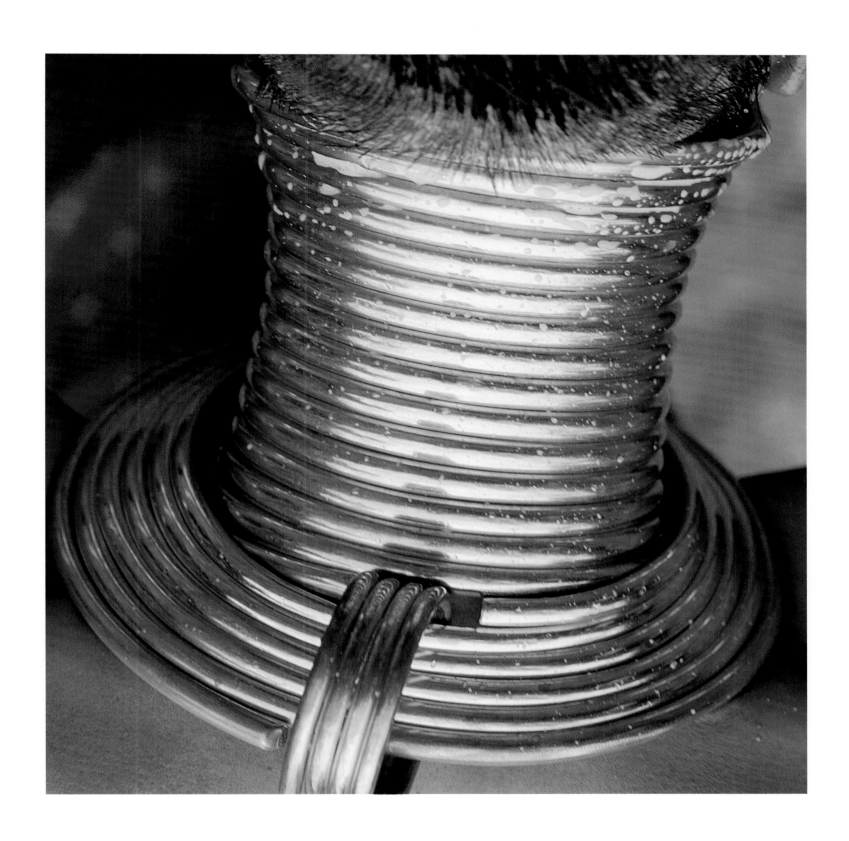

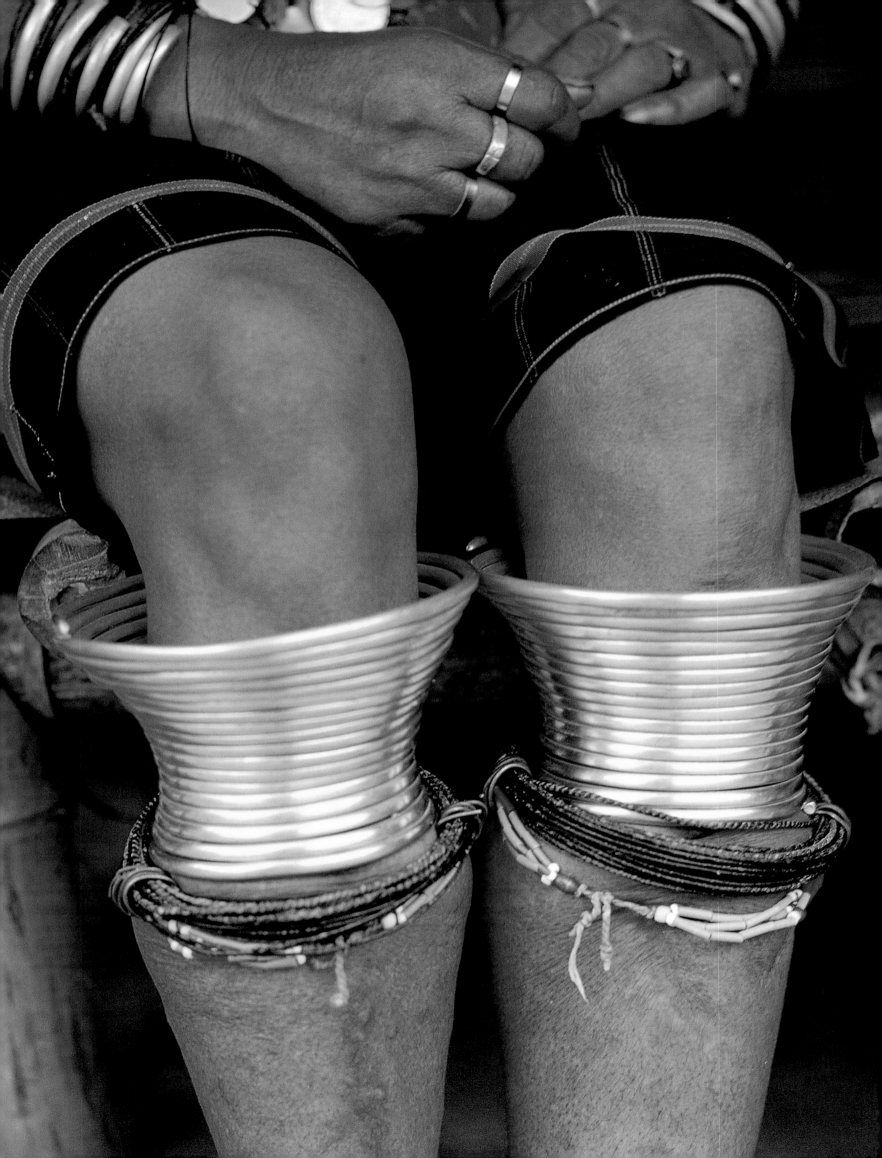

Leg-Rings

Opposite: Under the hollow at the back of their knees, the women of the Bre, a sub-group of the Karen from Myanmar, wear brass spirals like those of the Padaung, but compact enough not to prevent the women from bending their knees.

Above: Great numbers of lacquered loops made of fine plant-fibre threads adorn the knees and legs of the Kayah women. This is why, like the Padaung women, they usually stretch their legs out when they are sitting on the ground.

Distinctive Dress Codes

Above left: The bamboo water-pipe from which this old woman is smoking tobacco is to be found among all the mountain peoples of this area. The mountain peoples of the Golden Triangle, an area of Thailand close to the border with Myanmar, can be recognized from their distinctive traditional clothing. The Yao women, who spend most of their free time embroidering textiles, can be distinguished by their black or indigo turbans and their striking red collars.

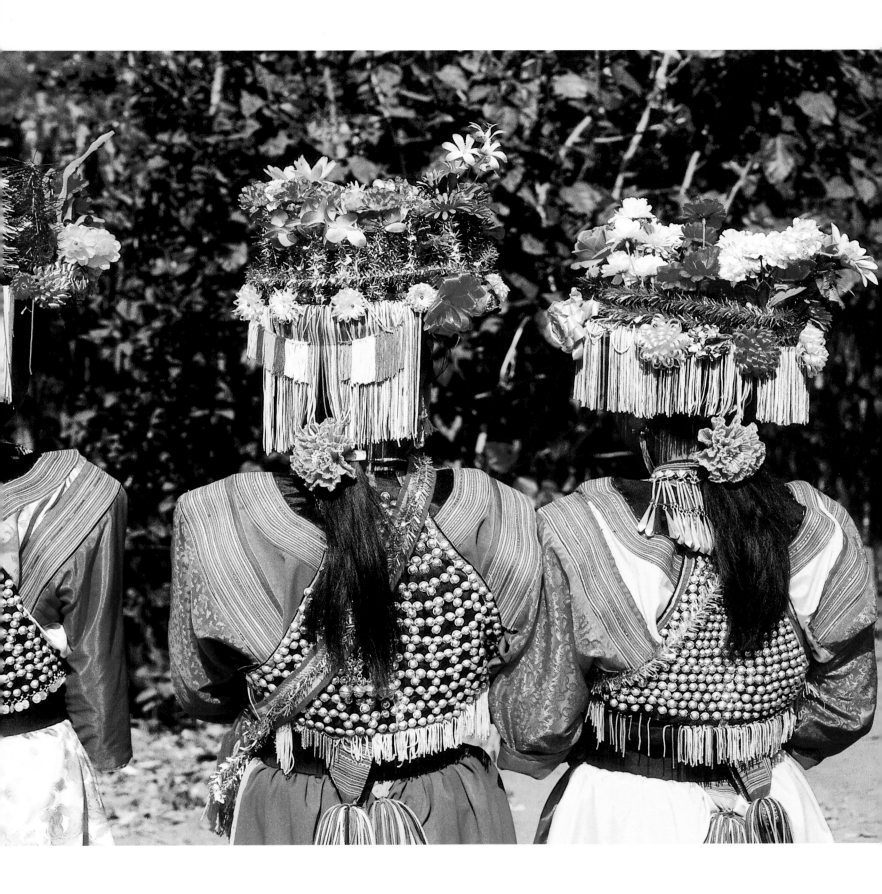

Above right: During the New Year celebrations, the Lisu women dress up in their brightest coloured costumes and silver jewelry.

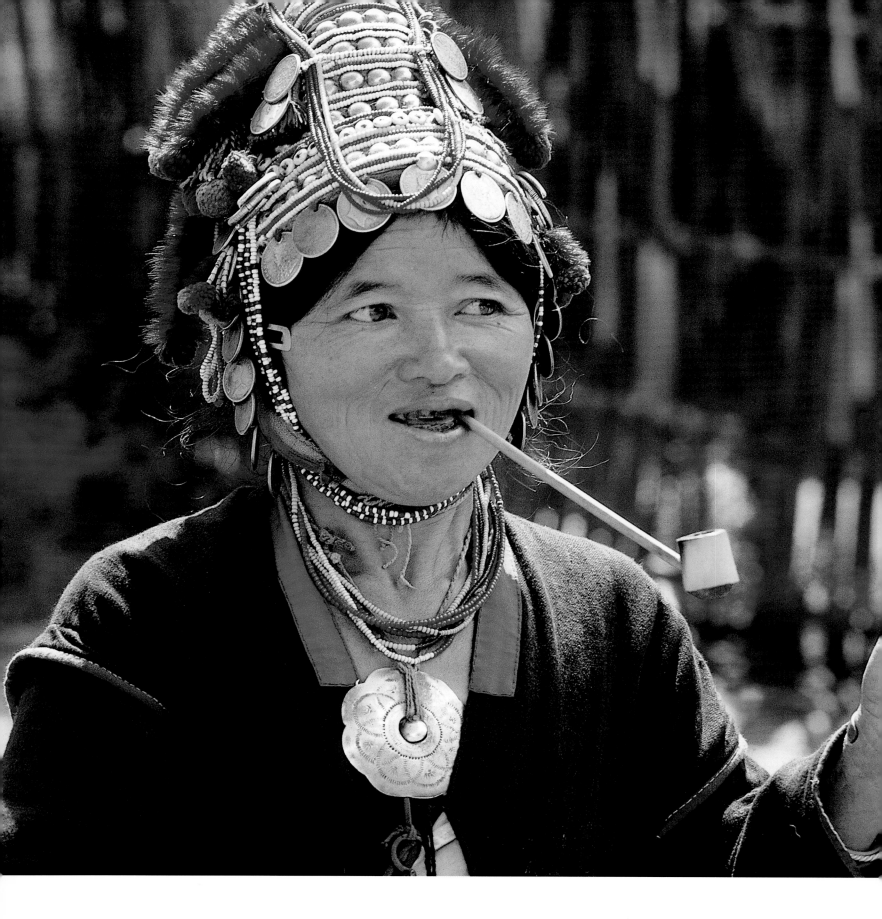

Akha Headdresses

Akha women from the Golden Triangle wear their magnificent headdresses even when they are working. The cone-shaped bonnet, decorated with silver coins and red-coloured gibbon fur, is typical of women of certain clans (left). The cotton caps worn in other groups of the Akha are decorated with an array of silver coins and hammered silver half-spheres. Other accessories include silver pendants that hang down at their sides, and necklaces made from glass beads and white seed pods.

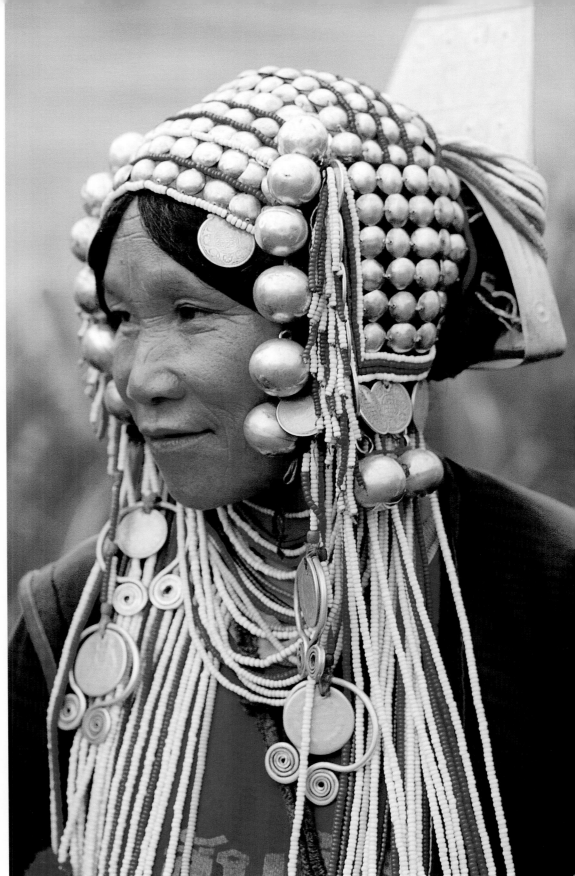

Above: The headdress of a married woman is completed by the addition of a silver-plated trapezium-shaped panel on the back. Since the 1970s, theft has become commonplace and the silver plate is often replaced by aluminium.

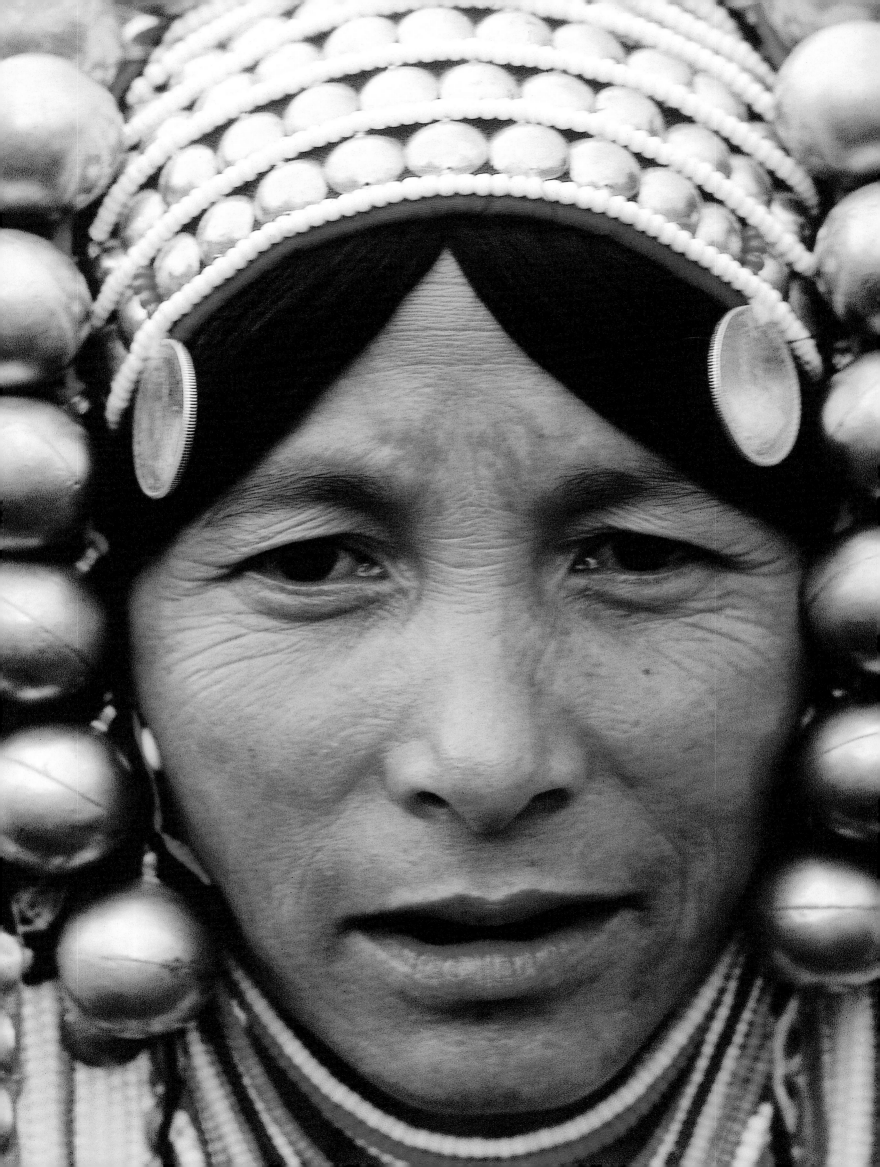

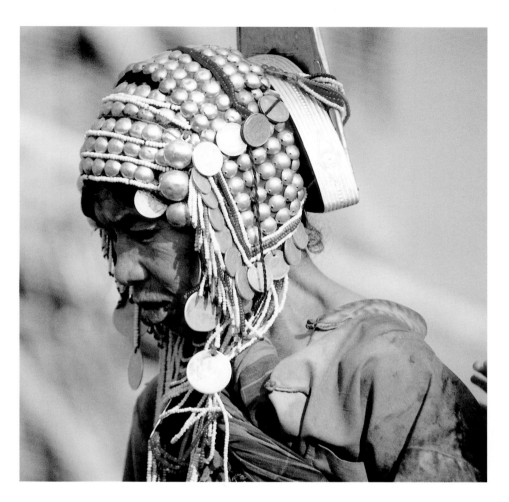

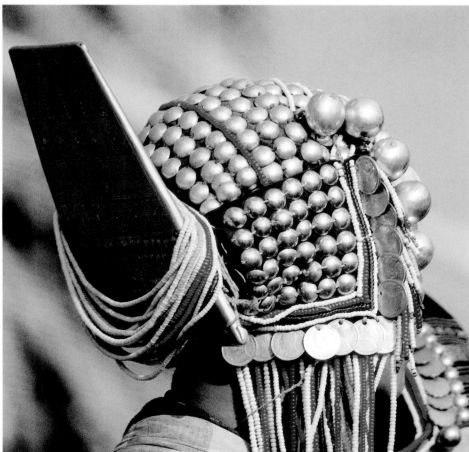

Sparkling Silver

A range of Akha headdresses
from the border country between
Thailand and Myanmar.

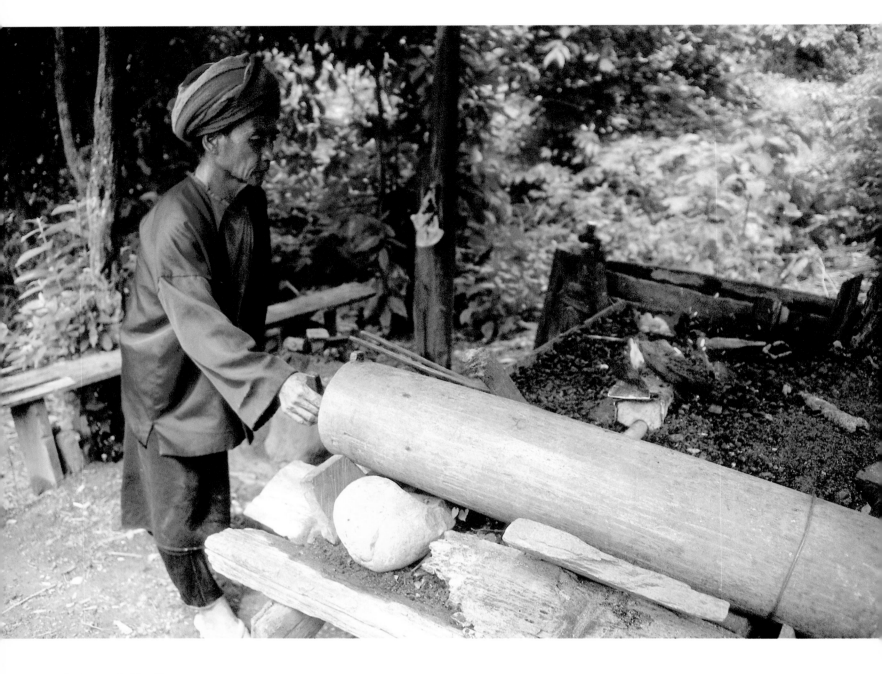

Arts and Crafts

The silversmiths of the mountain tribes are held in high esteem, many of them having learnt the craft from Shan and Chinese masters. The silver itself is either obtained from Chinese merchants in the form of ingots or from the melting down of old jewelry and silver coins. Nowadays there is a preference for nickel silver, known as *packfong* in Chinese, because it is easier to work, although it is simply an alloy of zinc, copper and nickel. Some blacksmiths are also involved in jewelry production.

Above: A smith of the Lahu people from the Chiang Saen region with wooden flask and bamboo cylinder. The air-pipe in the middle has a clay valve fitted to it, which links the piston blower to the chimney.

Right: A smith of the Meo from northern Thailand in traditional dress, using a pump drill with a pointed chisel to bore a hole in a silver coin.

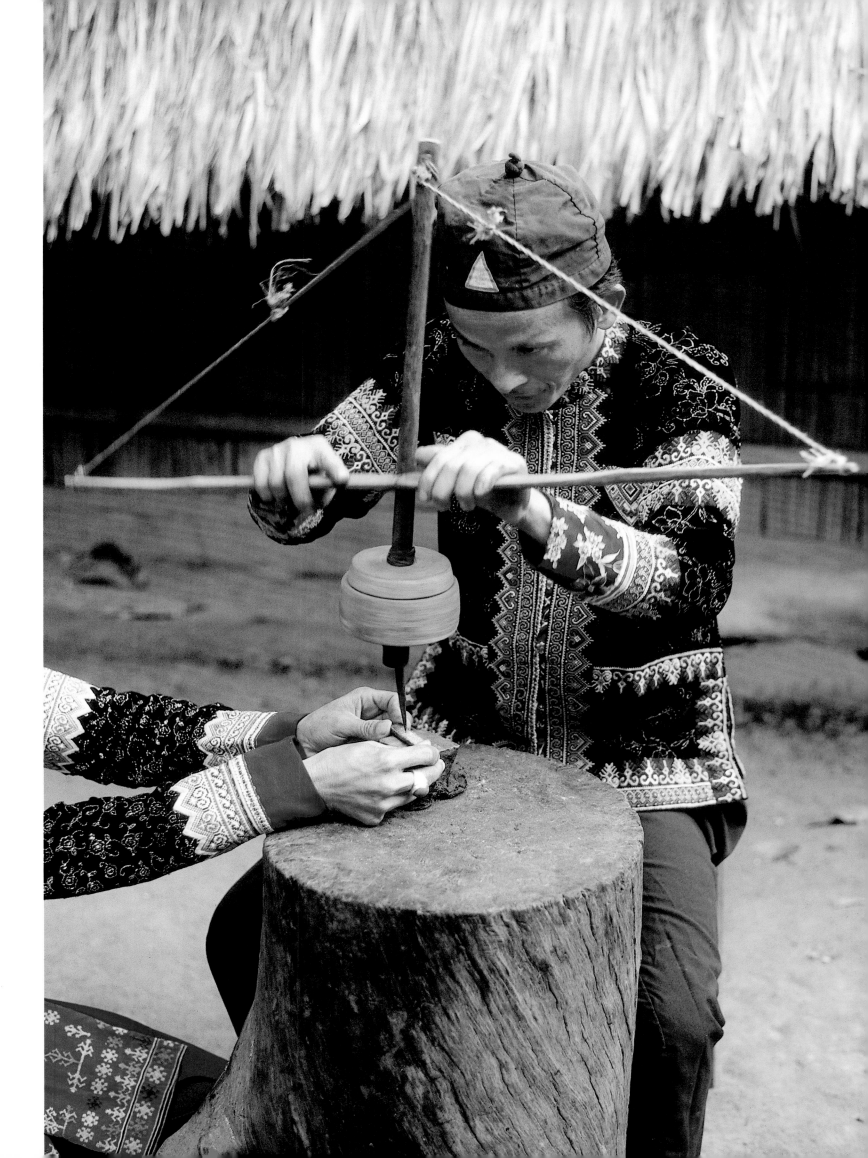

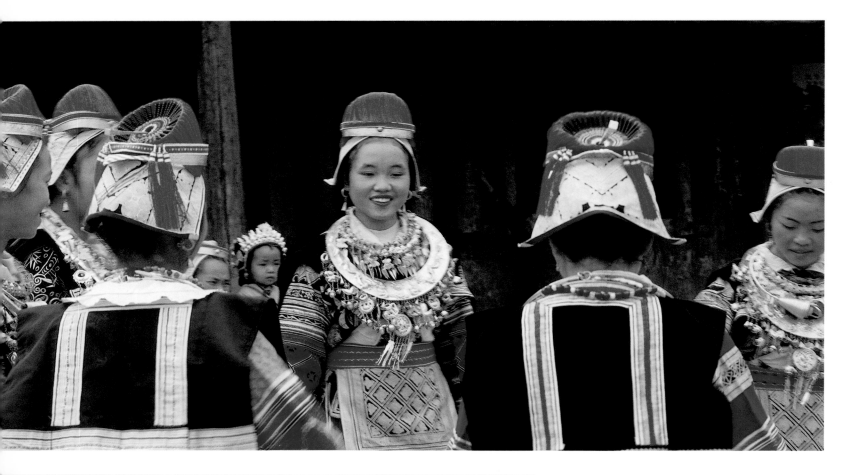

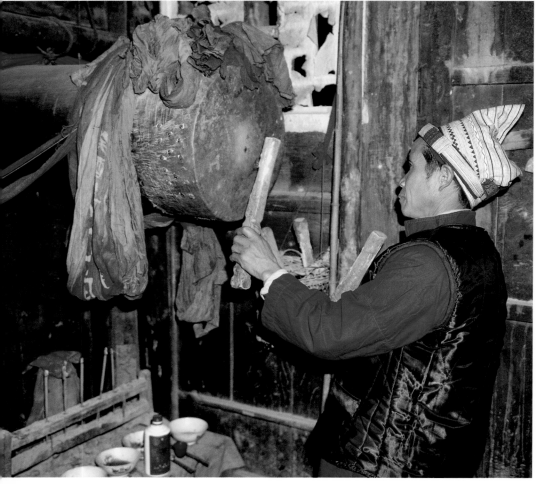

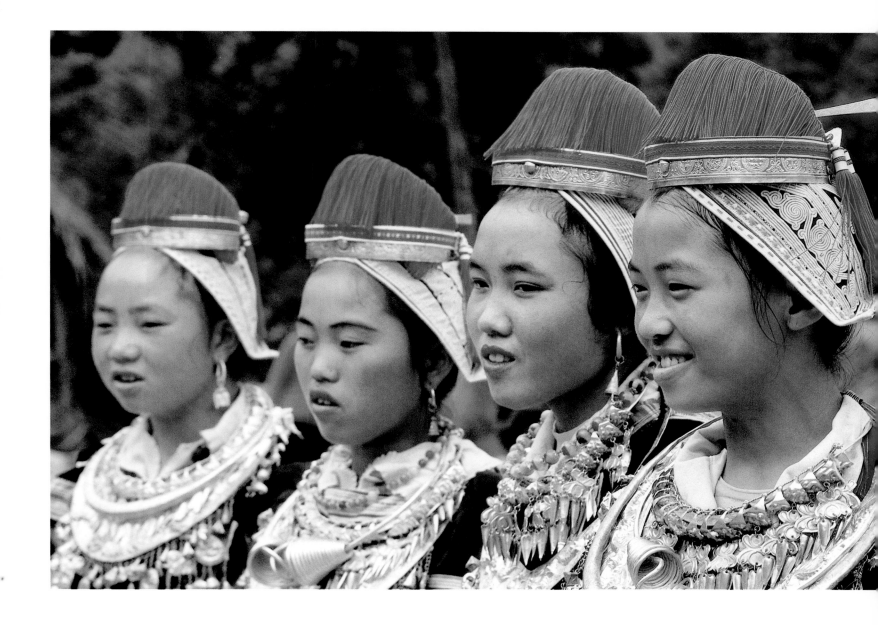

The Arts of the Chinese Minorities

A variety of ethnic minorities in the mountain regions of south-west China have succeeded in preserving their traditional ways of life in the face of government measures that attempt to enforce uniformity. The cultures of the Miao and the related group, the Gejia, boast extraordinarily precious traditions in their rich and varied silver jewelry-making and artistic textile techniques.

Above and opposite, above: The girls of the Gejia of Guizhou wear magnificent silver jewelry and clothes in radiant colours, decorated with fine batik patterns and embroidery. A few years ago, the Gejia were granted the status of an independent ethnic minority, which brought them the advantage of not being bound by China's one-child law.

Opposite, below: For the Gejia, the drum plays an important role in ancestor worship.

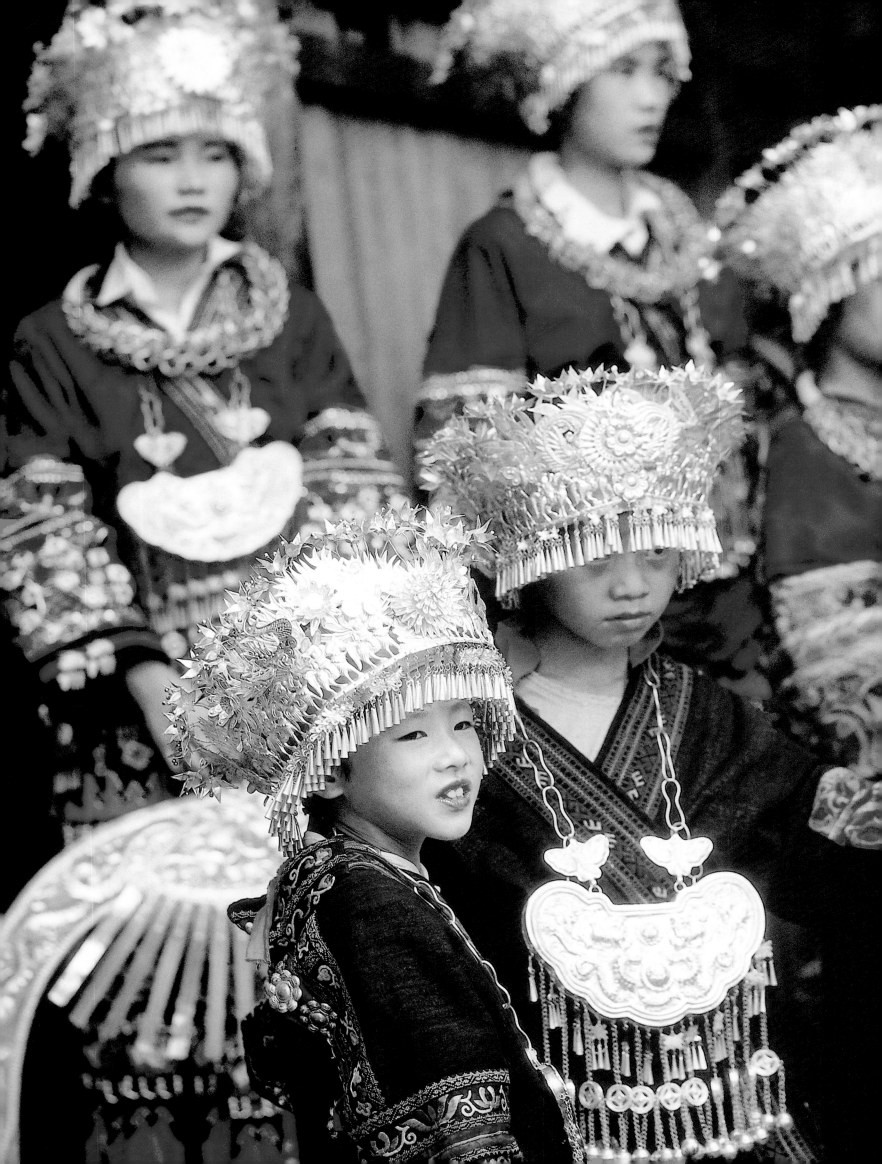

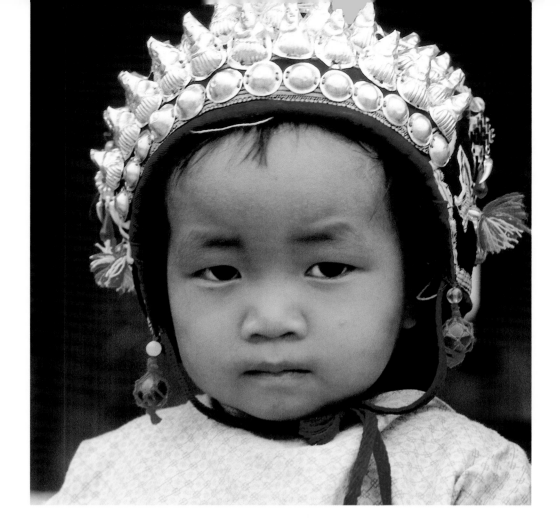

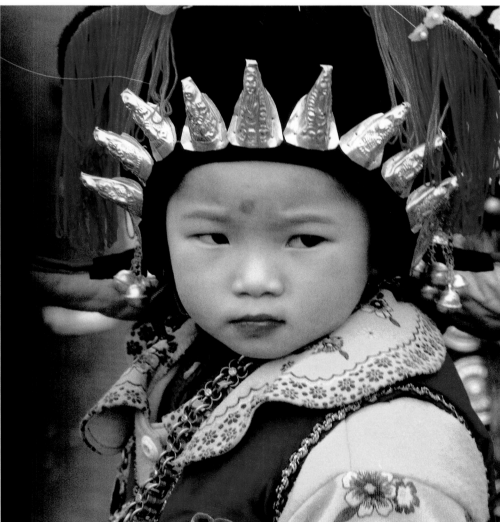

Children's Crowns

Even as babies, these children wear silver crowns, decorated with symbols to ward off evil. They also serve the function of keeping the soul firmly in the body.

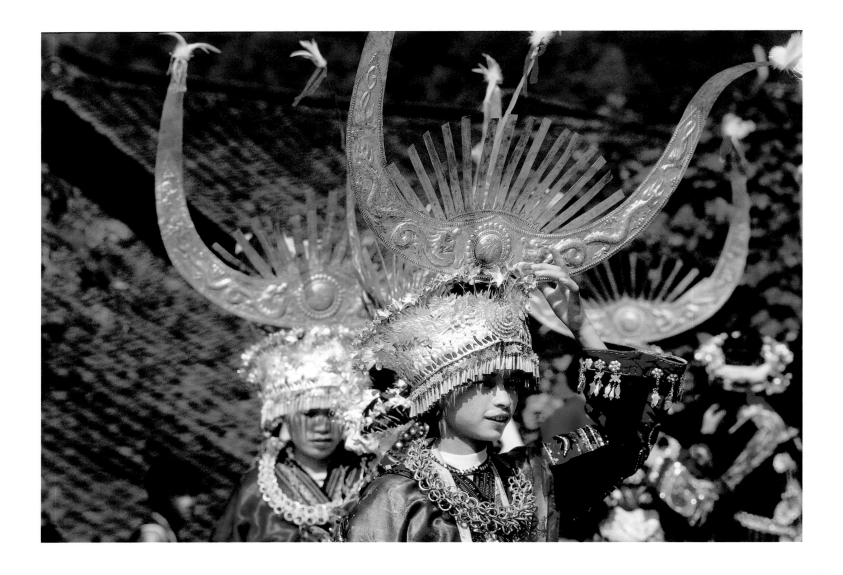

The Horns of the Dragon

The Miao people are spread out over a large area ranging from the western part of southern China through Vietnam and Laos as far as northern Thailand. Their silver jewelry is considered a symbol of the light that drives away dark forces and protects the wearer from illness and evil. At their ceremonial feasts, the Miao bedeck themselves from head to foot with a huge quantity of silver jewelry, the production of which calls for between 10 and 15 kilograms of raw silver.

Above and opposite: The silver headdresses of the girls from Langde in Guizhou represent 'the horns of the dragon', a symbol of good fortune that drives away evil spirits. These remarkable crowns of silver horns are decorated with various motifs including the phoenix, the magpie, the turkey and plum blossoms. They are also a sign of prosperity, forming part of a bride's dowry.

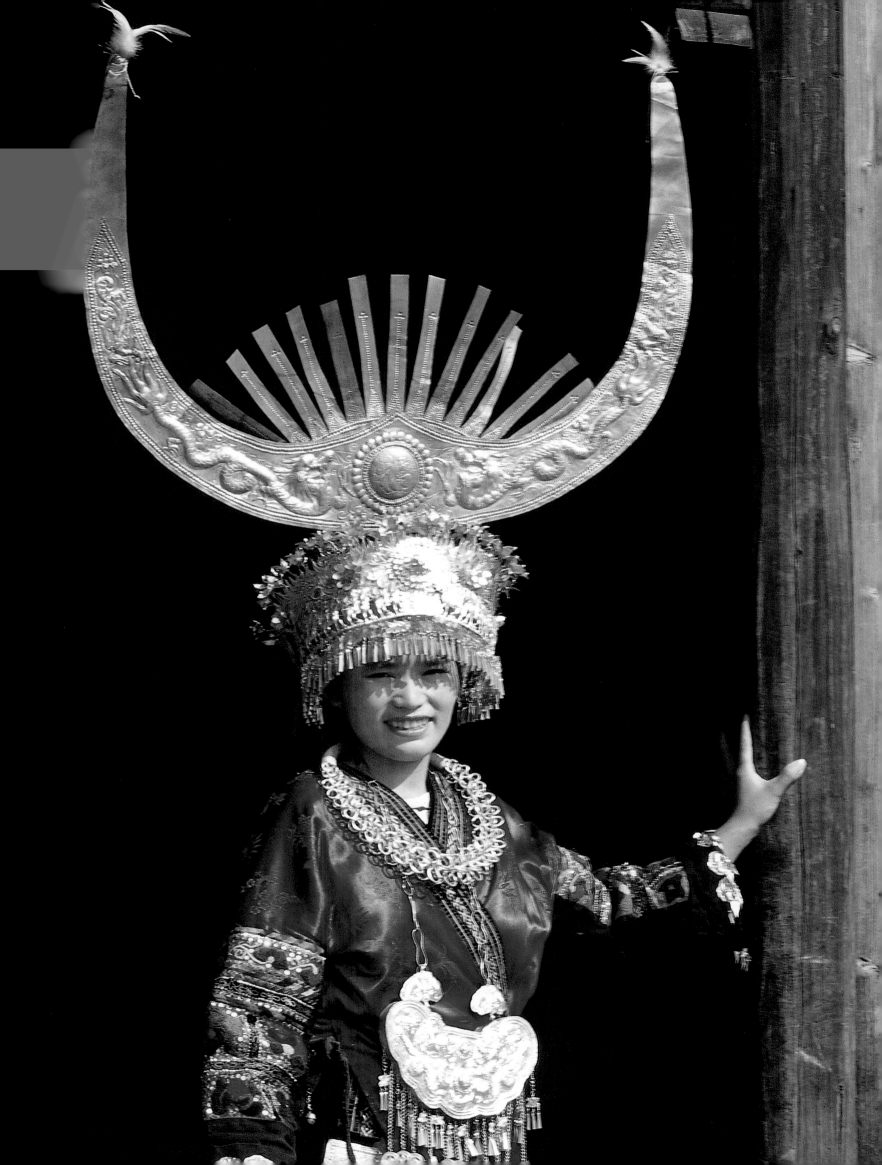

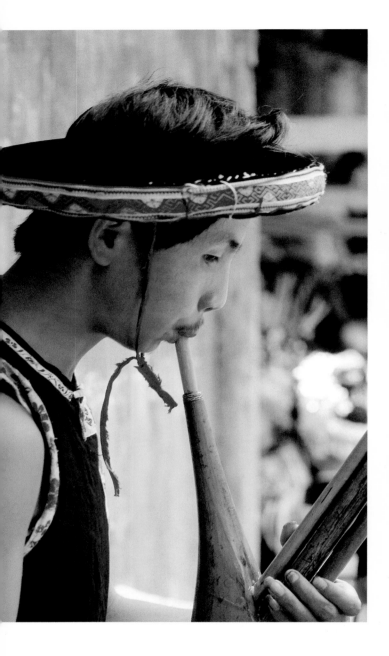

Miao Musicians

Right: At a feast, the men of the traditional Miao village of Langde are joined by the shaman in his hat in making music on the *lusheng* instruments made of long bamboo pipes.

Above: The young Miao wearing traditional costume is from Taijiang and is playing a mouth-organ.

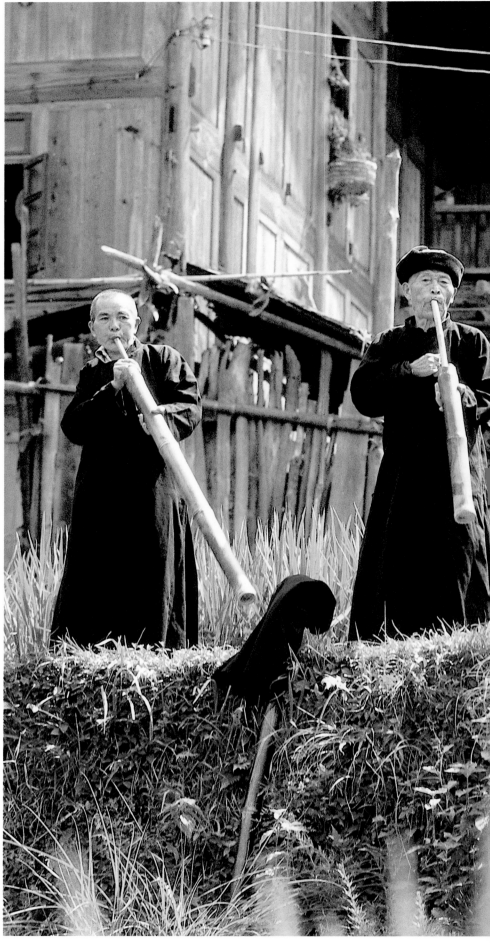

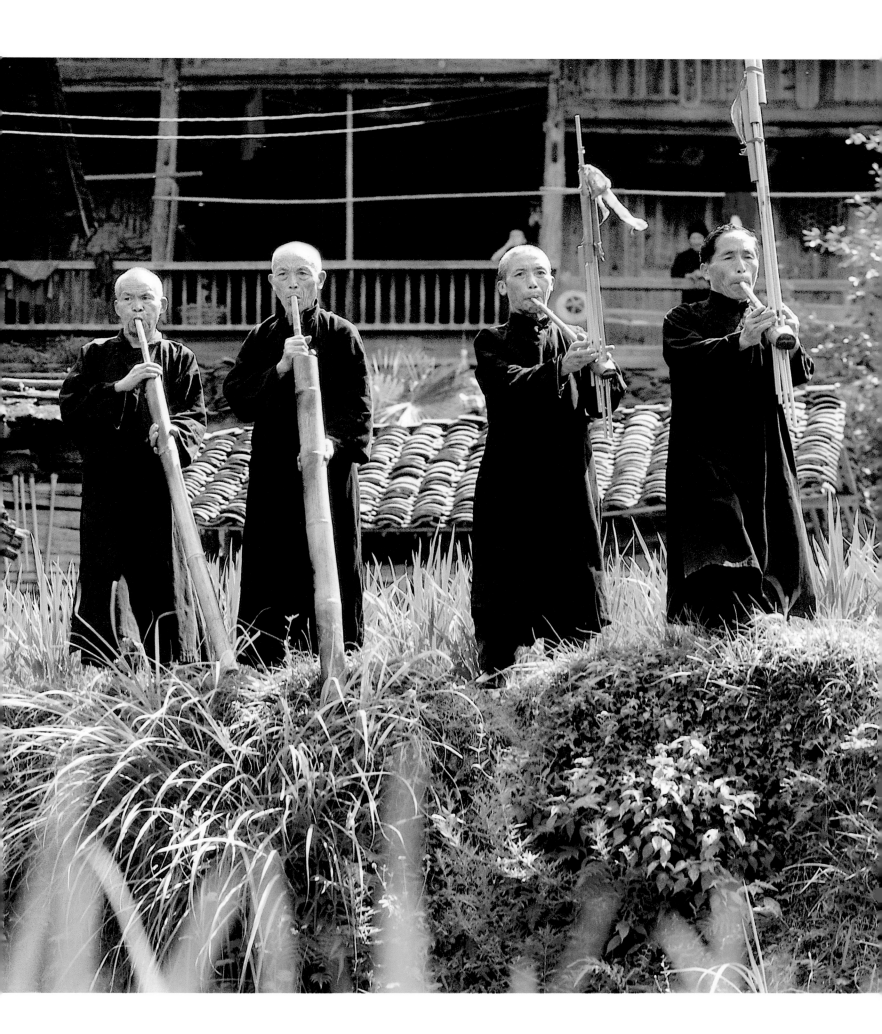

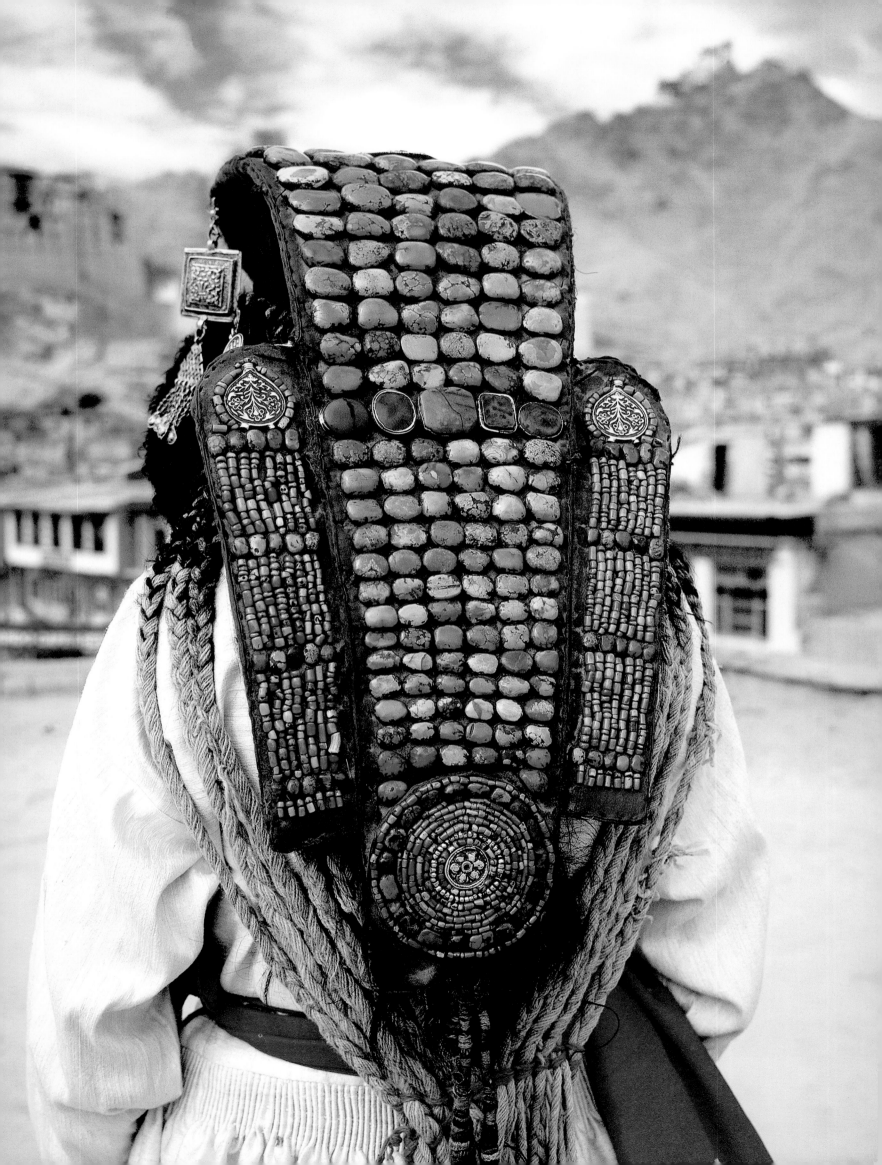

Chapter 5

The Roof of the World

Where Mountains Are Gods

The 'Roof of the World' is the highest plateau on earth and lies in the heart of Asia surrounded by the Hindu Kush, Pamir, Karakoram and Himalaya ranges. These four mountain ranges rose as the result of the massive tectonic forces caused by the primeval collision of the Indian sub-continent with Asia. The majestic splendour of this mountain world has a dramatic beauty that captivates every traveller who sets eyes upon it. It boasts imposing glaciers, snow-clad highlands, sandy mountainous deserts and broad grassy expanses interrupted by wild mountain chasms and isolated valleys.

In spite of the impassable nature of this mountain country, and its general lack of resources, there are many fertile oases and pretty valleys where a variety of peoples grow fruit and vegetables and are settled in hamlets and villages. The region's history has been crowded with incident. Two thousand years ago it was already traversed by a number of the ancient trade routes, notably a branch of the Silk Road. Mule and camel caravans brought silk, tea and porcelain from China, negotiating troublesome paths over high passes through to the plains of the Indian subcontinent.

Bartering brought them gold, ivory, precious stones and spices. The 2,500-kilometre-long Himalayas protect the Tibetan highlands from the monsoon coming from the south, thus forming a climatic divide. The Tibetan side of the Himalayas is the non-rainy side and it is only in the areas with irrigated land that barley, buckwheat and potatoes are grown. The peasants in these areas live in small farmsteads built from dried mud bricks or stones.

On the huge plateaux over 4,000 metres above sea level, the Tibetan nomadic herdsmen are almost the only humans to be seen. In Changtang in western Tibet, a dry area with climatic extremes and temperatures as low as minus 40 °C, peaceful livestock breeders live with their yaks, goats, sheep and horses. The grasslands and steppe areas of the north-eastern and eastern plateau – China's 'wild west' – are home to formerly warlike nomadic tribes. In the ancient Tibetan region of Amdo, which has now been made part of the Chinese province of Qinghai, the Golok people roam with their herds through strictly demarcated pastures.

In earlier times the Golok were notorious for the pillaging they committed on extensive raids and were viewed with fear on all sides. In the 1950s and 1960s these nomadic tribes offered fierce resistance to the invading Chinese troops. South of Amdo, the Khampa, a people who were until recently almost unknown to the outside world, live as herdsmen in the

The perak headdress of this woman from Leh, the capital of Ladakh, represents the accumulated wealth of several generations.

185

Rock engravings on the upper Indus in northern Pakistan, depicting Buddhist stupas.

Kham area, now a part of the Chinese province of Sichuan. The Khampa were famous as courageous fighters – they earned a living as dangerous bandits and specialized in laying ambushes for traders along the tea caravan route. These events are hardly in accordance with stereotypical notions about peace-loving Buddhists, but have long since become a thing of the past. However, the tribesmen have remained loyal to other traditional values such as frugality, selflessness and hospitality, and it was they who accompanied the Dalai Lama when he was forced to flee over the Tibetan border to India.

Although Tibetan nomads have few material possessions, they love to adorn themselves with precious objects such as heavy silver necklaces, magnificently decorated amulet boxes, turquoises and red coral, amber and cowrie shells. Jewelry and other personal objects form an integral part of any dowry and are also used for barter. One cannot but admire the brightly coloured hair decorations of the Khampa nomads, who weave red or black bands into their hair and decorate their pigtails with ivory clasps and silver ornaments. The men also wear decorative strike-lighters, knives and amulet cases on their belts.

The history of the Himalayan lands has been largely determined by the extreme geographical factors that characterize the region. The steep mountains of the Himalayas, from the snow-clad slopes to the sweltering plains, have in fact been home to a variety of ethnic groups from time immemorial. The inhabitants of the cold northern parts of Nepal, Sikkim and Bhutan are Mongol peoples of Tibetan origin. The Sherpa live high in the Himalayas at the foot of Mount Everest; they first came from eastern Tibet in the sixteenth century. They are true kings among mountaineers; as is well known, Everest would never have been conquered by a Western mountaineer without the help of a Sherpa. Many traditions have been kept alive by the semi-nomadic yak herdsmen of Mustang and Dolpo in north-western Nepal. Other tribal peoples such as the Gurung and the Magar in the west and the Tamang and the Rai in the east are famed for their bravery and their service in the Gurkha regiments of the British Army.

A notable example of the northward movement of Indo-European language groups, mostly members of Hindu castes who pushed north and settled in the valleys of the Nepalese hills, is provided by the Tharu who live at the foot of the Himalayas in the Terai valley and wear a fascinating range of silver jewelry. Many ethnic groups and religions met in the Kathmandu valley, creating conditions in which centres of urban culture could develop. This is where the Newar people live, the best artists and craftsmen of Nepal. Many of the finest pieces of jewelry found in Nepal's remote valleys are in fact Newar work.

Tibetan women, in contrast with their counterparts in the Hindu and Muslim worlds, enjoy high social status and can show themselves in public without having to hide behind a veil. In rural areas it used to be customary for women to take two or more brothers as husbands. The original purpose of this form of polyandry was to prevent the dividing up of property; it also kept the birth rate down, and is still practised in some remote areas. The eldest of the brothers is considered the father of all the children and the eldest son inherits both the house and the land. The workload is thus divided between several family members, but the system has unsurprisingly enough sometimes resulted in a surplus of unmarried women.

Given the bareness of the land and the frequent evidence of poverty, it is amazing to see the treasures that the women are given to wearing. Jewelry has

magical and social functions, but its prime function is to show the wealth of the wearer. The unusual and magnificent headdresses of the peoples of highland Asia have a particular significance. The Kalash Kafirs in the Hindu Kush wear black bonnets decorated with cowrie shells, the Buddhist Dards of the Indus valley stick bouquets of flowers into their hoods, and the Ladakhi people carry veritable treasure troves on their heads. Both the women and the men of the Khampa nomads are known for their unusual hair jewelry containing turquoises, coral and amber. It may be that these jewelry traditions are connected with the fact that the head is considered the seat of life energy. The reason may also lie in the simple fact that in a climatic region where thick clothing must be worn all year round, the head is the only part of the body that can be visibly decorated.

The artistic forms and traditions cultivated by these peoples share some common features, and are all closely connected to a magical-religious world view. There are often no clear borders between the different religious and ethnic groups that coexist peacefully in this area. In spite of Hindu and Buddhist predominance, many elements of the pre-Buddhist Bön religion have survived, as have shamanistic and animistic traditions. When faced with difficult life experiences, such as illnesses, or when in need of fortune-telling or exorcism, people will tend to turn not only to the Buddhist lamas or Hindu brahmans but also to the local shamans.

'Where there is a god, there is a demon' is an old Tibetan proverb. The traditional world of the Tibetans is full of supernatural forces that can influence human lives for good or for evil. Everyone has his or her personal guardian spirits that reside in particular parts of the body or in objects. Archaic rituals, magical protective signs and amulets are used to provide protection against the constant threat of evil spirits and demons. Everyone in the Tibetan cultural area believes that certain materials are highly effective in protecting one from harm and warding off the forces of evil. Some stones, for instance, can help women to conceive, and others can release good spirits that may be put to work for one's own ends.

Many of the materials used in jewelry making can be found without having to cross borders. Silver is mined in the mountains, gold is panned in the Indus and turquoises are found locally. Cowrie shells and coral have to be imported; they came to the Tibetan highlands from the Indian Ocean, and the coral was even brought from as far away as the Mediterranean. Ritual objects made from human bones also come into this category, but these are rare, and are reserved for shamans and Tantrists only. In some ceremonies the black-hatted dancers wear netlike, finely carved aprons made from human bones to remind participants of the transience of human life.

The so-called *gzi* stones are worn as central stones in necklaces and are particularly valued for their protective qualities. They are usually roller- or cylinder-shaped and are in fact polished agates with black-and-white or brown-and-white striped patterns. The most valuable are the ones with small circles or 'eyes'; these guard against illness, imminent harm and, above all, the evil eye. All Tibetans believe that *gzi* stones were originally the favourite stones of the gods, but the gods kept the most beautiful of them and threw the rest down to earth. The legend explains that this is why individual *gzi* stones have often been found by peasants when ploughing the fields. The great demand for them meant that agates and carnelians were already being polished and etched with acid in very

early times. Many old pieces are made in a glass-like substance made by a process that is no longer known. The many recent imitations produced by Chinese or Indian porcelain factories are in fact made with black or white sealing wax. After the Chinese invasion, many Tibetans fled to India and most were obliged to sell a large portion of their jewelry in order to survive.

There are also rich jewelry traditions in the impassable mountain valleys of the Hindu Kush and the Karakoram, where the population is a colourful mosaic of peoples who took refuge in the mountains many centuries ago and have meanwhile mostly converted to Islam.

The Hunza people have become particularly famous because of the claim that they have no knowledge of illness. They live in a beautiful valley in the Karakoram and survive in winter on loaves of flatbread, vegetables and dried fruits. Their healthy diet and the mineral content of their river water probably explain why centenarians are quite common among the *Hunzakutz*, as they call themselves.

The Pashai are an interesting ethnic group who live in the southern Hindu Kush and are regarded as having originated the so-called Gandhara culture. Although they are strict Sunni Muslims, they have retained many pre-Islamic elements in their culture including notions of spiritual essences and conceptions about the soul that can only squared with Islamic beliefs with the greatest difficulty. The surviving ancient elements of their culture include figurative and ornamental carvings on their houses and tombs.

The peoples of the Hindu Kush have acquired a certain fame because it is not uncommon to find people among them with fair complexions, light-coloured hair and blue eyes. Although there is a theory that they were the descendants of Alexander the Great and his armies, who did indeed reach as far as the Indus river in the fourth century BC, this idea is undermined by the fact that even before Alexander's time Greek historians were already talking of fair peoples living in the Hindu Kush.

One of the less accessible valley areas of the Hindu Kush was home to an ethnic group that had never converted to Islam and that still retained its archaic beliefs. In the eyes of the Muslims these were infidels, or *Kafirs*, worshipping sacrilegious idols and practising animal sacrifice and magical fire rituals; as if that were not bad enough, they also drank wine rather than pure water.

This extraordinary culture was first brought to the notice of the wider world by the publication of George Scott Robertson's *The Kafirs of the Hindu Kush* in 1896. He described their many-layered pantheon, their complex system of rank and their 'feasts of merit', with their goal of exchanging of riches for prestige. He also documented their fascinating works of art, the famous equestrian pictures, the wooden temples with columned halls and the magnificent carvings reminiscent in certain aspects of the ancient Greco-Buddhist and Islamic traditions. Their silversmiths made splendid jewelry for the tribal chiefs. It is one of the most savage ironies of history that the year that Robertson's book was published was also a fateful and fatal year for Kafir culture. The Kafirs were defeated by the Afghans and forced to accept Islam. Their ancient artworks were almost entirely destroyed and their land was renamed Nuristan, 'Land of Enlightenment'.

The last Kafirs to survive without being converted to Islam are the Kalash Kafirs, a small group who still maintain the culture and nature religion described above. They occupy the three small highland valleys of Bumburet, Rumbur and

Birir in Chitral on the Afghan border in the extreme north-west of Pakistan. Their stable, rectangular houses have no windows, but just one small opening and are often built on rocky outcrops or on slopes. In spite of ever-increasing pressure exerted by orthodox Islamic fundamentalists in Chitral, the Kalash Kafirs have held on to their ancient religion and traditional way of life. They are animists and ancestor worshippers and they celebrate lavish feasts in honour of the changing seasons of the year. Living in permanent contact with their gods, both male and female, they are careful not to infringe their laws and taboos. The purity and impurity laws are considered to be particularly important and they regulate the whole of Kalash Kafir life. Like many other peoples of the Hindu Kush and Karakoram they believe in spirits of the air and demons who operate as mediators between men and their gods. The good spirits are believed to inhabit the fragrant air produced by burning juniper branches.

This is the land of legends, where the gods sit enthroned on the mountain peaks while the realm of Shangri-La and the kingdom of Shambhala lie deep in hidden valleys – those mythical places where paradise is said to await, if only we can find it. But Galen Rowell was perhaps right when he wrote that 'the real Shangri-La is not a place that can be visited, but a state of consciousness, and sadly it is one that has already been lost in many parts of the Himalayas.'

Endless knots such as these are an important Buddhist symbol of eternity.

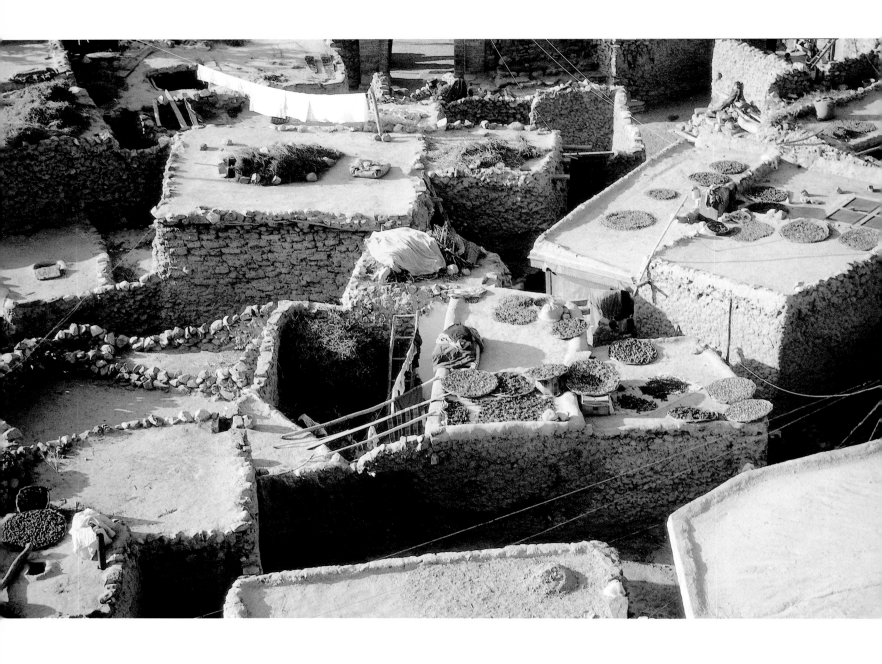

Land of the Hunza

Above: Apricots are laid out to dry on the flat roofs in a village that lies in the shadow of the ancient Hunza fortress. These fruits, dried or ground, are an important source of nourishment in winter.

Opposite: A watchtower in Altit, the thousand-year-old tribal castle of the Hunza princes, from where they controlled the Indus valley trade route.

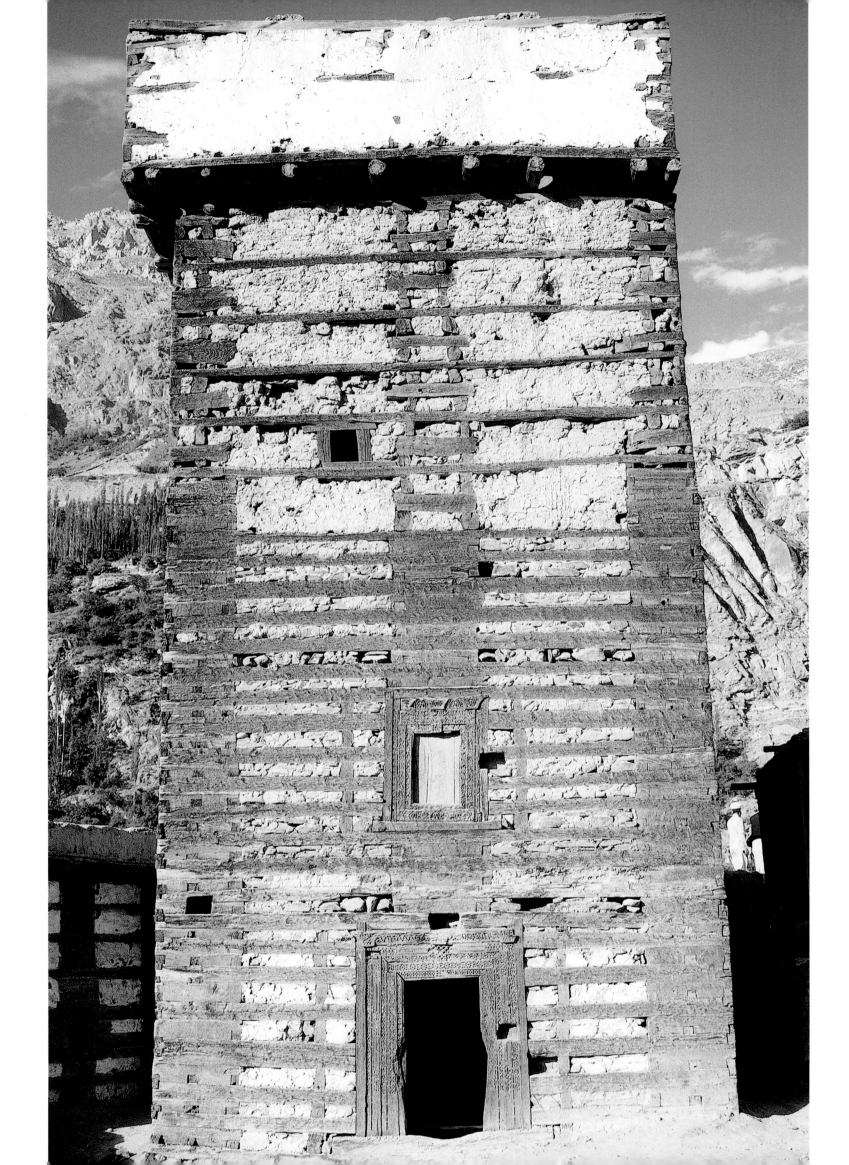

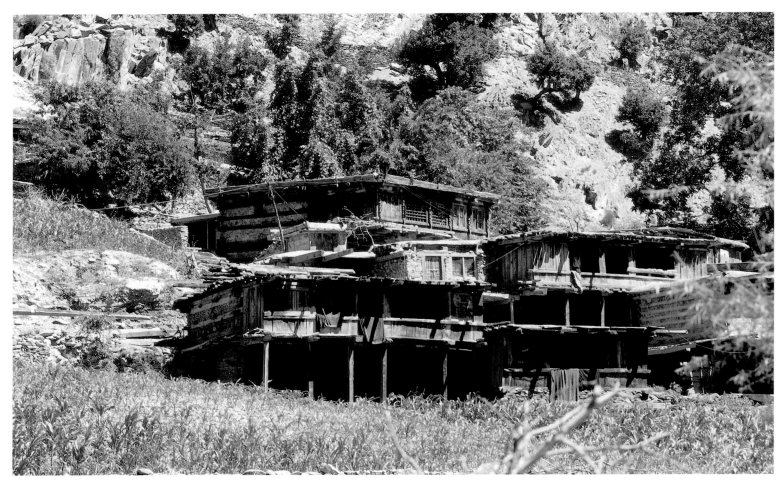

Kalash Ritual Sites

Above: The two-storey houses built of several layers of wood, stones and air-dried bricks, are built into the mountainside. The filling of fissures in the caves with small stones is a proven measure against earthquakes.

Left: Figure of a male ancestor in cedar wood near a cemetery in the Rumbur valley. Sculptures like this one may only be erected for high-ranking people after their death. The turban symbolizes his bravery, while the necklace represents his wealth and the merit he acquired through giving generously to the people of the village. Old sculptures are now a rarity, many having been stolen for the high prices they fetch on the art market.

Above: Above a village in Rumbur valley stands a shrine to the god Mahadeo. Four horse's heads carved in wood project out of an altar construction, symbolizing Mahadeo's presence. In the background are branches cut from the sessile oak (*Quercus petraea*), considered a holy tree.

Right: View from a temple platform over a settlement in Rumbur valley. In the foreground stands a carved ritual stela.

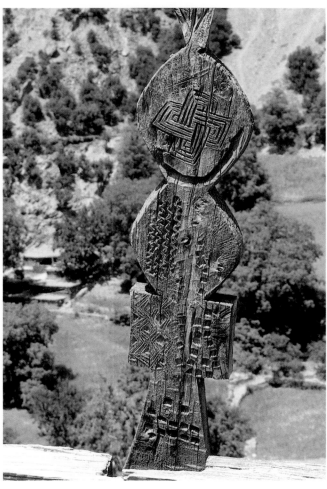

Faces of the Karakoram

Above: A Muslim Dard from Gilgit wearing a typical *chitrali* cap. The Dards live in scattered valley communities in the Karakoram and speak an Indo-European language.

Opposite: Two fair-skinned Kalash Kafir girls from Bumburet valley, wearing their traditional black clothing and headbands embroidered with colourful patterns. The two floors of the house are joined by a heavy wooden staircase made out of a tree trunk with carved-out steps.

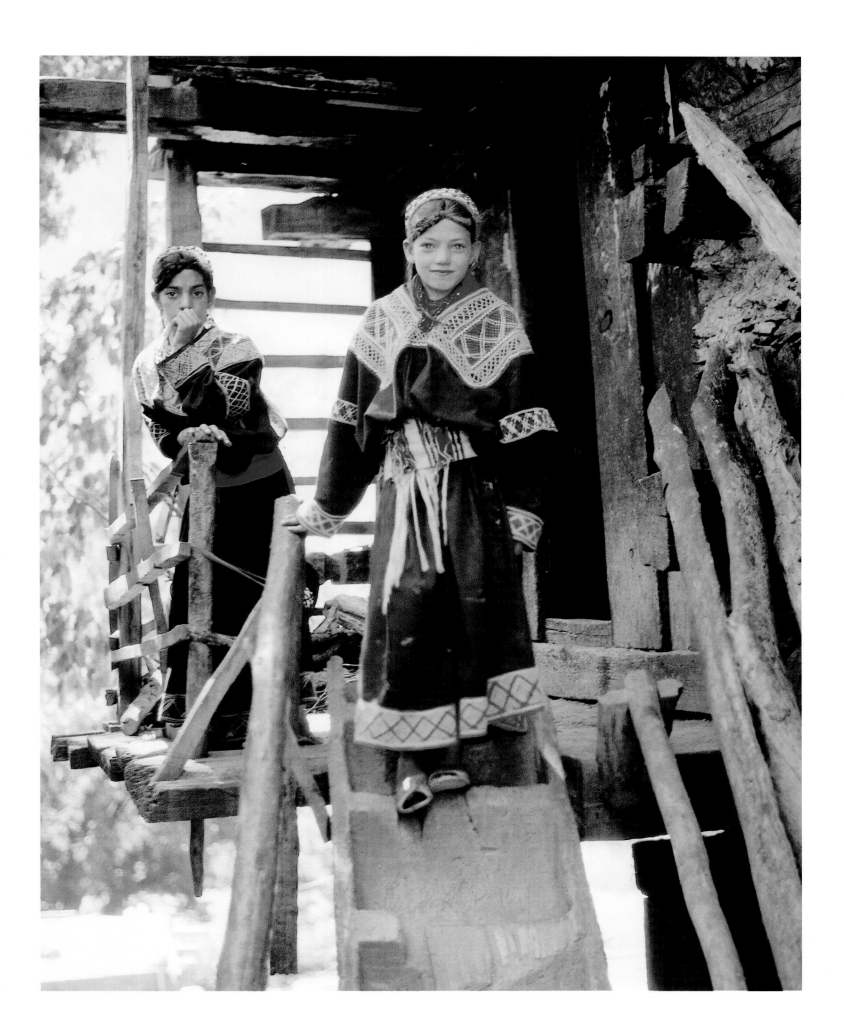

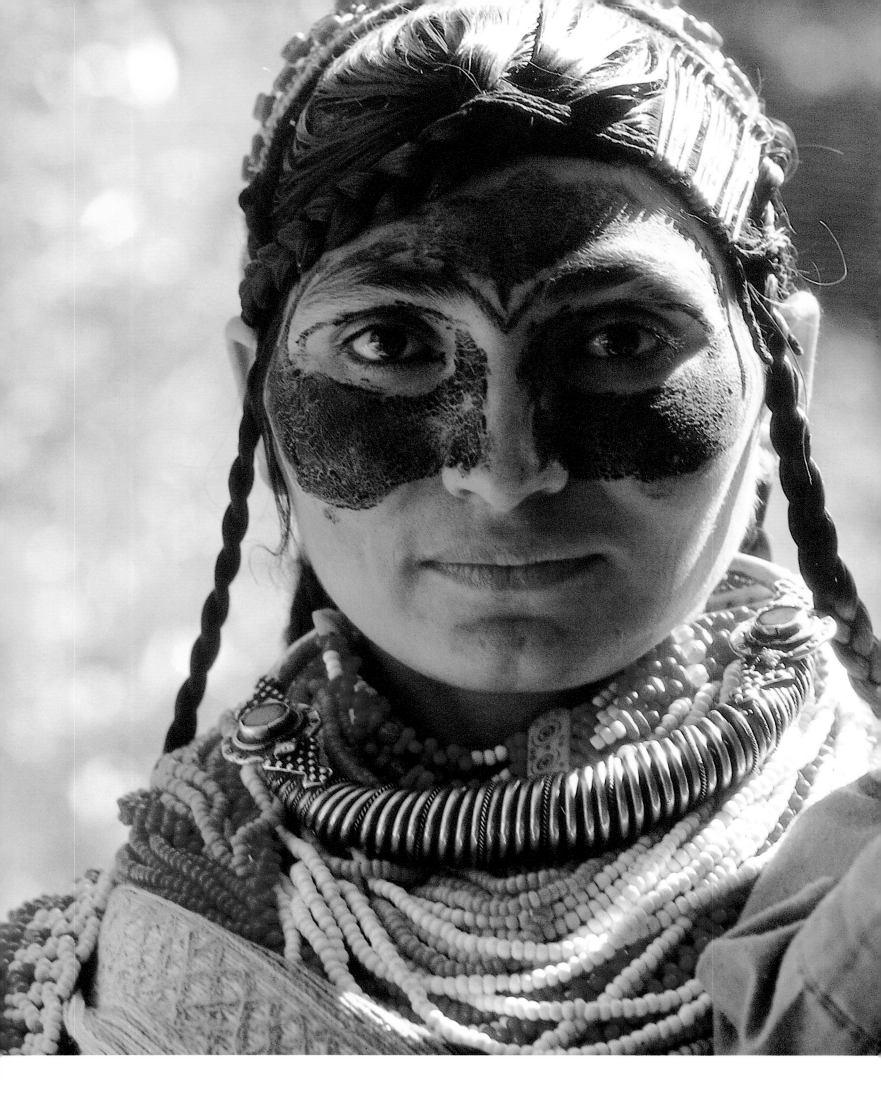

Magical Make-Up

A Kalash mother with a heavily painted face. The colour she uses is a black paste made from ground and burnt pulverized goat's horn mixed with water. The make-up is not washed off but left to peel off, because as well as protecting the skin from the powerful rays of the sun, it is also thought to have magical powers and to protect the wearer from evil.

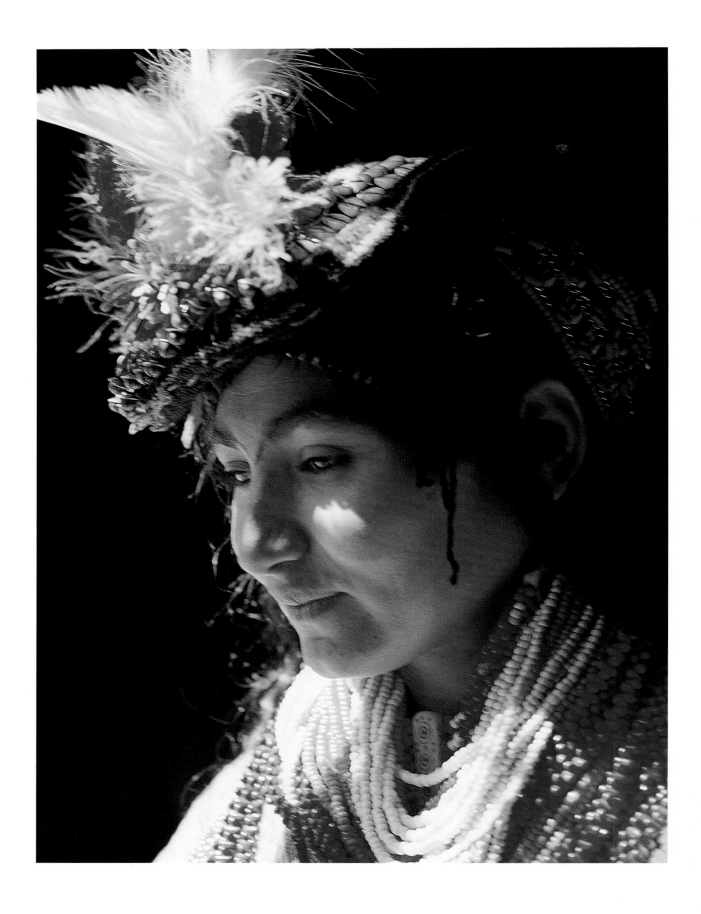

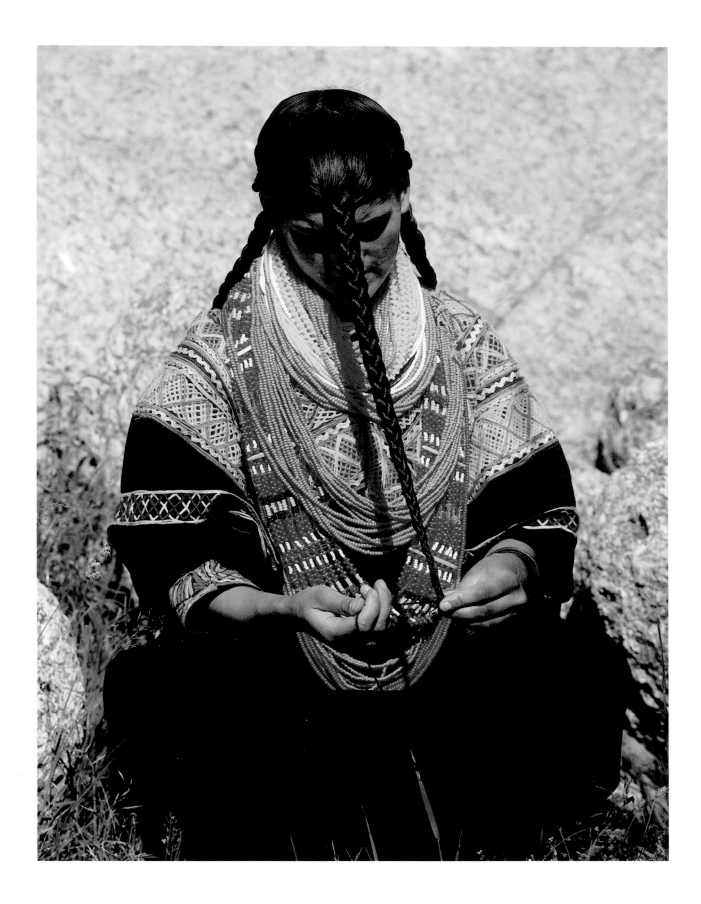

Kafir Costumes

Opposite: Feathers are used to decorate the *kupa*, a traditional heavy bonnet.

Above: Braids add a finishing touch to this woman's festive costume with its glass beads and embroidery.

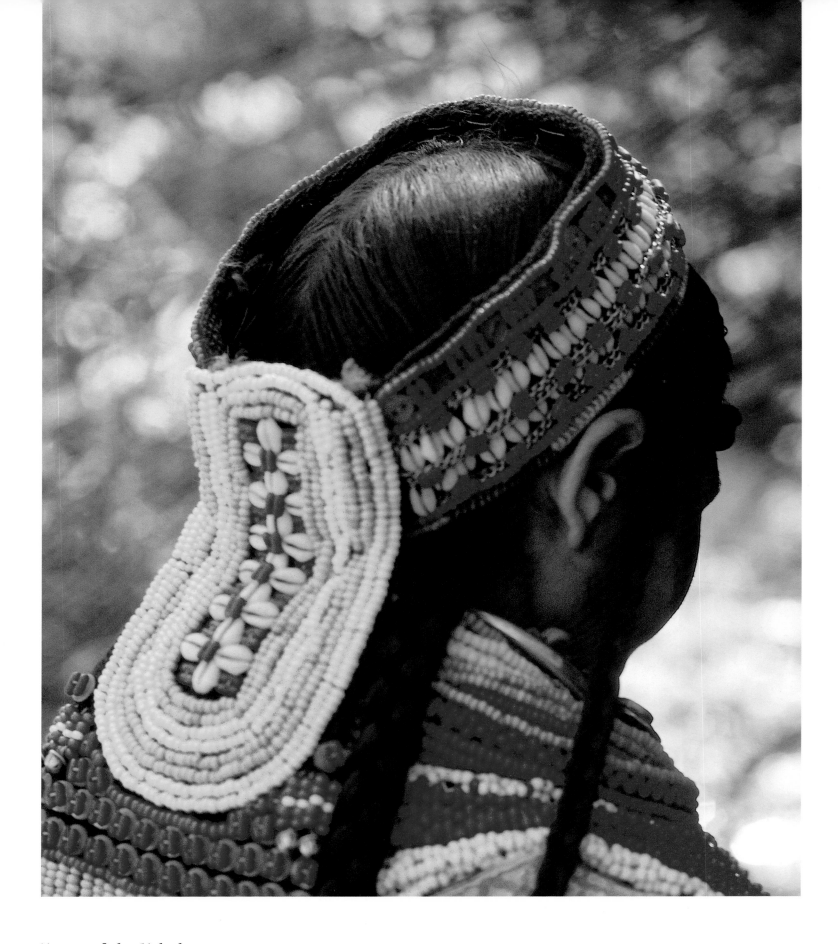

Kupas of the Kalash

Married Kalash women wear a *kupa*, a heavy bonnet lavishly set with cowrie shells, coloured buttons or bright glass beads. No woman leaves home without her headdress, which indicates her ethnic identity. The cowrie shells represent fertility, symbolize the life force and protect the wearer from bad luck. They originally came from the Indian Ocean and reached the mountain regions through trade and bartering. The *kupa* is held on by a woollen band.

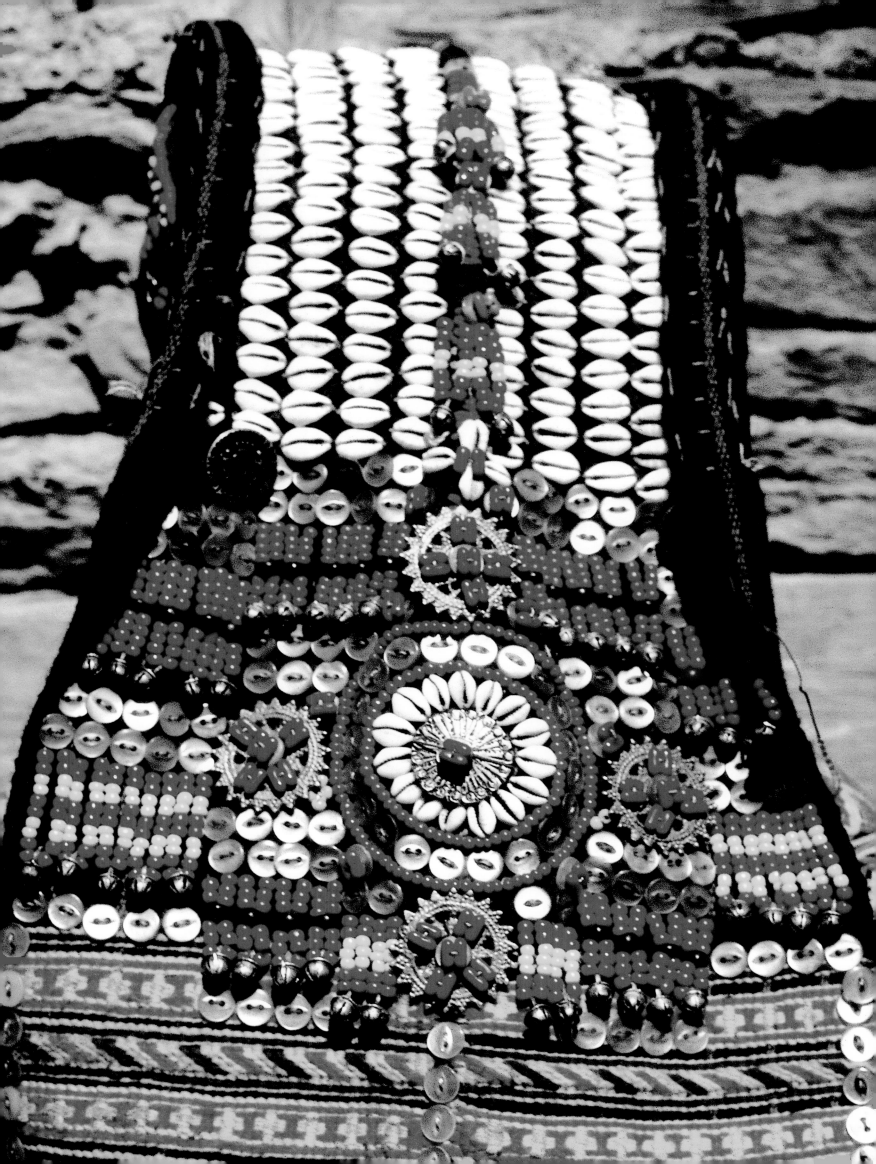

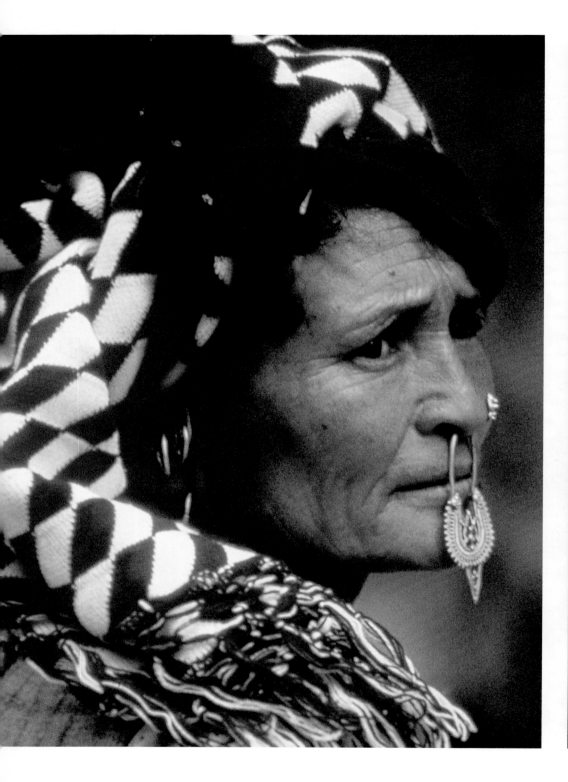
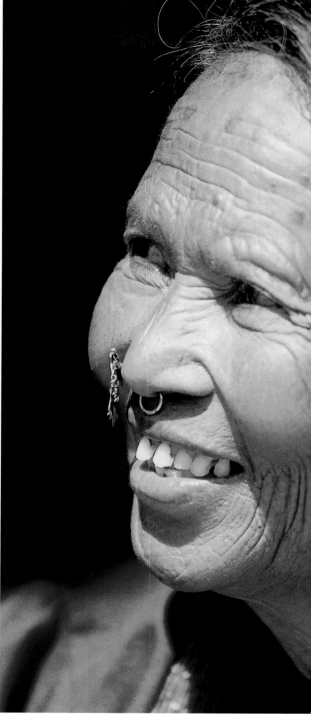

Nose Ornaments

A distinctive feature of Himalayan women's jewelry is their
nose-rings. The septum is pierced when they are still young girls,
a procedure often accompanied by a ceremonial celebration.

Above left and right: Garhwali women from the Indian Himalayas.
Above centre: A Tamang woman from central Nepal.

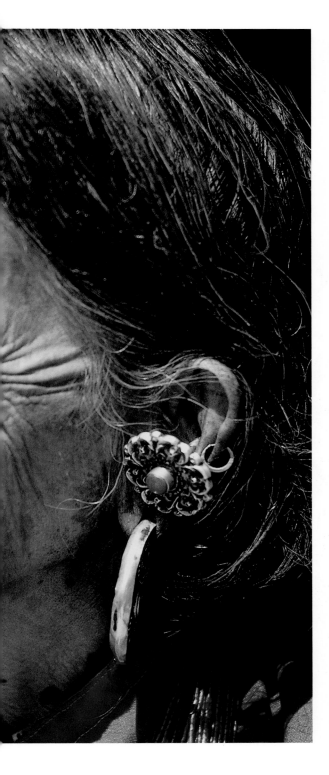
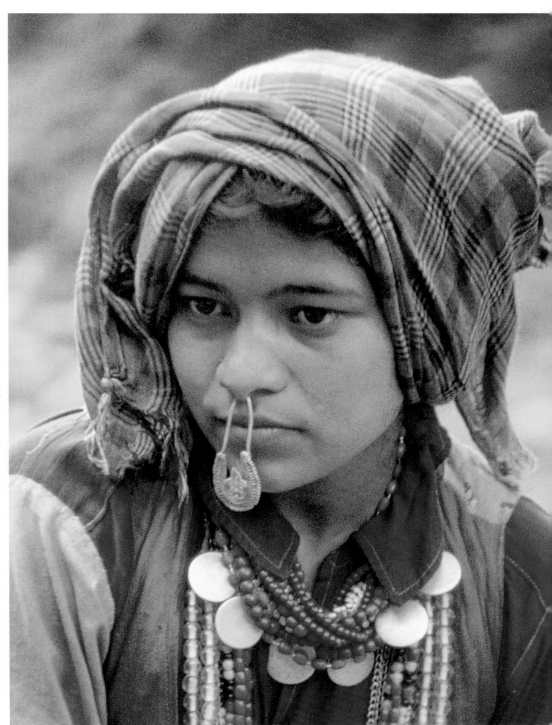

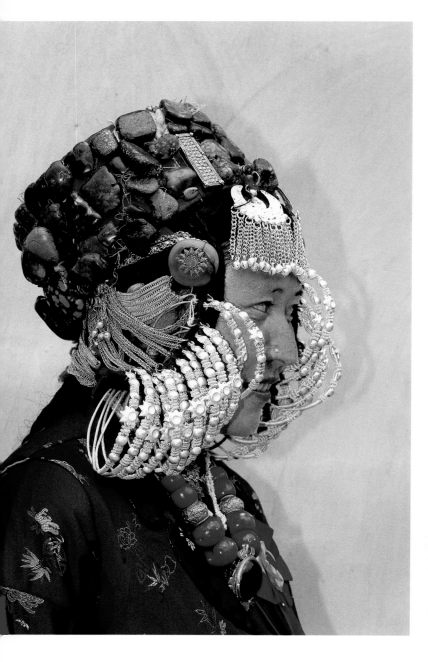
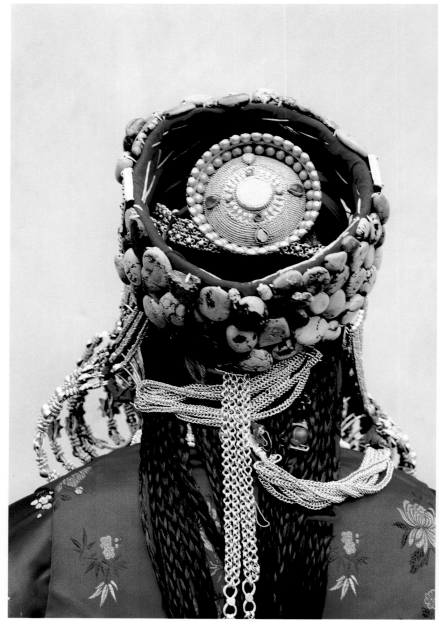

A Variety of Styles

Above: A Tibetan influence is evident in the headdresses worn in the Lahul Valley in the Indian state of Himachal Pradesh. Married women wear a lavishly ornamented headband set with turquoises and a decorative gold cap worked into the hair on the back of the head.

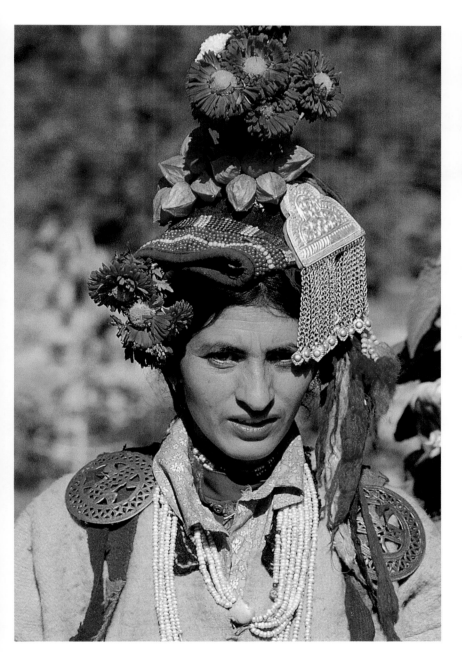

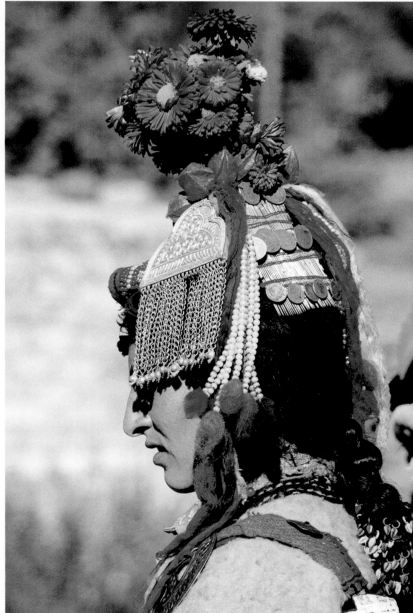

Above: A woman from the Drupka of the Dah-Hanu region in Ladakh, the last refuge of the Buddhist Dards, wearing a bonnet decorated with silver jewelry and long-lasting flowers. The Dards are a minority group in Ladakh, and the only people there to speak an Indo-European language.

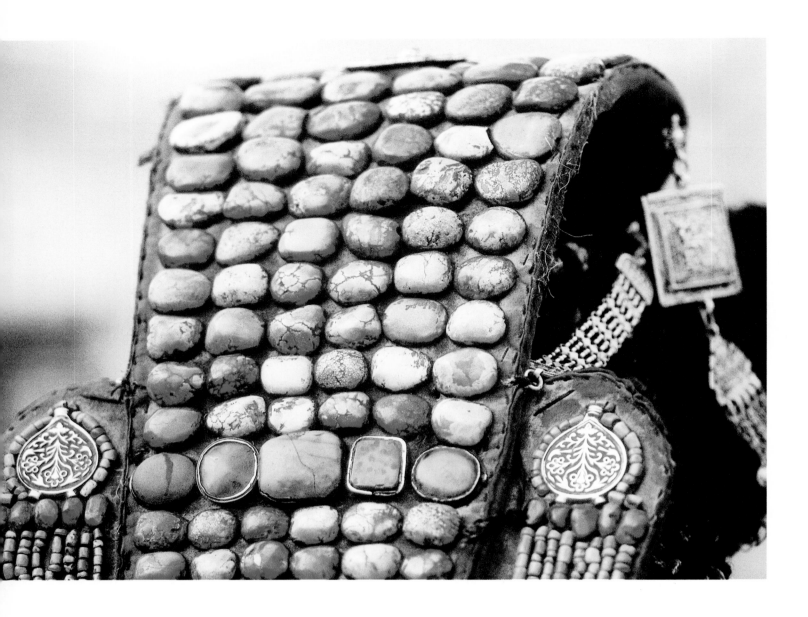

The Perak

Women in Ladakh in the western Himalayas wear a unique form of headdress, the *perak*, which consists of a leather and felt band lined with red material, with two 'ears' of black sheepskin attached to the band and sticking out on either side. Peraks are veritable treasure troves, decorated with valuable turquoises, corals and gold or silver amulet cases, from the accumulated dowries of several generations. It is not for nothing that the word 'perak' is derived in part from *per*, an ancient Ladakhi word for turquoise. On the sides, small amulet cases and silver plaques hang down into the woman's hair. The headdress is complemented with gold and silver jewelry worn at the neck.

When seen from the front, the perak is reminiscent of a cobra with its hood opened wide and ready to strike. Several rows of strung corals and pearls are set on the back at around shoulder level, representing the snake's tail. The cobra is highly respected in many Asian religions, notably in Tantric Buddhism, because it keeps guard over the treasures of the earth, including the precious turquoises. Peraks used to be passed down from mothers to their eldest daughters when they married, but nowadays, these large-sized antique peraks have become a rarity.

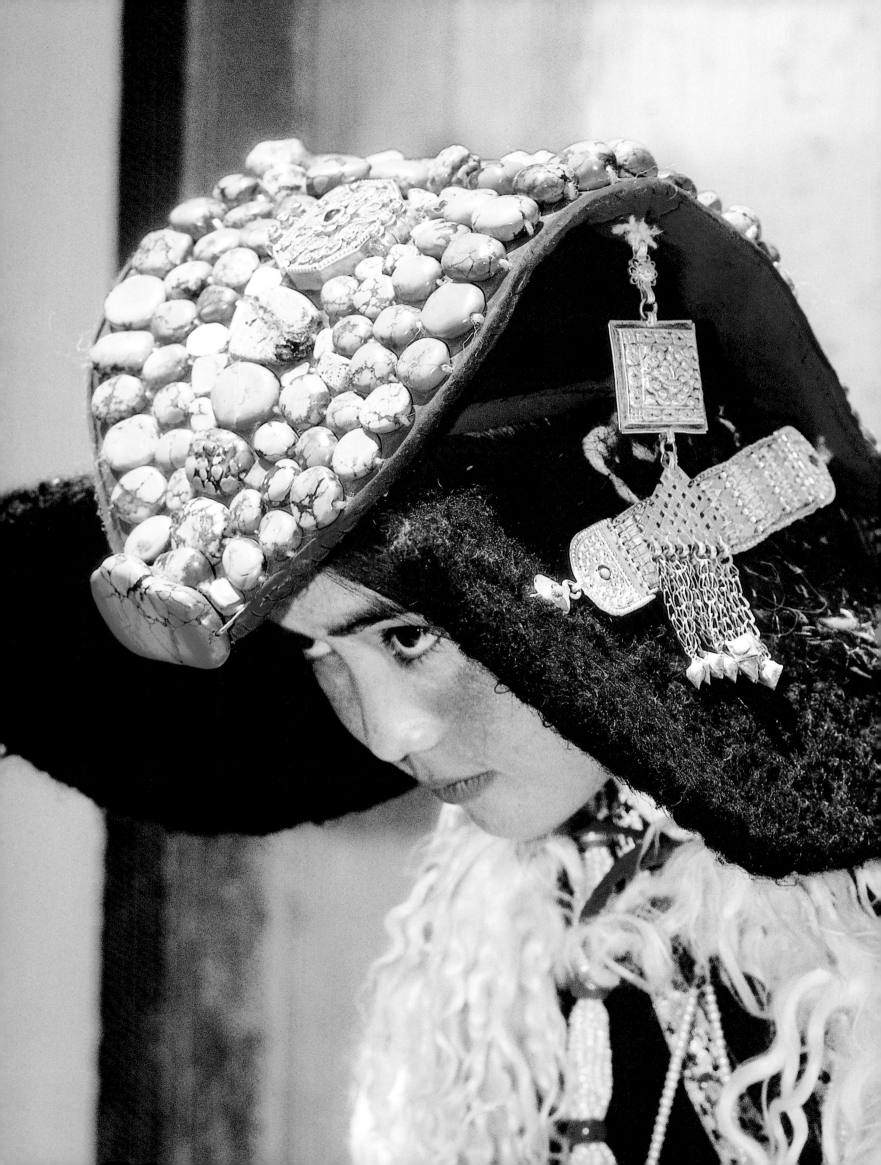

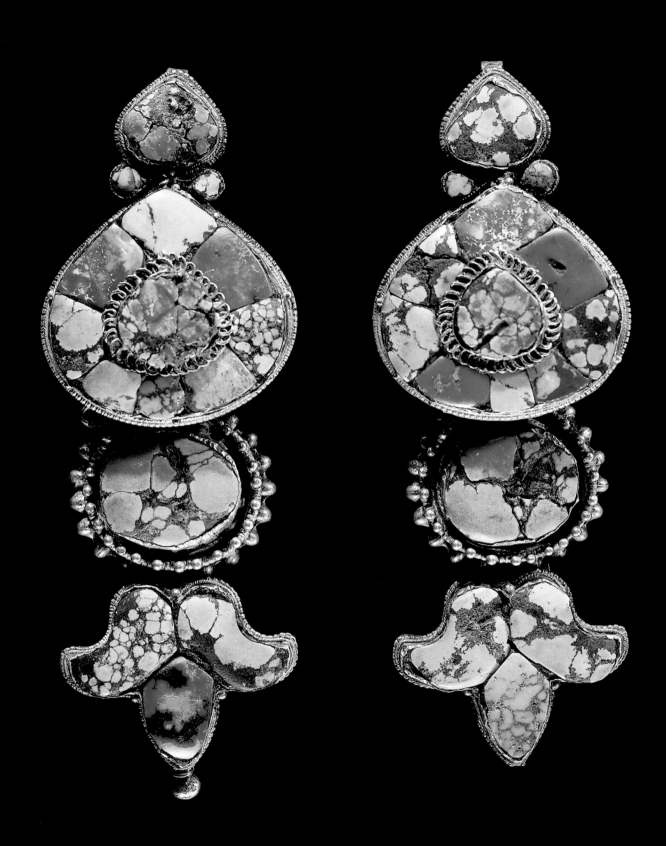

Turquoise and Coral

Magical powers are attributed to turquoises throughout the Tibetan cultural world – they protect the wearer from certain illnesses and the evil eye, and prevent the shadow-soul from leaving the body. A turquoise worn in an earring, for instance, prevents the wearer from being reborn as a donkey in the next life. They also bring good luck and function as talismans.

For the Tibetans, the turquoise symbolizes the divine blue of the sky over the Roof of the World and the peaks of the Himalayas; consequently, the stones that are most highly valued are those with a clear, sky-blue surface. In order to achieve this, they are polished until they acquire a silky patina. Tibetans compare the turquoise's natural ageing process, which is accompanied by a gradual decrease in brightness, to the human experience of life and death. Stones that are full of life have a healthy, light blue colour, but dead stones are dull and opaque, which is why a lively, bright turquoise is an indicator of long life for the wearer.

Red coral is second only to turquoise in its popularity with Tibetans. The two elements, the red of fire and the blue of the sky, are often worn next to one another. Coral promises wealth and beauty while turquoises stand for health and happiness.

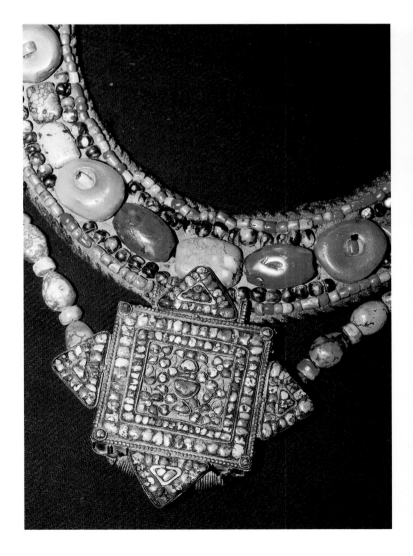

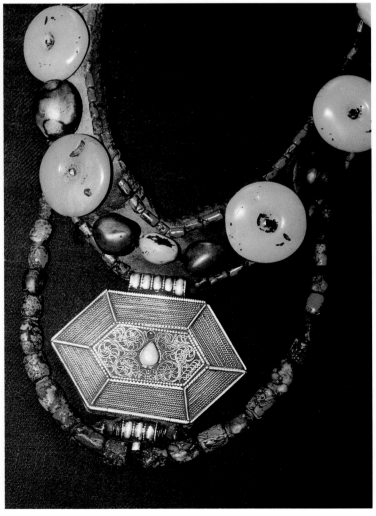

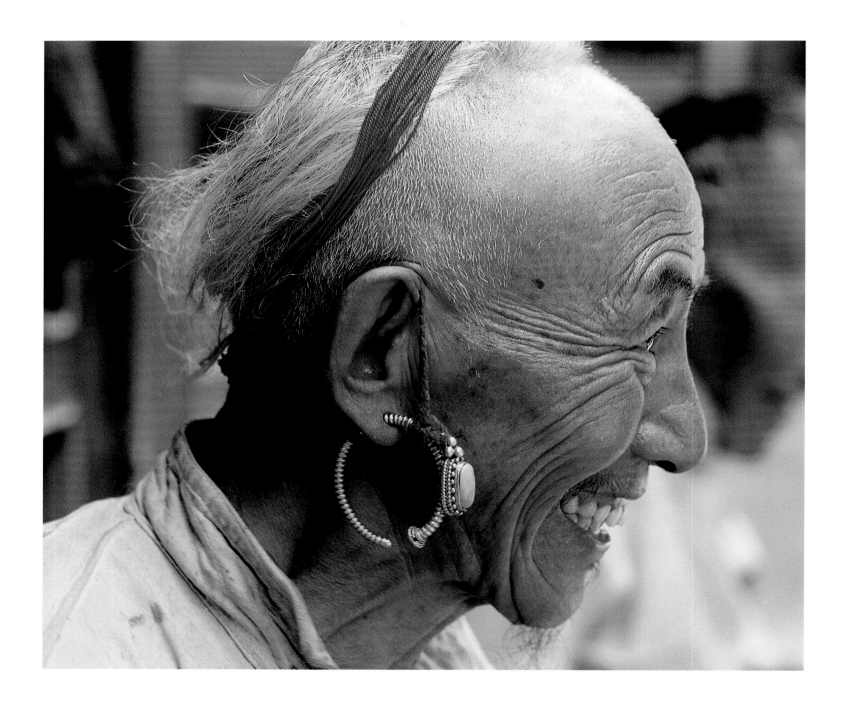

Symbols of Status

Above: Members of the nobility had the exclusive right to wear certain kinds of jewelry, such as the earring worn by this man from Lhasa.

Opposite: On feast days, this woman from Gyangzé wears an unusual headdress that used to be typical of women from the rural nobility in the southern province of Tsang. It consists of a wooden framework covered with red material and a semi-circular arch attached by means of two broad bands of glass and coral beads. It is decorated with turquoise and amber.

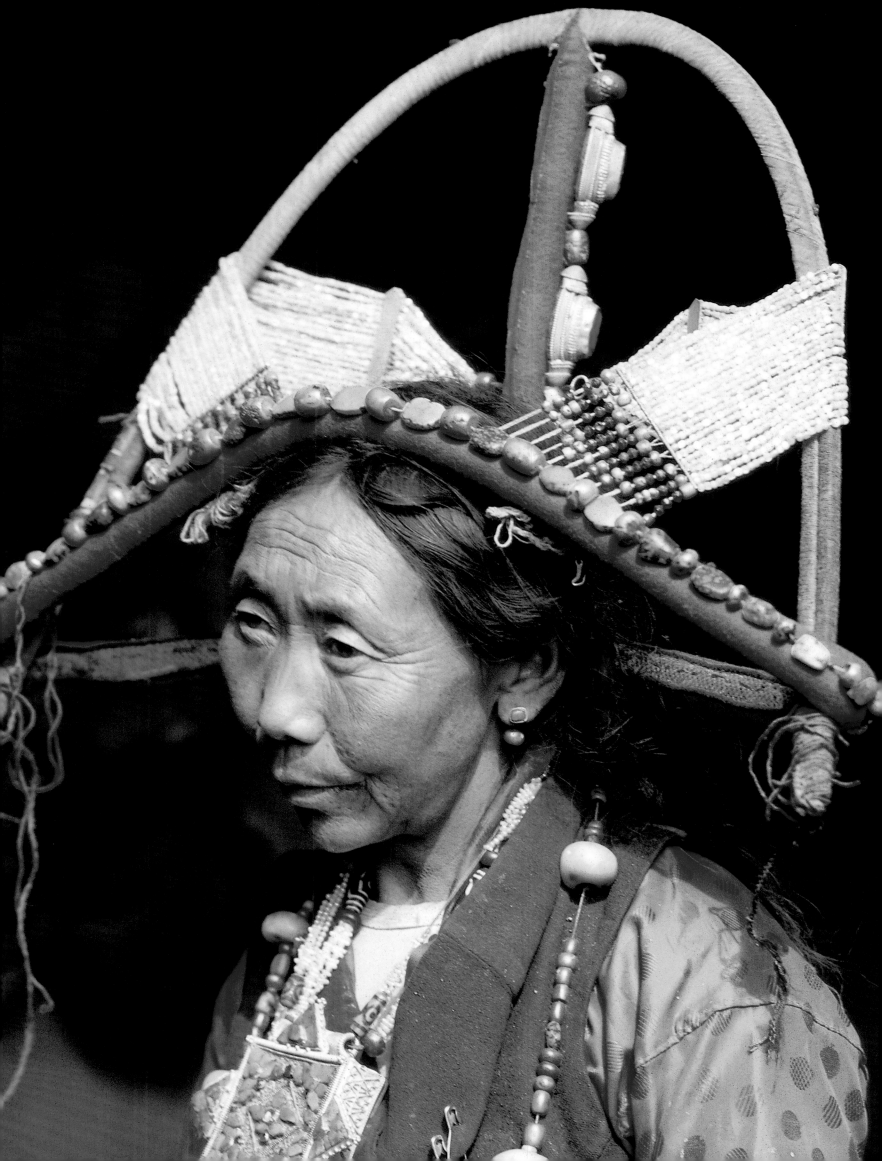

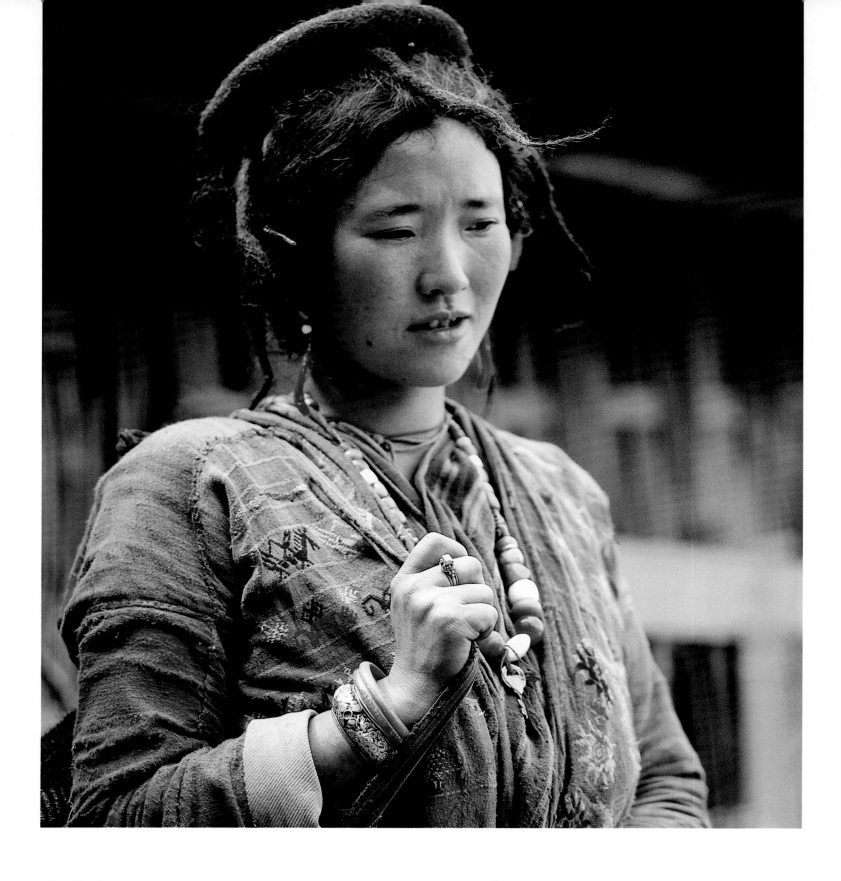

The Brokpa

Among the Brokpa, both men and women wear felt caps made from yak hair (above and opposite), with five tassels that help to channel the rain away from the face, an important feature in this wet and stormy area. Jewelry, however, is almost only worn by the women and consists of heavy silver and turquoises.

For the Brokpa, marriage is not a sacred institution, but is a commercial transaction. Polyandry is quite common, with a number of brothers sharing a wife and living with her in the same household. Polygyny, with a number of sisters being married to one man, is also accepted, but is usually practised only in families with daughters but no sons. The main reason for polyandry is to prevent the division of family property.

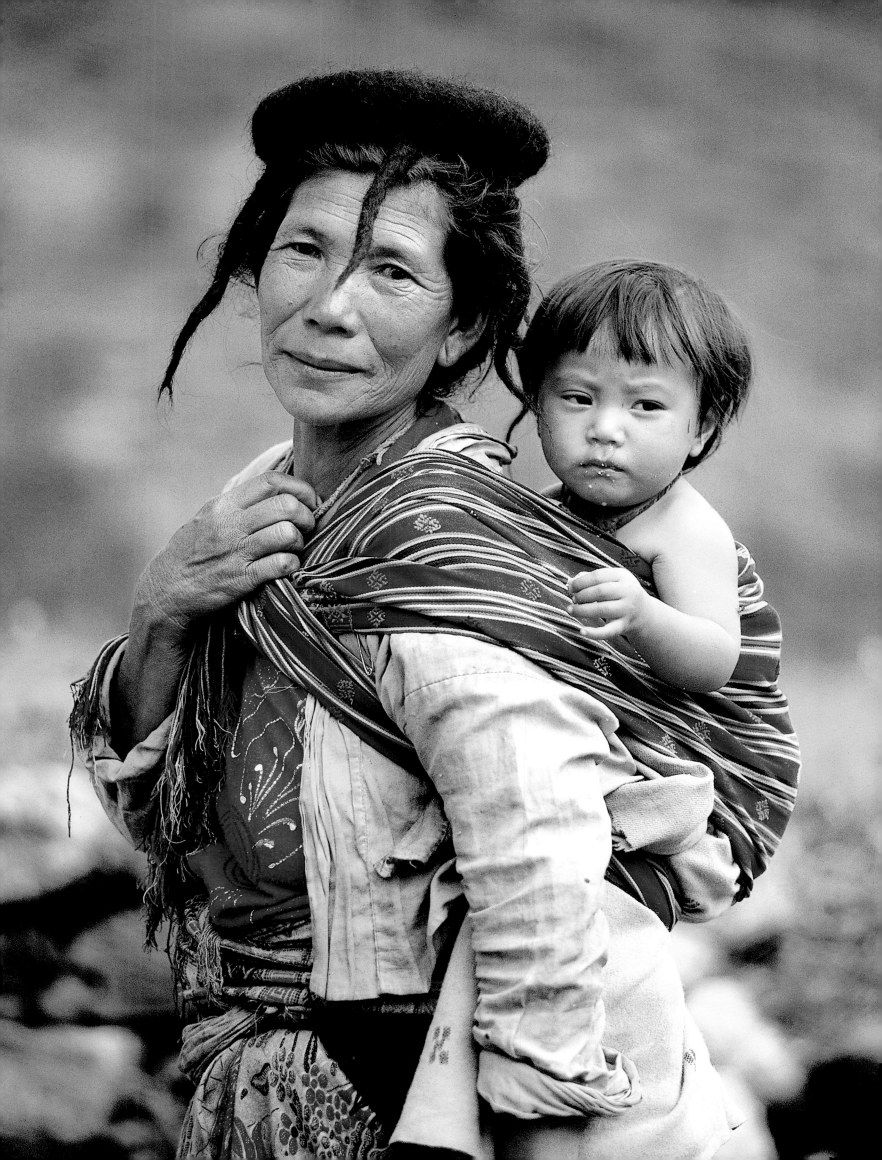

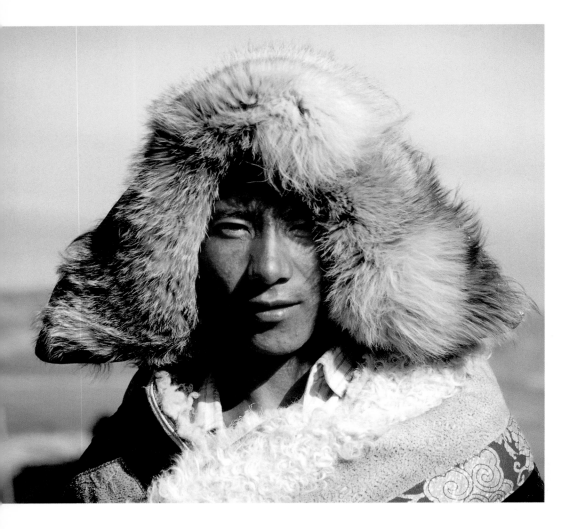

Golok Nomads

The inhospitable high mountain climate, with temperatures as low as minus 40 °C in the winter months, has always played an important role in determining the character of the spiritual and mythological world of the Golok nomads (above and right). Tibetans see their gods and demons as being active in the mighty forces of nature. This is why they do not believe in setting foot or hands on the mountains, for which they have at the same time great fear and profound respect.

The Golok's feeling for life derives from primal experiences that bond them closely to the mountains and their unpredictability. Everything that happens in their world, the world of the high plateaux, is fused in the consciousness of man into a mysterious and ineluctable unity.

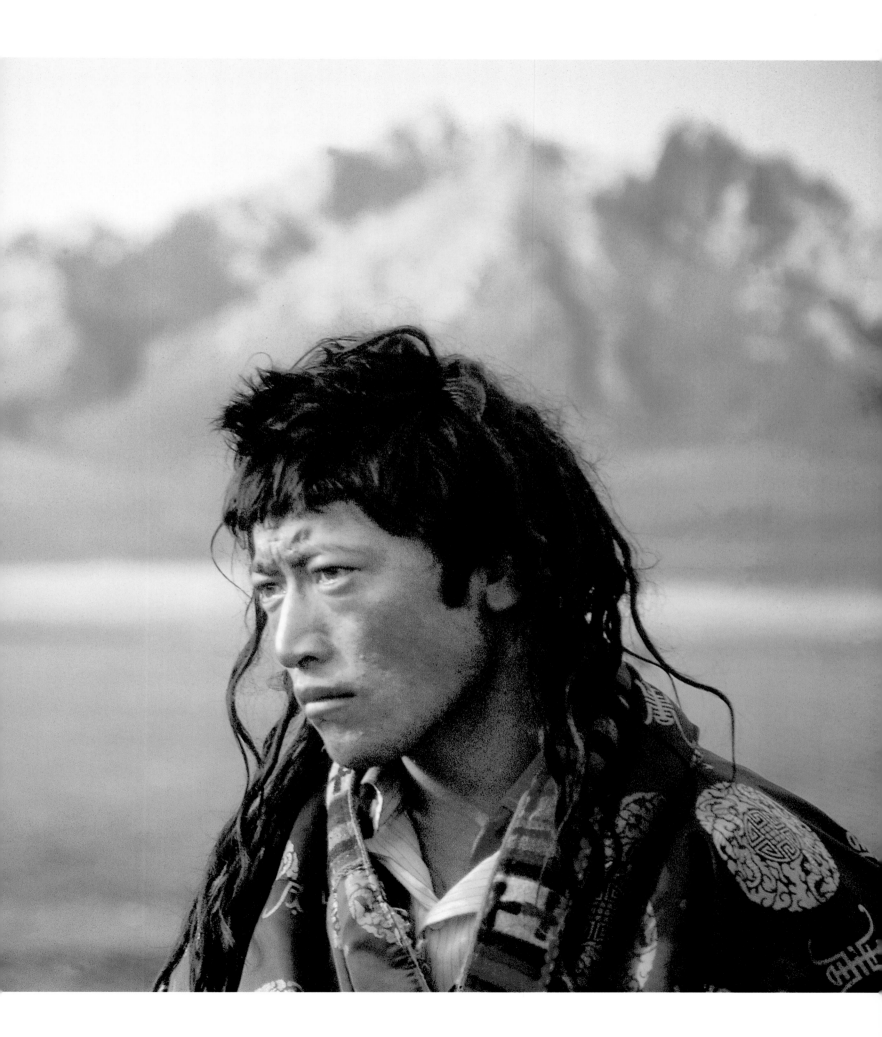

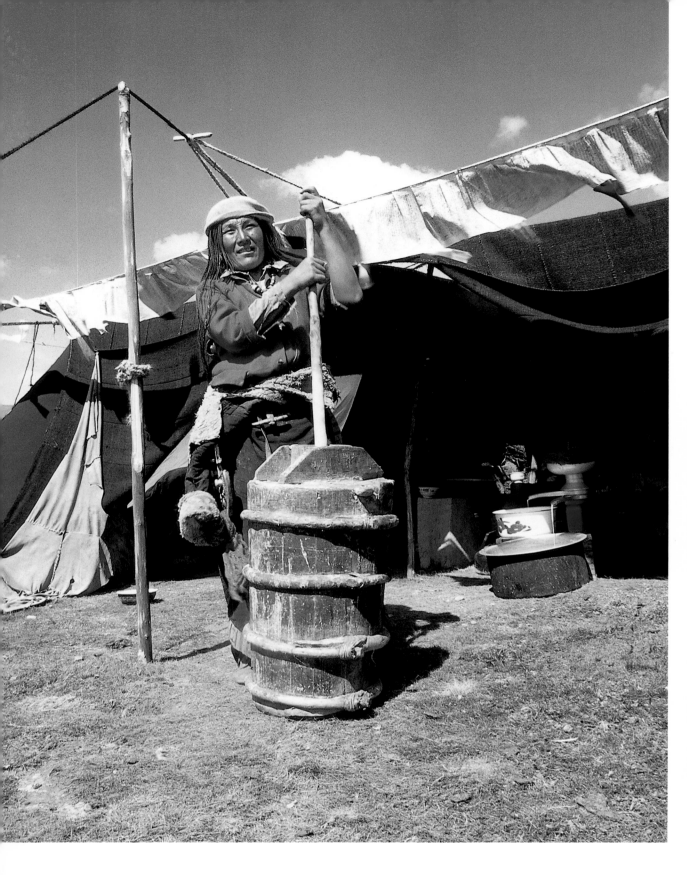

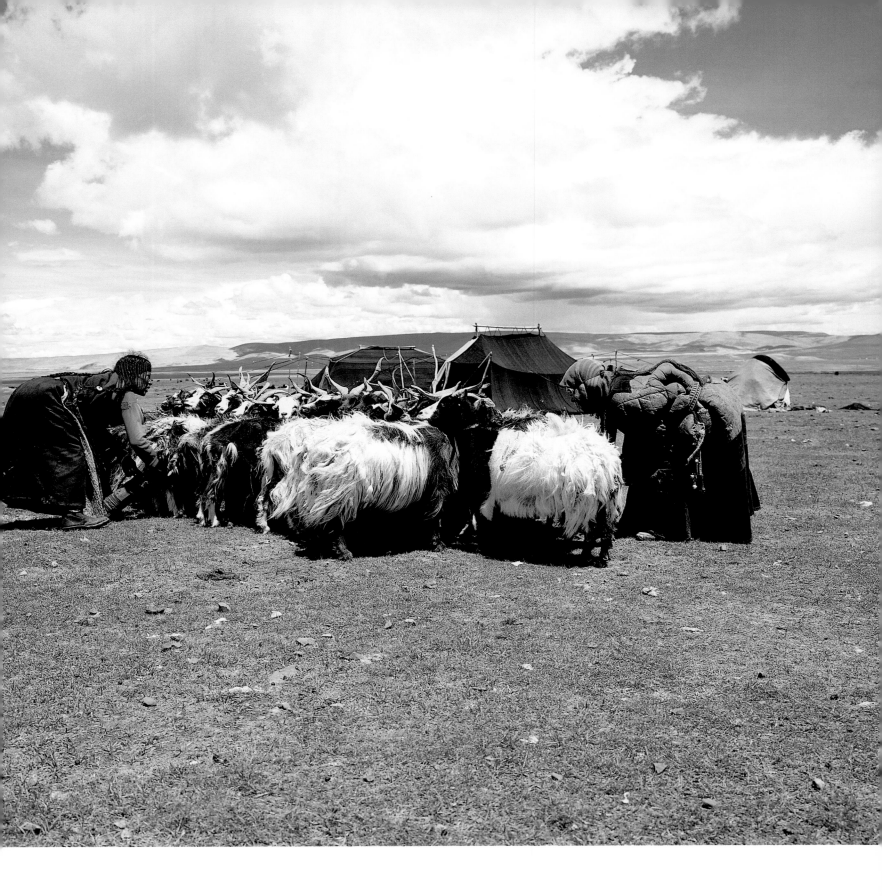

Everyday Survival

Opposite: Boiled milk is being beaten into butter in a wooden barrel. Butter is consumed almost exclusively in the form of butter tea, mixed with black tea and salt.

Above: At the daily milking time, goats are bound together head to head. This is done to prevent them from moving around and to make life easier for the nomad woman who is milking them.

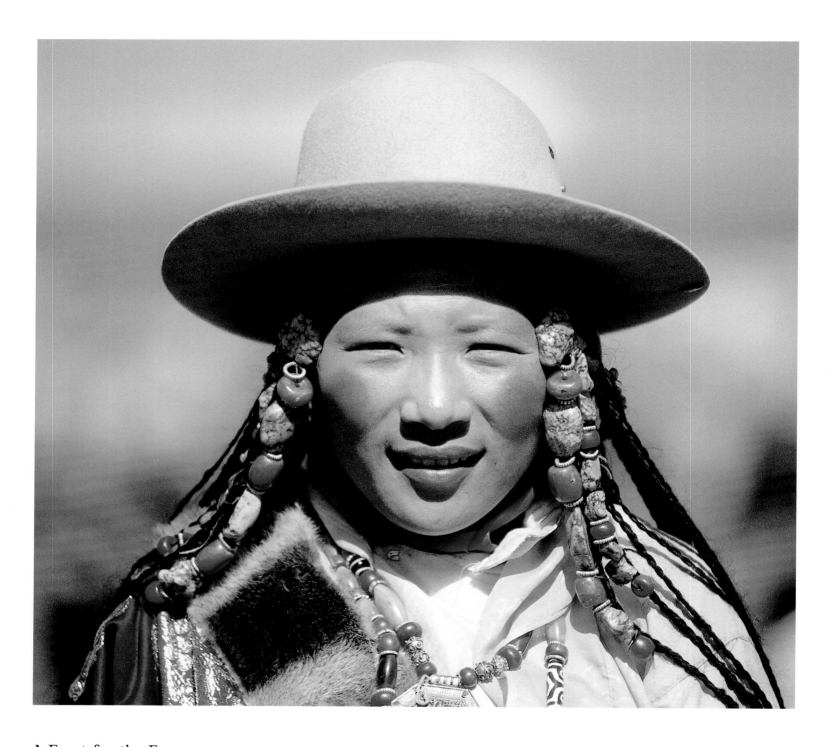

A Feast for the Eyes

Above: A lavishly adorned nomad woman from central Tibet with valuable corals and turquoises and the highly valued *gzi* stones, which are not only attractive but also magical and protective in function.

Opposite: This Golok woman from the steppe region south of Lake Kokonor is wearing a magnificent Tibetan mantle decorated with turquoises, coral beads, and silver bowls of various sizes.

Young women of the Golok braid their hair into 108 plaits, a figure with mystical significance for Tibetan Buddhists. Their plaits are lengthened by adding strands of black yak wool and then sewn on to a broad band that is decorated with turquoises and coral.

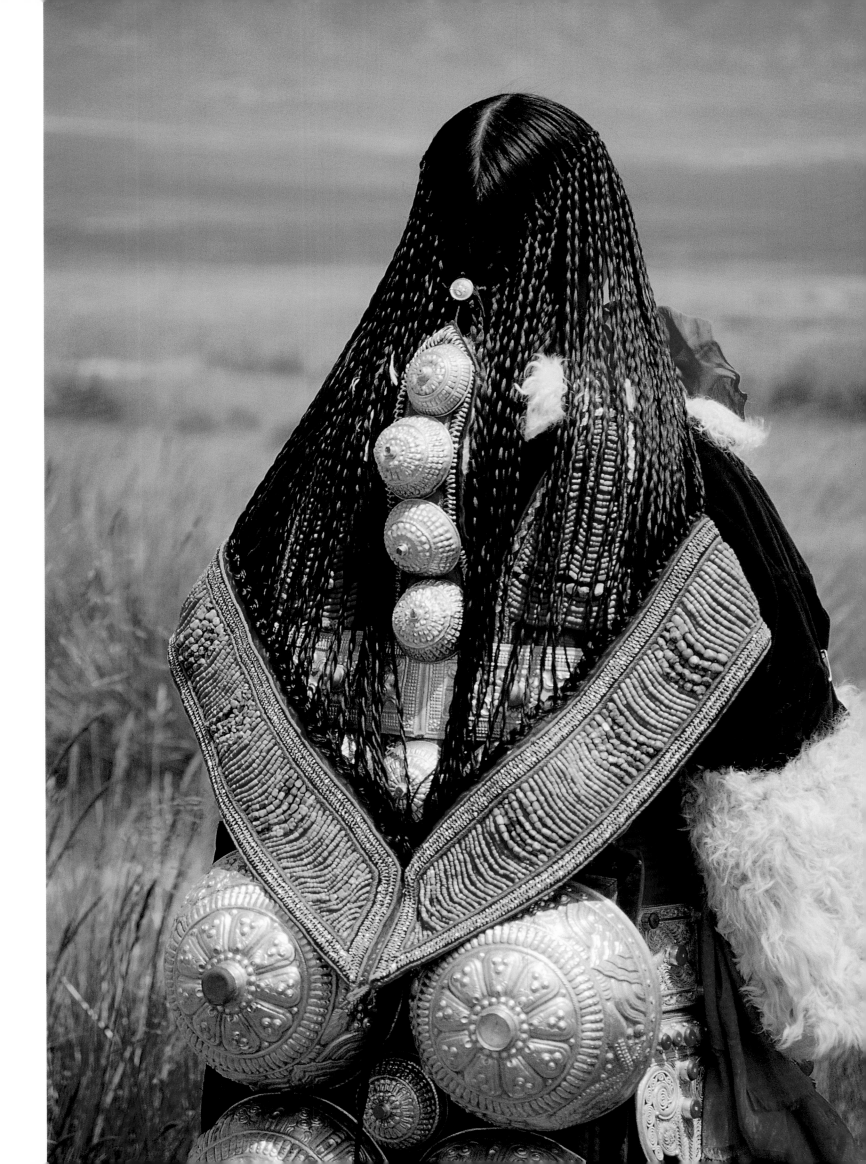

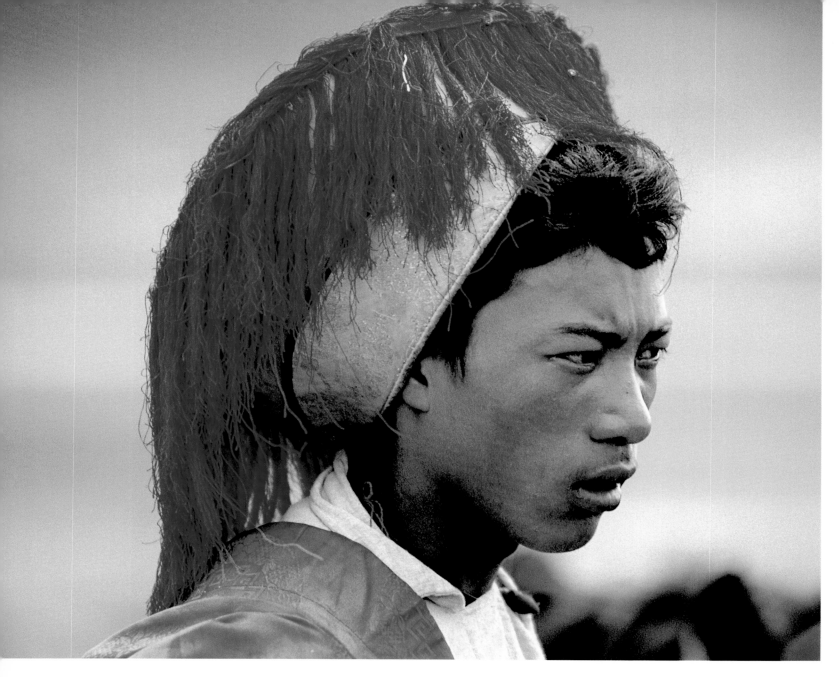

Tasselled Headdresses

Above and opposite: Changtang nomads with red headdresses that are only worn at weddings. The nomads usually braid their hair and adorn it with all sorts of decorations.

Left: Turquoises and red coral, symbolizing longevity and fire respectively, are an indispensable part of the jewelry of the Khampa women, as are silver bangles. A striking hat completes her festival costume.

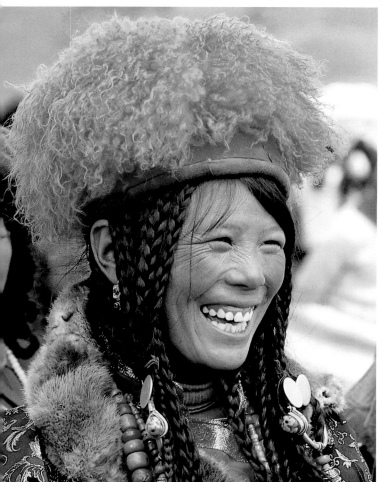

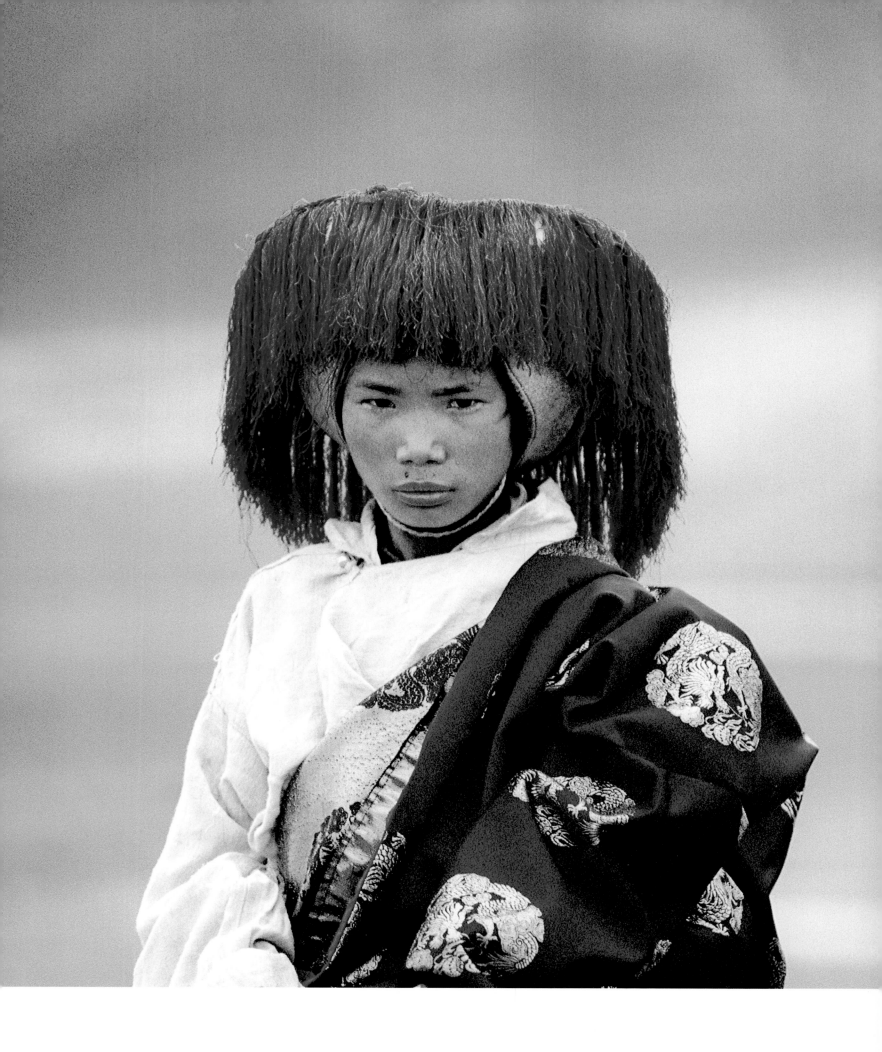

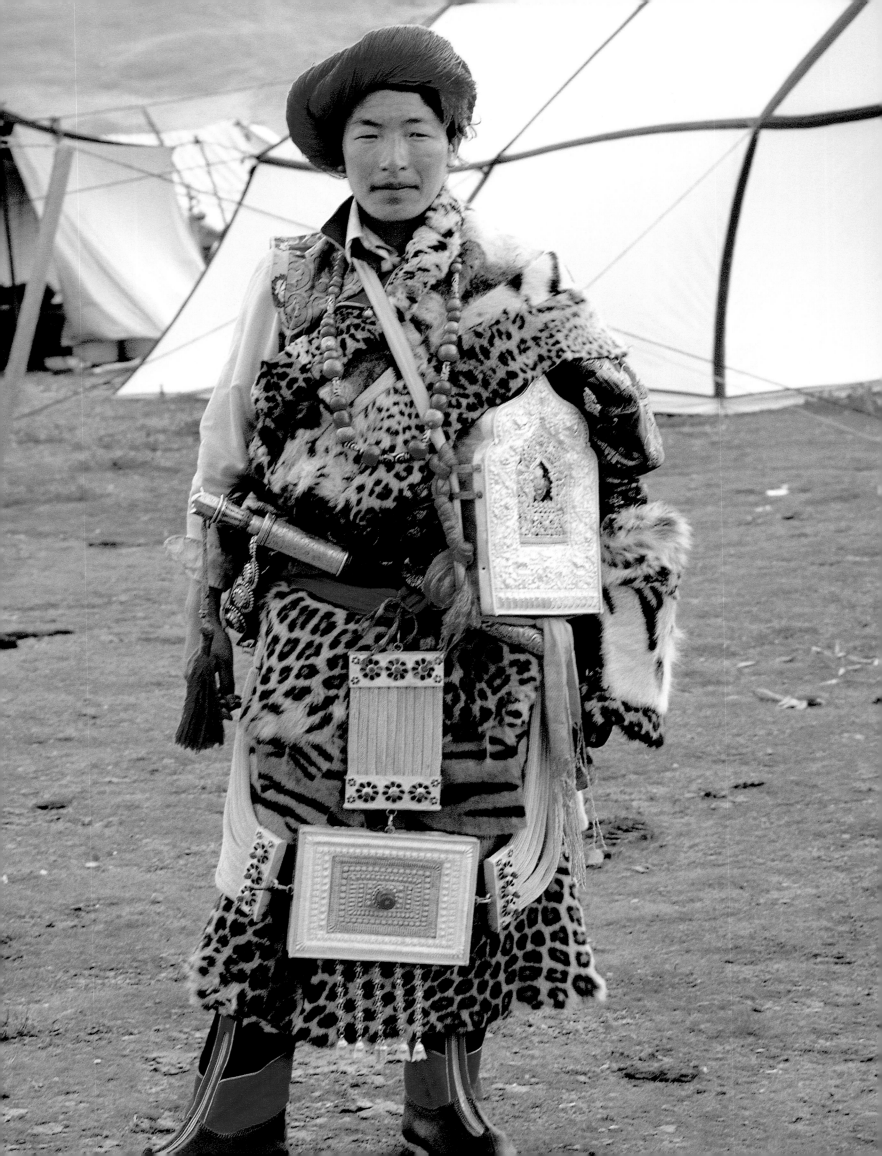

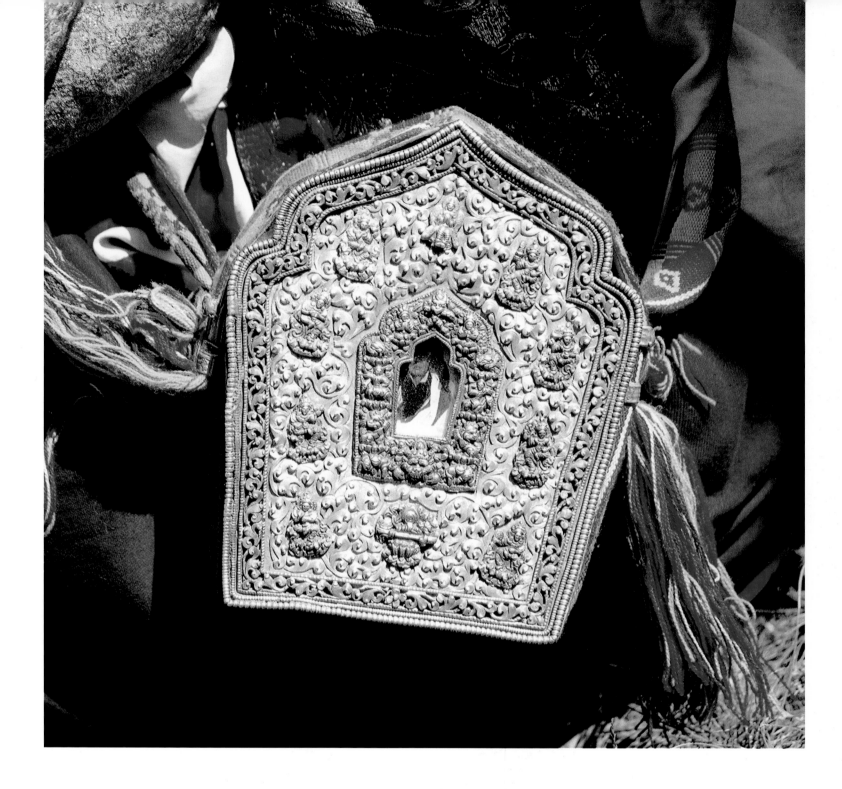

Altars and Amulets

Opposite: The external appearance of this Khampa man reflects his social status and personal wealth, which is based not only on the livestock he owns but also on the magnificence of his brocade garments and his mantle of snow-leopard skin.

Above: Particularly striking are the portable altars and amulet cases that are always worn on the body on long pilgrimages. Ritual acts are carried out to keep danger away and to turn the workings of supernatural forces to one's own advantage.

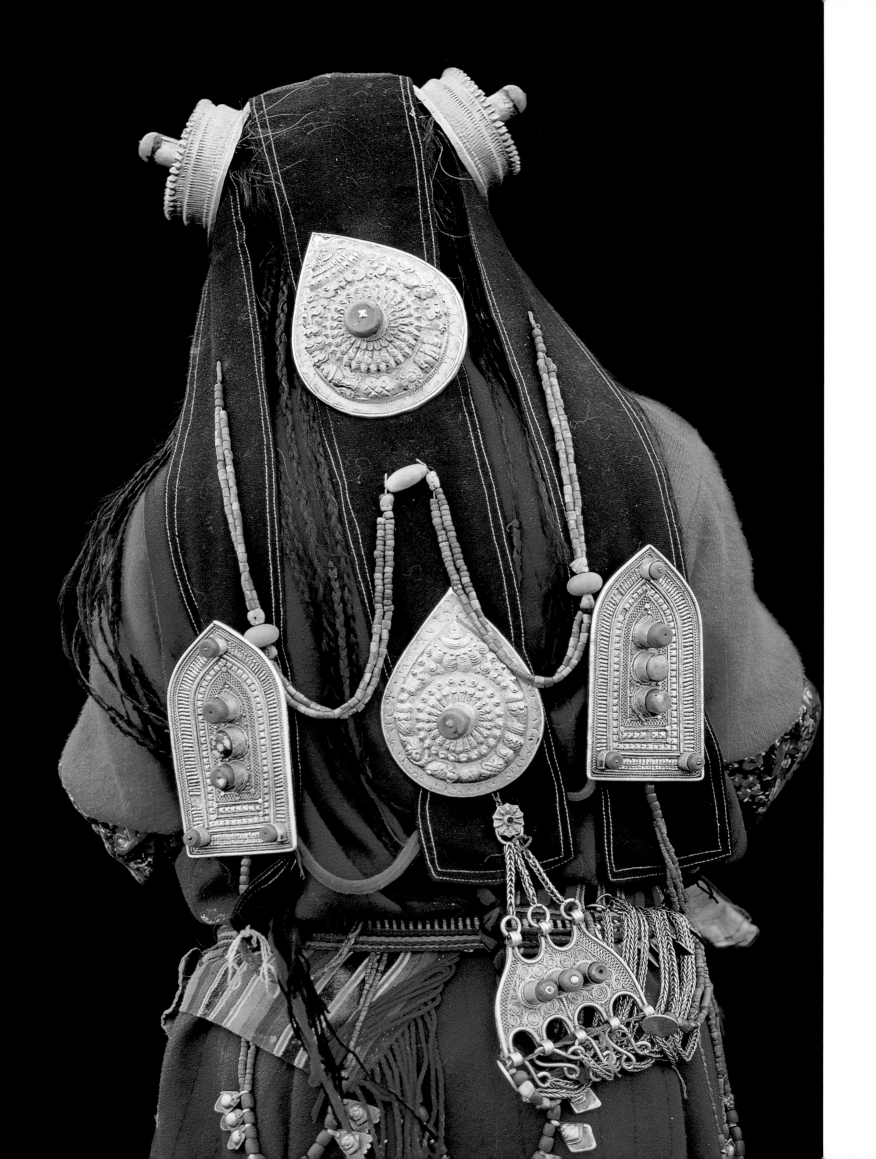

Protection from Evil

Protective symbols differ from region to region and also serve to differentiate between ethnic groups.

Opposite: A woman from Lithang wearing a collection of valuable silver amulets. These are her most precious possessions and she will only very rarely take them off.

Left and above: Feast days provide a fine opportunity for braiding the hair and adorning it with jewelry.

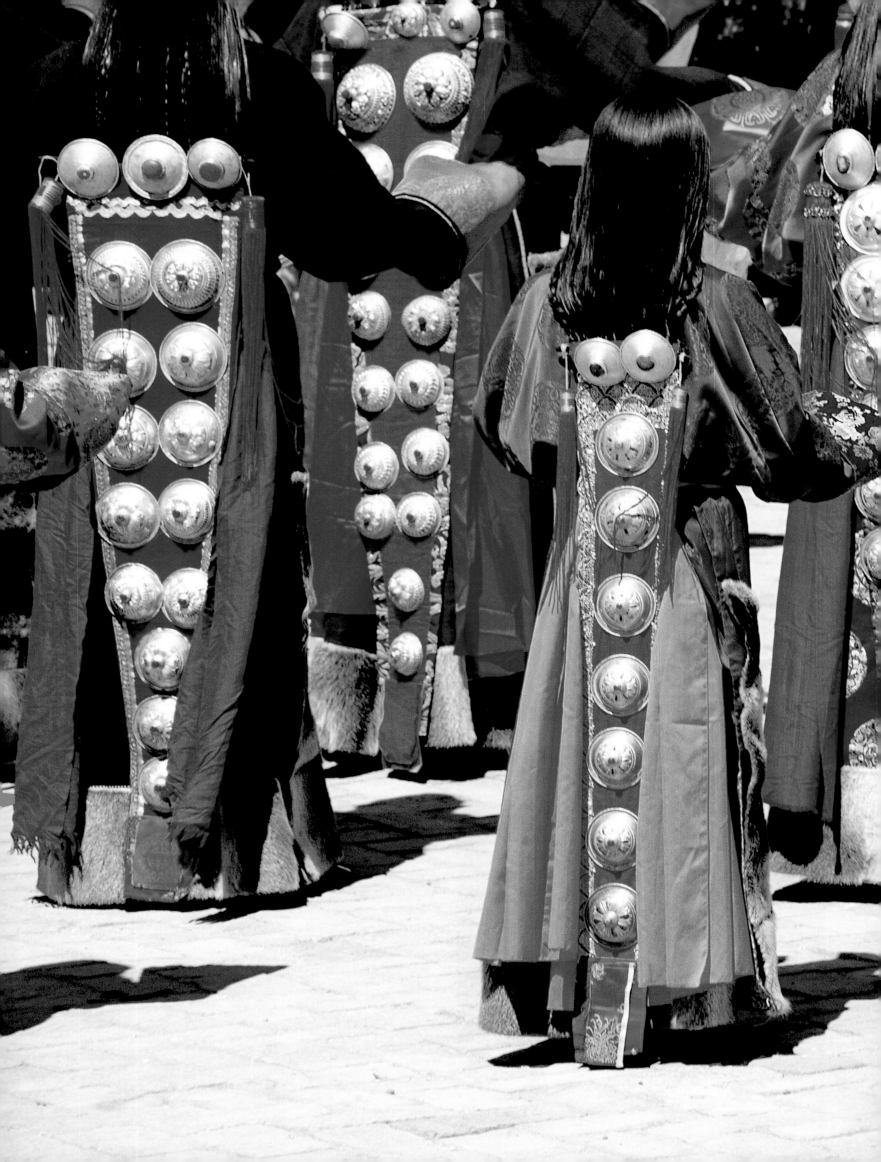

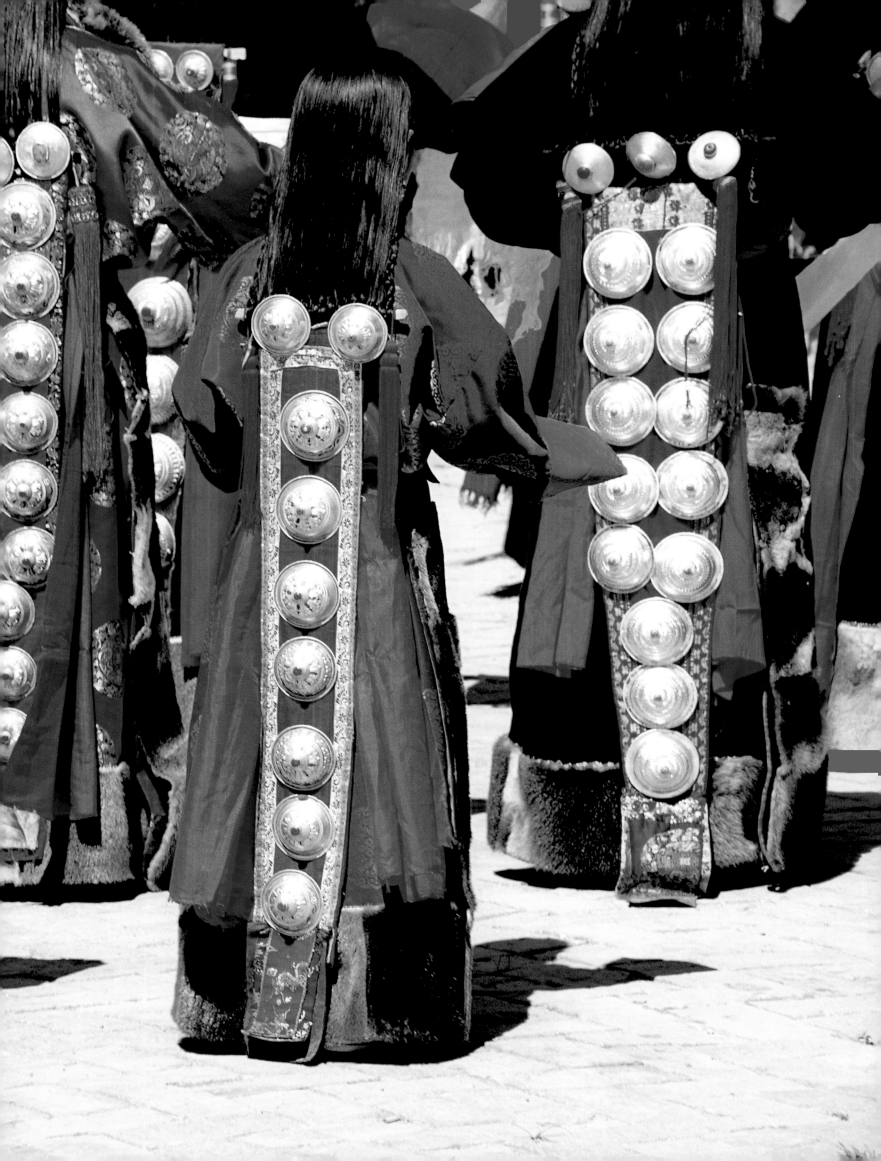

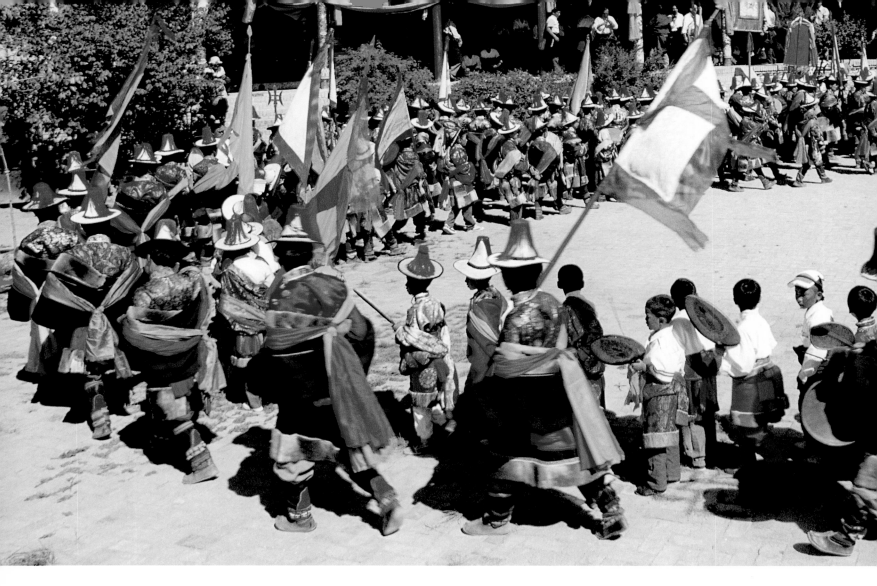

Celebrations of Life

Whether at *losar*, the Tibetan New Year, or at a *tsechu*, a monastery feast, or simply at a secular celebration, cultural identity is given full expression by the hundreds of dancers who participate in the ceremonial festivities, lasting for days at a time.

Previous pages:
The solemn ceremonial dances of the women of Amdo are reminiscent of the mystery plays of the ancient religions.

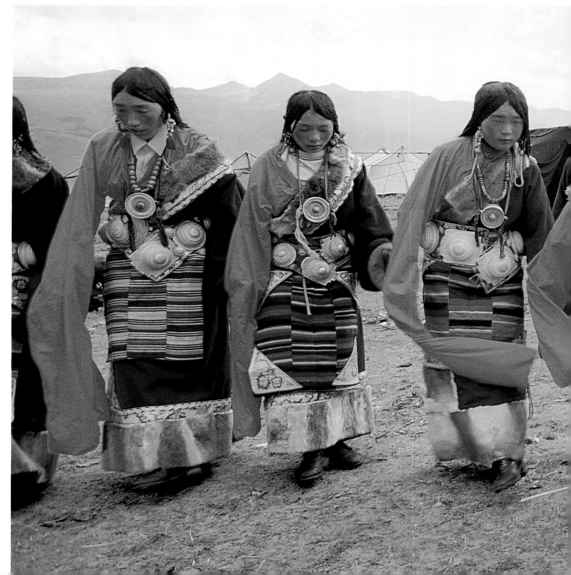

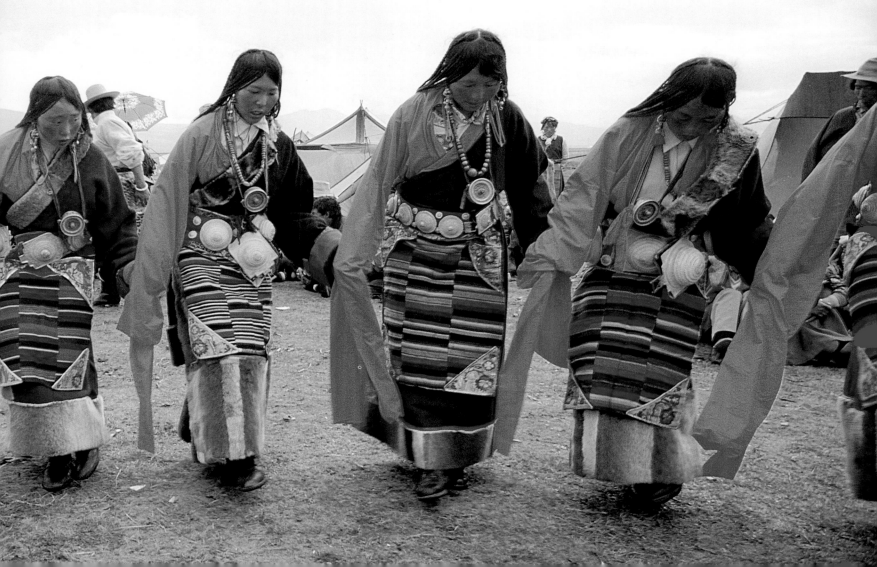

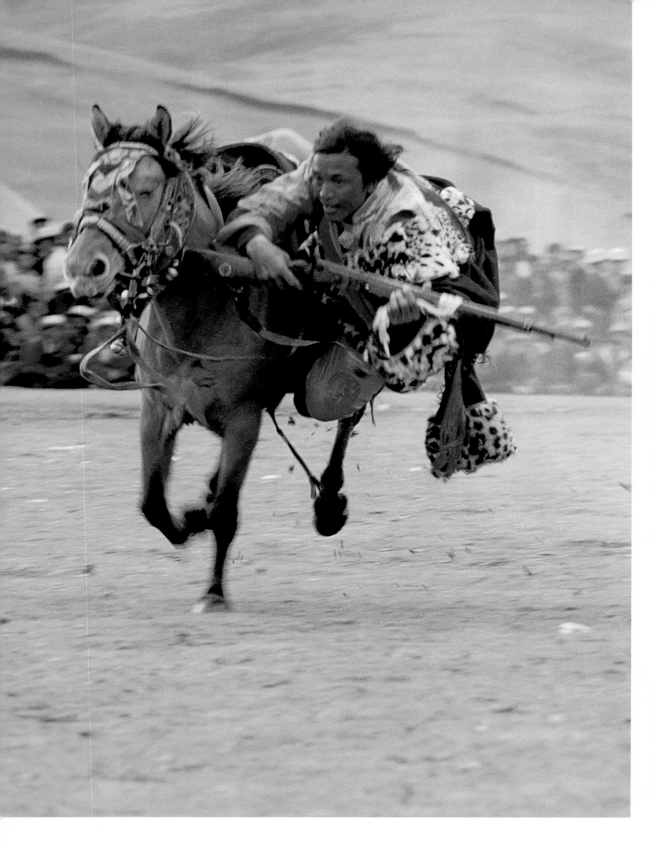

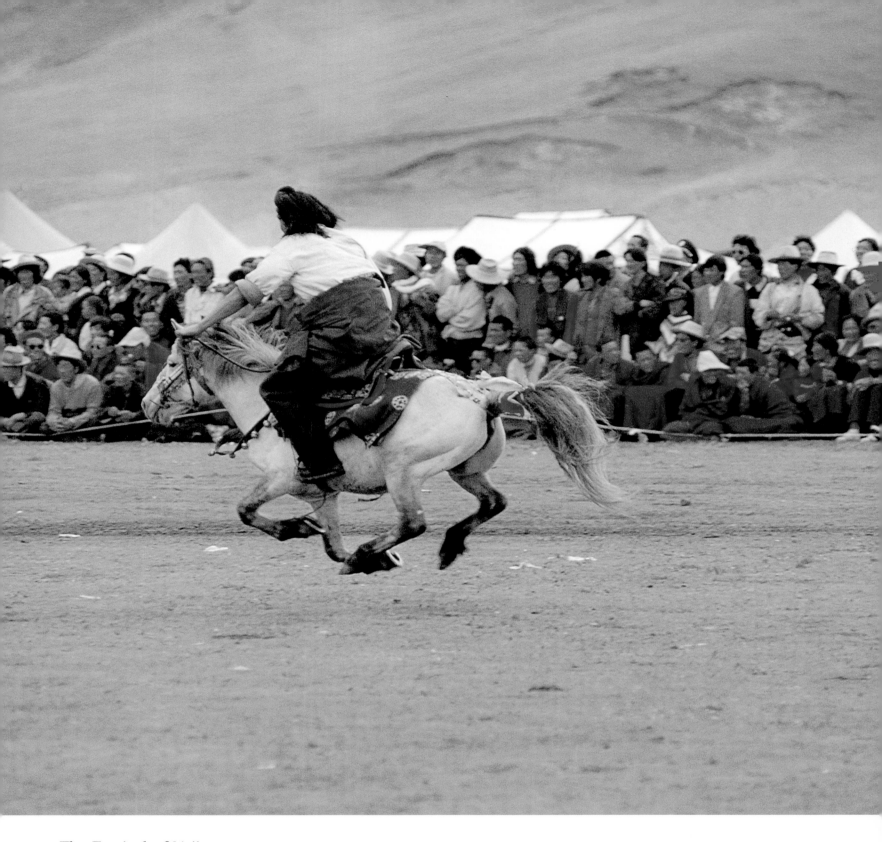

The Festival of Yaji

The dates for the summer festival known as *Yaji* are set by the Khampa nomads according to the lunar calendar and the festivities normally last from one to two weeks. A popular feature are the riding tournaments in which daredevil riders pit their skills against one another in a variety of contests. Hordes of armed Khampa riders gallop past thousands of onlookers, firing loaded rifles. It seems that they have lost none of the consciousness of their ancient identity as free, unfettered

nomads, and that they only require the slightest opportunity to give it free rein. The whole procedure is clearly as enjoyable for the horses as it is for their riders, and there is no end to their determination to impress their fellow competitors and the attendant throng. Snorting proudly, the horses raise their heads high as they thunder past the jubilant crowds. At the time of *Yaji* it seems as if the ancient vision of unconquered warriors has become a reality once again.

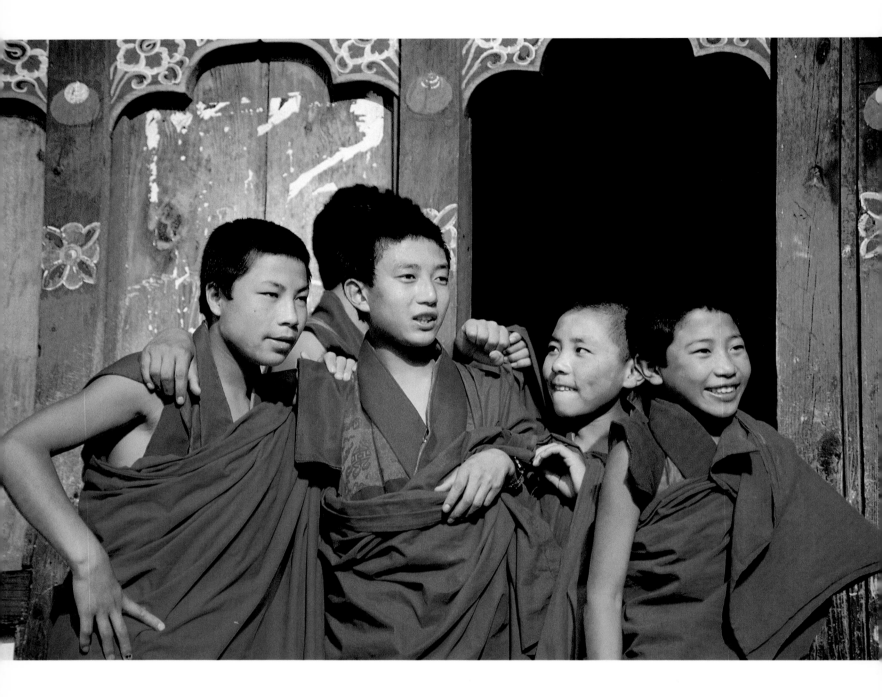

Monastery Life

Above: Novices from the Punakha Monastery in Bhutan.
Monks often enter the monastery as small children. It is
usually the second son who embarks upon the religious life,
often for financial reasons – many families cannot afford to
give all their children a decent wedding.

Opposite: The prerequisite for achieving the highest goal
of Buddhism – enlightenment – is a life rooted in prayer,
meditation and manual labour. The habit worn by this monk
from the Dranang Monastery is a sign that he has turned his
back on the delights of the world.

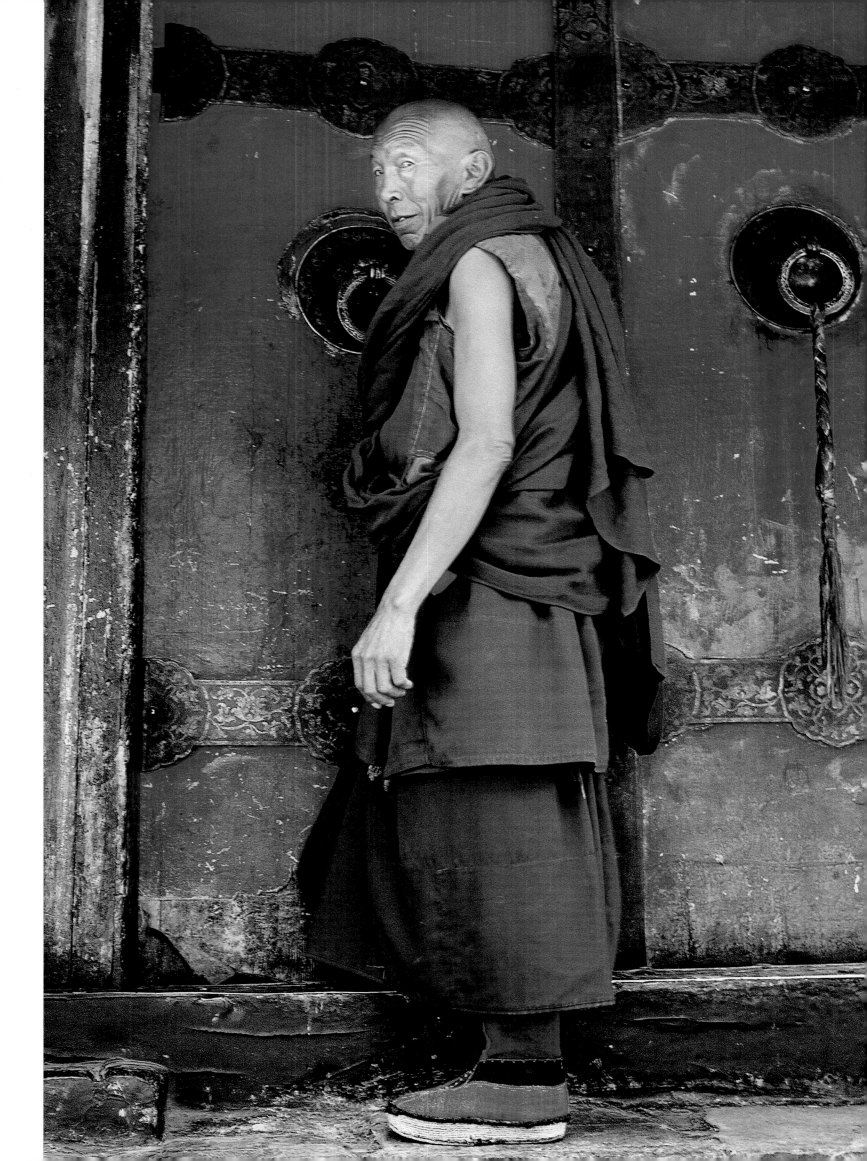

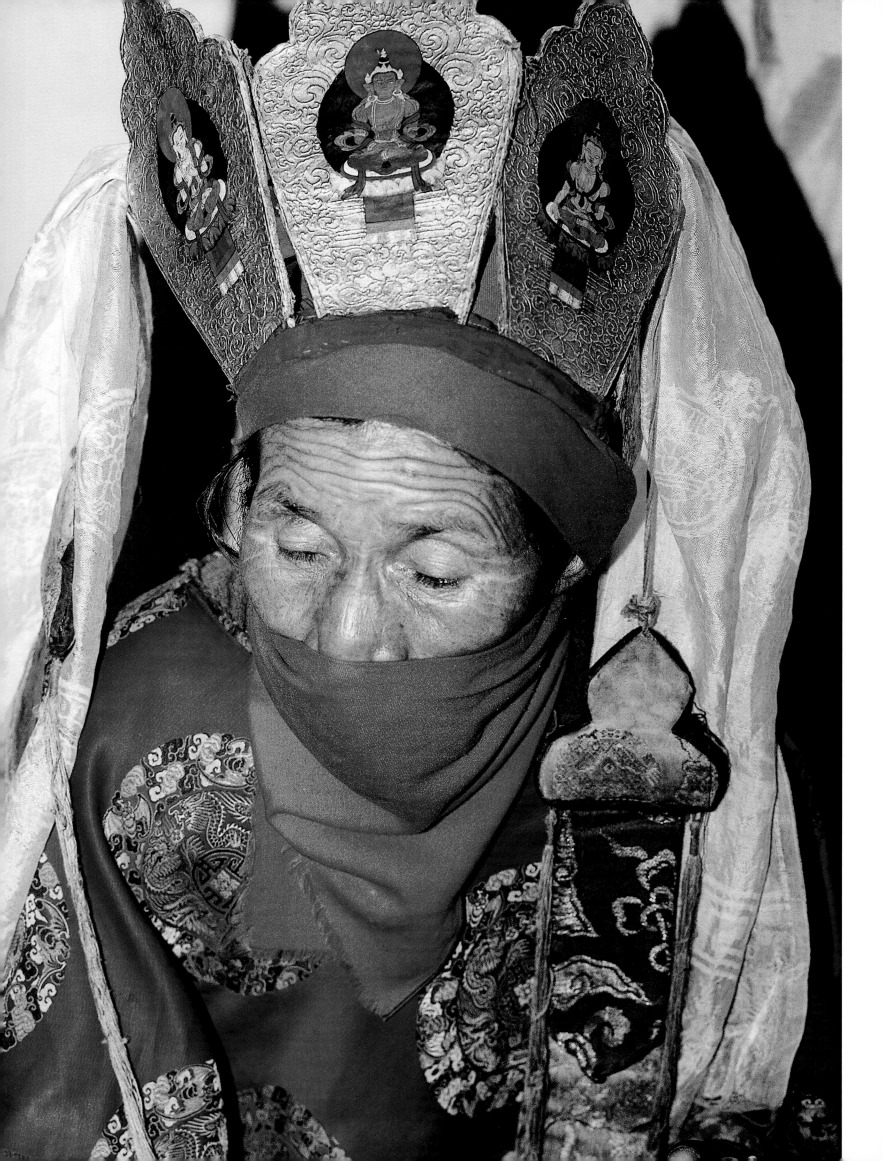

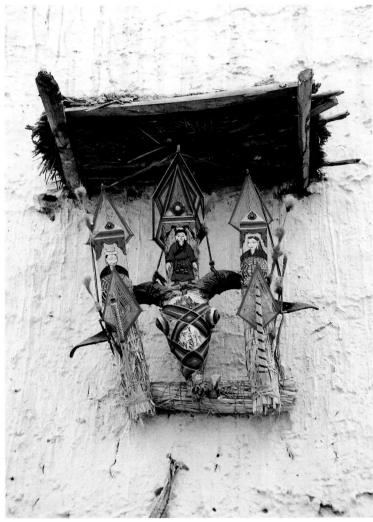

Oracles and Magic

Opposite: Sonam Zangmo is considered a woman of great wisdom and lives a few kilometres outside Leh, the capital of Ladakh. She is a priestess of the oracle and known for her ability to contact spirits that help her to heal the sick. She wears ceremonial garments and a crown with five leaves, and her ritual accoutrements include skull-drums and thunderstones. When she is in a trance she is believed to suck illness, which is considered to be a material substance, out of the body of the sick person.

Above: Thread crosses with animal skulls to ward off evil spirits over the fortified gate of the Stock Palace in Ladakh. The finely woven cross of threads forms a trap that is intended to catch demons so that they can be banished.

Butter Lamps in Gyangzé Monastery

Pilgrims fill the butter lamps with homemade butter. The simplicity
of the light emphasizes the goal they are pursuing, namely
concentration upon the essential things in life. The rituals of
lamp cleaning and prayer are performed several times a day.

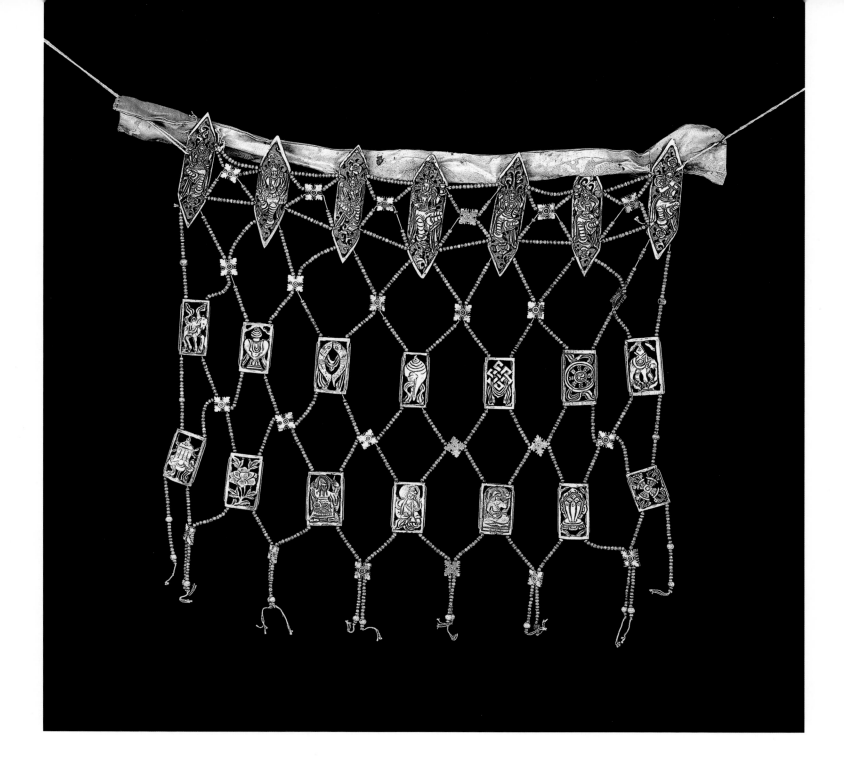

The Tibetan Bone-Cult

Tibetan devotional objects are often carved from human bones, preferably those of high-ranking lamas. This traditional practice reminds the faithful of the transience of human life. Human bones or fragments of bones are collected at the places where bodies are cremated or dismembered, and then worked into decorative objects. The bone-cult, which plays an important role in many ceremonies of Tibetan Tantrism, probably has its origins in the shamanistic practices of the pre-Buddhist Bön religion.

Above: This 'apron' of finely carved human bones is a striking example of its kind and is just one element in a costume of several parts, all made out of human bones. The filigree work forms a net that covers the whole body, not only the waist area but also the forehead, arms and feet. Each element, as well as bearing wheel symbols and depictions of deities, is made up of a specific number of bone beads. The costume is worn by magicians to drive away evil spirits at important ceremonies.

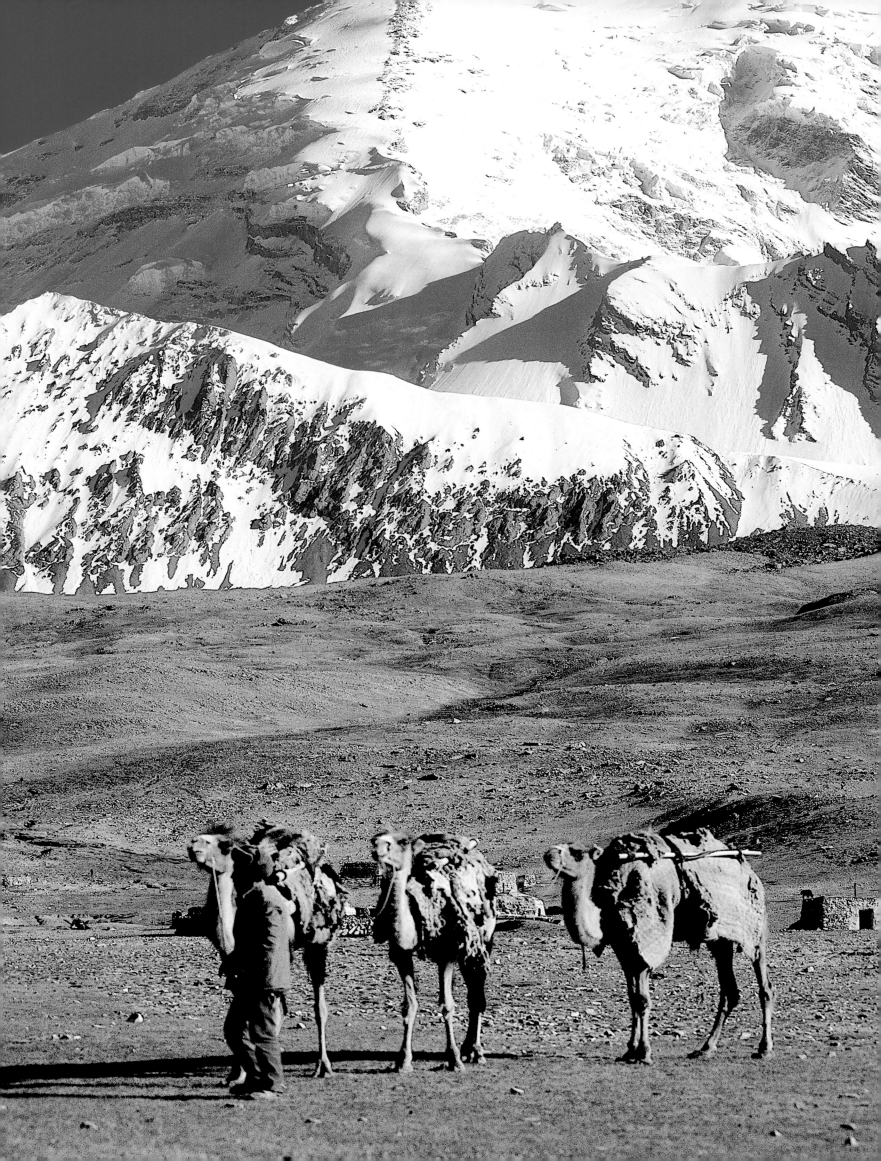

'It was as if I stood on the border of that immeasurable space in which mysterious worlds circle from eternity to eternity. Only one step divided me from the stars, and under my feet I felt the earth turning on its axis and rolling through the night of the universe.'

Sven Anders Hedin (Central Asian explorer, 1865–1952)

Chapter 6
Central Asia
Nomads and Shamans

The nomads of Central Asia have been living in steppes, deserts and high mountain areas for thousands of years now, regions reckoned among the most desolate in the whole world. But they have learnt the art of living there, adapting their ways to the natural world around them and engaging in a day-to-day struggle to wring their daily existence from this unpromising environment. They only survive because their whole life is characterized by the habit of limiting themselves to what is absolutely necessary. Faced with the choice between independence and simplicity of life and the riches that they might be able to enjoy if they gave up their traditional lifestyle, they choose the former.

The cultural, religious and political landscape of Central Asia is just as varied as its geographical landscapes. Although the predominant religion in Central Asia is Islam, the region's proximity to the Silk Road and many major migrations have meant that its tribes have felt the influence of all the world religions.

Among the current population of about 2.5 million Kyrgyz, the few families who have remained loyal to the old traditions live as semi-nomads on the broad high plateaux situated around the mountain massif of Muztagh Ata. The outward appearance of the Kyrgyz who live here is marked by some Mongol features – they are tall of stature and dark in complexion, their narrow eyes are dark in colour and they have prominent cheekbones. Their changing fortunes over the course of history have brought about equally frequent changes in their clothing. A flat embroidered skull-cap, the *tjubeteika*, is worn directly upon the hair of the head. On top of the *tjubeteika* the Kyrgyz wear a felt cap, lined with black velvet and with an upturned rim. The women always wear a brightly coloured headscarf.

The Kyrgyz have been Muslims since the seventeenth century. The Muslim leaders were very well aware of how to integrate the new religion with the ancient rites of ancestor worship, the belief in spirits of the home and of nature, and the shamanic practices of healing the sick and telling the future. The proximity of the Silk Road and the consequent contact with other cultures meant that there were always alternative religious beliefs around with which one might equally well feel comfortable. This was the case whether the religious practices were orientated towards the worship of the forces of nature to which the local population were exposed, or whether the people of the region set their sights on making contact with the gods beyond the visible world by practising sacrificial and ceremonial rites. All the world reli-

Camel caravan at the foot of Muztagh Ata.

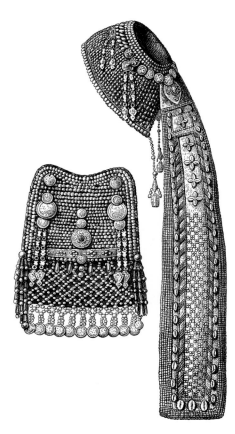

A Bashkir woman's chestpiece and bonnet.

gions have made their mark in Central Asia and all have changed its countries and its people at a fundamental level.

In summer, the Kyrgyz live in the highland pastures in yurts, known as *akoi*. The yurts of several families are pitched in a large circle, creating a small village-like community. The family plays an important role in this system. It primarily provides protection and care in the case of illness or old age, but it also offers help and support when economic catastrophe hits. Time-honoured customs and moral values are cultivated and handed down within the family.

If their somewhat uneventful lives are interrupted by some kind of exceptional event, the whole of local society is affected. It is, for instance, an old tradition that everyone from the near vicinity is invited to take part in celebrating the circumcision of a young boy. The liberalization that began in the early 1990s, putting an end to State-regulated atheism, has meant that an increasing number of boys take part in this ritual event. Weddings and births are among the many other events to which all friends and neighbours from near and far are invited.

At all celebrations, music is made on the *komuz*, a slender three-stringed lute-like instrument with a long fingerboard. In addition to the *komuz*, all the other string instruments that are common in the Islamic culture of Central Asia may also be used, as well as flutes and particularly drums, such as the *nagora* and the *doira*. All these instruments are used to play a non-notated folk music. Strictly speaking, no one simply listens to it, since all present are actively involved, singing along, clapping rhythmically or dancing.

A wedding is initiated by one of the fathers of the bride or groom, and after it has taken place, the father's new daughter-in-law moves in with her in-laws and falls under their protection. Married sons and their children remain in the household of their parents, or put up their yurts next to that of their parents. Highest respect is paid to the father. He is the representative of the family in all dealings with the outside world and is also responsible for any business matters. The mother has the say in the yurt and in domestic matters.

The most important animal in the cultural history of the Central Asian peoples is the horse, and its significance cannot be overestimated. This is particularly true for the Mongols, for whom the horse is still a fundamental part of life, a symbol of status and a trusted friend. The small, stocky and tenacious horses are so dear to the hearts of the Mongols that it has always been customary to mention the two in one breath. Mongolian horses are at the most 1.4 metres high and 1.5 metres long, while the average weight of a well-nourished stallion is around 350 kilograms.

In this context, man and animal form a unit that is quite unparalleled anywhere else in the world. Small children sit on horseback before they can even walk. Mongols commonly laugh about the fact that they are much more familiar with the names of the grandparents, great-grandparents and even the more distant ancestors of their horses, and the great deeds that they did, than they are with those of their own human forebears.

No Mongolian nomads are happy going on foot, and the Dzakchin people least of all. There are always horses beside the traditional Mongol dwelling-place, the felt yurt, tied to a rope stretched between two pegs or poles. One of them will always be saddled, meaning that a horse is always at hand to speed off to the herds in case of an emergency. All the other horses are left to graze unsupervised until one day they are chosen for duty. Riding horses are changed over

every one or two weeks. As a result of the sparse vegetation, the animals who have to spend their time tied up by the yurt find that they have little to eat and soon lose their strength. Changing the horses is considered a pleasant task that brings a little variety into the daily round. Usually it is the young men who ride out, equipped with the *urga*, a long pole with a loop of rope at the end, in order to choose horses for duty who are well-rested and strong.

Mongolia has about two million people – and about two and a half million horses – living in an area of 1,560,000 km^2, making it one of the most thinly populated areas in the world. It is therefore no surprise that life without horses is quite unthinkable in the endless expanses of this country. Being able to rely upon one's horse is a matter of life or death.

Among all the nomads of Mongolia it is customary to cook only once a day, preferably in the evening. In the morning and in the course of the day they drink milk tea, supplemented with dairy products and leftovers from the evening before. It is quite normal to dunk cold pieces of meat or even cold cheese into the tea.

The mares are only milked in the summer and their milk is made into the popular drink *kumiss*. Kumiss contains about three per cent alcohol; that is to say, it is only slightly alcoholic, and Mongols claim it is very healthy. It is produced by putting the mare's milk into a large leather sack in which dregs are left to stimulate fermentation; it is beaten regularly to make it foam until fermentation is complete. It is drunk frequently and in great quantities right through the summer months.

A considerably stronger drink is a type of schnapps made from sour milk or yoghurt and known as *archi*. Its preparation involves the milk being heated in a simple evaporation vessel, the steam being condensed off and run into a pot, which is heated up before the process of distillation is repeated. The more the process is repeated, the stronger the resulting drink; an extremely high-proof beverage, its strength should not be underestimated.

In many respects, the lifestyle of the Dörbed nomads is similar to that of the Dzakchin. They both live in yurts and are both bound by tradition to five breeds of animal; although they change their dwelling place regularly, they are constantly exposed to extremes of weather and landscape in surroundings with neither trees nor bushes. The rules that govern their lives are also similar. These were set down in the times of the great Mongolian rulers and although they have been subject to some change in the course of time they remain essentially the same for all the nomads of Mongolia. They govern birth and the education of children, marriages and death and also extend to strict rules concerning family behaviour, clothing, food and eating habits.

Like all nomads, the Dörbed are masters of the art of adapting themselves to the prevailing circumstances, choosing their animals, for instance, in accordance with their eating habits, so that one animal will not fight for another's fodder. This is why the size of the herd will vary according to the type of animal and the external circumstances. Sheep can graze where cattle are incapable of finding enough food and goats, who are the least demanding of the animals, can be put out in places where none of the other animals would venture to set foot.

The Dörbed live at the foot of the Altai Mountains at heights of up to 3,000 metres, surrounded by snow-clad mountains, and also on the extremities of the Gobi Desert. It may be several kilometres to the nearest source of water and they

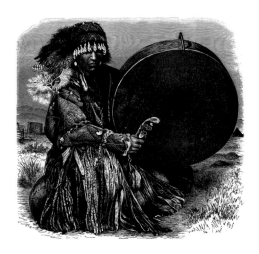

Shaman with drum.

have to migrate about twenty times a year. There are around 600,000 Bactrian camels in Mongolia, giving the country the third largest camel population in the world. These two-humped beasts have a mild disposition that makes moving on from place to place a relatively easy affair, which is a very important factor under the circumstances.

Whenever the opportunity presents itself, both the Dörbed and the Dzakchin are happy to show that they are true Mongol nomads by eating and drinking to their heart's content. *Kumiss* and *archi* flow generously whenever a visitor arrives, and in huge quantities when there is something to celebrate. But in general, the restricted range of food on offer makes it unavoidable that their diets are relatively simple and even rather monotonous. Traditionally, food in summer consists mainly of dairy products, known as 'white food', and in winter mainly of meat. A few harvested wild plants may be added, especially some types of leek and mushrooms. Barley and wheat are also eaten, and flour is milled from these to make little pastries that may be eaten with a meat filling or simply baked in hot fat. When a feast day comes along, then the fare will include small cakes fried in butter.

Tea and dairy products are the basic elements in Mongolian hospitality; anyone who comes into a yurt is immediately served tea, which is usually either ready at hand or just being prepared. The tea is offered together with cheeses in various stages of ripeness. Tea is not only the most important drink but also the basic form of nourishment. The cup is proffered with the right hand while the left hand is held under the right elbow – a procedure that is to be observed whenever it is served.

Many of these rules stem from the thirteenth century, the period in which the peoples of Mongolia first came into contact with Buddhism and developed Lamaism, the Tibetan form of Buddhism in which the lama acts as a mediator. Lamaism spread more widely in the sixteenth century and the predominantly animistic world view gave way to the belief that mankind is at the mercy of a range of natural forces. The elements that were considered to be the seat of these powers were, first and foremost, fire, earth and water, and certain rites had to be followed when dealing with these elements. Shamans acted as mediators between the here-and-now and the other world. One reason why Lamaism spread so vigorously was because it could be integrated with a faith in the old gods and with the practices associated with those beliefs. Those who live in such awe-inspiring surroundings as the Dörbed understand why it is necessary to respect the rules of nature, and these have always provided – and will continue to provide – the Mongol people with a sense of security and stability.

Traditionally, the Tsaatan are nomads in the fullest sense of the word, deriving their living from reindeer herds, and belong to the Tuva, a Turkic people. They are very few in number, and it is now thought that the last true Tuva total only around eighty men, women and children. The rest number about 130,000; they live in Russia in the Minority Republic of Tuva, and have given up the nomadic way of life entirely.

The Tsaatan live at a height of 2,500 to 3,000 metres above sea level in the transitional area between the impassable mountain world of the tundra and the taiga (coniferous forest) zone; that is to say, in a region of the earth that is among the least favourable to human life. The Mongols gave the Tsaatan their present name, which means 'those who have reindeer', but their own name for them-

Bronze Age rock image in northern Mongolia. The places where this type of rock art is to be found were chosen for the performance of certain rituals, and are ancient places of sacrifice.

selves is *sojon-uriangchaj*. As nomadic herdsmen they are the preservers of an ancient tradition that goes back as far as the Bronze Age. They view the universe is a living community or organism, in which all beings both visible and invisible are harmoniously and reciprocally related.

The Tsaatan have the knowledge required to survive in these conditions, living with a high level of ecological awareness and optimally adapted to their natural environment. Their reindeer provide the basis of their livelihood and are at the same time their only capital, providing milk, cheese, meat, leather and bones. The Tsaatan live almost exclusively on dairy products, berries and meat. In spite of this somewhat restricted diet, they survive perfectly well, a living refutation of the theories of the modern world on nutritional matters. They live on what nature supplies to them. The reindeer are able to seek out the best pastures on their own and provide their masters with milk, from which they make yoghurt and cheese. This state of affairs is another example of a symbiosis between man and animal. As well as serving as beasts of burden, the animals can also be ridden.

Winter in this part of the world is characterized by snowstorms and temperatures as low as minus 45 °C, and the Tsaatan children spend it wrapped in furs around the fire. At this time of year there is very little room for them to play, and they do not recover their freedom until the spring. The children represent the Tsaatan's only hope of preserving their traditions, and so parents are generous with the time they devote to their offspring, playing every evening with toys such as building blocks or dominos made from animal bones. As in the case of many steppe peoples, it is taken for granted that the old people will be looked after by their children. In a yurt community, elderly parents live together with at least one of their sons. Sometimes their herd of reindeer is only just enough for them to survive on.

The Tsaatan move their camp once every twenty days. It is only just before the cold winter months that they move to more sheltered, lower-lying places at the foot of the mountains or in narrow mountain valleys, and then they will remain for up to three months in one place. Only by so doing are they able to maintain numbers in their herds, for the animals have difficulty coping with the extreme temperatures and the general lack of fodder in winter. The Tsaatan follow their herds in search of new feeding grounds and only stop when the herds have found the mosses and fungi that are their preferred food. The Tsaatan's only enemies are snow leopards and wolves, which must be constantly avoided. Each family clan has its own strictly demarcated territory, both for pitching camp and for hunting, so that conflict in this respect is precluded.

Stone stelae such as these are sometimes as much as four metres in height. The obelisk is always positioned with its face to the east.

Breaking camp and packing up personal possessions are procedures that are carried out with great care. The stove with its fire, so vital to life, is left standing until the time of departure, as tea must be drunk once again before departure. But the fire is significant for another more important reason. The spirits of the fire communicate the desires of the living – for health, for luck in the hunt, for protection of the herd – to the spirits of the dead, to the world beyond ours and to the gods in heaven. Fire is the element of purification and creates space in the mind for new knowledge and thoughts.

The head of the family keeps watch at night over the fire that gives both life and warmth. Roots, lichens and reindeer dung are used as fuel, all of which are collected daily by the women and children, hung out to dry and stored in front

Iron headdress belonging to a Mongol shaman.

of the tent. Contrary to what one might think, the dung does not smell and has a high energy content.

The material possessions of the Tsaatan are extremely modest. In accordance with their fully nomadic way of life, they only possess as much as is needed for survival – a tent, a stove, a few pots, fur blankets to sleep under and a gun for hunting. Anything else would be superfluous ballast, and would simply be a burden to have to carry around. They also have a personal preference for not occupying themselves with too many things at once. Materialism is not their world. They see no point in it – after all, at the end of the day everything has to be packed up and carried on the next camp. What more does one need to live, or – to be more precise – to survive? The future is uncertain and the present is a constant struggle to make the future possible.

The Tsaatan are served by shamans, who mediate between the here-and-now and the other world, between the forces of nature and the gods. The shamans play many roles in society: they are healers, controllers of the weather, fortune-tellers, astrologers, miracle-workers for the hunt and masters of ceremonies. Every shaman – man or woman – is assisted by personal guardian spirits from the other reality. When one of the members of a family group dies, the shaman accompanies the spirit of the dead person on its way into the next world. Eagles are thought of by the Tsaatan as the embodiment of deceased shamans. Spirits love what is beautiful and so shamans try to call up the spirits and make contact with them by means of song and by dressing in fine garments. In a state of trance, the shaman contacts his guardian spirits and the demons who cause illness; he finally captures them both in his drum, to appeal to the former for protection and help, and to render the latter harmless. He also requests help and protection on behalf of his fellow men, so that they may survive the winter unharmed and carry on their traditions, and also on behalf of the reindeer, that they may escape unharmed from the snow leopards and wolves. As Western medicine is still unknown in this remote area, the shaman also functions as a healer. If the Tsaatan show symptoms of any illness, the shaman tries to chase these out of the body of the sick person by means of songs and magic spells.

Both men and women may be called to be shamans and to pass on the vocation in their turn. The signs that they have a vocation consist in extraordinary physical markings and in modes of behaviour that mark them out as different. The Tsaatan even speak about a particular illness that shamans typically suffer from; it is often compared with epilepsy when spoken of by Western medical experts. The principal function of the shaman is to bring about harmony and balance between the physical soul and the spirit soul of the sick person. Healing first takes place on a spiritual level, and only after this has happened are therapeutic measures carried out on the patient. A patient's session with the shaman ends when a diagnosis is provided and a programme for healing given. Healing ceremonies can last hours or even days. The shaman does not stop until there has been some success. His tasks also include ensuring successful hunting and guaranteeing the welfare of the herd.

The Tsaatan's shamanist world view, in which nature and our environment are endowed with souls, is still alive and well. They use song as a special form of communication, not only with animals, but also with wind, thunder and rain, and with the spirits of nature. They have also developed an extraordinary ability to imitate animal cries.

Their animistic beliefs personify the powers of nature; the lakes, rivers and stars have souls just as humans and animals do, and these souls must be treated with respect. The Tsaatan see the sky as male, for it provides the earth with light and moisture, whereas the earth is believed to be female, because it endows all living beings with fertility and nourishment. Every day the Tsaatan make a milk sacrifice to the rising sun: milk tea is sprinkled in all the directions of the compass and the rest is thrown into the stove fire. This is a way of appealing to the spirits and the gods to make the day a successful one and to protect the families and their herds.

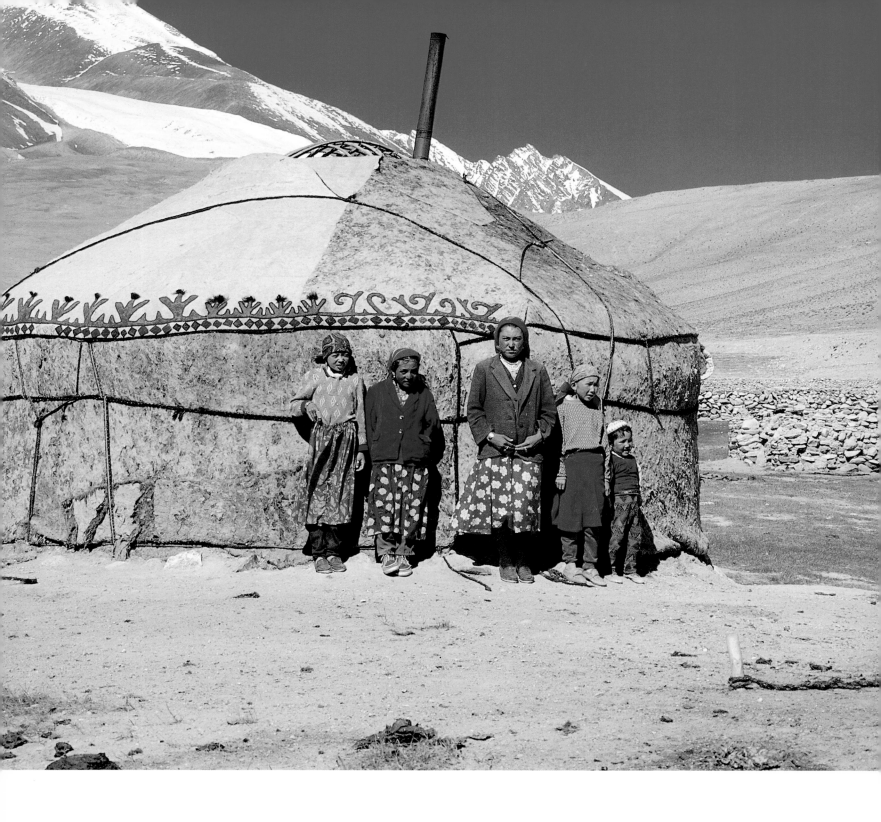

Among the Kyrgyz

In a yurt camp, helping one's neighbour is something that is taken for granted, whether it is a matter of lending a hand with the herds, of helping a family that has fallen on hard times, or of carrying out maintenance work on facilities used by the whole community. Normally it is the eldest man, the *alsakal* or 'white-bearded one', who coordinates these activities and it is to him that everyone turns in times of need. Kyrgyz nomads rarely turn down any request for help.

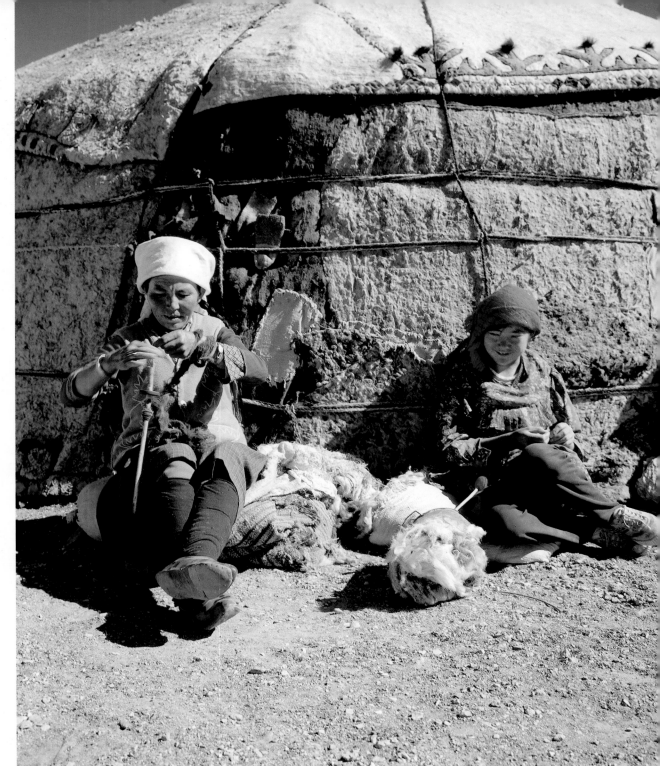

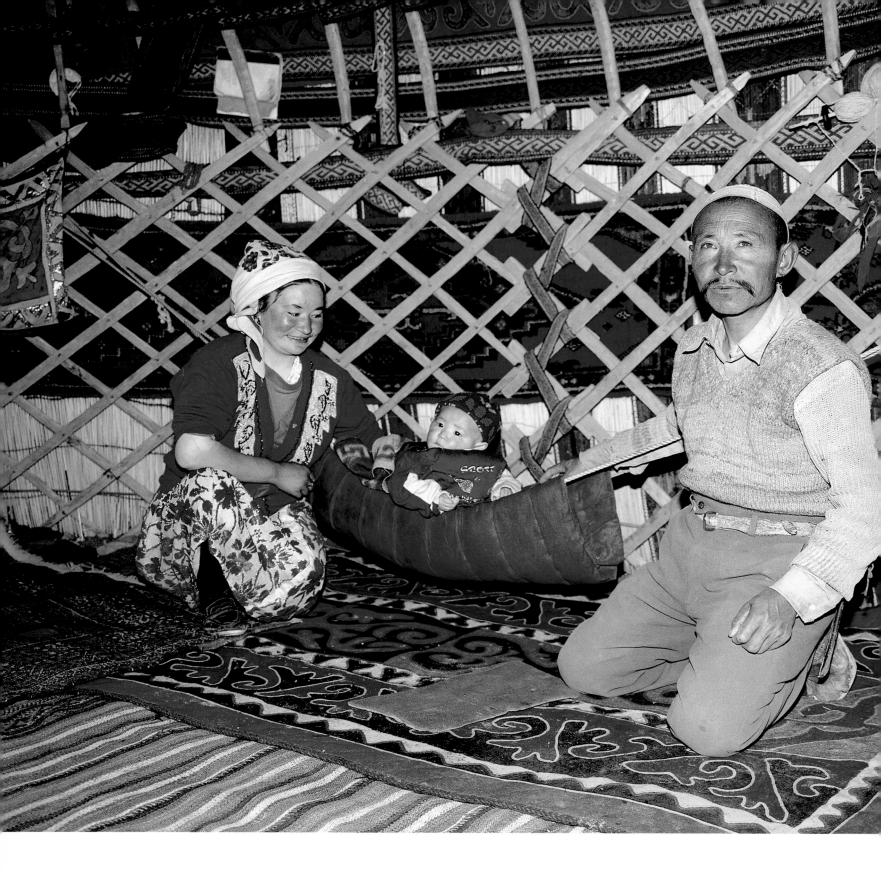

Extended Families

Although parents have on average two to four children, the extended family not only includes parents, children and grandparents, but also all other relatives who have no one to care for them. If children move away from home and acquire any money or a well-paid job, then as a matter of course they will make some of their wealth available for the family or community from which they come. All the adults help to erect the family yurt at each camp (above right and left).

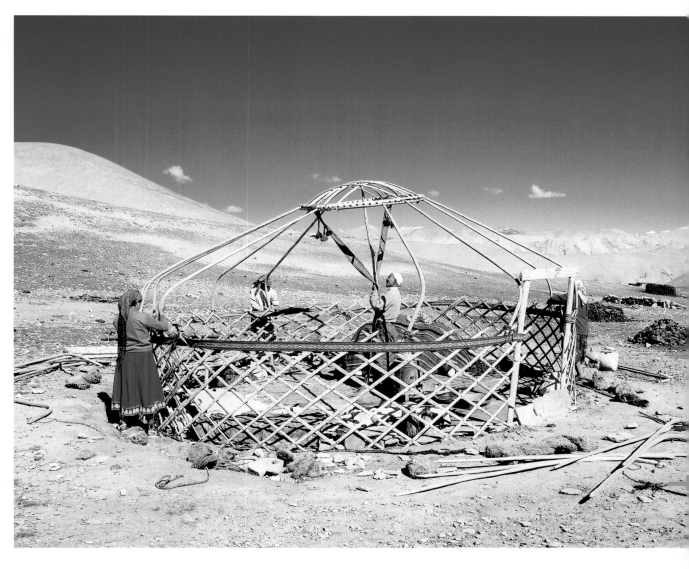

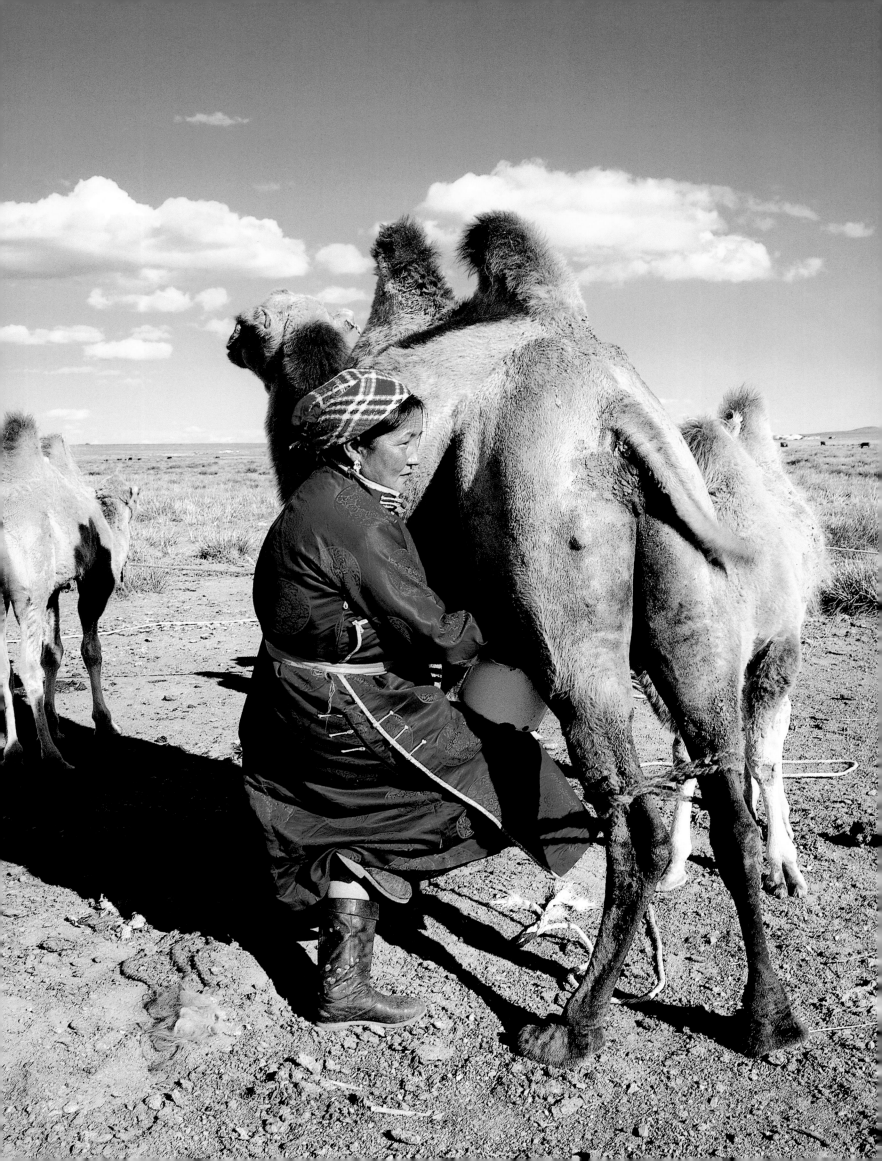

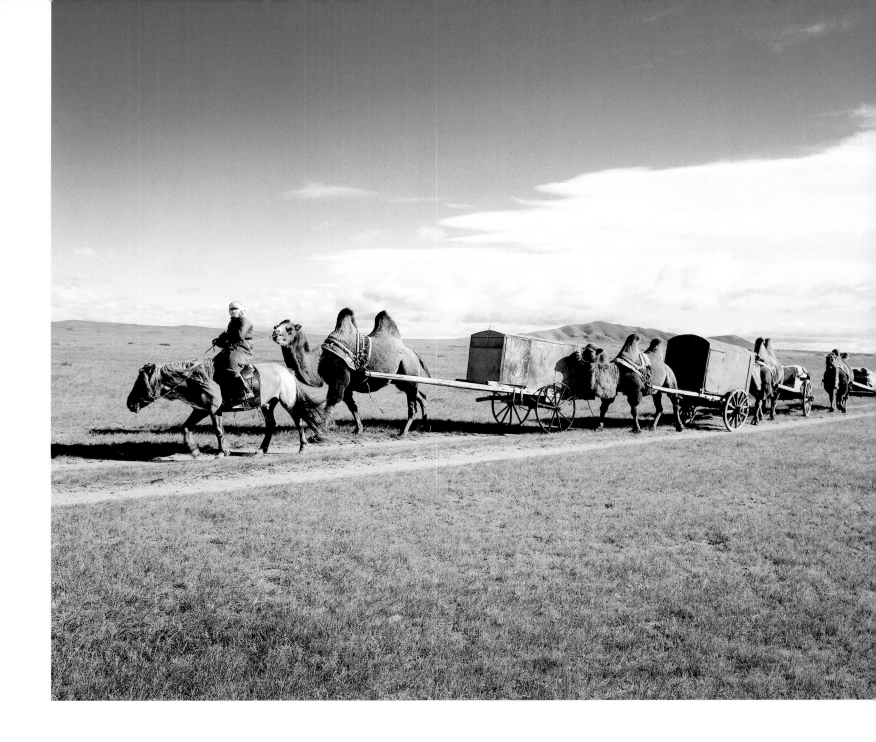

The Camels of Mongolia

In the vast dry expanses of the Gobi Desert, camels are often kept as a substitute for cattle. A fully grown animal reaches a weight of between 500 and 800 kilograms, and the Dörbed eat camel meat instead of beef. Like the mares of the Dzakchin, the camels are milked in seasonal cycles, and their milk is used to produce a variety of dairy products. Fresh camel milk is only drunk for medicinal purposes, especially for gall bladder and liver complaints. Camels are only milked for one or at most two months of the year, and once this period is over, they are returned to their herd.

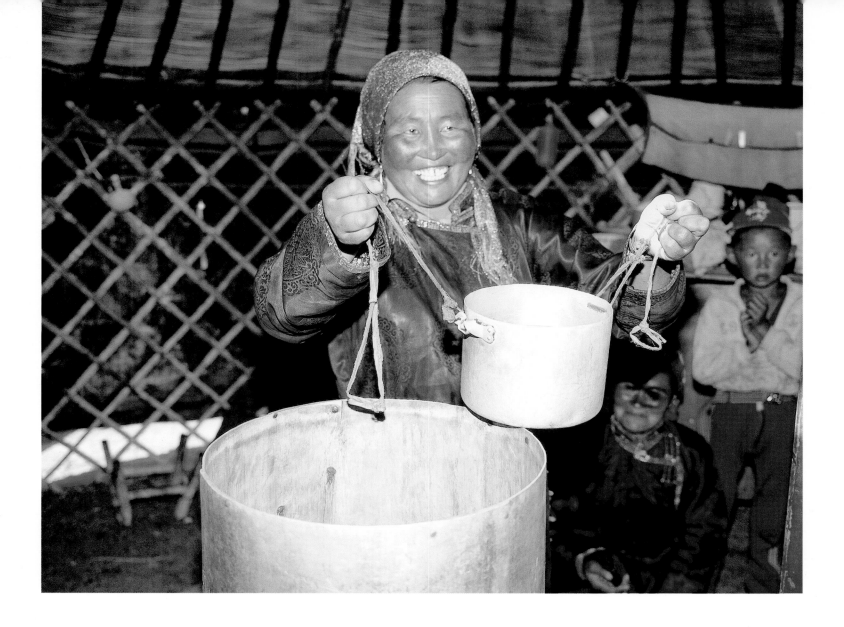

Kumiss and Felt

Above: The mares are only milked in the summer but it is their milk from which the popular alcoholic drink *kumiss* is made. It is produced by putting the milk into a large leather sack in which leftovers are placed to stimulate fermentation. The milk is then beaten regularly to make it foam until fermentation is complete. Mare's milk is also taken as a medicine in the case of tuberculosis, and lung and gastric complaints. Everything from milking through to the processing of all dairy products is considered the province of the womenfolk.

Opposite: Felt is one of the most important homemade products, and is made from the basic raw material of sheep's wool mixed with horsehair. The wool and the hair are laid on a large leather sheet made of a number of hides and then thoroughly wetted, before being covered with the so-called 'mother felt'. The whole thing is then rolled on a long pole and fastened with leather thongs, some of which hang down from the ends of the poles and are attached by two riders to their horses' saddles. After the package has been rolled for a first session lasting several hours, it is opened up and more wool and water are added before the next rolling session begins. The process is repeated until the desired quality has been reached. Felt is principally used for the walls and roof of the yurts and as matting or carpet underlay. It is also used for many everyday articles such as blankets, saddle cushions, bags, shoes and travelling mats. When the Dzakchin are travelling for several days, they consider a felt blanket sufficient protection against rain and wind, and use it as a mattress when sleeping outdoors.

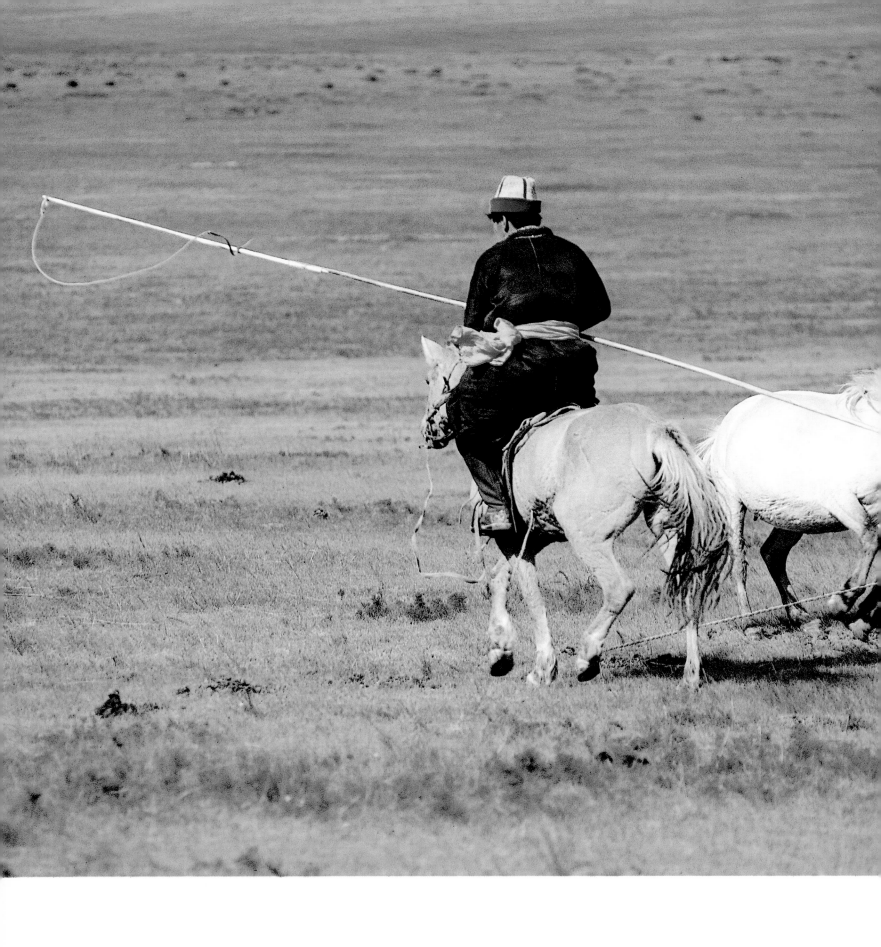

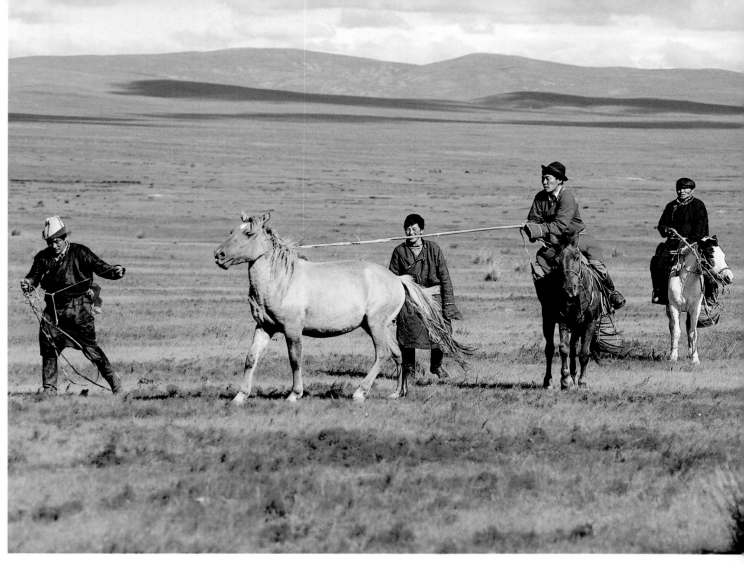

Changing Horses

It is usually the young men who ride out to select strong and well-rested riding horses from the herd. They do this using the *urga*, a long pole with a loop on the end. They are skilful at surrounding the herd and selecting a horse, which of course tries to get away. But one of the young nomads spurs his own horse on and the chosen horse's neck is soon caught in the loop, which does not tighten but simply serves to hold the horse back. The others have meanwhile rushed to the spot and now fit the horse with a saddle, bit and reins with equally admirable skill and speed. One of the young men swings himself up into the saddle and does his best to bring the horse under control. Once the process has been repeated as many times as necessary, the horses that have recently been doing duty as riding horses are allowed to enjoy another period of rest and freedom.

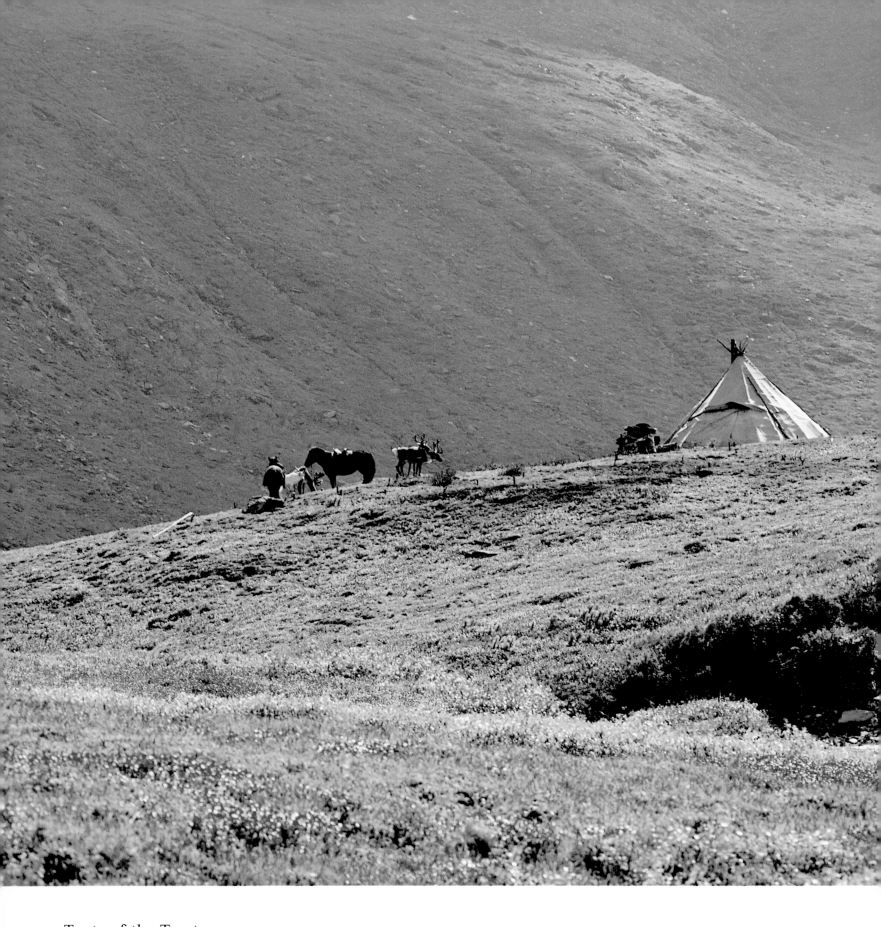

Tents of the Tsaatan

The Tsaatan yurt is similar to the tents of the Native Americans; stretching a point, one might even claim that the Tsaatan developed the prototype for the North American tepee. The *urts* – as they call the yurt – is covered with leather, animal skins, felt

and sometimes even with birch bark, and held up with the trunks of young pines. For each yurt, three trunks are put together to form a pyramid and bound at the top with strips of leather. The remaining poles are then erected in a circle around

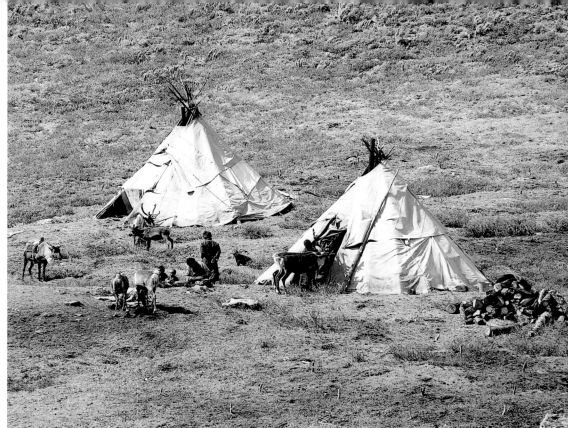

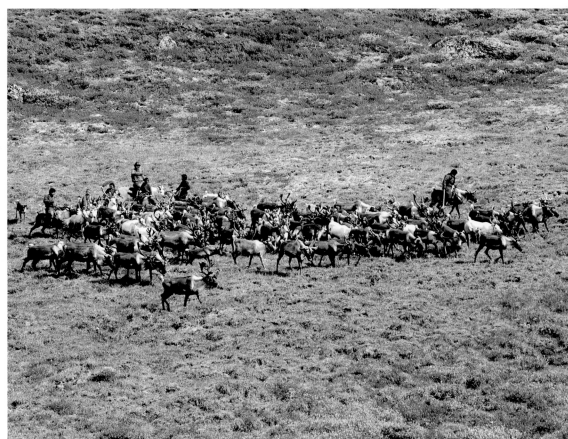

this inner triangle, to form a tent that, although not particularly well-sealed, is able to withstand everything that the most inclement weather conditions can throw at it, while affording protection and warmth for four to six people. The Tsaatan do not have the magnificently decorated entrances that are to be found among many other nomadic tribes in Mongolia. They simply draw back a section of the tent and tie it up with a rope. In the middle of the yurt is a small stove that provides life-giving heat.

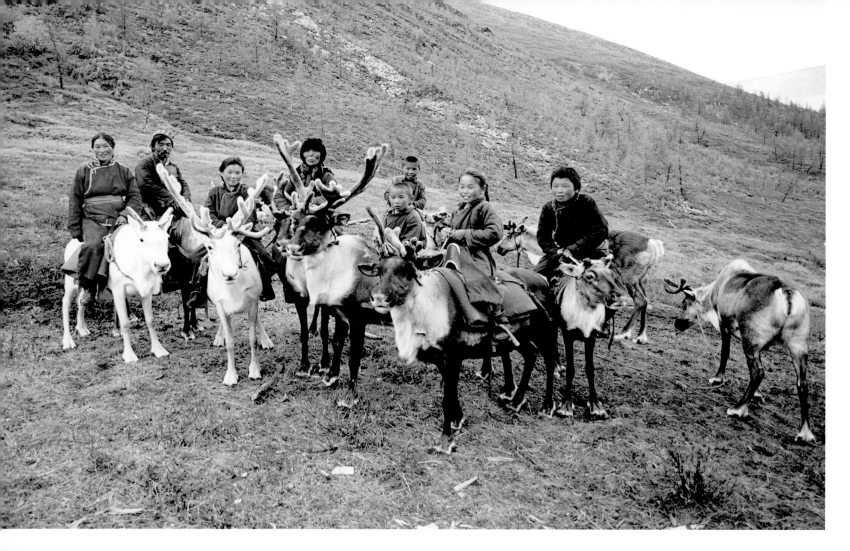

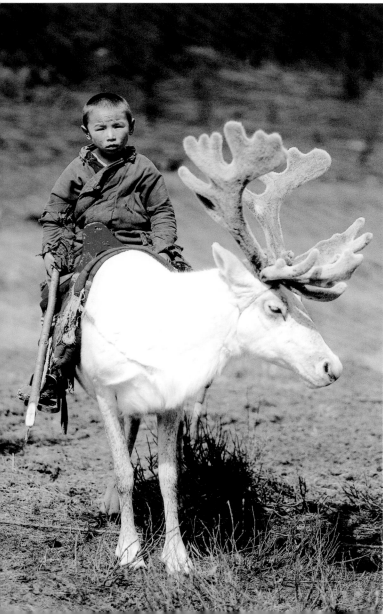

Riding Reindeer

The invention of the saddle in Central Asia allowed for the development of horseback nomads, but the Tsaatan have made their own contribution to this great tradition by saddling and riding reindeer. Tsaatan children are born into a world of snowstorms with winter temperatures as low as minus 45 °C. They grow accustomed to a life where they are constantly on the move, striking camp every two or three weeks and following the reindeer to fresh pastures.

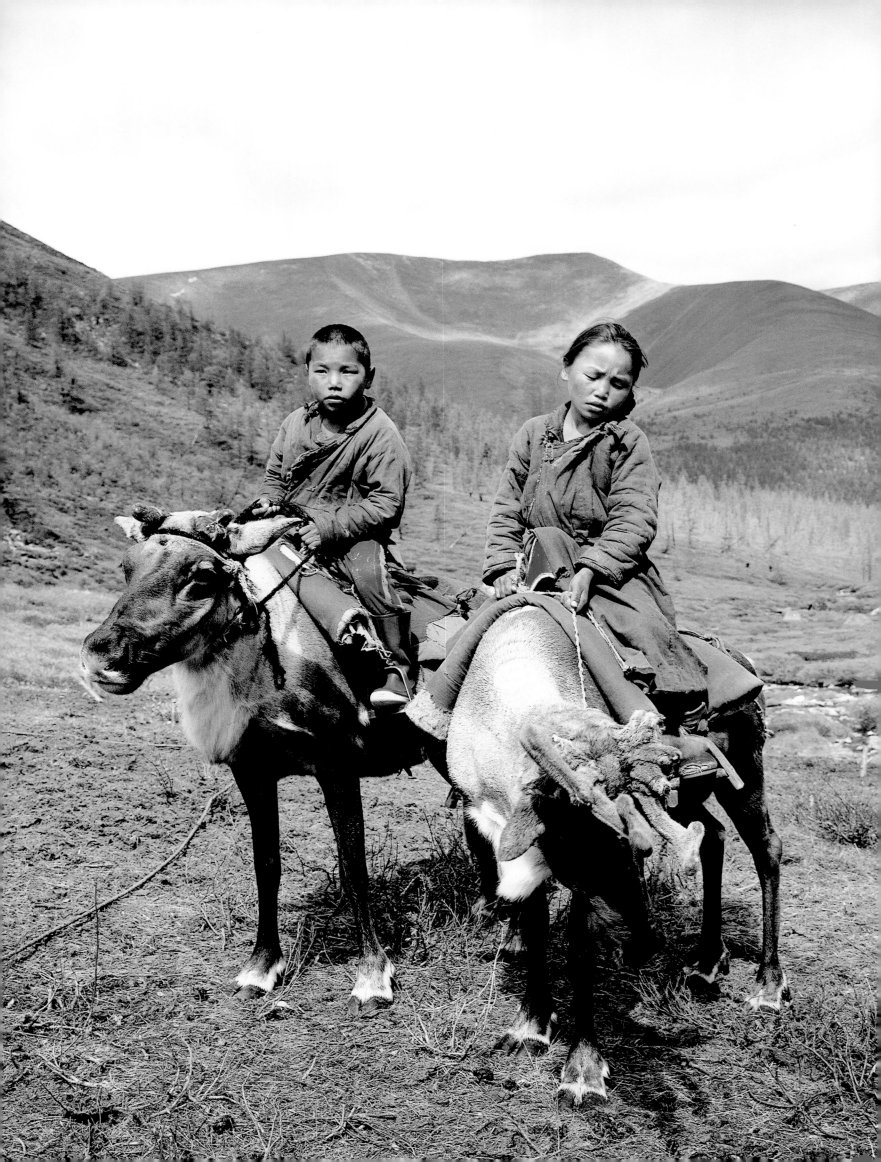

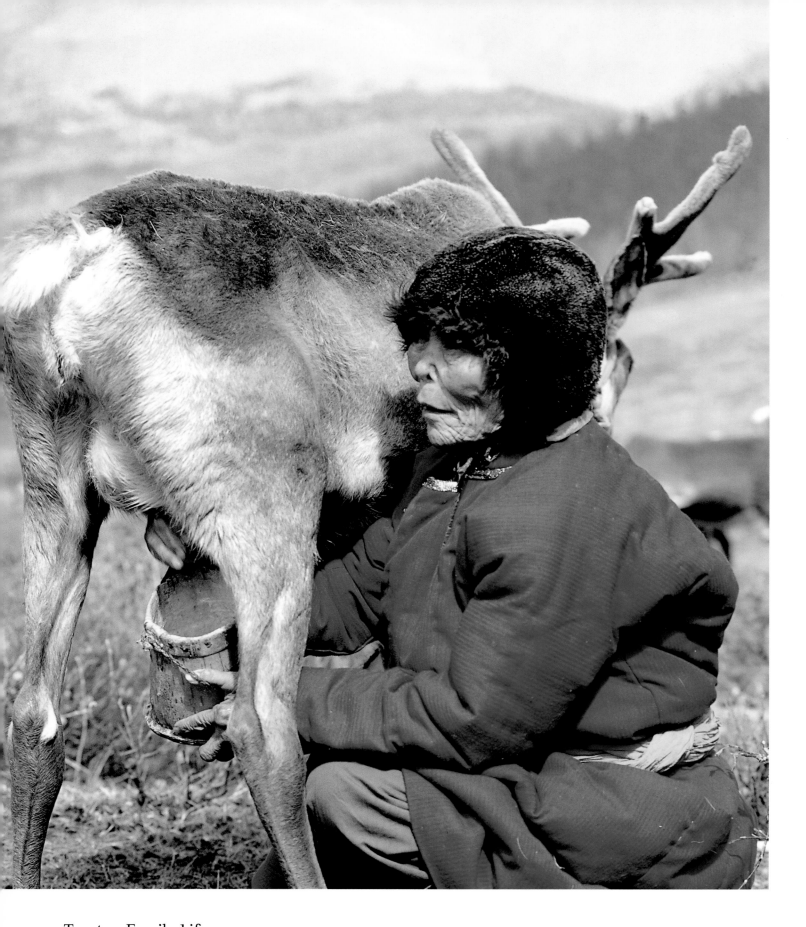

Tsaatan Family Life

Above: For the Tsaatan, the reindeer herd is fundamental to survival, providing them with meat, milk to make cheese, and hides and bones to make storage receptacles and tools.

Opposite: Family life is carried on in and around the yurt. The only time for leisure is the evenings, when, exhausted from the day's work, family members relax with their nearest and dearest. Evening chatter often focuses around songs and storytelling.

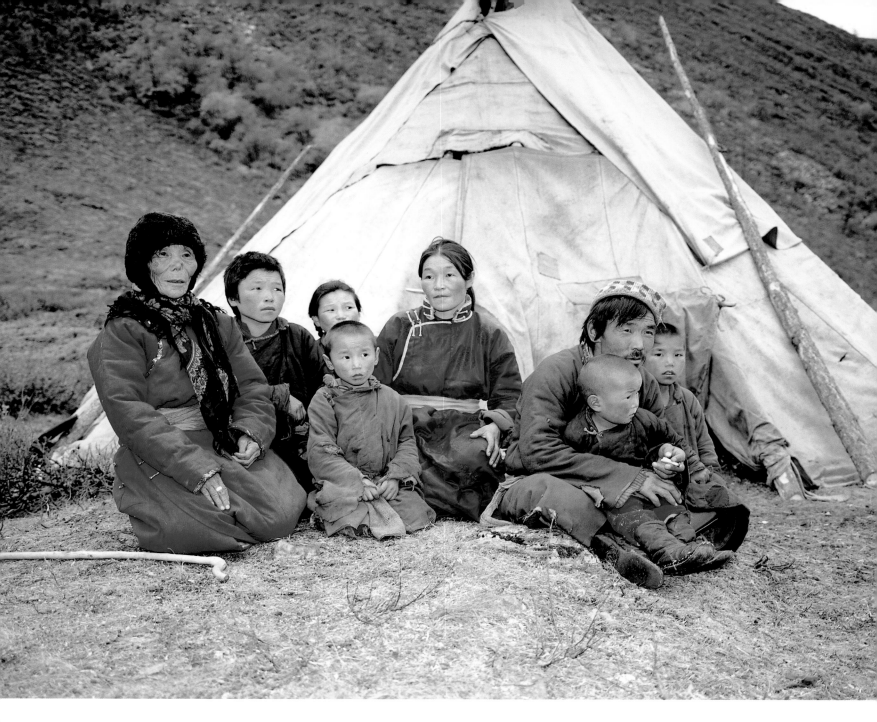

Shamans

The pounding rhythm of the shaman's large drum – his *dunger* – puts him into a trance in which he can call upon the gods for help. In this trance, or state of ecstasy, the shaman can leave his own body and travel to the realm of the spirits, where he can bargain not only with good spirits and ancestors but also with demons for the welfare and salvation of men. Wearing a heavy mantle, colourful tassels, metal plaques and a cap with eagle's feathers, the shaman sings and dances to lure the spirits to aid him. A shaman's yurt contains an altar, placed in a position of distinction in the northernmost part and hung around with many lengths of fabric on strings. By the altar are *ongons*, ancestral spirits in the form of dolls made of cloth and animal skin. These are the sources of the shaman's healing powers. The more numerous and mighty they are, the more powerful is the shaman. The altar is only set up for the shaman's seance and is carefully dismantled and packed away afterwards.

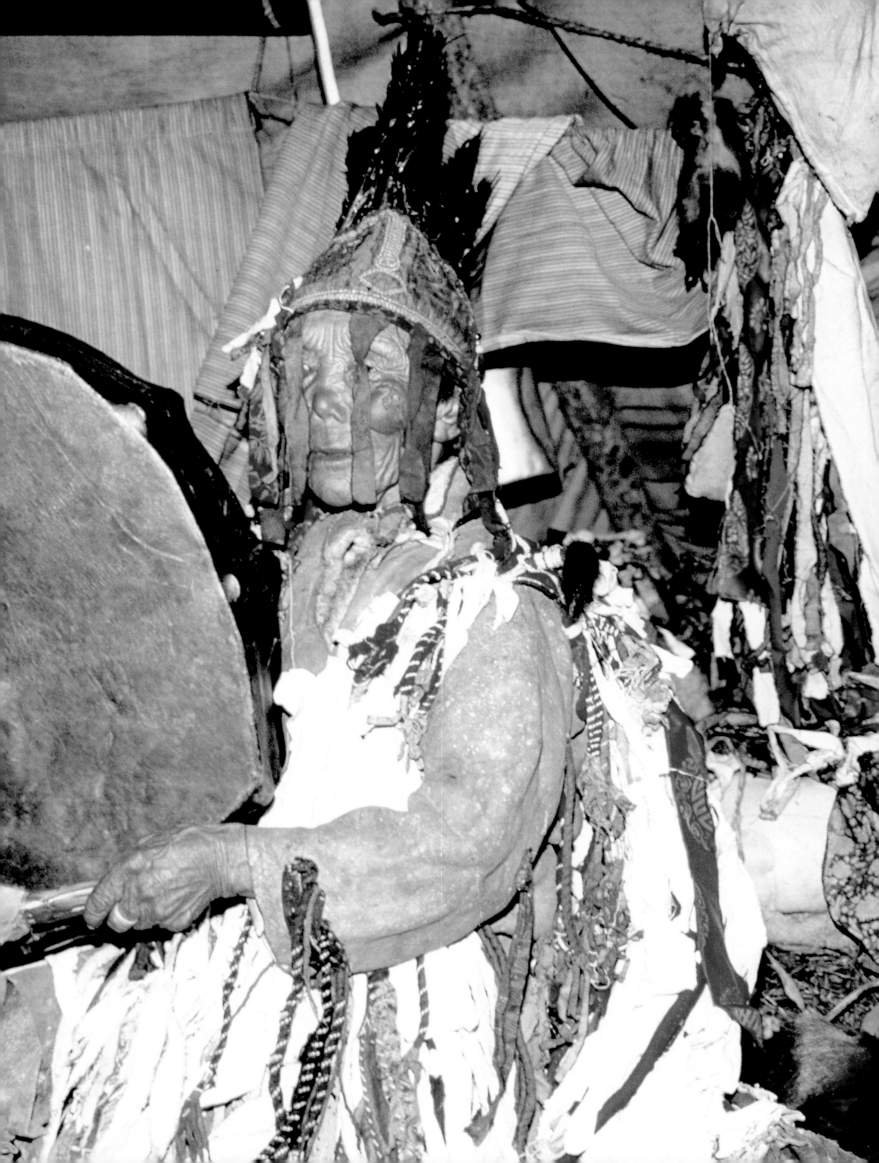

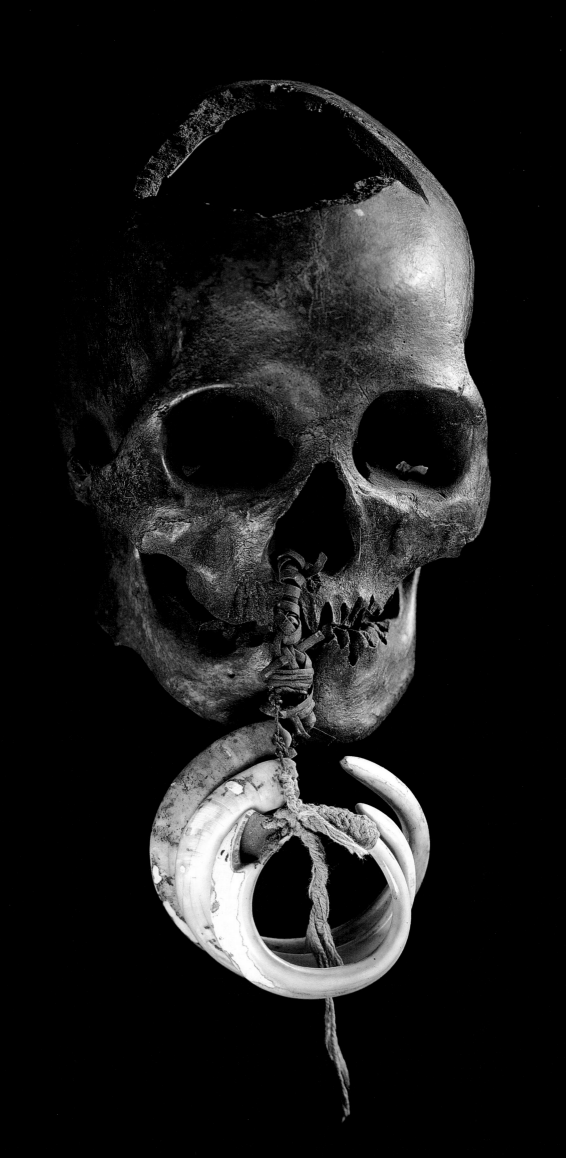

*'We adorn ourselves and put flowers in our hair so that our soul will
rejoice and will refrain from escaping to its ancestors. If it did, we would die.'*
A Sakuddai islander from Siberut, Mentawai, from the film *The Sakkudai*,
based on a book by Reimar Schefold

Chapter 7
The Malay Archipelago
Islands in Time

The islands of South-East Asia span the Equator and stretch from the Philippines to Indonesia, forming a bridge between the Indian Ocean and the Pacific Ocean. The huge area covered by the Malay archipelago and the fact of its being geographically divided into so many small units means that it has equally many faces – from the tropical rainforests and mangrove swamps of Borneo and Sumatra to the dry bushland and grassy landscapes of the south-eastern Sunda Islands, from the skilfully built rice terraces of Bali, Java and Luzon to the many active volcanoes that regularly erupt with astonishing power. The largest archipelago in the world, it has always been a cultural crossroads and home to peoples who originally came there from eastern and south-east Asia. Because of its geographical situation this chain of islands has always had a colourful history – advanced cultures and great wealth existed here long before the Europeans arrived.

The ancient maritime trading routes that criss-crossed the archipelago provided links between the cultural centres of China, Vietnam, India and Arabia. As early as the Bronze Age, the art forms of Indonesia were influenced by the Dong Son culture, named after the site of an excavation in the Tongking area of Vietnam. This resulted in the spread of a range of metalworking techniques and a rich style of ornamentation, the influence of which is still in evidence on some islands today. Its most typical feature is the regular dividing up of surfaces with stylized geometrical lines. This decorative style used spirals and meandering lines and developed into a hallmark of Indonesian decorative art.

As time went by, all the great religions of the world found a footing on the thousands of islands of the Malay archipelago. The main influences on the early cultures were Hinduism and Buddhism, which coexisted harmoniously for many hundreds of years. Islam, which is now by far the dominant religion, entered the islands peacefully from all sides. Finally came Christianity, mainly in the wake of traders from Holland and Portugal who had come in search of spices. For this reason, the oldest Christian communities are to be found on the eastern islands; Christianity did not spread over the entire archipelago until the colonial era.

*Decorated Dayak
skull trophy.*

Bartering in trading goods developed at a very early stage, particularly in those areas that were most accessible to influences from overseas. Cultural influences spread from the coasts,

265

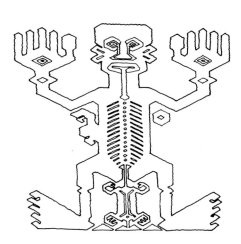

Stylized figure used as a motif on an ikat *textile from the island of Sumba.*

where the inhabitants were mainly Malay and Chinese, to the hinterland, and exotic goods of all kinds were already exchanging hands during the first millennium AD. Even in inland parts of Borneo, in the longhouses of remote tribes living in inaccessible spots, one may often find pieces of old porcelain and pots that have clearly been passed down over many generations. The Chinese traders who explored this island world in their large junks brought silk, bronze objects, glass beads, coins and valuable ceramic jugs and bowls, all of which were particularly highly valued by the local people. In exchange the Chinese received rhinoceros horns, hummingbird feathers, amber, furs or precious rhinoceros hornbill beaks, which were considered more valuable than ivory. Swifts' nests were also considered valuable objects; taken at risk of life and limb from the caves where these birds nested, they still play an important part in the hunting and gathering activities of the Punan people. What the Chinese value most in the nests is the sputum used by the birds to build the nest – it is made into soup and considered a delicacy and an aphrodisiac of the highest order.

For all the cultural and religious variety of the south-east Asian archipelago, it should not be forgotten that it is also home to many ethnic groups who have only been superficially influenced by the larger cultures. All of these ancient Malay tribal peoples have animist world views, and these have often been repressed or overridden by Islam and Christianity to a greater or lesser degree. But all the ethnic societies of Indonesia follow the *adat*, a traditional system of values that prescribes etiquette and social norms. On the Sunda Islands, which lie to the east of Bali, there are strict regulations governing who may marry whom, what should be given as a wedding gift and how high the dowry should be. Marriages bring with them certain rights and duties that are also significant in economic, social and religious terms. The relationships of ritual exchange that arise between bride-givers and bride-receivers also serve to link different communities together.

Some ethnic groups have been successful in making sense of the crossing of the two elements, of the cross-fertilization between the new religion and the old way of life, between Allah and *adat*. The Minangkabau in western Sumatra, at the same time as being strict Muslims, still maintain their old matrilinear social structure in which the mothers are the figures of authority. And the predominantly Christian Toraja of the island of Sulawesi (Celebes) or the Toba Batak of Sumatra, some of whose number have become top civil servants and members of the Indonesian government, often still celebrate the ancient rites. Others have not been able to cope with the massive changes that the incursions brought with them, and have lost their vitality and cultural identity. There are cases of splinter groups withdrawing to remote island areas and thus being able to keep alive many elements of their traditional way of life.

In their works of art and ritual creativity, the ancient Malay peoples have produced true masterpieces that are shot through with spiritual and symbolic meaning – notable examples include filigree carvings in materials such as bird's beaks, ivory, antlers and seashells, bronzes, gold and glass beadwork, and the magnificently coloured Indonesian textiles.

Craftsmen and artists are as well respected today as they always have been. In the old times it was believed in some tribes that the souls of the great master craftsmen were strengthened by guardian spirits that gave them supernatural powers to allow them to complete their work.

'Dayak' is a collective name for the indigenous peoples of Borneo, who used to be feared as headhunters. They live in longhouses supported on stilts, the individual dwellings being decorated with extensive paintings and the entrance watched over by skilfully carved totem poles. Each family has its own compartment in these wooden constructions, which are up to 300 metres long and large enough to offer shelter to a whole village. The unmarried men sleep on the veranda, which functions as a kind of village street and is also the place where feasts are held. The basis for their economy is agriculture and rice is the most important crop. Sadly enough, many of these peoples, particularly the Iban, have fallen for the attractions of other lifestyles and are consequently giving up their old longhouses; these are now used for tourists while the locals prefer to live in quickly-built modern dwellings.

Among the largest tribes are the Iban, the Kayan and the Kenyah, who developed remarkable skill at many forms of artistic and musical expression. They manufactured their own jewelry out of bronze and brass, and forged magnificent swords for severing heads on hunts. The individual Dayak groups have all made a name for themselves through their work in a specific craft. The women of the Iban have earned high status, almost comparable with that of the headhunters, through weaving the sacred *ikat* textiles. The Bahau of the Mahakam river carved exquisitely beautiful sword handles from staghorn and the Ngaju are known for their figuratively carved pole sculptures.

Two typical features of Dayak art are surface decoration and sculpture work. The Kayan and the Kenyah in central Borneo are famous for their curvilinear decoration, a style that incorporates motifs ranging from abstract spirals and flourishes to extensive patterns made up of faces and figures. One of the most frequently used ornamental motifs is the stylized representation of the *asu*, a composite spiritual being with the head of a dog and the mouth of a dragon, sometimes with the body of a dog and sometimes of a water-serpent. The *asu* is thought to symbolize the underworld and has the task of warding off imminent harm and keeping evil spirits at bay. Other important motifs are the tree of life and the rhinoceros hornbill bird, as symbols of the world above.

Body decoration plays an important role for many tribes. Tattoos are an indication of social status or of specific achievements. The men of the Iban are allowed to tattoo themselves with particular patterns after having been on a successful headhunt, and the women are similarly allowed to tattoo their arms when they have produced particularly beautiful ceremonial textiles. Important life events, or experiences from dreams, are also etched into the skin by tattoo artists, always in a ritual context. The point of the act is to endow the motifs with magical powers that will protect the wearer from harm. The patterns are tattooed on with a stamp or drawn freehand. High-ranking women cover their shoulders, chin, hands, arms, legs and feet with fine and specifically chosen motifs, while the men tattoo their cheeks, chest, hips and legs. As well as their decorative function, the tattoos may be done out of the belief that only tattooed people will be able to be reunited with their family members after death, because the darker the skin is coloured, the brighter the deceased person will shine in the after-life.

Tattoos are not the only form of permanent body decoration common in the archipelago. Some correspond to commonly held ideals of beauty such as the piercing of the ear lobes or the cosmetic treatment of teeth, which may be sharpened with special tools, polished down or even knocked out. Coloured teeth

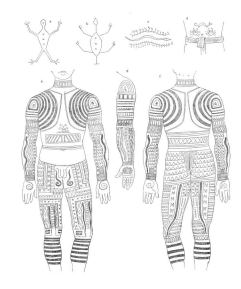

Igorot tattoos, Luzon, Philippines.

Basket of a Dayak headhunter decorated with a hanging half-skull.

were also considered attractive, as some people of the islands believed that only wicked witches had long white teeth. The gold-plating of teeth was also practised in Java and Bali. One last form of physical deformation should also be mentioned – it was formerly customary among the Dayak to pierce the penis and to insert a small peg into the opening to act as a pleasure stimulant during sexual intercourse.

Ritual headhunts were widespread in the whole of the archipelago. For many peoples in Borneo and Sulawesi, as well as on Seram and the Lesser Sunda Islands, headhunting and human sacrifice had a magical-religious justification. The main point was not the head, but the killing of a man. There is a creation myth that gives a strong indication of the connection between death and fertility and explains the significance of the headhunt; it relates that a deity was killed and that it was from the various parts of its body that the first edible plants and herbs grew up. It was assumed that the heads that had been collected on hunts possessed supernatural powers that would grant fertility to both plants and humans. This was why regular headhunts were considered necessary if the welfare of the group was to be guaranteed. The custom furthermore had the purpose of fulfilling blood vengeance and settling old scores that sometimes went back to the previous generation or earlier. There was a time when a young man of the Dayak could only marry or take part in certain ceremonies once he had a head to his name, which also explains the necessity for periodic headhunting expeditions, in which it was of no importance whether the killing took place in hand-to-hand fighting or by ambush. The head was severed from the body with a swordstroke and brought triumphantly home. Warriors were dressed in a particular way, were adorned with decorations and were allowed to use certain tattoo motifs. The skulls were also decorated and kept in the longhouse. Headhunts continued up until the beginning of the twentieth century.

The Punan are the last nature people living in the rainforests in the heart of Borneo. They roam through the jungle areas, gathering the pith of the sago palm, hunting and fishing. Gathering the produce of the rainforests provides them with an important source of income.

All their necessary material possessions have to be very light. Above all things they value old pearls, which are sometimes considered in themselves to have enough value for a dowry. The Punan are thought to be the greatest experts in the processing of rattan, an extremely tough kind of liana or bushrope that grows up to a hundred metres long and attaches itself to any wood it can get its barbs into. The Punan use it to produce the finest of woven articles, magnificent baskets and wonderful sleeping mats that are much in demand all over Borneo. Their sedentary neighbours, the Kayan, are even said to have composed songs in their honour, celebrating their skill at weaving.

Since time immemorial the Punan have lived off the forests without overexploiting them. In recent years, however, Borneo's forests have been subjected to merciless deforestation, and this has deprived many forest people of their livelihood.

The remote Mentawai Islands off the west coast of Sumatra are home to tribal groups who live from the cultivation of sago, and from hunting and fishing. Until very recently, they had maintained an animistic culture in which man and nature lived in balance. Before the men went hunting, shamans called up the souls of the animals and pleaded for forgiveness and reconciliation. They have a partic-

ular feeling for beauty, and they wear jewelry to foster the well-being of the soul. This remarkable culture is now however in the direst need as a result of unscrupulous deforestation on the islands and pressure from the local authorities. The community houses, which are works of art in themselves, have almost completely disappeared, Muslim traders join with the police in forcing the shamans to do menial work on the plantations, in order to stop them from performing their religious duties.

Abuse of traditional tribal cultures is ubiquitous on the islands of Indonesia. The drive for conformity brings about economic dependency and embitterment in the tribal peoples, who have no option but to wear the prescribed Islamic headwear or Christian clothing if they are not to be marginalized any further. But it is now very late in the day, as Christian missionaries, Muslim zealots and the Indonesian government have already been largely successful in breaking the back of the Malay archipelago's traditional tribal cultures.

Dayak representations of spirits, Borneo.

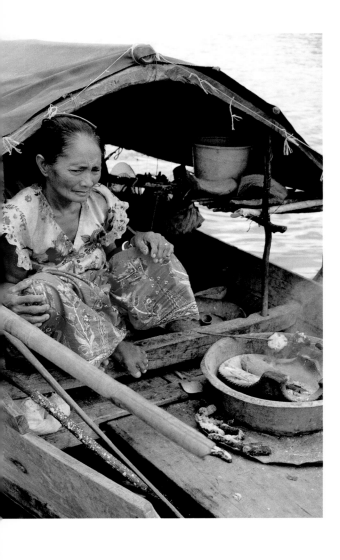

Nomads of the Sea

The Badjao people have been sailing
the waters of the Sulu Sea between
Mindanao and north-eastern Borneo for
hundreds of years now. They are among
the last surviving *orang laut*, or 'sea
people', who in earlier times were to
be found all over the Malay archipelago.
They spend almost their whole lives
on the decks of their houseboats and
they only rarely return to the pile
constructions that they build on the
coral reefs where the sea is shallow
enough to make this possible.

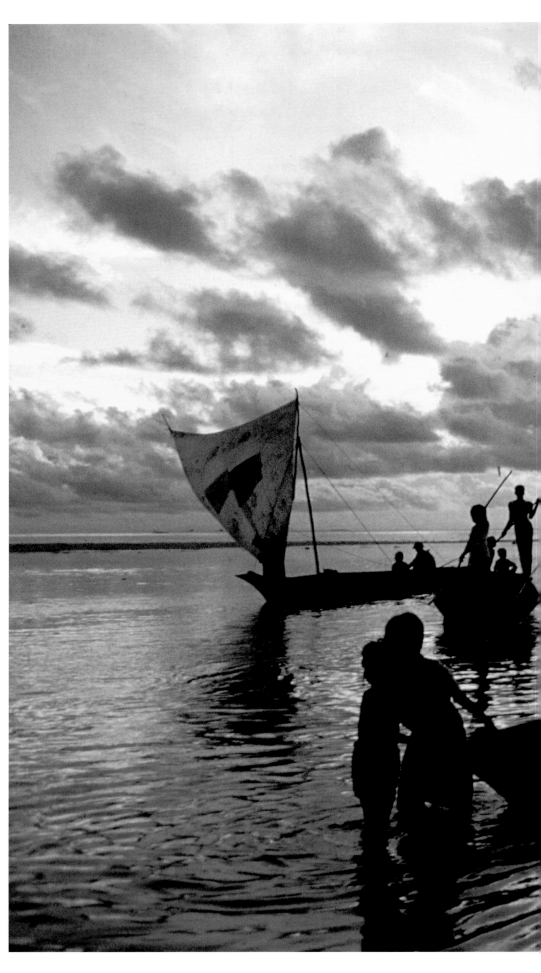

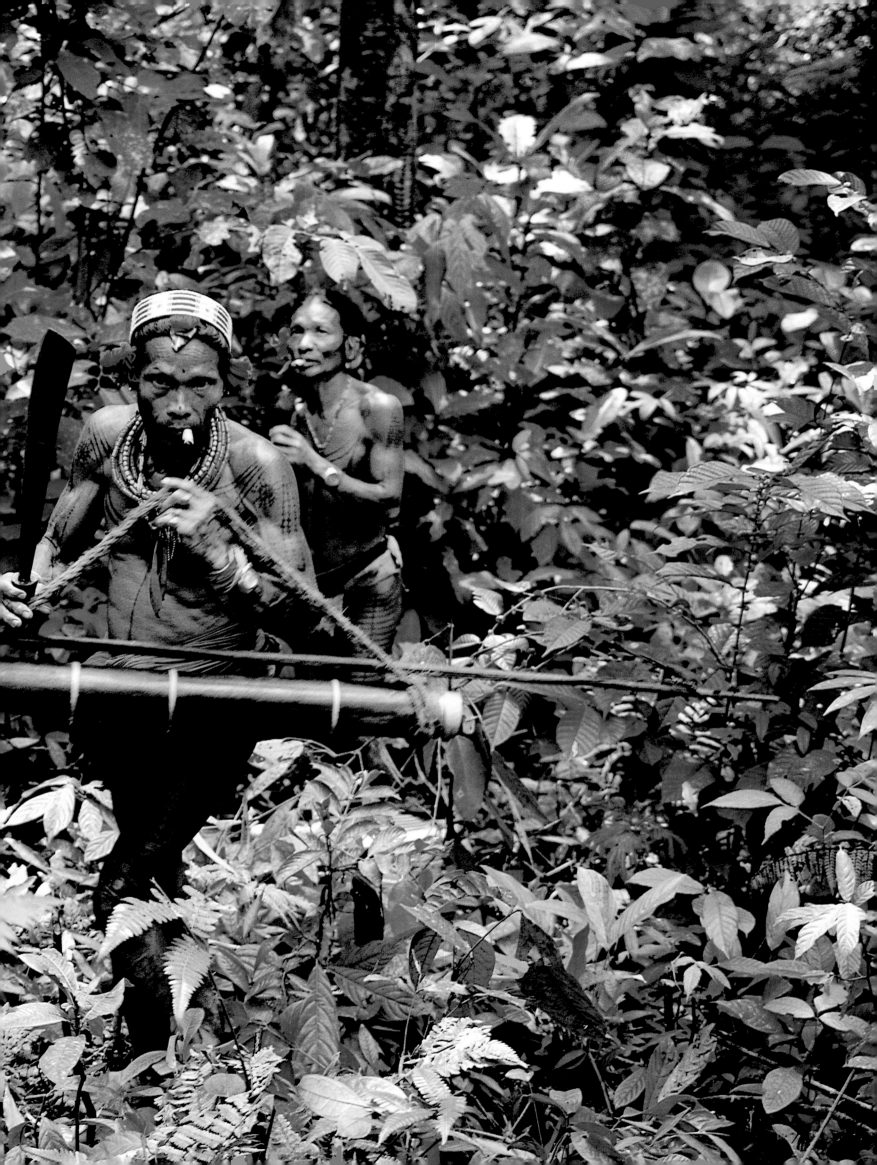

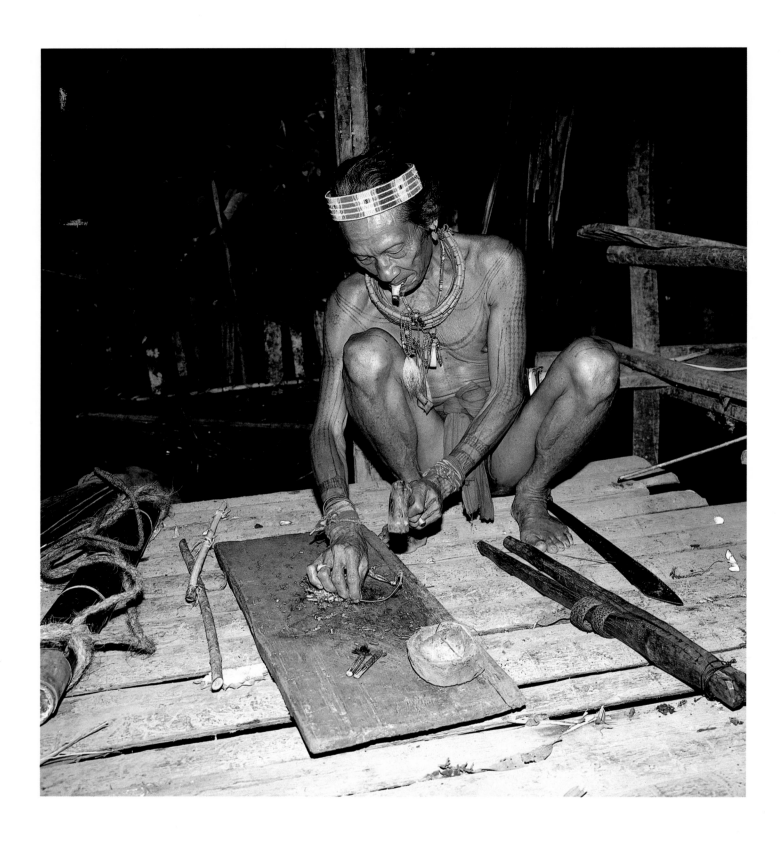

Sakkudai – People of the Rainforest

Previous pages:
Only very few Sakkudai live from hunting in the way
that their forebears did, because their territories on the
Mentawai Islands have been seriously affected by
deforestation and the introduction of arable farming.

Above and opposite: Preparations being made for one of
the shamanic rituals that play such an important part in
maintaining the balance between man and nature.

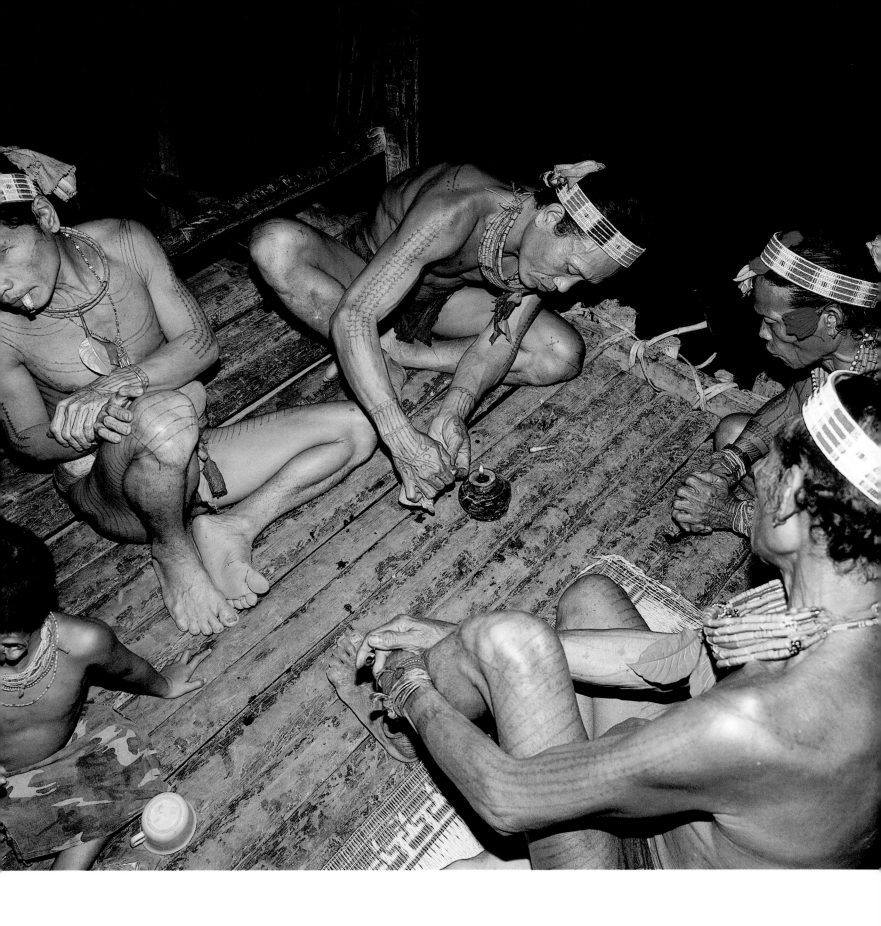

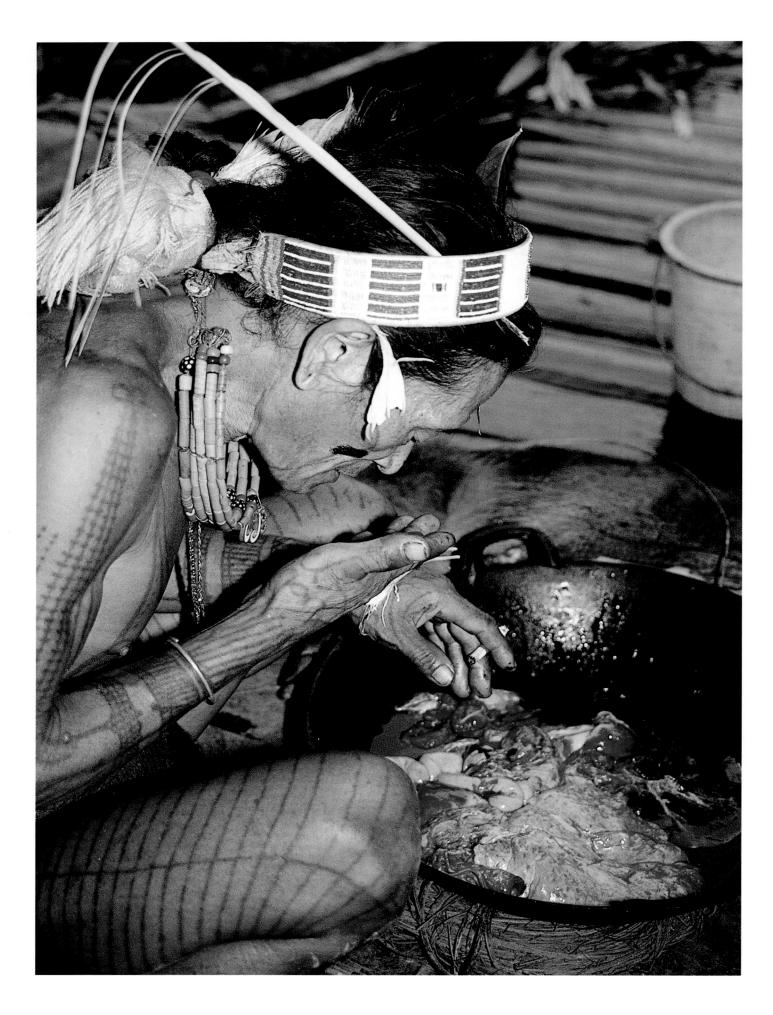

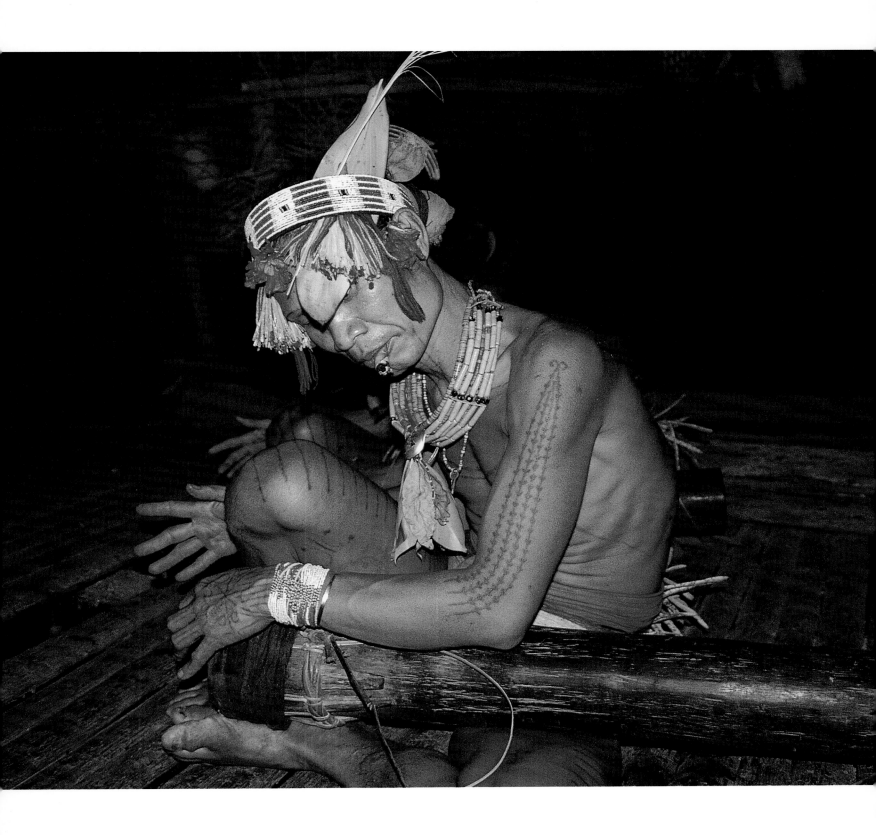

Looking for Omens

Opposite: Before an important decision is made, the shaman asks for an oracle by examining entrails. A chicken or pig is killed and its intestines are removed; the connective tissue gives information about the kind of illness a person is suffering from, or the result of a planned hunting excursion.

Above: The rituals are accompanied by the rhythm of the drum.

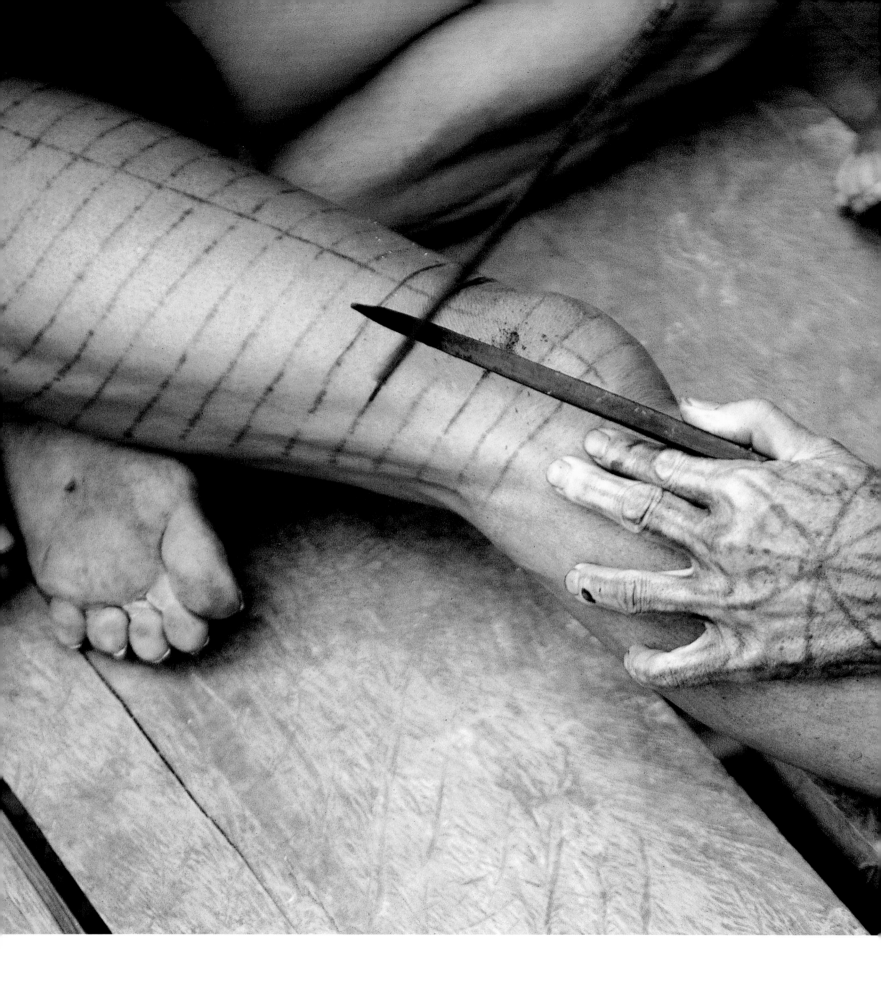

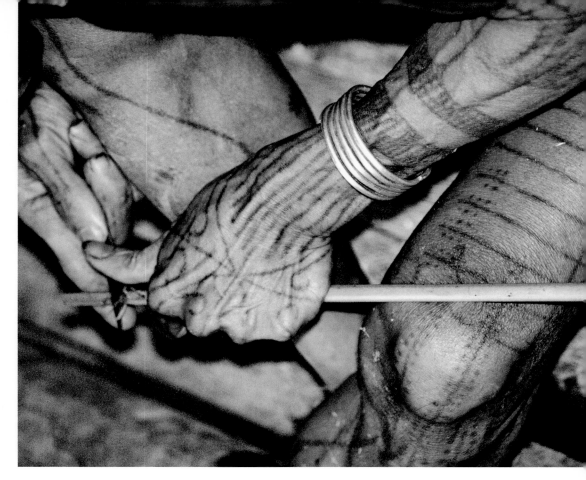

Bodies Beautiful

Of all forms of body decoration, the tattooing traditionally practised by the Mentawai Islanders is one of the most fascinating. The tattoos are applied to the body over the course of the years, and are not only decorative but have a talismanic function, protecting the person in question from illness and harm. For the Mentawai Islanders, these tattoos are so important that they willingly submit to the pain of acquiring them. Their master tattooists use sharp bamboo sticks to inject plant extract dyes under the skin. Although the motifs have been handed down over many generations, tattooing has now been prohibited by the Indonesian government.

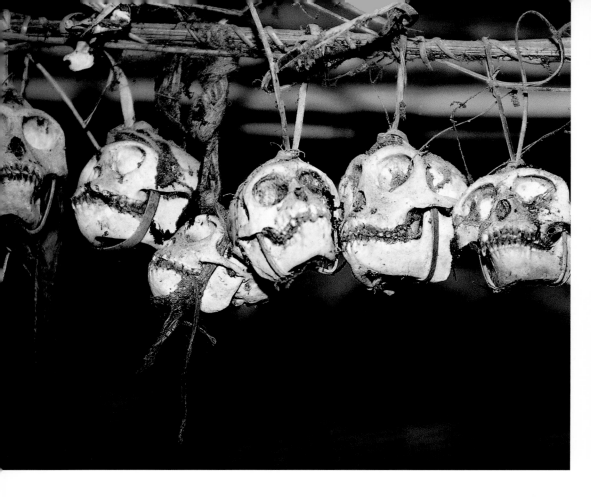

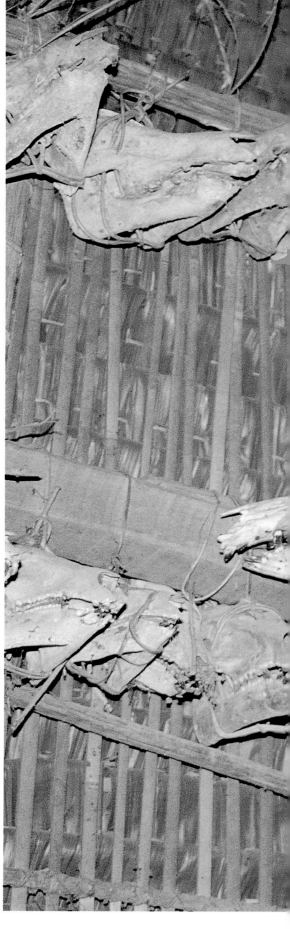

Skull Trophies

Right: A tattooed man hangs up a newly won hunting trophy on the bamboo wall of the community house. Animal skulls such as these are supposed to bring good luck in future hunts.

Above: A row of monkey skulls.

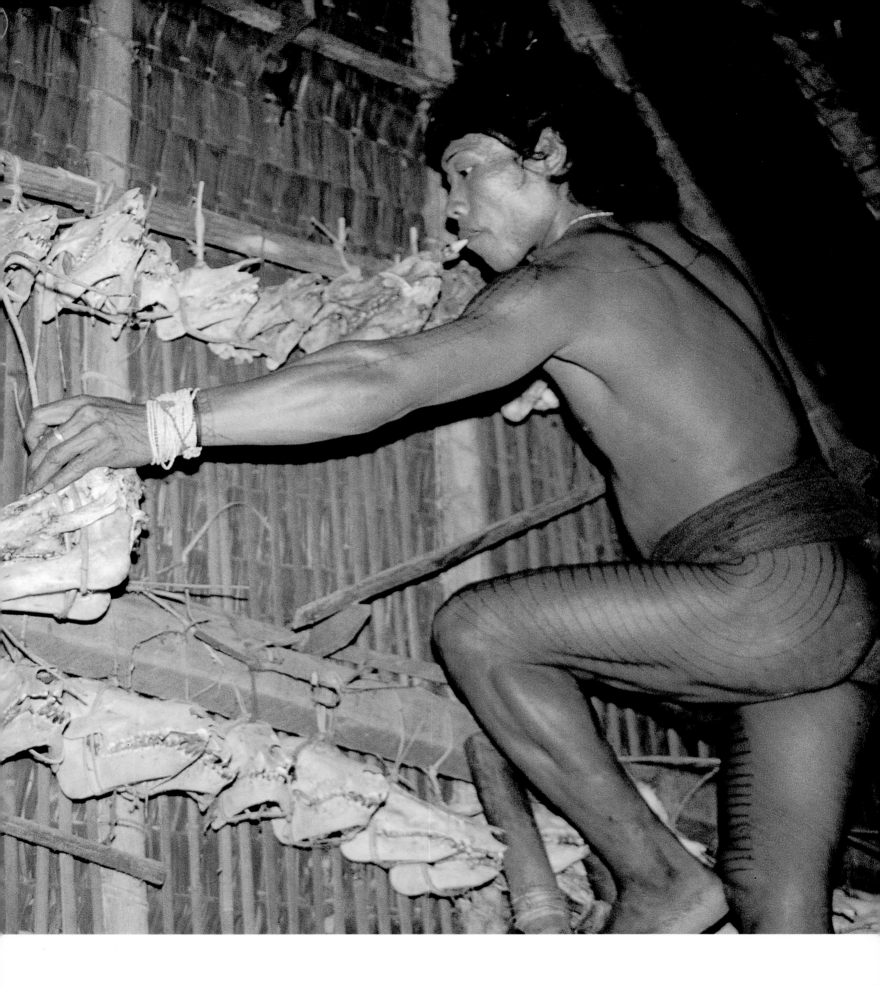

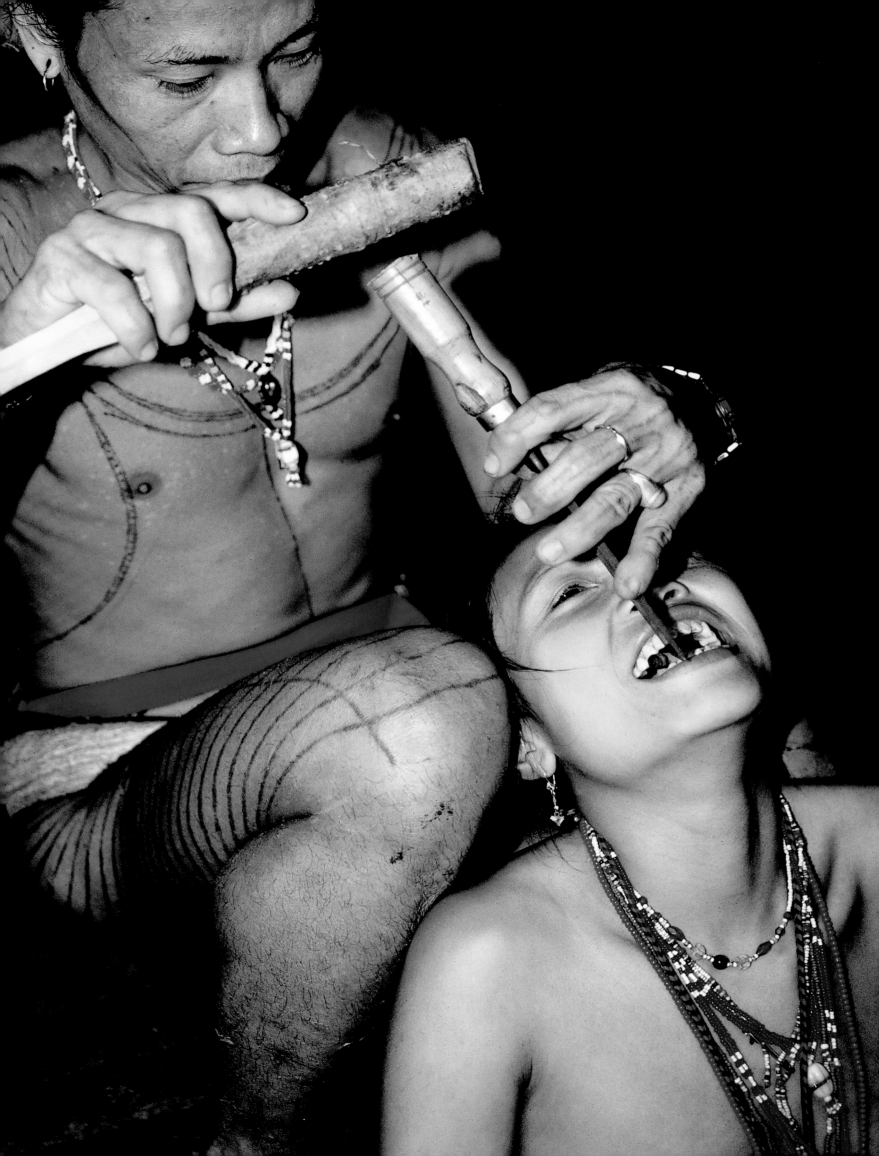

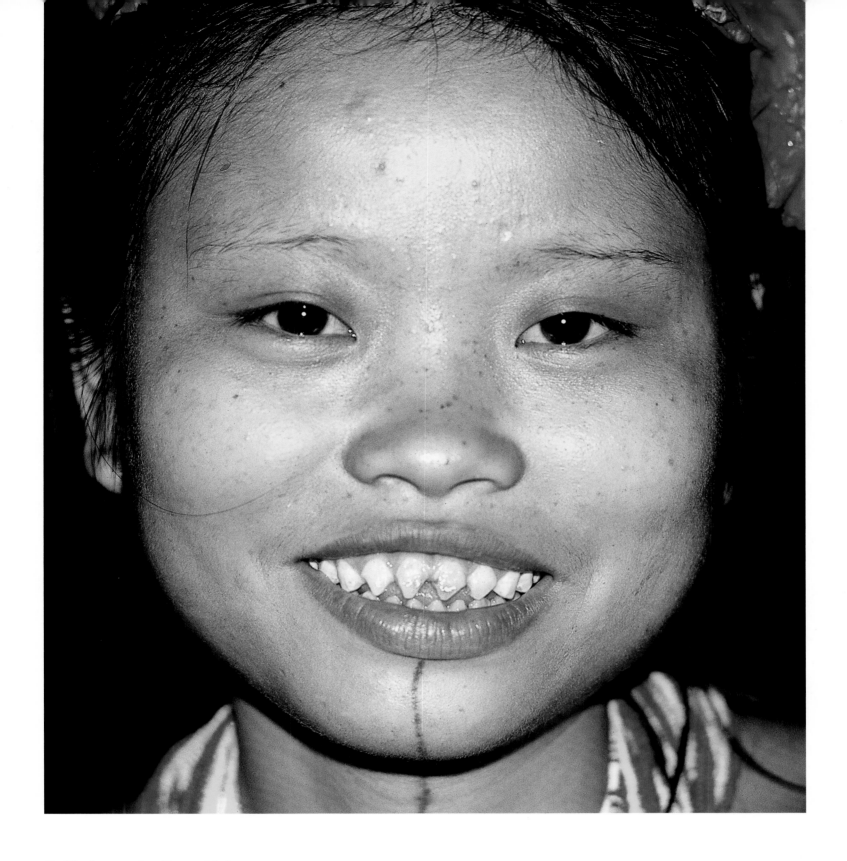

Suffering to be Beautiful

Another facet of the Sakkudai culture of female beauty is the practice of sharpening the teeth. A hammer and chisel are used to grind down the enamel in this painful procedure.

Living Myths

Opposite, left: An impressive number of buffalo horns decorate the supporting column of a Toraja house. The facade of this ceremonial house, or *tongokan*, in the highlands of Sulawesi is embellished with fine, curvilinear decoration and figurative designs. Buffalo horns represent prestige and wealth and once had symbolic relevance for headhunters. The water buffalo are slaughtered with one blow of a sacrificial sword, then have the task of leading the souls of the dead to the ancestral realms.

Above: Skulls of pigs, deer and monkeys, and carved figures of birds decorate the roof timbers of an *uma*, a traditional house of the Mentawai Islanders. The hunting trophies are intended to calm the spirits of the animals that have been killed, and to ensure success in future hunts. Animists see humans and animals, and the material and spiritual worlds, as being woven together in unity.

A Memorial to the Dead

Above: *Kirekat* memorial signs in a Sakkudai *uma*. A sago leaf is used to take the outline of the hands and feet of the deceased, and these are then reproduced on a wall in the house. The house board, which is always decorated with intaglio hands, feet and moons, serves as a memorial to deceased relatives.

Toraja House Decorations in Sulawesi

The wooden houses of the Toraja rest on stone pedestals and are true wonders of architectural design. Animal motifs and geometric patterns are carved into the gable walls. The wall paintings are executed in sacred colours – red, yellow and black. The house is considered a symbol of the universe and is always oriented on a north-east to south-west axis, the directions that point to the realms of the ancestors in Toraja mythology. The exact type of decoration depends on the social status of the owner of the house. A traditional pile house is built entirely without nails.

Sacrificial Animals

Above left and centre: Among the Toraja, both pigs and water buffalo are served up at funeral ceremonies. The pigs are tied up and brought as gifts by the mourners. The expense of a funeral can often lead to financial ruin for the family that has to host it.

Above right: This water buffalo, decked out for the occasion, is here being killed with an iron lance in the course of a funeral ceremony on the island of Sumba. Buffalo play an important role in many Indonesian tribal cultures as sacrificial animals and status symbols, and figure in tribal myths.

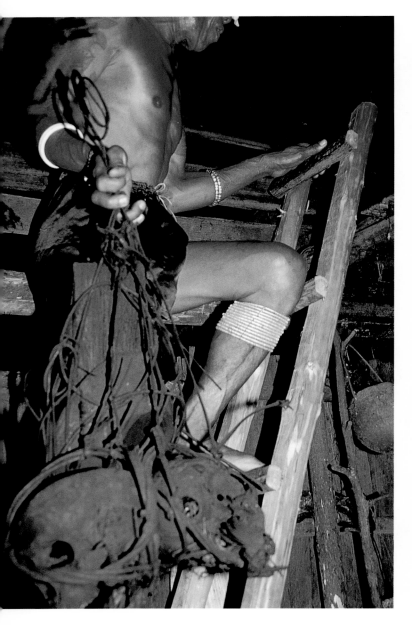

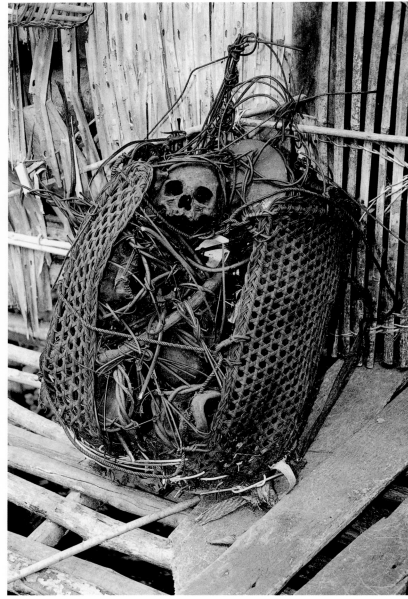

A History of Headhunting

According to the religious beliefs of the Dayak, death and dying are necessary in order for new life to come into being. The practices of headhunting and human sacrifice were directly related to fertility both in the plant and the human world. A local myth tells of how two divinities, one female and one male, were killed and dismembered. From the parts of their bodies sprang up man's first edible plants and cultural artifacts.

Above left: Trophy skulls were thought to increase the prestige of their owner, to store life energy, and bring good luck and fertility. In remote areas they are still stored in the roof timbers of the longhouse.

Above right: Iban Dayak charred skulls in rattan baskets.

Opposite and overleaf: Dayak trophy skulls.

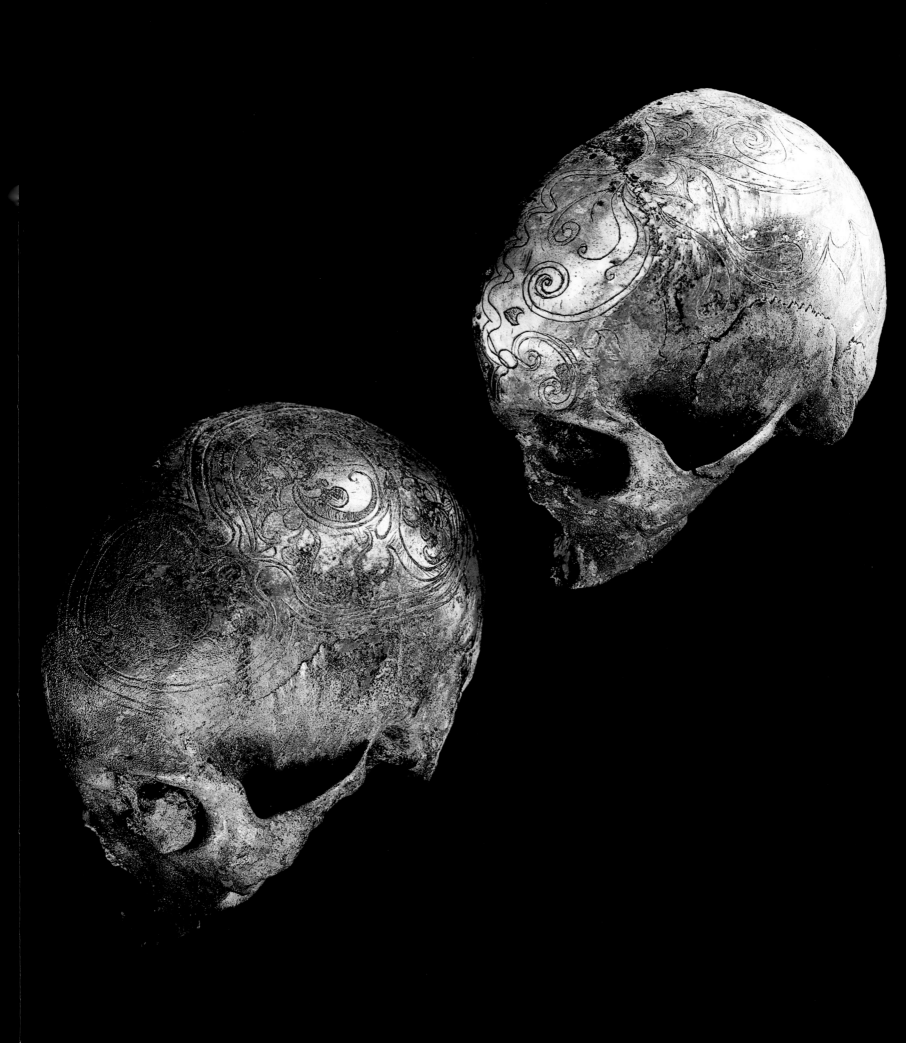

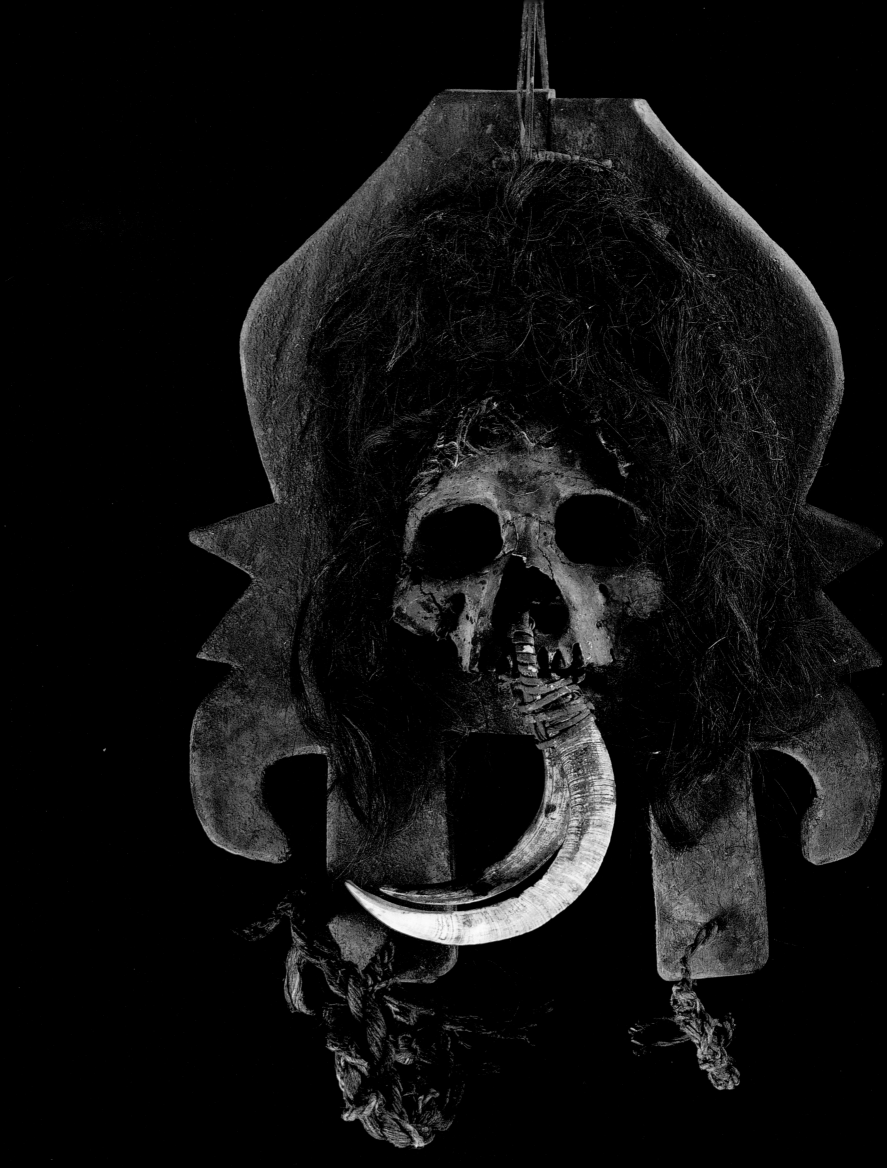

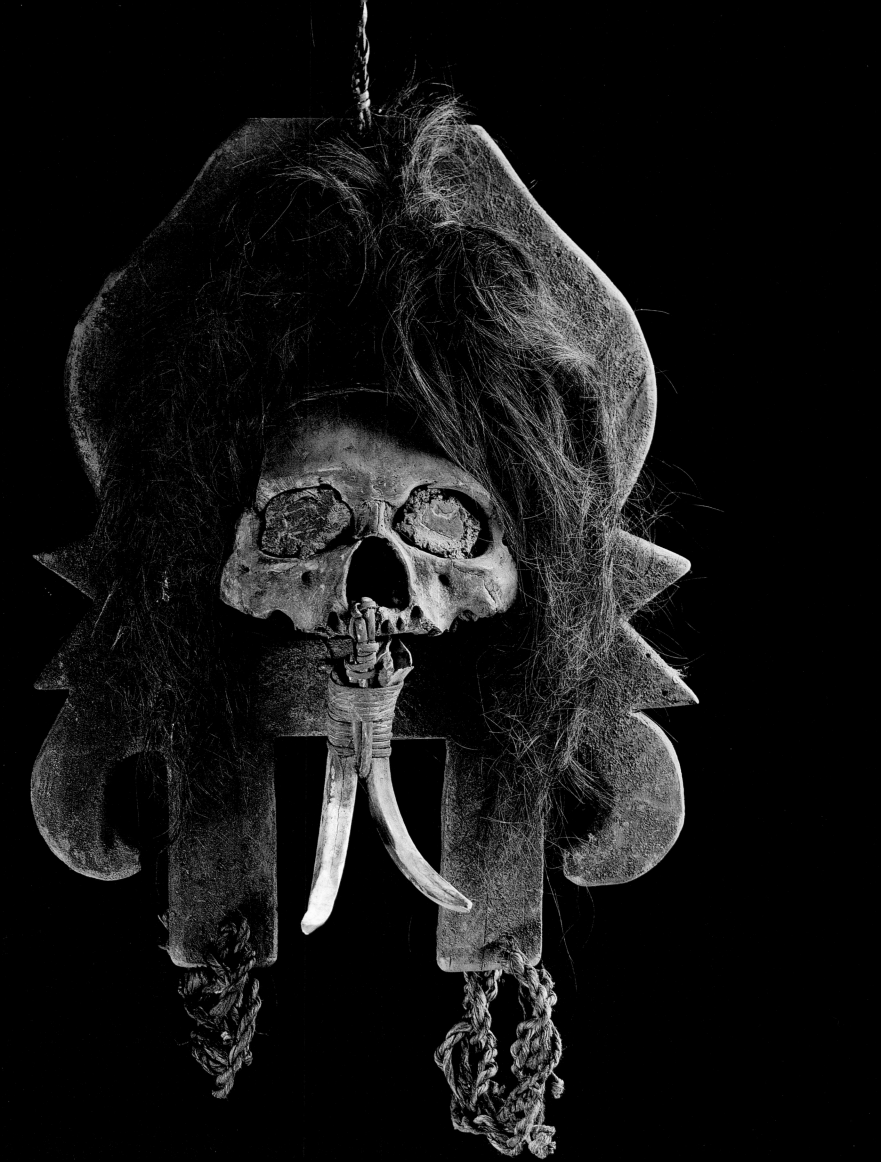

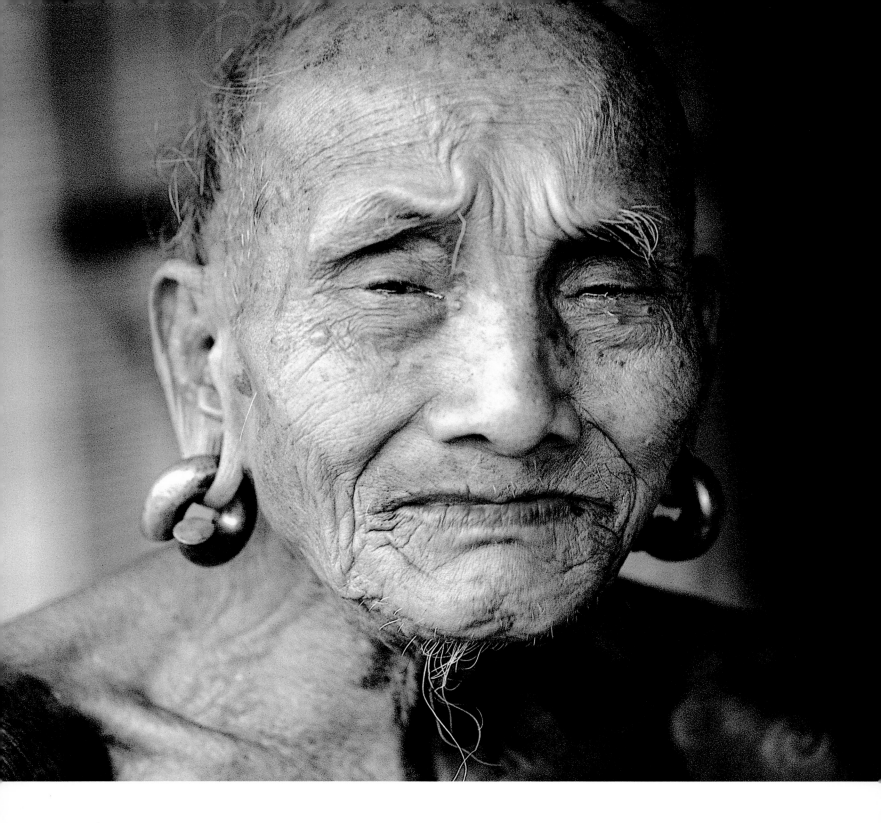

Dayak Earrings

One characteristic feature of the Dayak tribes
used to be their heavy bronze or brass earrings.
Nowadays these are only worn by the elderly.

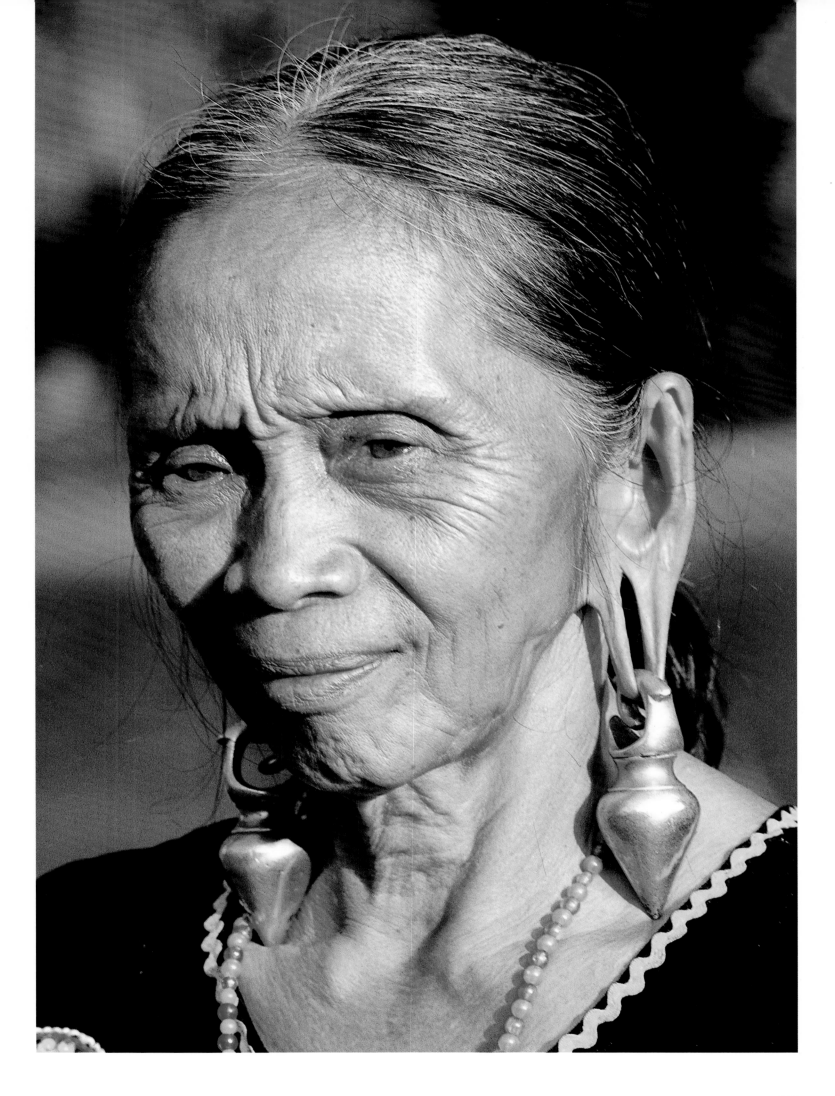

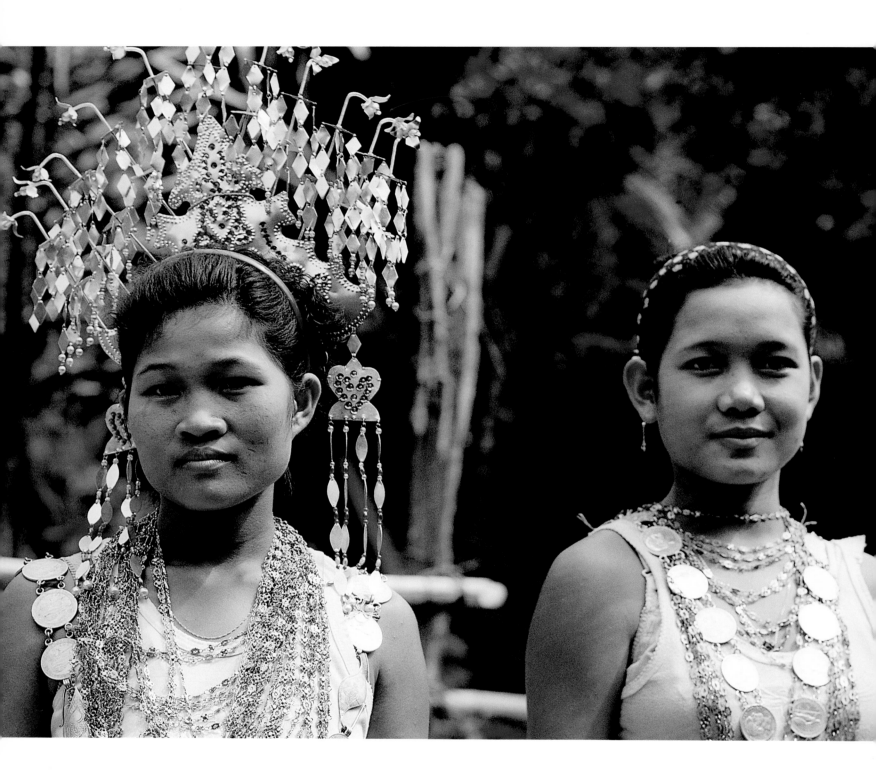

Jewelry of the Iban Dayak

Above: Young girls wearing ceremonial silver crowns and necklaces.

Right: Corset made of woven rattan bands with chains of silver coins.

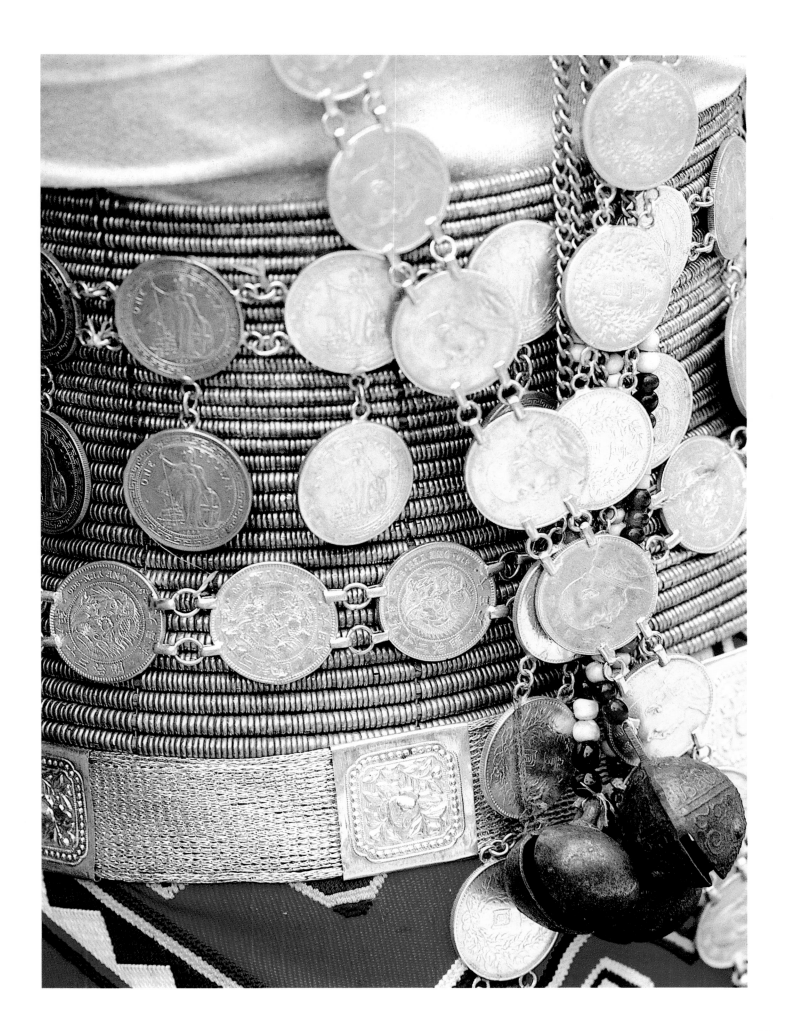

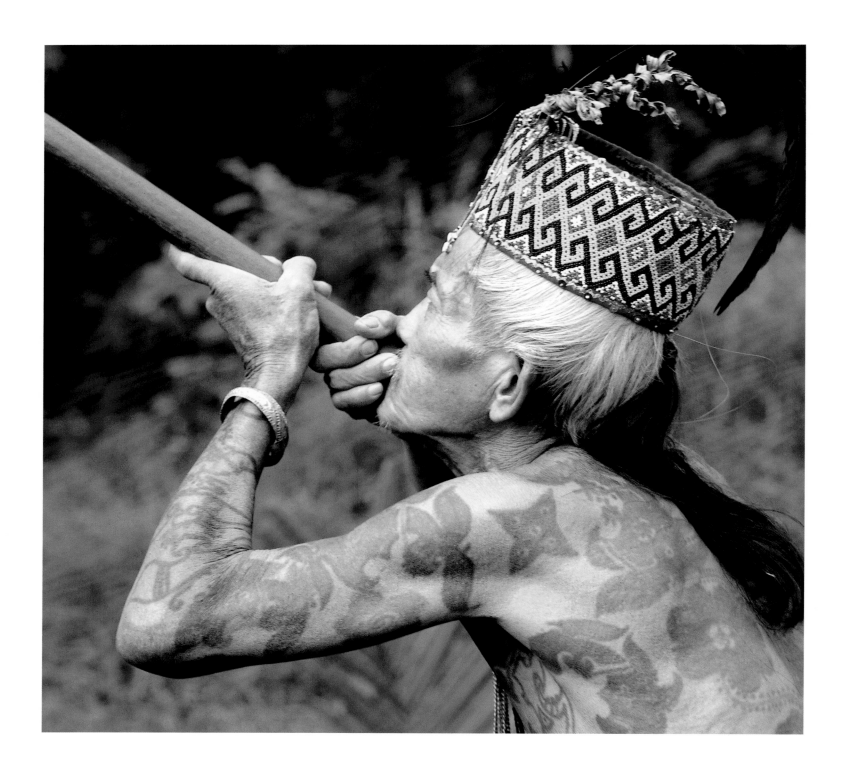

Dayak Tattoos

Tattooing is an important form of body decoration for the Iban; these tattoos are indicators of social status and particular achievements. Iban men used to earn the right to certain tattoos when they had carried out a successful headhunt, and women were permitted to tattoo their arms when they had made particularly beautiful ceremonial cloths.

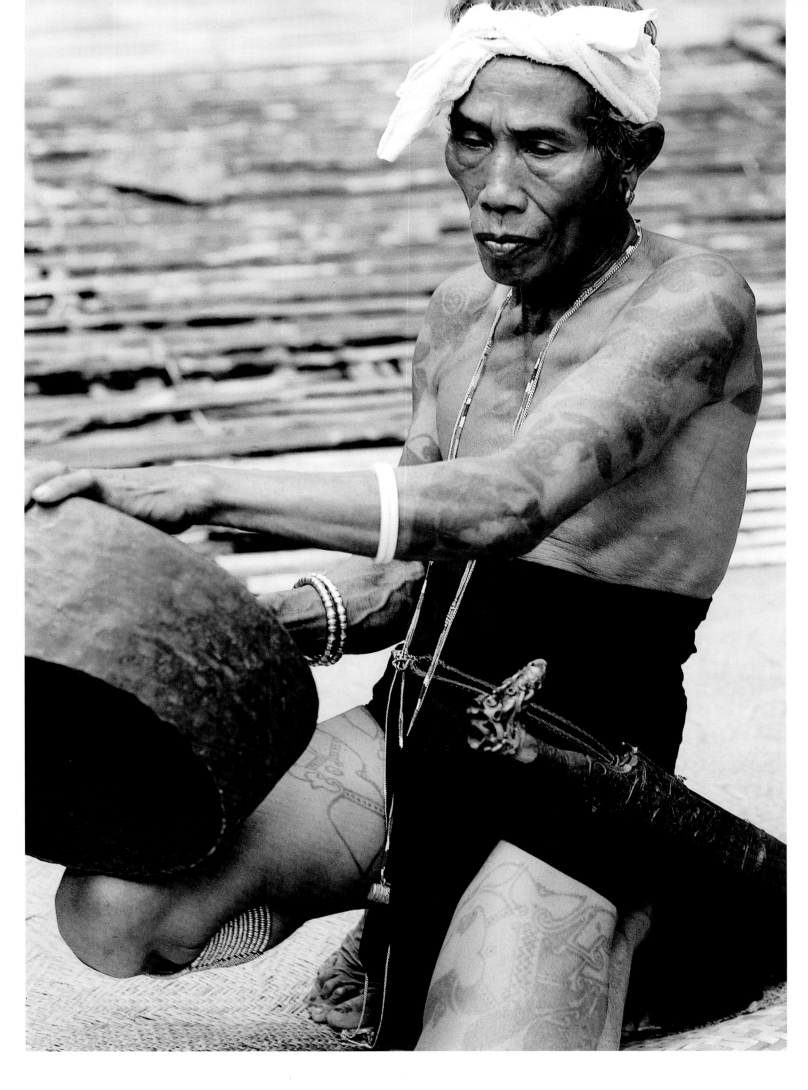

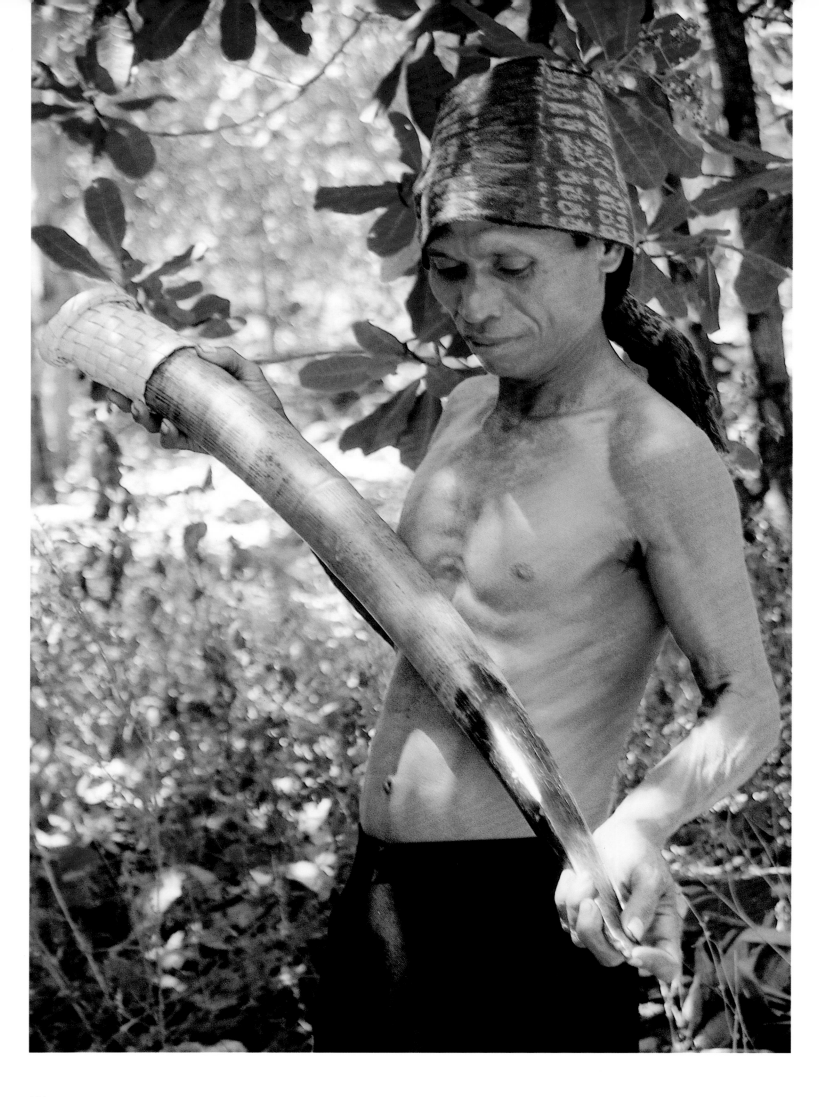

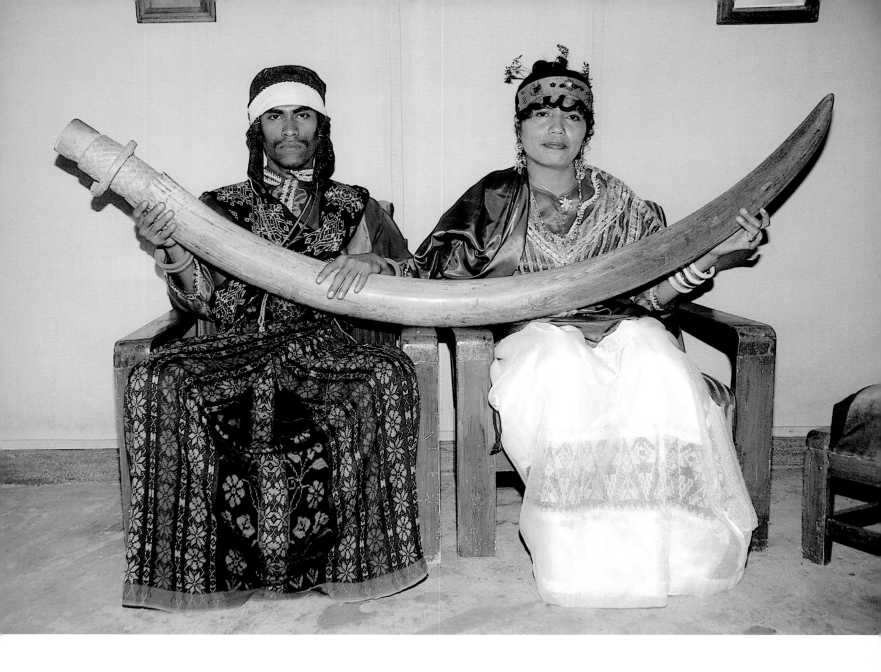

Antique Ivory

Opposite: On the island of Flores, elephant tusks are a major part of any bridal price; their value is judged by their length. They were originally acquired from East Africa in exchange for slaves.

Above: The large tusk on the lap of this couple dates from the sixteenth century and once belonged to the Raja of Sikka, in the centre of Flores. It is now in the Maumere Museum, Flores.

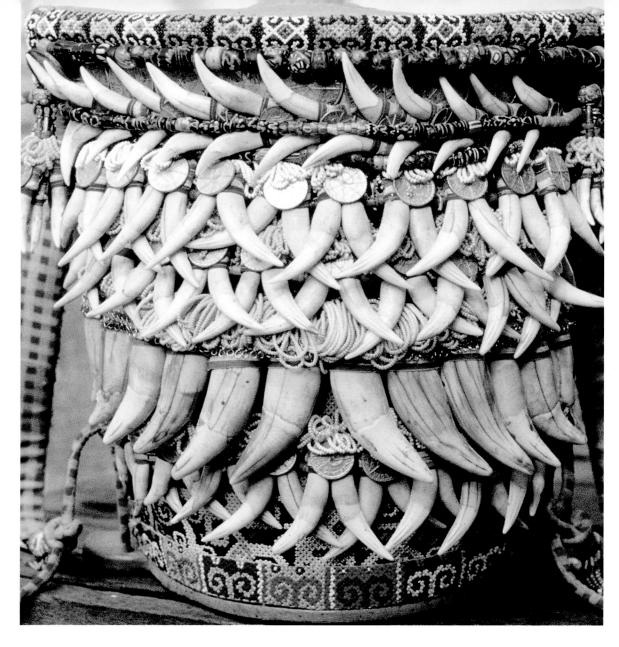

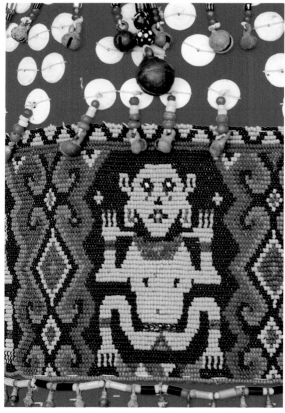

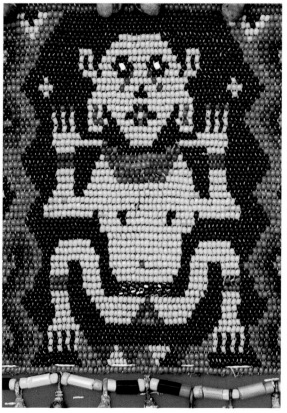

Beautiful Beadwork

Since the early twentieth century, the traditional pearl bead has had competition from the newer but less valuable glass (or even plastic) bead. The women of a number of Dayak tribes weave them together into fascinating patterns that are believed to serve the same kind of magical protective function as *ikat* textiles. Great imagination goes into the patterns of tiny glass beads that are used to decorate baskets or wide flat sun-hats; the bead patterns are a typical feature of ceremonial costumes and are also used to decorate the unusual baby baskets that are sometimes the most valuable piece of property that a family possesses.

The Kelabit, Kenyah and Kayan peoples call this type of baby basket a *ba*; mothers use them to carry their babies around on their backs during the first few months after birth. The framework for the basket is usually made of woven rattan, which is then decorated with a complex fabric of beads. Magical amulets made of old beads, shells or animal teeth are often loosely attached; the slightest movement creates a rattling noise that is meant to keep evil spirits at a healthy distance. The bead patterns also indicate the social status of the baby's parents. The *ba* of a noble family will be decorated with a human figure or the *asu* (dog-dragon) motif, while lower-ranking tribal members use geometric patterns. An experienced seamstress will take several months to create a major piece of beadwork.

Opposite, above: Kayan baby basket with beaded decoration and a lavish selection of animal teeth from bears, snow leopards and crocodiles.

Opposite, below: Glass bead decoration with a stylized human figure, shell discs and little bronze bells.

Right, above: Baby basket with beaded fabric, large antique beads and protective amulets in the form of bronze bells.

Right, centre: A representation of the Aso river in glass beads and cowrie shells.

Right, below: Detail of an apron in beaded fabric with stylized abstract motifs.

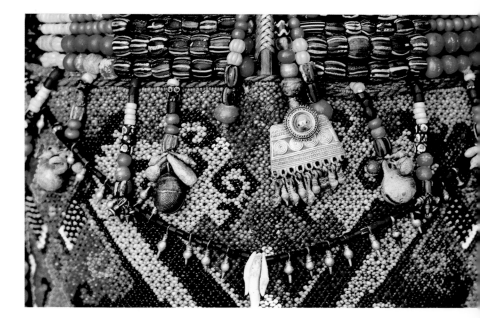

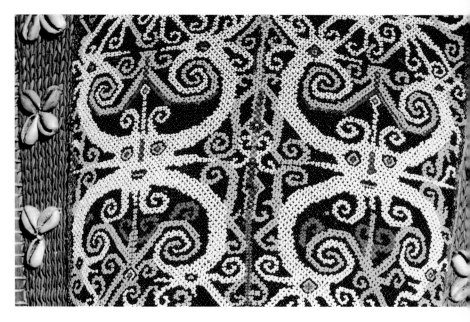

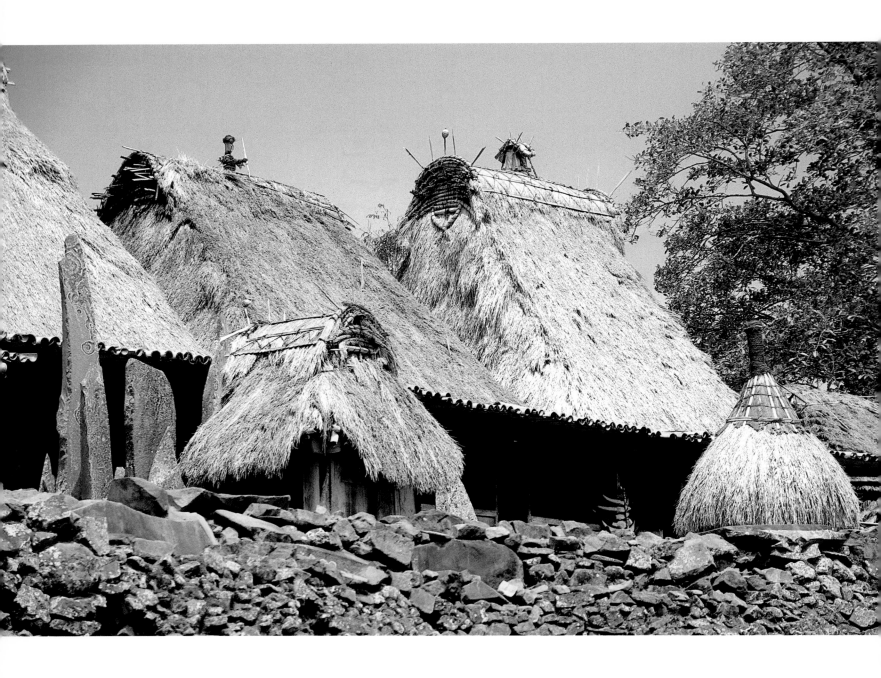

Adat Houses

Adat law is still held sacred in these traditional clan houses on the eastern islands. They are holy places where gold jewelry, ivories, bronzes and textiles are stored, true treasure houses that derive their spiritual power from the long, uninterrupted lines of descent going back to mythical ancestors. They symbolize the cosmos with its three levels: Down at the bottom live the animals, on the middle platform lives man, and the area under the roof is the realm of the ancestors and gods.

Above: A traditional village of the Bajawa on the island of Flores with ancient standing stones and small ancestor shrines. Some houses have protective figures on the rooftops. The groups of standing stones serve to mark the places where the elders of the village hold their assemblies.

Opposite: A Sumba house with a striking roof built from bamboo and ylang-ylang grass (*Cananga odorata*). The higher the roof, the higher the status of its residents. The standing stones in the foreground still have important ritual functions.

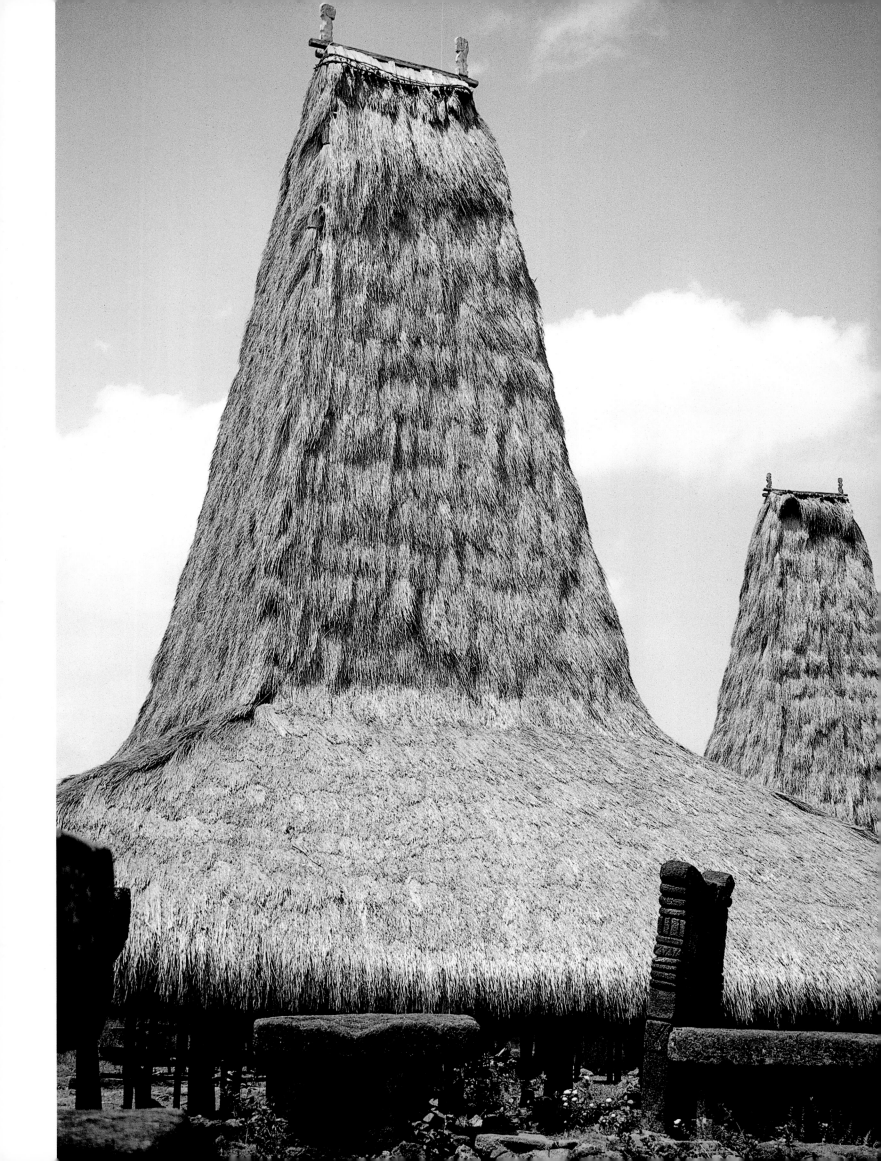

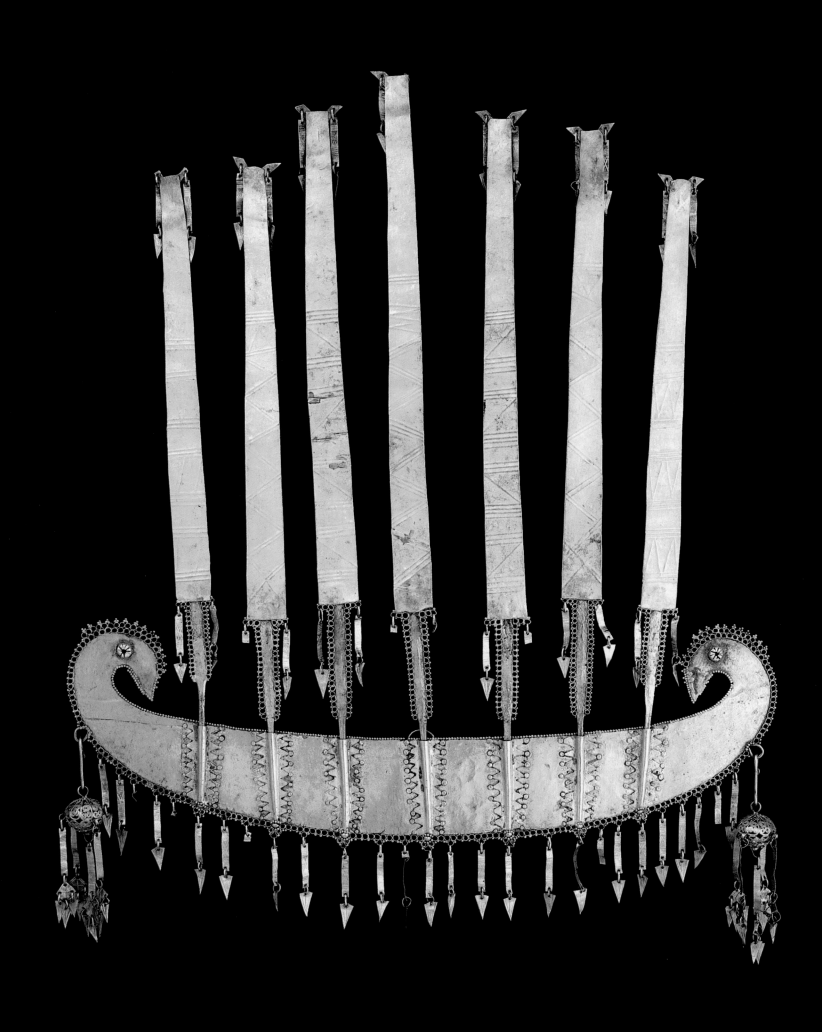

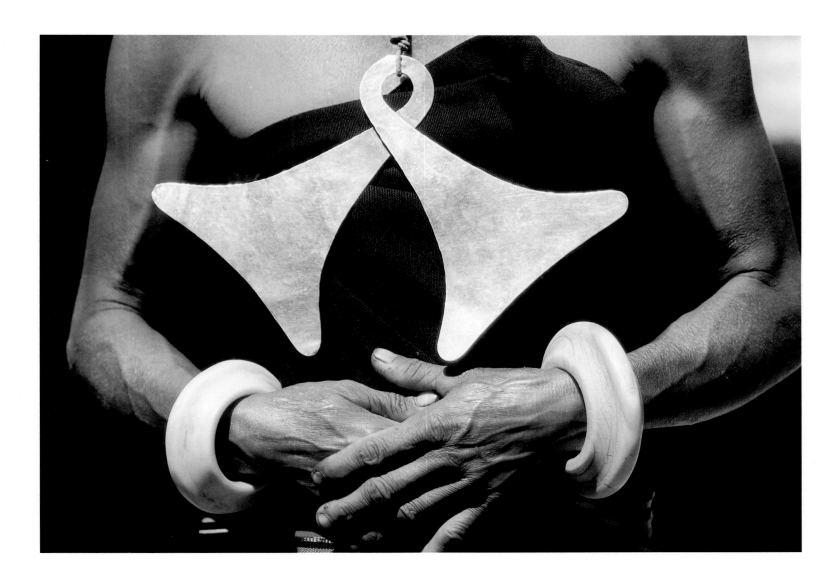

Golden Treasures

To possess the finest works of the goldsmith's art was very largely the exclusive privilege of the noble Raja families of Flores and Sumba. These valuable heirlooms were kept in the *adat* houses and passed down from father to son. The most precious of these were considered sacred, as they were part of the paraphernalia of the divine ancestors, who had endowed them with supernatural power. They are symbols of wealth and power and some still function as ritual currencies of exchange. The gold was obtained from melted-down colonial coins that were originally obtained from the Dutch in exchange for sandalwood and horses.

Above: A noblewoman from East Sumba wearing a piece of solid gold jewelry known as a *marangga*, and ivory bangles. Before putting the jewelry on, she must ask her ancestors for permission to do so.

Opposite: This particularly beautifully worked gold crown was worn for important ceremonial gatherings by a Raja from the Nage region in central Flores. Some authors believe that the prototype for this kind of headdress was derived from representations of feather crowns similar to those that can be seen on the famous old bronze drums or kettle gongs.

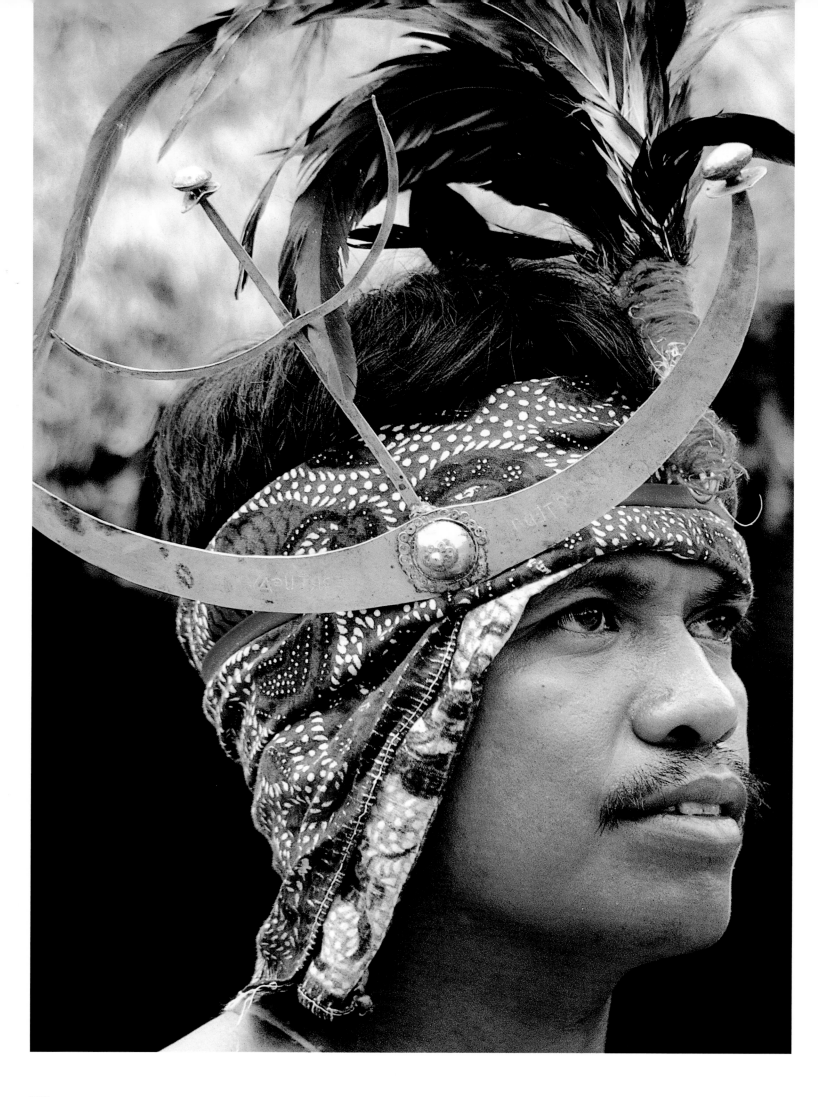

Symbols of the Moon

These dancers from East Timor are wearing a traditional island ornament on their forehead or temple. It is made of gold alloy and is in the shape of a crescent moon. In the Tetum language, this kind of jewelry is known as a *kaibuk* and it symbolizes the moon, the partner of the sun, shedding its light upon the earth during the night. It is an indicator of the wearer's social status and is often depicted on the wooden panels of the ancient Belu houses.

Overleaf:
Dancers in ritual dress with long swords from the treasure chest of the Raja of Besikama, one of the last representatives of the ancient kingdom of Wehali. This small town lies on the south coastal plain of Timor and was once the ritual centre of the island. Wehali society was strongly matriarchal.

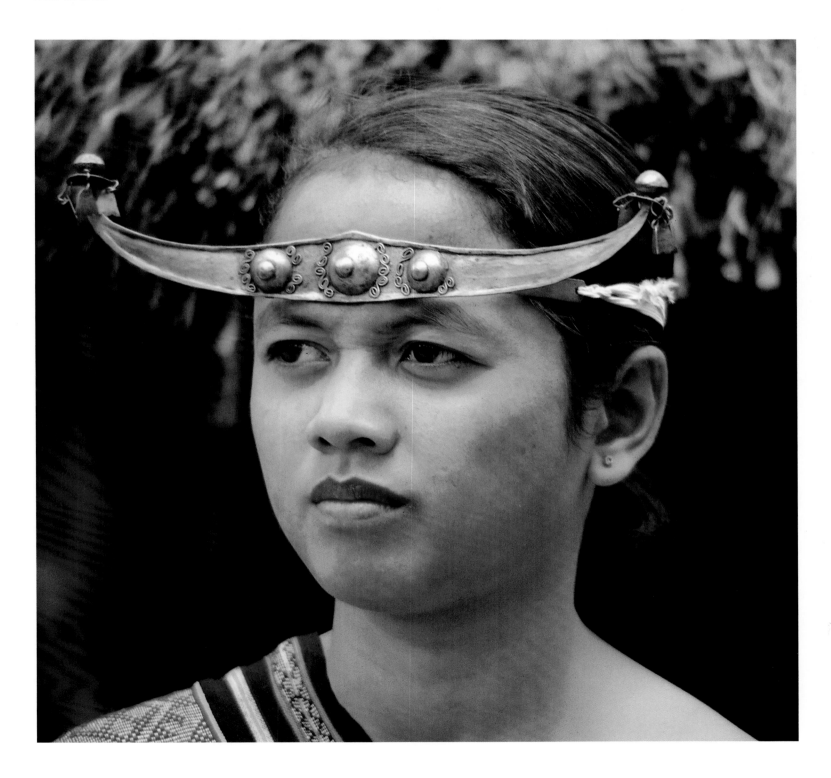

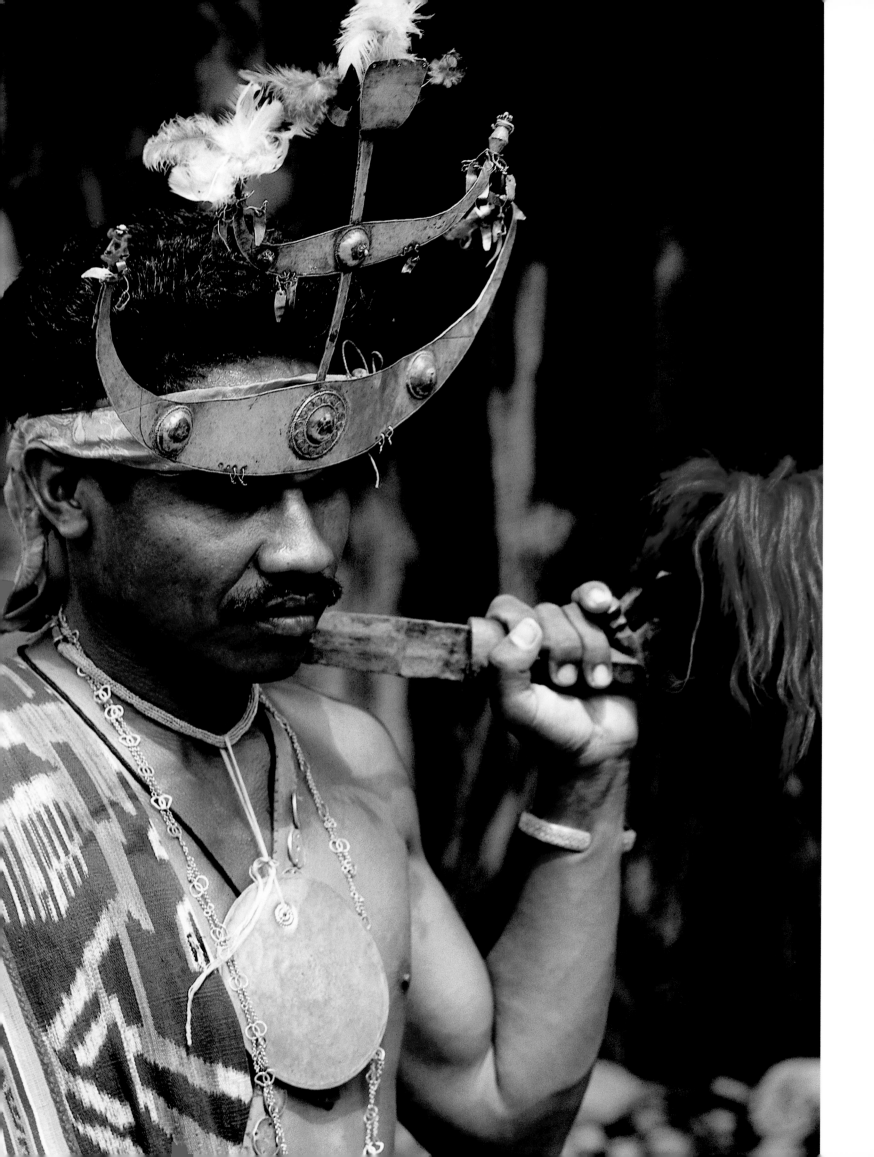

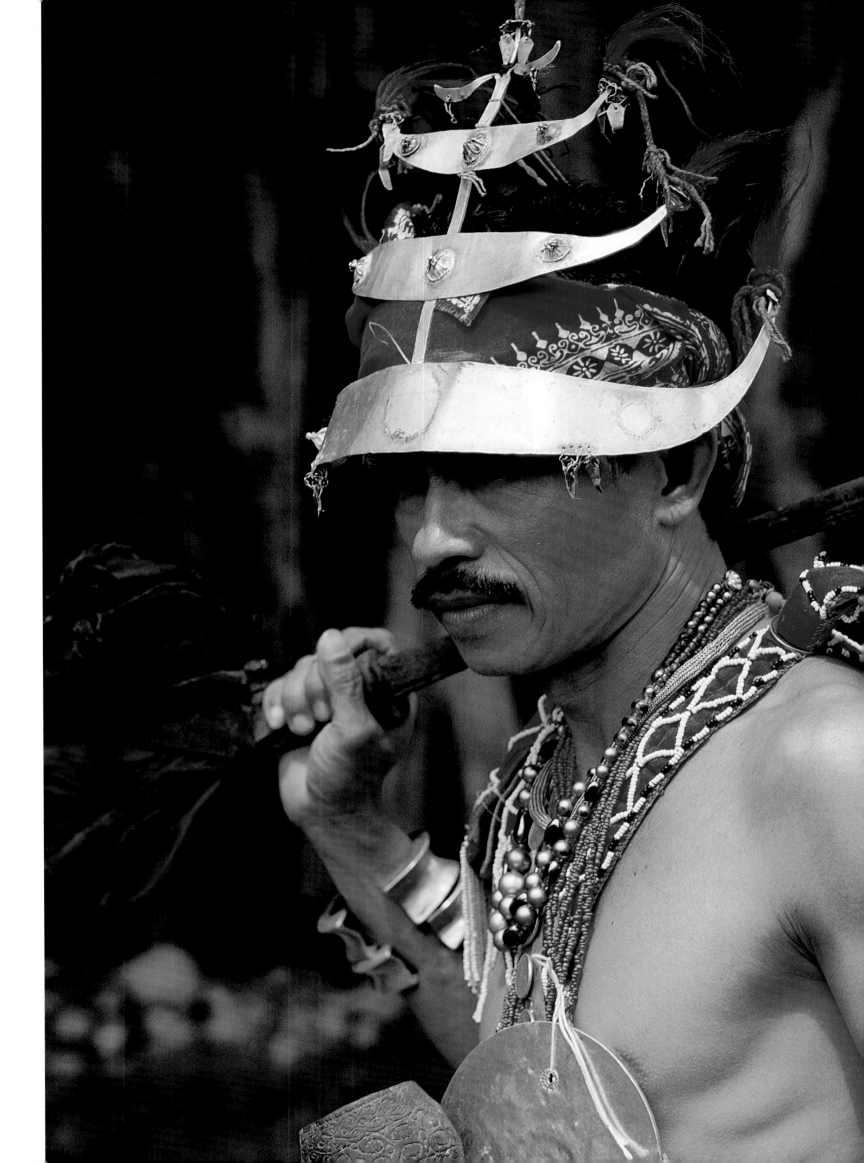

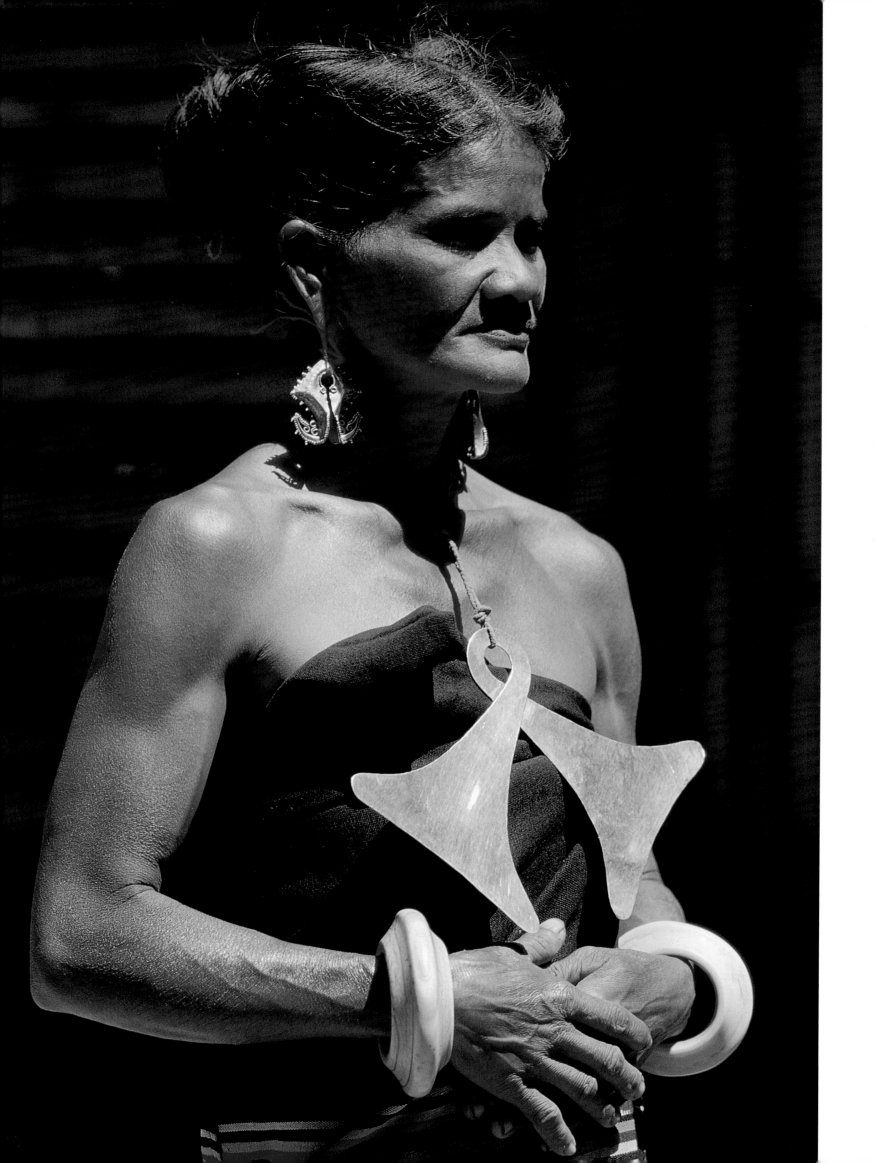

Rituals of Giving and Taking

A complex network of symbolic exchange relationships, sometimes going back over several generations, govern human relationships on the eastern Indonesian islands. The old *adat* traditions determine the course that life will take, which groups of clans will 'give' wives and which clans will 'receive' wives. Every marriage is based on a ritual exchange of gifts and on the rights and duties that are derived from this exchange. The relatives of the bride receive precious jewelry and elephant tusks, while the bridegroom's family receives valuable *ikat* textiles. Typical exchanges once included boats, pigs or slaves.

Opposite and right, above: Married women wear the *mamuli*, a piece of jewelry typical of the people of Sumba, that is worn as a pendant around the neck or on the ear. A woman will receive this piece of jewelry either on the death of her mother or as a bridal gift from her husband. The *mamuli* is omega-shaped and symbolizes the female sexual organ. Its own particular magical power promotes fertility and protects the wearer from illness. It also helps priests to make contact with ancestral spirits.

Right, below: A richly decorated stone stela on a grave in East Sumba, featuring *marangga*, *kaibuk* and *mamuli* symbols in striking relief. The motifs suggest that the deceased was a member of a noble family.

Overleaf:
Gold objects are symbols of masculine power. Gold symbolizes the sun because it 'burns' with a holy and dangerous heat. The value of gold is even measured in terms of this 'heat', which must be 'cooled' with sacrificial gifts and rituals. Gold objects are passed down through ancestral lines of descent that are mythical in origin.

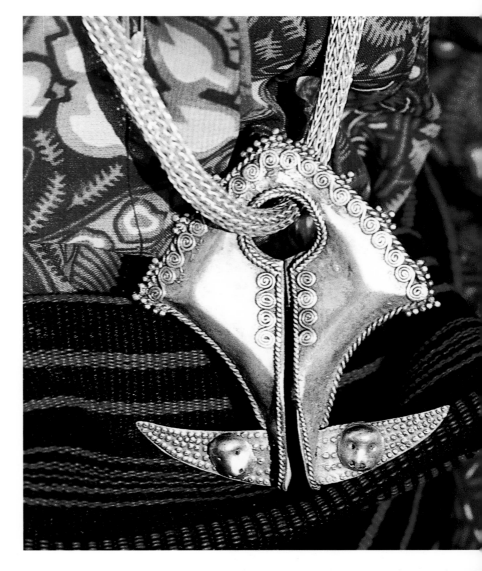

Golden Symbols

From top left to bottom right:
A *lamba*, or gold forehead decoration in the form of a water buffalo's horns; Sumba.

A *kantara*, or solid gold chain, with two *marangga* shapes at its ends; East Sumba.

A *mamuli*, an earring or pendant with warrior figures in sheet gold; Sumba.

A *marangga* (pectoral) in 18-carat sheet gold, intended to be worn on a ceremonial gold chain or *kantara*; Tanimbar.

A disc-shaped gold pectoral with a stylized face; Tanimbar.

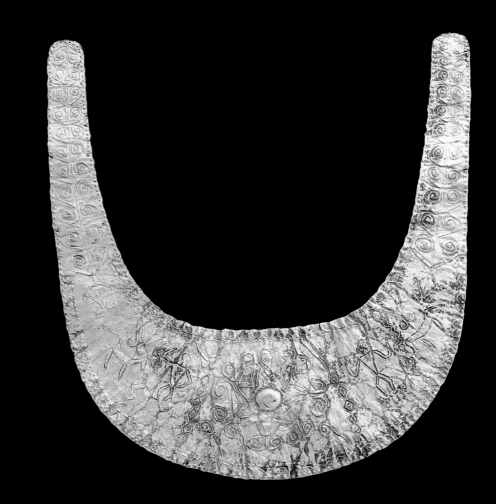

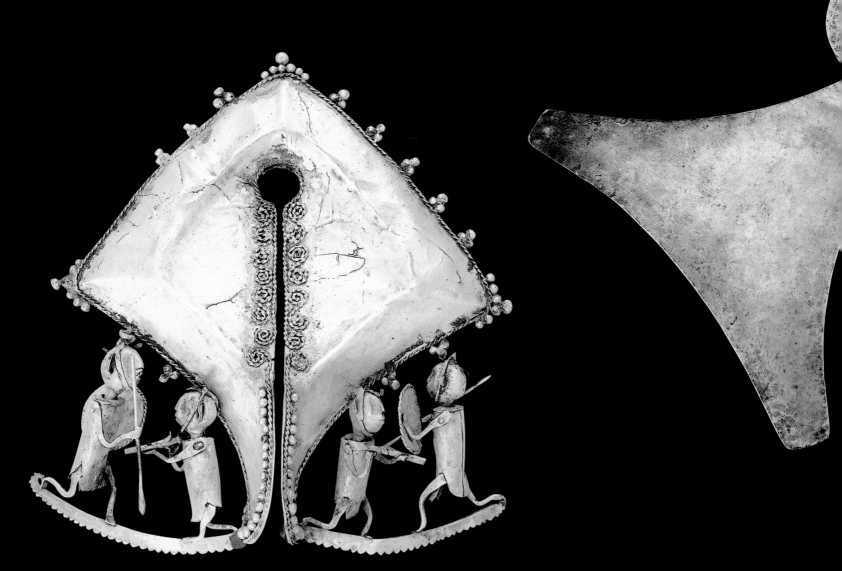

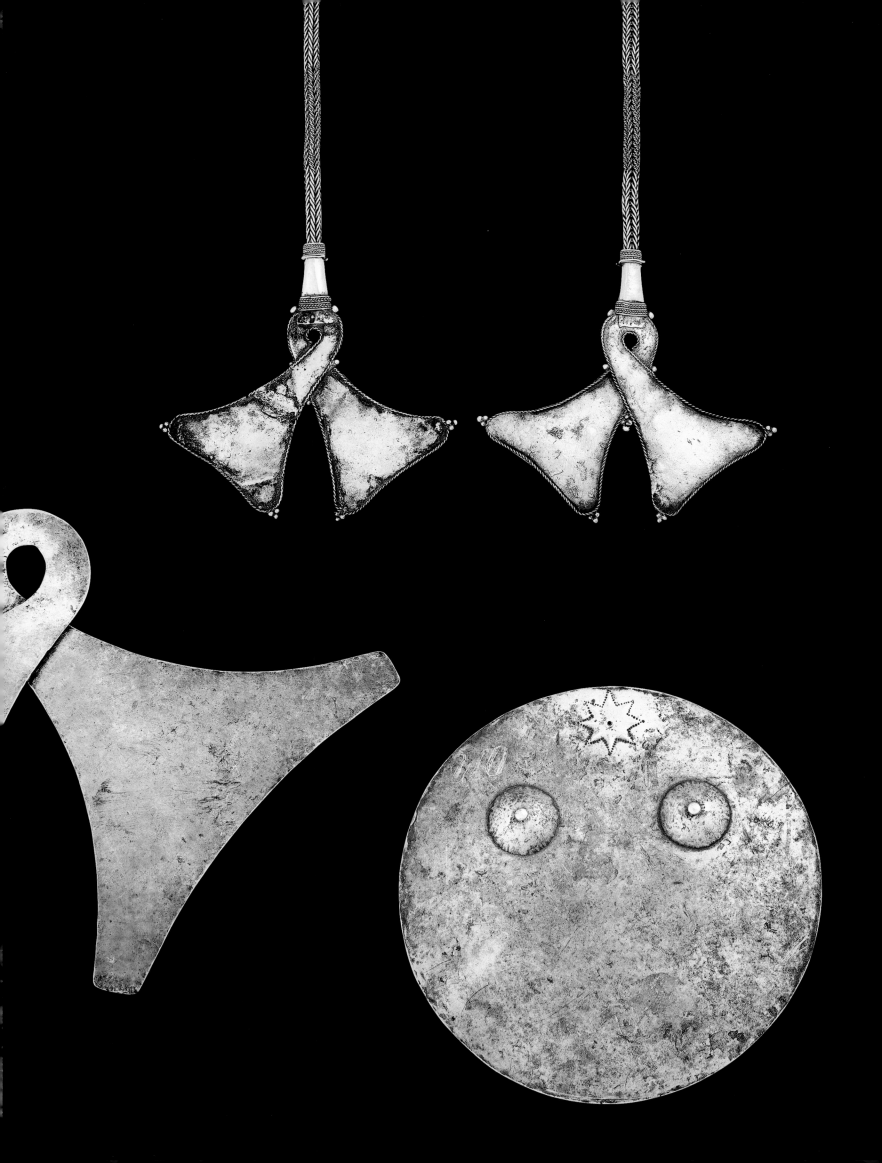

Acknowledgments

I originally intended to write a book about the art forms of tribal Asia, but despite a number of attempts, this never came to fruition. However, the unfulfilled wish finally bore fruit in this collaboration with my good friend Robert Schmid, to whom I owe a special debt of thanks for his excellent organizational skills.

It would be impossible for me to thank by name all the many people to whom I owe a debt of gratitude for helping me, actively or in an advisory capacity, in the course of my thirty years of travels through Asia. The names of a number of friends who accompanied me on difficult journeys, and who have made photographs available to us, appear in the picture credits. Among those who supported me and showed me hospitality during my work in India, I wish to offer heartfelt thanks to John R. Edwards and his wife Oreno, who comes from Nagaland, and to Srikant Mishra from Bhubaneshwar in Orissa.

I would also like to thank the Cultural Department of Upper Austria and the Viktor Adler Foundation for the small sums of money that enabled me to fund one of the many minor projects necessary for the completion of this book.

Last – but by no means least – my deepest thanks go to my children Alexander and Claudia, and to my wife Ilse, not only for the lively commitment that they brought to our travels, but also for having faith that we would one day see this book in print.

Fritz Trupp

Had it not been for the support of my partner Marion Schützenhofer and her understanding for my life as a modern nomad, I would never have had the strength to get through my intensive travel programme as successfully as I did.

My nineteen years of travel all over Asia have nurtured many friendships, some of which have literally been life-savers. My sincerest thanks go to my loyal travelling companions Efried Malle, Oswald Bendl, Alfred Sabitzer, Andreas Schürz and Manfred Poor, without whose help this book would never have been written.

Robert Schmid

Picture Credits

Photos from Asia:
Edwards, John R.: pp. 122, 123
Friedhuber, Sepp: pp. 202 left, 203 right
Hummer, Gerhard: pp. 270–71
Hutticher, Hans: pp. 169, 174
Kirchgäßner, Ditmar: pp. 276, 281, 284
Laub, Eugen: p. 302 above
Marechau, Pascal: pp. 20, 41
Moritz, Wolfgang: pp. 277, 279
Ploner, Ingrid: pp. 24, 32
Schmid, Robert: pp. 76, 78, 79, 81, 82, 89, 98, 116 above, 117, 118 below, 119, 126, 128, 129, 130 centre, 131, 132, 133, 136, 137, 140, 142, 148, 149, 152, 154, 155 above, 158, 159, 160, 176, 177, 179 below, 202 centre, 212, 213, 216, 217, 218, 220, 221, 222, 223, 224, 226, 227, 228, 229, 230, 231, 235 right, 236, 238, 242, 243, 246, 247, 248, 249, 250, 251, 252, 253, 254, 255, 256, 257, 258, 259, 260, 261, 262, 263, 272, 273, 274, 275, 278, 280, 282, 283, 286, 288 centre, 295
Trupp, Alexander: pp. 205, 304
Trupp, Claudia: p. 204
Trupp, Fritz: pp. 10, 14–19, 21, 22, 23, 25, 27, 28, 30, 31, 34–37, 42, 48–75, 78, 80, 83–88, 90–97, 102–115, 116 below, 118 above, 120, 121, 124, 125, 127, 130, 134, 141, 142, 150–53, 155, 156–59, 162–68, 170–72, 174, 175, 177, 178, 179 above, 180–84, 190–201, 206, 207, 209–11, 215, 225, 232–35, 285, 288, 289, 290, 294, 296–301, 302 below, 303, 305, 307, 308–13
Trupp, Ilse: pp. 26, 214, 219

Photos of objects in private collections:
Humer, Helmut: pp. 38, 40, 41, 138, 139, 208
Schepe, Christian: pp. 29, 265, 291, 292, 293, 306, 314, 315
Weissenegger, Alfred: p. 237

Graphics:
Elwin, Verrier (1959): p. 101
Ratzel, Friedrich: pp. 144, 240, 241, 268
Fischer, Joseph: p. 266

Jewelry from private collections:
Museum Schmiding: pp. 138–39, 208, 237
Private collection, Kuching: pp. 302–3
Private collection: p. 209
Funke collection: pp. 306, 314–15
Konzett collection: pp. 264, 291–93
Trupp collection: pp. 29, 38, 40–41, 54

Bibliography

BARBIER, Jean-Paul, *Art of Nagaland: The Barbier-Mueller Collection, Geneva*, exhibition catalogue, Los Angeles County Museum of Art, Los Angeles, 1984

BARBIER, Jean-Paul, and NEWTON, Douglas (eds.), *Islands and Ancestors: Indigenous Styles of Southeast Asia*, Munich, 1988

BARTHEL, Hellmuth, *Mongolei – Land zwischen Taiga und Wüste*, Gotha and Leipzig, 1971

BAUMER, Christoph, *Tibet's Ancient Religion: Bön*, trans. Michael Kohn, Trumbull, Conn., 2002

BERNATZIK, Hugo Adolf, *Akha and Miao: Problems of Applied Ethnography in Farther India*, trans. Alois Nagler, New Haven, 1970

BERNATZIK, Hugo Adolf, *The Spirits of the Yellow Leaves*, trans. E. W. Dickes, London, 1958

BERTRAND, Gabrielle, *Secret Lands Where Women Reign*, London, 1958

BIDDER, Irmgard and Hans, *Filzteppiche, ihre Geschichte und Eigenart*, ed. Peter Thiele, Braunschweig, 1980

BODROGI, Tibor, *Art of Indonesia*, Greenwich, Conn., 1972

BOREL, France, *The Splendour of Ethnic Jewelry*, London, 1994

BRAUNS, Claus-Dieter, and LÖFFLER, Lorenz G., *Mru: Hill People on the Border of Bangladesh*, trans. Doris Wagner-Glenn, Basel and Boston, 1989

BUTOR, Michel, *Adornment: Jewelry from Africa, Asia and the Pacific*, London, 1994

DAUM, Werner (ed.), *Yemen: 3000 Years of Art and Civilisation in Arabia Felix*, Innsbruck and Frankfurt, 1988

DOSHI, Saryu, *Tribal India: Ancestors, Gods and Spirits*, Bombay, 1992

ELWIN, Verrier, *The Art of the North-East Frontier of India*, Shillong, 1959

ELWIN, Verrier, *The Tribal Art of Middle India*, London, 1951

FELDMAN, Jerome (ed.), *The Eloquent Dead: Ancestral Sculpture of Indonesia and South-East Asia*, Los Angeles, 1985

FISCHER, Eberhard, and PATHY, Dinanath, *Murals for Goddesses and Gods: the Tradition of Osakothi Ritual Painting in Orissa, India*, New Delhi, 1996

FISCHER, Joseph, *Threads of Tradition: Textiles of Indonesia and Sarawak*, Los Angeles, 1979

FISHER, Nora (ed.), *Mud, Mirror and Thread: Folk Traditions of Rural India*, Santa Fe, 1993

FOX, James J. (ed.), *Religion and Ritual: Indonesian Heritage*, Singapore, 1998

FÜRER-HAIMENDORF, Christoph von, *The Naked Nagas, Head-Hunters of Assam in Peace and War*, Calcutta, 1946

FÜRER-HAIMENDORF, Christoph von, *Himalayan Barbary*, London, 1956

GABRIEL, Hannelore, *Jewellery of Nepal*, London, 1999

GANGULI, Milada, *Naga Art*, New Delhi, 1993

GANGULI, Milada, *A Pilgrimage to the Nagas*, New Delhi, 1984

GRÖNING, Carl (ed.), *Decorated Skin: A World Survey of Body Art*, London, 2001

GRUNFELD, Frederic V., *Wayfarers of the Thai Forest: the Akha*, Amsterdam, 1982

HAASE, Gesine, and HÖPFNER, Gerd, *Metallschmuck aus Indien*, Museum für Völkerkunde, Berlin, 1978

HAM, Peter van, and STIRN, Aglaja, *Buddhas Bergwüste. Tibets geheimes Erbe im Himalaya*, Graz, 1999

HAM, Peter van, and STIRN, Aglaja, *The Seven Sisters of India: Tribal Worlds Between Tibet and Burma*, Munich, London and New York, 2000

HÖRIG, Rainer, *Selbst die Götter haben sie uns geraubt. Indiens Adivasi kämpfen ums Überleben*, Göttingen, Vienna and Berne, 1990

HUYLER, Stephen P., *Village India*, New York, 1985

JACOBS, Julian, *The Nagas: Hill Peoples of Northeast India. Society, Culture and the Colonial Encounter*, London, 1990

JAIN, Jyotindra, and AGGARWALA, Aarti, *National Handicrafts and Handlooms Museum, New Delhi*, Middletown, NJ, 1989

JAIN, Jyotindra, and SARABHAI, Mallika, 'Ornaments', in Dhamija, Jasleen (ed.), *Crafts of Gujarat*, New York, 1985

JANATA, Alfred, *Schmuck in Afghanistan*, Graz, 1981

JONGE, Nico de, and DIJK, Toos van, *Forgotten Islands of Indonesia: The Art and Culture of the Southeast Moluccas*, Singapore, 1995

KENNARD, Jefferson S., 'Timorese Tribal Bracelets', in *Arts of Asia*, Hong Kong, July–August 1995

KEYES, Charles F., *The Golden Peninsula: Culture and Adaptation in Mainland Southeast Asia*, Honolulu, 1995

KORTLER, Fritz, *Altarabische Träume. Pilgerreise in eine andere Welt und eine andere Zeit*, Wörgl, 1982

KREISEL, Gerd, *Rajasthan – Land der Könige*, exhibition catalogue, Linden-Museum, Stuttgart, 1995

KUBITSCHECK, Hans-Dieter, *Südostasien. Völker und Kulturen*, Berlin, 1984

KUNSTADTER, Peter (ed.), *Southeast Asian Tribes, Minorities, and Nations*, 2 vols., New Jersey, 1967

LEBAR, Frank M., HICKEY, Gerald C., and MUSGRAVE, John K. (eds.), *Ethnic Groups of Mainland Southeast Asia*, New Haven, 1964

LEIGH-THEISEN, Heide, *Der südostasiatische Archipel. Völker und Kulturen*, exhibition catalogue, Museum für Völkerkunde, Vienna, 1985

LEIGH-THEISEN, Heide (ed.), *Indonesien. Kunstwerke – Weltbilder*, exhibition catalogue, Oberösterreichisches Landesmuseum, Linz, 1999

LEWIS, Paul and Elaine, *Peoples of the Golden Triangle: Six Tribes in Thailand*, London, 1984

LOUDE, Jean-Yves, and LIÈVRE, Viviane, *Kalash Solstice: Kalash Winter Festivals in Northern Pakistan*, Islamabad, 1987

MARÉCHAUX, Pascal and Maria, *Yemen*, London, 1998

MÜLLER, Claudius C., and HEISSIG, Walter (eds.), *Die Mongolen*, Innsbruck and Frankfurt, 1989

MÜLLER, Claudius C., and RAUNIG, Walter (eds.), *Der Weg zum Dach der Welt*, Innsbruck, 1982

NIGGEMEYER, Hermann, *Kuttia Kond. Dschungelbauern in Orissa*, Munich, 1964

NOVGORODOVA, E. A., *Drevniaia Mongoliia*, Moscow, 1982

POSTEL, Michel, *Ear Ornaments of Ancient India*, Bombay, 1989

POURRET, Jess G., *The Yao: The Mien and Mun Yao in China, Vietnam, Laos and Thailand*, London, 2002

RAJAB, Jehan S., *Silver Jewellery of Oman*, Tareq Rajab Museum, Kuwait, 1997

RATZEL, Friedrich, *Völkerkunde*, 2 vols., Leipzig and Vienna, 1895

RICARD, Matthieu and Föllmi, Olivier and Danielle, *Buddhist Himalayas: People, Faith and Nature*, London, 2002

RODGERS, Susan (ed.), *Power and Gold: Jewelry from Indonesia, Malaysia and the Philippines from the Collection of the Barbier-Mueller Museum*, Munich, 1985

ROSS, Heather Colyer, *Bedouin Jewellery*, Fribourg, 1981

ROWELL, Galen, *Mountains of the Middle Kingdom: Exploring the High Peaks of China and Tibet*, San Francisco, 1983

SCHEFOLD, Reimar, *Spielzeug für die Seelen. Kunst und Kultur der Mentawai-Inseln*, Zurich, 1980

SCHEFOLD, Reimar (ed.), *Indonesia in Focus: Ancient Traditions – Modern Times*, London, 1988

SCHENK, Amelie, *Schamanen auf dem Dach der Welt. Trance, Heilung und Initiation in Kleintibet*, Graz, 1994

SCHINDLER, Manfred, and SCHUBERT, Johannes, *Roter Fluss und blaue Berge. Durch Dschungel und Urwald von Assam*, Leipzig, 1960

SCHMID, Robert, and BENDL, Oswald, *Die letzten Nomaden. Vom Leben und Überleben der letzten Hirtenvölker Asiens*, Graz and Vienna, 1997

SCHREYER, Claudia, 'Ethnischer Schmuck im hinduistischen Himachal Pradesh', degree dissertation, Vienna, 1996

SCHUSTER, Gerhardt W., *Das Alte Tibet. Geheimnisse und Mysterien*, St Pölten, Vienna and Linz, 2000

SELLATO, Bernard, *Hornbill and Dragon: Kalimantan, Sarawak, Sabah, Brunei*, Jakarta and Kuala Lumpur, 1989

SHARMA, Lakshmi C., *Census of India 1961: Himachal Pradesh: Gold and Silver Ornaments. Rural Craft Survey*, Bombay, 1967

SIBETH, Achim, *The Batak: Peoples of the Island of Sumatra*, London, 1991

SOMARÉ, Grata, and VIGORELLI, Leonardo, *The Nagas: Disciplined Forms of Beauty*, Bergamo, 1992

STEINMANN, Axel, *Blickfänge – Schmuck aus Nordafrika*, exhibition catalogue, Museum für Völkerkunde, Vienna, 1995–96

STOCKHAMMER, Sonja, 'Der Schleier. Der Schleier in der abendländischen Tradition und der Gesichtsschleier des Orients', degree dissertation, Linz, 1996

Tanimbar Maliku: The Unique Moluccan Photographs of Petrus Drabbe, Alphen aan den Rhin, 1995

TAUBE, Erika and Manfred, *Schamanen und Rhapsoden. Die geistige Kultur der alten Mongolei*, Vienna, 1983

THESIGER, Wilfred, *Arabian Sands*, London, 1959

THIEL, Erich, *Die Mongolei. Land, Volk und Wirtschaft der mongolischen Volksrepublik*, Munich, 1958

TICHY, Herbert, *Himalaya*, trans. Richard Rickett and David Streatfeild, London, 1971

TSULTEM, N., *Mongolian Arts and Crafts*, Ulan Bator, 1987

TUCCI, Giuseppe, *The Religions of Tibet*, trans. Geoffrey Samuel, London, 1980

UHLIG, Harald, 'Einführung. Südostasien und der Austral-pazifische Raum', in *Südostasien – Austral-pazifischer Raum*, Frankfurt, 1975

UNTRACHT, Oppi, *Traditional Jewellery of India*, London, 1997

VÖGLER, Gisela (ed.), *Die anderen Götter. Volks- und Stammesbronzen aus Indien*, Cologne, 1993

WALD, Peter, *Yemen*, trans. Sebastian Wormell, London, 1996

WATERSON, Roxana, *The Living House: An Anthropology of Architecture in South-East Asia*, Oxford and New York, 1990

WEIHRETER, Hans, *Schätze der Menschen und Götter. Alter Goldschmuck aus Indien*, Augsburg, 1993

WEIR, Shelagh, *The Bedouin*, British Museum, London, 1990

WIGGERS, Frank, *Indonesian Tribal Gold*, Jakarta, 1998

WINDISCH-GRAETZ, Stephanie and Ghislaine, *Himalayan Kingdoms: Gods, People and the Arts*, New Delhi, 1982

WUTT, Karl, *Pashai. Landschaft – Mensch – Architektur*, Graz, 1981

ZACKEN, Wolfmar. *Galerie Zacke. Alter exklusiver Schmuck aus Indien und Tibet sowie indischer Amulettschmuck*, Vienna, 1989

ZAINIE, Carla, *Handicraft in Sarawak*, Kuching, 1969

Index

KYRGYZ

PASHAI
KALASH

TIBETAN PEOPLES

HUNZA

BANJARA
BISHNOI
RABARI
BHIL

ARABIAN
BEDOUINS

KHON
BONDO
GADA
SAOR

GOND

YEMENITES